CARAVAGGIO

& HIS FOLLOWERS IN ROME

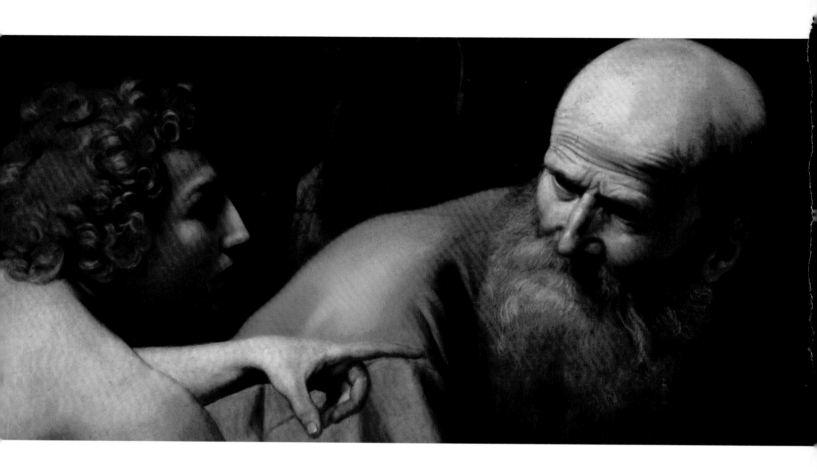

DAVID FRANKLIN & SEBASTIAN SCHÜTZE

CARAVAGGIO

& HIS FOLLOWERS IN ROME

YALE UNIVERSITY PRESS NEW HAVEN & LONDON
IN ASSOCIATION WITH
THE NATIONAL GALLERY OF CANADA, OTTAWA,
AND THE KIMBELL ART MUSEUM, FORT WORTH

Published in conjunction with the exhibition
Caravaggio and His Followers in Rome organized by
the National Gallery of Canada and the Kimbell Art Museum,
and presented in Ottawa from 17 June to 11 September 2011,
and in Fort Worth from 9 October 2011 to 8 January 2012.

Supported by the Department of Canadian Heritage through the
Canada Travelling Exhibitions Indemnification Program

Published by Yale University Press, New Haven and London,
in association with the National Gallery of Canada, Ottawa

NATIONAL GALLERY OF CANADA
Acting Chief of Publications: Ivan Parisien
Editor: Lauren Walker
Photo-editor: Andrea Fajrajsl
Translators: Donald Pistolesi, Käthe Roth

Printed in Italy by Conti Tipocolor, Florence

FRONTISPIECE
Michelangelo Merisi da Caravaggio, *Sacrifice of Isaac*, 1601–02,
Galleria degli Uffizi, Florence. Detail of cat. 52.

COVER/JACKET ILLUSTRATION
Michelangelo Merisi da Caravaggio, *The Gypsy Fortune Teller*, 1595,
Pinacoteca Capitolina, Rome. Detail of cat. 13.

Library of Congress Cataloging-in-Publication Data
Franklin, David, 1961–
 Caravaggio and his followers in Rome / David Franklin.
 p. cm.
 Catalog of an exhibition held at the National Gallery of Canada,
Ottawa, June 17, 2011–Sept. 11, 2011 and at the Kimbell Art Museum,
Fort Worth, Tex., Oct. 9, 2011–Jan. 8, 2012.
 Includes bibliographical references and index.
 ISBN 978-0-300-17072-6 (cloth : alk. paper)
 ISBN 978-0-88884-891-8 (paper : alk. paper)
 1. Caravaggio, Michelangelo Merisi da, 1573–1610–Exhibitions.
 2. Caravaggio, Michelangelo Merisi da, 1573–1610–
influence–Exhibitions. I. Caravaggio, Michelangelo Merisi da,
1573–1610. II. National Gallery of Canada. III. Kimbell Art Museum.
IV. Title.
 ND623.C26A4 2011
 759.5–dc23
 2011017190

Also published in French under the title: Caravaggio et les peintres
caravagesques à Rome
 ISBN 978-0-88884-892-5 (paper : alk. paper)

CONTENTS

LENDERS TO THE EXHIBITION

THE NATIONAL GALLERY OF CANADA and the Kimbell Art Museum are grateful to the following institutions whose generous loans made this exhibition possible:

Apsley House, London
Art Gallery of Ontario, Toronto
Barbara Piasecka Johnson Collection Foundation
Blanton Museum of Art, University of Texas at Austin
Capitolini – Pinacoteca Capitolina, Rome
Collection Speed Art Museum, Louisville Kentucky
Detroit Institute of Arts
Fondazione de Studi de Storia dell'Arte Roberto Longhi, Florence
Galleria Borghese
Galleria degli Uffizi, Florence
Galleria Palatina, Palazzo Pitti, Florence
Galleria, Museo e Medagliere Estense, Modena, Italy
Kimbell Art Museum, Fort Worth, Texas
Koelliker Collection
Kunsthistorisches Museum, Vienna
Kunstmuseum Basel, Switzerland
Los Angeles County Museum of Art, Los Angeles
Memphis Brooks Museum of Art, Memphis, Tennessee
The Metropolitan Museum of Art, New York
Musée du Louvre, Paris
Musei di Strada Nuova, Genoa
Musei Vaticani, Vatican City

Museo Civico Ala Ponzone, Cremona, Italy
Museo di Capodimonte, Naples
Museo Nacional del Prado, Madrid
Museo Thyssen Bornemisza, Madrid
Museu Nacional de Arte Antiga, Lisbon
National Gallery of Art, Washington
National Gallery of Canada, Ottawa
National Gallery of Scotland, Edinburgh
National Gallery, London
The National Museum of Art, Architecture and Design, Oslo
North Carolina Museum of Art, Raleigh
Palazzo Reale, Naples
Philadelphia Museum of Art
Philbrook Museum of Art, Tulsa, Oklahoma
Royal Picture Gallery Mauritshuis, The Hague
Saint Louis Art Museum
Strasbourg, Musée des Beaux-Arts
The Art Institute of Chicago
The John and Mable Ringling Museum of Art
The Nelson-Atkins Museum of Art, Kansas City, Missouri
Toledo Museum of Art
Wadsworth Atheneum Museum of Art, Hartford, Connecticut
Walters Art Museum, Baltimore, Maryland
Worcester Art Museum, Massachusetts

FOREWORD

MICHELANGELO MERISI DA CARAVAGGIO IS the most
contemporary-seeming of the Old Masters, and an exhibition on his
legacy needs no justification. *Caravaggio and His Followers in Rome* explores
the creation of a new style of painting, a set of common practices and
references derived from the master's art. It also reveals the individual voices
of the painters who adopted this common language. This is an exhibition
literally about *looking*: first, about Caravaggio's engagement with the world,
the product of his practice of painting after the life. Second, it is about the
attentive, sustained engagement of other painters with his work and, thanks
to his example, with the world. The *Caravaggisti* have for too long been
dismissed as mere followers, not the sophisticated viewers and makers of art
they were. They are our precursors, the first interpreters of Caravaggio's work.

The exhibition tells two parallel stories, charting both Caravaggio's
development through the course of his years in Rome, and the varied
responses to this work over the next decades. A thematic approach permits
us to witness the creation and dissemination of new subjects and the
transformation of older imagery under Caravaggio's radical influence in
early seventeenth-century Rome. We hope this challenging and stimulating
display will allow us to see the paintings with fresh eyes, encouraging close
looking. Ideally, visitors will imagine themselves as painters – bringing an
artist's eye to the works, seeing the dynamic exchange between model and
response that is fundamental to this art.

We wish to thank the many public and private collections, which lent
so generously. The exhibition will, we hope, introduce new audiences to
their paintings and inspire new ways of thinking about them – a kind
of recompense for the owners' generosity in temporarily parting with
their works.

We would also like to express our gratitude to the Canadian Association of
Petroleum Producers for their generous support in presenting this exhibition
at the National Gallery of Canada. The Italian Embassy in Ottawa has also
contributed invaluable assistance throughout the development of this show.

Finally, we should like to thank David Franklin, formerly Chief Curator at
the National Gallery and now Director of the Cleveland Museum of Art, and
Sebastian Schütze, Professor and Chair, Department of Art History at the

University of Vienna. *Caravaggio and His Followers* is theirs – the product of their creative vision and scholarship. Their achievement is remarkable. The National Gallery of Canada has a long tradition of supporting scholarship of the highest calibre, and we are grateful to Francesca Cappelletti, Nancy E. Edwards, Christopher Etheridge, Michael Fried, Sandra Richards, and Rossella Vodret for their insightful contributions to the catalogue. From the Kimbell Art Museum, we would like to acknowledge Malcolm Warner, Deputy Director, and Nancy E. Edwards, Curator of European Art, whose critical reflection and thoughtful collaboration have been essential to the success of this exhibition.

An exhibition is the work of many people, and we wish to close by acknowledging the dedication and creativity of the staff at both the National Gallery of Canada and the Kimbell Art Museum.

Marc Mayer
Director,
National Gallery of Canada

Eric M. Lee
Director,
Kimbell Art Museum

ACKNOWLEDGEMENTS

DAVID FRANKLIN and Sebastian Schütze wish to express their gratitude to all those who assisted them in their work, especially the following:

Monique Baker-Wishart
Patricia Bertolli
Claire Berthiaume
Jean-Francois Bilodeau
Alexandra Buchanan
Stefan Canuel
Jean-François Castonguay
Alessandro Cecchi
Danielle Chaput
Keith Christiansen
Judy Ciccaglione
Karen Colby-Stothart
Brian D'Argaville
Marina Daimon
Nelda Damiano
Patty Decoster
Sonia Del Re
Virginie Denis
Béatrice Djahanbin
Christine Dufresne
Sybille Ebert-Schifferer
Christopher Etheridge

Andrea Fajrajsl
Sylvia Ferino Pagden
Gordon Filewych
Anne-Louise Fonseca
Jonathan Franklin
Christine Gendreau
Stephen Gritt
Sergio Guarino
Berthold Hub
Liz Johnson
Suzanne Haddad
Michael Horvitz
Gabriel Jones
Jackie Kelling
Elisabeth Kieven
Anna Kindl
Petra Lamers-Schütze
Eric Lee
Stéphane Loire
Gillian Malpass
Danielle Martel
Isabelle Martiliani
Patrick Matthiesen
Marc Mayer
Christine Minas Heise
Lorenza Mochi Onori
Antonio Natali
Ivan Parisien

Scott Patterson
Donald Pistolesi
Wolfgang Prohaska
Geoff Rector
Alfred M. Rankin, Jr.
Antonia Reiner
Fanny Reiner
Megan Richardson
Käthe Roth
Christine Sadler
Claire Schofield
Karl Schütz
Greg Spurgeon
Ilana Steele
Claudio Strinati
Gudrun Swoboda
Serge Thériault
Alana Topham
Anne Troise
Mariella Utili
Lise Villeneuve
Rossella Vodret
Lauren Walker
Malcolm Warner
Diane Lafrance Watier
Clovis Whitfield

CONTRIBUTORS TO THE CATALOGUE

Curatorial Committee

David Franklin
Director, Cleveland Museum of Art,
 Cleveland

Sebastian Schütze
Professor of Art History, University
 of Vienna

With contributions from

Francesca Cappelletti
Professor of Modern Art History,
 University of Ferrara

Nancy E. Edwards
Curator of European Art, Kimbell
 Art Museum

Christopher Etheridge
Curatorial Assistant, International
 Art, National Gallery of Canada,
 Ottawa

Michael Fried
J.R. Herbert Boone Professor of
 Humanities and the History of
 Art, The Johns Hopkins
 University

Sandra Richards
Sobey Research Fellow, National
 Gallery of Canada 2005–2007

Rossella Vodret
Superintendant, Special Directorate
 for Historical, Artistic and Ethno-
 Anthropological Heritage and for
 the Museums of the City of Rome

and the assistance of

Nelda Damiano
National Gallery of Canada, Ottawa

THE PUBLIC CARAVAGGIO

DAVID FRANKLIN

THIS EXHIBITION REVOLVES ON CARAVAGGIO as an artist working for private collectors in Rome and so it seems sensible by way of general introduction to describe his documented public career with a consideration of the paintings that could not travel.[1] To review his early life: the artist was baptized on 30 September 1571 in Milan, though his ancestors came from Caravaggio – a town about 40 kilometres east of Milan in the province of Bergamo.[2] His parents were Fermo Merisi, a builder and Lucia Aratori. In April 1584, the young apprentice entered the workshop of Simone Peterzano, who may have been a Titian pupil, in a contract that tied him to the master for four years.[3] His father had died in 1577 and his mother was dead before the end of 1590. Caravaggio is last documented in Milan in 1591 and 1592.

While there are no early documents for the artist, he is assumed to have reached Rome in the summer of 1592, after which point secondary sources provide all we know about him for a time. Caravaggio passed through several workshops initially in Rome until he met Cavaliere d'Arpino who provided a more serious and sustained environment. He seems to have practiced as a still-life specialist painter in that workshop, and this talent presumably facilitated his entry into the art scene in Rome. There he painted his first independent works. Whether by necessity or by design Caravaggio appears to have executed many of his initial paintings without formal contracts, typically combining single, or at least small numbers of figures with still-life elements, and attempted to sell them through dealers. Thus paintings from these relatively humble origins, including the *Cardsharps* (cat. 17) and the *Fortune Teller* (cat. 13), introduced a new genre to Rome that attracted such powerful patrons as Vincenzo Giustiniani and the cardinals Francesco Maria del Monte and Federico Borromeo. As incredible as it now seems he was not able to sell all these early works. In 1607 the possessions of Cavaliere d'Arpino were seized by Pope Paul V and among the paintings, later given to Scipione Borghese, were the *Sick Bacchus* and *Boy with a Basket of Fruit*, also in the Borghese. Presumably they either quietly remained in the master's studio when Caravaggio was part of the workshop or the older artist purchased them himself.[4] Caravaggio's name only first appears in a written document dateable around 1595 in the list of brothers of the painter's academy available to assist in the orations of the Forty Hours Devotion held at the Pantheon on the first Sunday of each October in honour of Saint Luke.[5] By the second half of the 1590s he was resident in the palace of Cardinal del Monte who owned a

facing page Michelangelo Merisi da Caravaggio, *Calling of Saint Matthew* (detail of fig. 1)

number of early works by Caravaggio, including the *Musicians*, now at the Metropolitan Museum of Art (cat. 1).

Essentially, Caravaggio's career in Rome spanned just one papacy, namely that of Ippolito Aldobrandini, who was elected as Clement VIII in 1592 and died in 1605.[6] He was an active and ambitious patron but had a preference for Tuscan artists and so the most innovative painters of the day like Caravaggio and Annibale Carracci did not receive his direct patronage. The closest thing to an official painter was Giuseppe d'Arpino, given *cavaliere* status by the Pope in 1600, who provided an important link for his one-time assistant Caravaggio to prominent art circles in Rome.

The Holy Year of 1600 was especially significant as more artists arrived in Rome to assist in the plethora of decorations required; the occasion was also the catalyst to complete palaces and churches, including Saint Peter's. The competition for commissions certainly intensified rivalries between artists. The Holy Year was also an important moment because it brought Caravaggio into the public domain for the first time with the order for the Contarelli chapel in the French national church of San Luigi dei Francesi. And so after nearly a decade of entirely private commissions during the 1590s, Caravaggio was launched into a public career. And not being Florentine or comfortable painting in fresco, it is clear that he was working against the prevailing taste and possibly doomed to a difficult time in the Rome of Clement VIII. But nothing could prepare one for the sheer turmoil of what transpired.

The Contarelli chapel would be the first of Caravaggio's six secure Roman church commissions, four of which were either substituted by the artist himself or rejected outright. His order for the two lateral paintings came on 23 July 1599 – no doubt with the renewed urgency of preparing for the Holy Year of 1600.[7] The chapel, dedicated to Saint Matthew, had a complex history dating back to the original contract for frescoes on the side panels, awarded to Girolamo Muziano as early as 1565. Cavaliere d'Arpino was later commissioned in 1591 for the vault frescoes, which he completed by 1593, as well as the lateral walls, which he did not properly commence. Caravaggio was eventually contracted to paint the side walls, presumably with d'Arpino's support, but also through the intervention of Cardinal del Monte who was part of the group responsible for seeing the chapel through to conclusion. He was paid 400 *scudi* for the two paintings and received the final instalment on 4 July 1600, indicating that they were in place by then.

The paintings survive in situ in the last chapel in the left nave before the high altar – a particularly prestigious location. These side paintings could sometimes be done in fresco in Roman churches so it is assumed there was a concession to Caravaggio's greater experience with painting on canvas. The paintings are set, typically for the period, in thick frames of coloured marble in a notably sumptuous effect.

The *Calling of Saint Matthew* (fig. 1) is arranged with a dramatic and energetic horizontal movement across the canvas from right to left. The inclusion of precisely seven figures suggests an attempt at compositional balance codified by Alberti in his *Della Pittura*. Christ is a strong, ample figure arriving mysteriously through a raking shard of diagonal light. Light is always a protagonist in Caravaggio's paintings and this aspect is present already in his earliest works. Christ's right hand beckons to Matthew to join the new faith in a pose famously recalling Michelangelo's *Creation of Adam*, while his open left hand gestures back towards the light source, so in addition to making an elegant pose of classical balance, he relates the second part of the narrative of his calling of Matthew instructed to carry out his mission in the world. Christ is portrayed in his canonical colours and is recognizable as a type but Matthew, with his hand on money, is not at all a familiar type for an apostle. Caravaggio intended to make the miracle personal to all viewers, particularly the well-to-do, as Matthew is richly dressed as a patrician tax collector with a belt and a coin in his hat but his affluence was insufficient protection for his life of trial and eventual martyrdom. He appears to fall backwards in surprise and confusion as his legs are ahead of his body. Two of his assistants concentrate greedily on their labour but the other young men closest to Christ react strongly, establishing a domino-like sequence from apathy to action. The figures would appear to be inside as there is a knob on the shutter which only makes sense in an interior space. The crude table on which they work in their improvised office contrasts with the majesty of the high altar table nearby in the real church. The insufficient faith of some and resignation to the power of Christ are the main themes in Caravaggio's treatment.

Compared with the private dignity and control of the *Calling* scene, the *Martyrdom of Saint Matthew* (fig. 2) is turbulent and painfully public. He would never again paint a work so complex. The dramatic execution is centralized on the canvas but recessed in the space for greater urgency and

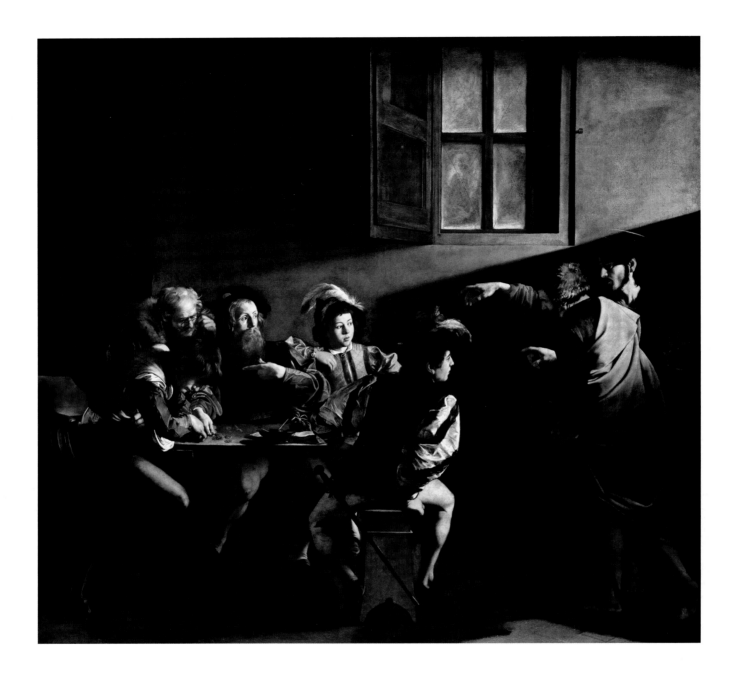

Fig. 1 Michelangelo Merisi da Caravaggio, *Calling of Saint Matthew*, 1599–1600, oil on canvas, 322 × 340 cm. Contarelli Chapel, San Luigi dei Francesi, Rome

dynamism. Blood spurts from the wound as Caravaggio depicts real violence of a kind he knew personally. If the *Calling* had a single flat viewpoint adjusted to the viewer's eye level, in the *Martyrdom* the artist wrestled with different pictorial spaces and times. There are many more figures and the space is layered and inclined to allow the viewer to catalogue all the action. The archaic Tau cross on the altar associated with the Old Testament is notable as the painter attempted to place the scene in an historic past.

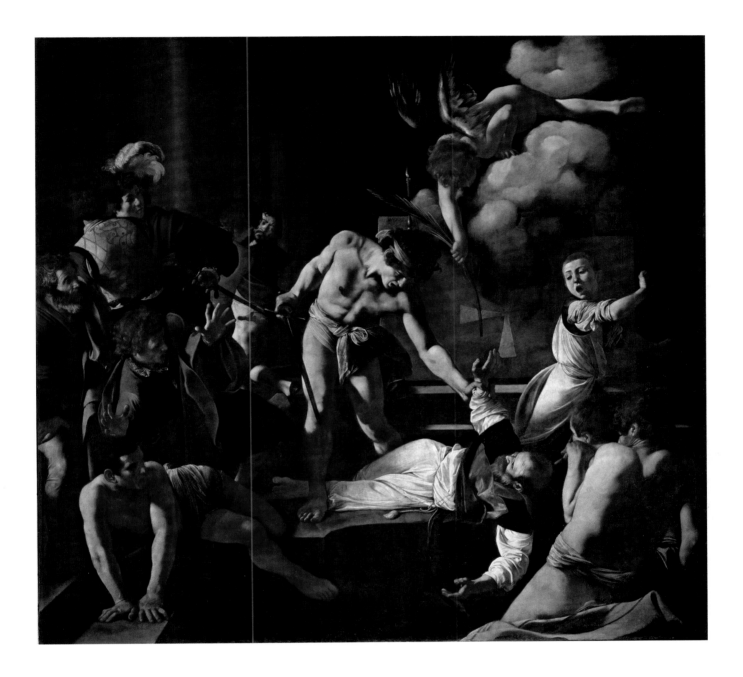

Fig. 2 Michelangelo Merisi da Caravaggio, *Martyrdom of Saint Matthew*, 1599–1600, oil on canvas, 323 × 343 cm. Contarelli Chapel, San Luigi dei Francesi, Rome

The divine is introduced with the contorted angel from whom Matthew takes the palm, thus another space is connected to the terrestrial ending with the baptismal tub. Of course, the image itself is a fiction that constitutes a different type of space, while the artist's self-portrait also brings the scene into the present. Even the painted altar extends the viewer's surroundings into a fictive transept parallel to the high altar to make the *Martyrdom* more vivid as it happens in our real space. The half-naked baptism candidates – their

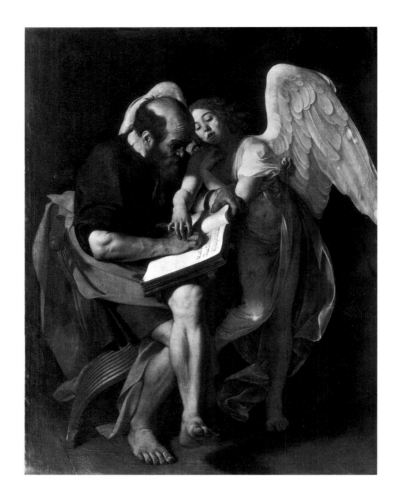

Fig. 3a Michelangelo Merisi da Caravaggio, *Saint Matthew and the Angel*, 1602. Formerly in Kaiser-Friedrich-Museum, Gemäldegalerie, Berlin (destroyed in 1945)

Fig. 3b (*facing page*) Michelangelo Merisi da Caravaggio, *Saint Matthew and the Angel*, 1602, oil on canvas, 296.5 × 195 cm. Contarelli Chapel, San Luigi dei Francesi, Rome

nudity a reminder of human frailty – recoil in horror at the tragedy that was to become a major theme in the artist's religious painting. The painting is also audible with the cry of the child – another consistent feature of Caravaggio's work.

On 7 February 1602 Caravaggio received a new contract for 150 *scudi* for the altarpiece in the Contarelli chapel featuring Saint Matthew. The first version (fig. 3a), destroyed in Berlin during the Second World War, was refused for its lack of decorum in the representation of the saint's legs and feet, establishing a pattern for his public work, but Caravaggio was allowed in this case to paint a second version immediately.[8] And by September 1602 the artist was given the balance due, at which point it can be assumed that the second version, which remains in situ, had been completed. *Saint Matthew and the Angel* (fig. 3b) features the saint writing his gospel at a precarious table with the assistance of an angel who, in the second version, appears in the sky rather than directly intervening with the action of composing. He is the largest figure in the entire chapel as he was given the appropriate emphasis.

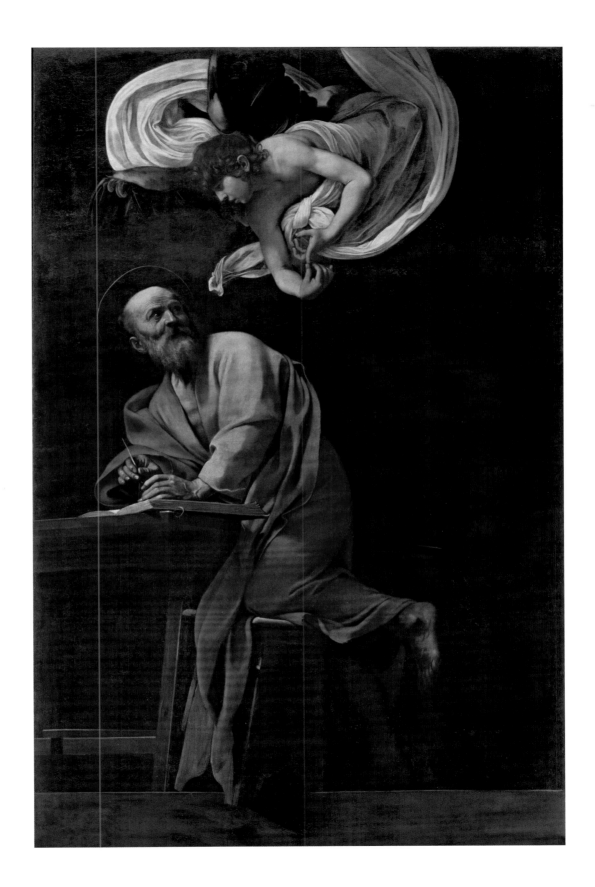

On 24 September 1600, shortly before the completion of the Contarelli chapel, Caravaggio signed a contract for his second major public commission in Rome with Tiberio Cerasi, treasurer to Pope Clement VIII, for his just-acquired chapel in the Augustinian church of Santa Maria del Popolo.[9] This commission was to produce two paintings, a *Conversion of Saint Paul* and a *Crucifixion of Saint Peter*, to be executed on cypress wood for a fee of 400 scudi, matching the first contract for the Contarelli chapel. As the works in the chapel are painted on canvas, Baglione's comment that the originals were rejected seems plausible in light of the alternate versions in existence, although this happened we know following the death of the original patron on 3 May 1601. The first version of the *Crucifixion* is still untraced, but what must be the first attempt at the Saint Paul painting survives in the Odescalchi collection (fig. 4). The design of this work is almost without parallel in Caravaggio's oeuvre, ambitiously dramatic and fantastically complex with a prominent landscape element, that would have been unique in his public painting had the work ever been installed. Paul is represented anonymously with red hair and a beard but his face is obscured by his hands except for his mouth crying out in shock. The reclining pose is here indebted to his counterpart in Michelangelo's Cappella Paolina fresco, though his debt was expunged in the second version. Christ descends accompanied by an angel from the upper corner as only a half-length – an overt feature of the narrative eliminated in the second attempt. The representation of his giant companion, a soldier with a Moorish crescent on his shield, who looks up but does not perceive Christ, is typical of Caravaggio's sensibility and one that would be retained in the second version of the design if in a different manifestation.

Caravaggio delivered the final two paintings on 10 November 1601, though for a reduced fee of 300 *scudi*, presumably a result of the change of materials and/or the missed deadline.[10] The altarpiece in the Cerasi chapel, features the *Assumption of the Virgin*, in honour of the chapel's new dedication, and was executed by Annibale Carracci, though the date of his work remains a matter for debate. The altar was formerly dedicated to Peter and Paul and this helps account for the choice of subjects for the side paintings, whose themes of conversion and martyrdom certainly also resonated in Rome around the Jubilee Year of 1600. Caravaggio's part in the decoration remains in situ and includes the two lateral canvases set in elaborate stucco frames deep in the chapel found in the transept left of the high altar. The chapel has a stepped

Fig. 4 Michelangelo Merisi da Caravaggio, *Conversion of Saint Paul*, 1600, oil on panel, 237 × 189 cm. Odescalchi Collection, Rome

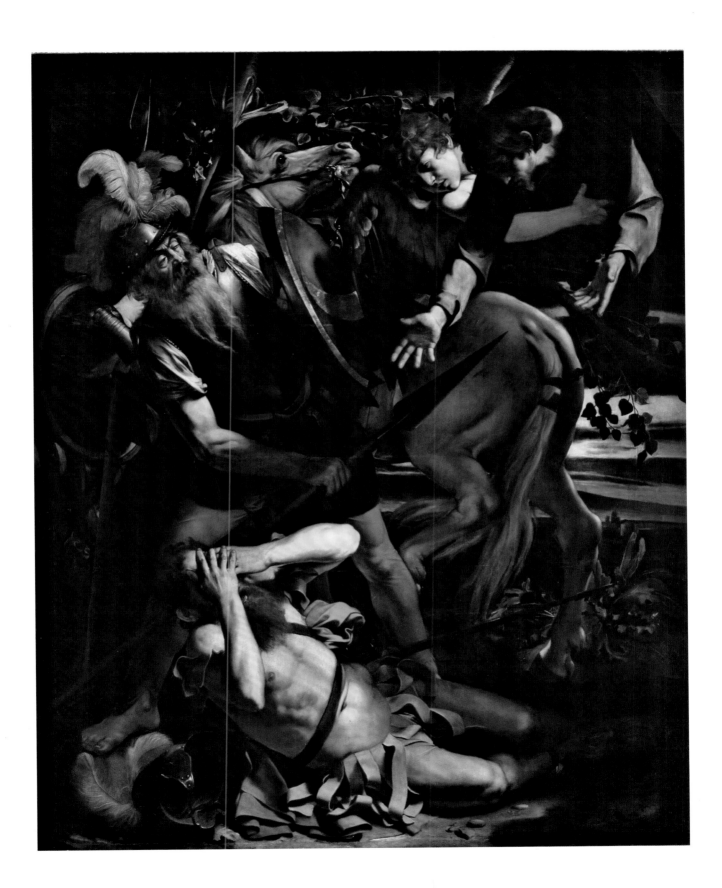

in arrangement, so the paintings are not that visible from the nave but discovered only when the visitor gains access to the altar area itself. The figures are of the same scale as in Annibale's altarpiece but it is not clear who influenced whom with regard to the gesture of the Virgin's and Paul's equally outstretched arms, though such respect for another artist seems furthest from Caravaggio's sensibility.

The *Conversion of Saint Paul* (fig. 6), found to the spectator's right, is dominated by the horse trying not to step on the prostrate saint, himself humbled like an animal. The animal knows instinctively what is occurring, unlike the servant who seems completely ignorant of the miracle happening before him. Typically for Caravaggio there is no witness to the event except the priest at the altar and by extension, the viewer. This picture is considerably quieter and more simplified than the first version. The face of the saint is not only more visible but youthful and thus more conventionally attractive, though it has to be said too that this well-dressed, tender young figure is still not an iconic type for this saint. The skilful virtuoso foreshortening of Saint Paul's body recalls the work of Andrea Mantegna and the Lombard tradition in which Caravaggio was trained. The image overall has a muted, pregnant air of revelation, almost suffocating in its intensity, though gentler than typical of his work.

The *Crucifixion of Saint Peter* (fig. 5), which is placed to the viewer's left, is by way of contrast almost painful to examine. The painting is arranged with aggressive diagonals and angular lines. The lengths of the nails used in the martyrdom are rendered visible in both the feet and hands reminding the spectator that Peter here shares his suffering with Christ, something reinforced by his white loincloth. For Caravaggio, tactility was one way he found truth in his art. Likewise, accuracy was his way of researching the past by making it seem visceral and present. Comparable with the *Conversion*, the two executioners are essentially faceless as the artist conveys a message of indifference to human suffering, preventing the viewer from expending hatred towards a visible, caricatured enemy. Again, there are no witnesses save for the spectator. The saint looks in the direction of the altar for some comfort but hope does not have an obvious presence in the picture. Only the light suffusing the image represents the promise of salvation and eternal joy. Hence, through brutal suffering and abandonment the painter delivers revelation on the human condition and the fathomless depth of faith. There is evident

strain in the action, but everything seems stilled, apodictic; and there is no action in the traditional sense, an approach that no doubt puzzled contemporary observers as much as the attitude towards subject matter. Here we witness Caravaggio making a public event into an intimate personal vision as if we could enter into the mind of the suffering protagonist.

Caravaggio is one of those few artists whose biography told without embellishment makes for captivating reading. In only the second document mentioning his name in Rome, he was cited in a judicial review document of 1597 involving an assault near San Luigi dei Francesi.[11] During the preliminary investigation, Caravaggio confirmed that he lived with Cardinal del Monte and was friends with Prospero Orsi and the Greek-born picture seller Costantino Spata. The enquiry was dropped and the artist never was called to give evidence. But this was not his last involvement with an investigation. The violent behavioural issues that eventually overshadowed his life as an artist were documented already early in his career. On 3 May 1598 he was incarcerated following his arrest near Piazza Navona for going about Rome carrying a sword in flagrant disregard of the ban on weapons in the city – not the first time he would be caught for this offense.[12] During the deposition concerning his arrest, he mentioned that he resided with del Monte with his own servant and a stipend. On more than one occasion, he would require the protection of powerful individuals such as the cardinal to escape punishment, though eventually he put himself in a position where no-one could help him. Despite some initial public success in this period after 1600 with the completion of the Contarelli and Cerasi commissions, the painter continued to court trouble. In November 1600 Girolamo Stampa from Montepulciano, a student of the Accademia di San Luca, accused the artist of assaulting him with a sword and rod in Via della Scrofa as he was returning from a class.[13] In February 1601 there is record of an order not to proceed with accusations brought against Caravaggio by Flavio Canonico, whom he had wounded with sword, though he was later that year arrested and jailed for carrying a sword in public.[14] On 28 August 1603 the painter Giovanni Baglione lodged his famous complaint against Caravaggio, Orazio Gentileschi and some other artists, for libel.[15] In this case, there was a lengthy trial and Caravaggio was temporarily imprisoned. It is not clear if he left Rome to escape trouble, but early in the new year he was in the Marche region where, on the recommendation of Lancellotto Mauruzi, a prominent citizen from Tolentino

Fig. 5 (*following page*) Michelangelo Merisi da Caravaggio, *Crucifixion of Saint Peter*, 1601, oil on canvas, 230 × 175 cm. Santa Maria del Popolo, Rome

Fig. 6 (*page 15*) Michelangelo Merisi da Caravaggio, *Conversion of Saint Paul*, 1601, oil on canvas, 230 × 175 cm. Santa Maria del Popolo, Rome

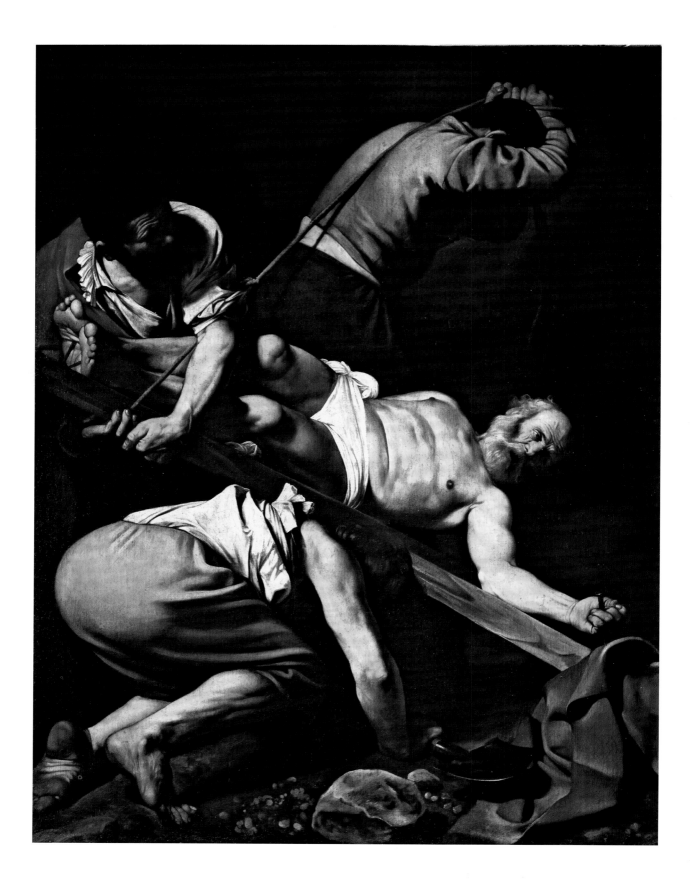

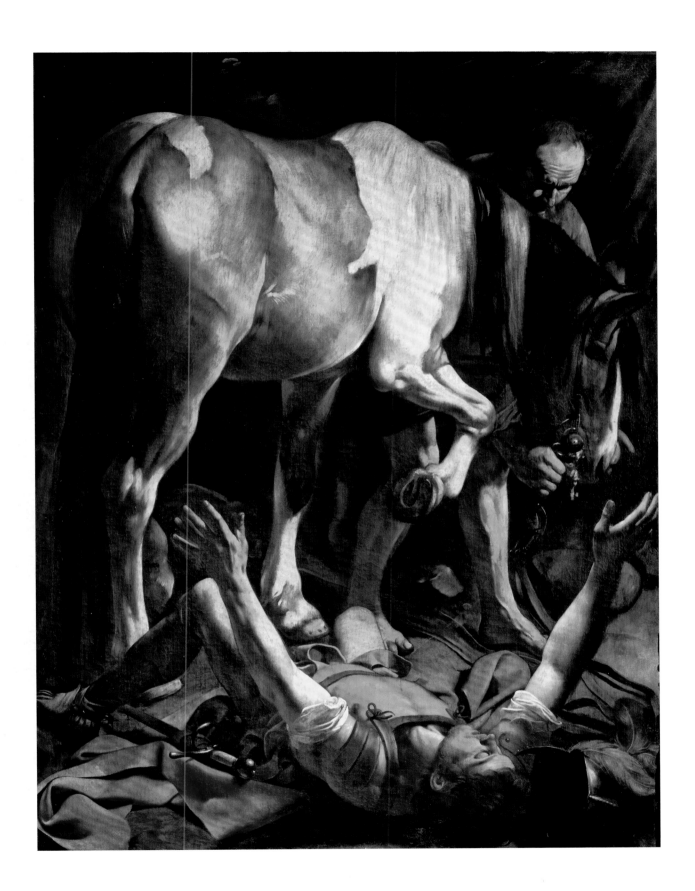

resident in Rome, Caravaggio was asked to execute a painting for the high altar in the Capuchin church of Santa Maria di Costantinopoli there, though it did not come to fruition.[16] He was back in trouble by April 1604 when a complaint was brought against him for throwing a plate of artichokes into the face of a waiter, though the artist was absolved likely because of del Monte's protection.[17]

The *Entombment*, now in the Vatican (fig. 7), was installed by 1 September 1604 in the second altar in the right nave of the Oratorian church of Santa Maria in Vallicella, known as the Chiesa Nuova, once owned by Pietro Vittrice.[18] It had probably been ordered in the years around 1602–03 against the backdrop of the artist's increasingly conflicted life. It is known that one of Caravaggio's friends was married to the heir of the original patron of the altar and this would account for the sympathy leading to this next Roman public commission.

The copy surviving on the altar helps us appreciate how two external windows to either side bring light into the chapel. The chapel is richly decorated with coloured marbles and one realizes that the dark, blank backgrounds in all Caravaggio's altarpieces while providing a mysterious, charged divine space, also served more practically to combat their ostentatious surroundings. A hint of light in the background of the painting barely relieves the sense of claustrophobia. The picture appeared in a sequence of altars illustrating the life of the Virgin Mary which accounts for her representation here as the unusually but appropriately aged mother of the adult Christ, as the artist acknowledged the broader narrative played out around this church. The image contains six monumental figures arranged in a cascade of heads that accentuate the weight and downward movement of the action. The obvious fiction here is that the real altar serves as the imaginary tomb. The stone and the arm of the Nicodemus-figure project outwards and so the viewer too physically occupies the fictive space with the severing of the conventional picture plane. This one character looks up to acknowledge the viewer and thus encourages us to collaborate in the mystery of death and burial. The actions of the two female protagonists – neither of which is easily identifiable as the Magdalen – provide signals for the appropriate range of mourning for the viewer from simple sadness and tears to a more overt outburst. In fact, except for Christ himself, none of the conventional types for this oft-depicted subject were respected. There appear to be no haloes as the

Fig. 7 Michelangelo Merisi da Caravaggio, *Entombment*, c. 1602–04, oil on canvas, 300 × 203 cm. Pinacoteca Vaticana, Rome

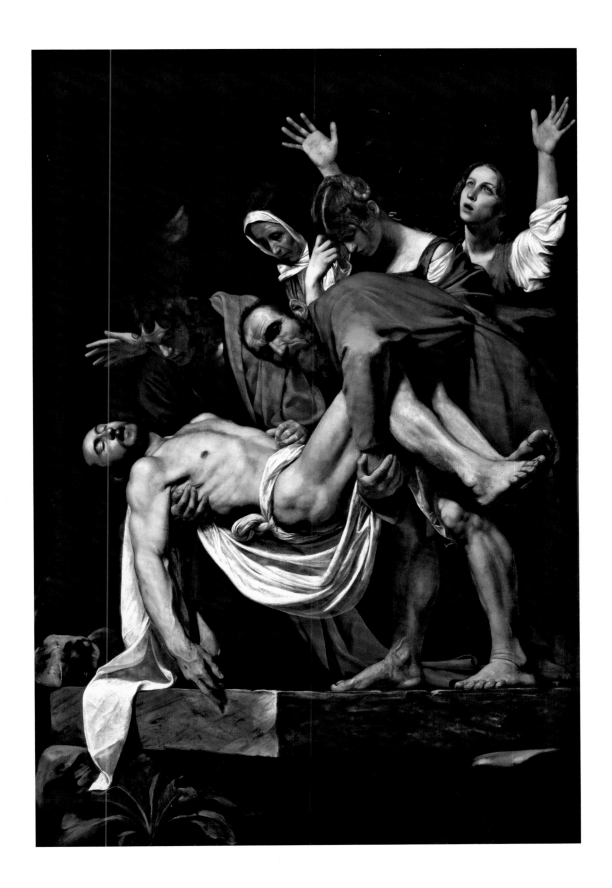

painter attempted, typically, to demystify the subject matter and pose no barriers to the viewer's access. Above all, Caravaggio strove for breadth and simplicity to create a large, powerful effect. How much a work of this nature betrays the artist's sympathies for the Oratorians and Saint Filippo Neri remains a matter for debate. Given how often his work was rejected, one must remain suspicious of this type of spiritual connection directly influencing his approach to subject matter in that it tends to domesticate a deeply personal and innovative artist frequently at odds with official church teachings.

Also of this middle period is Caravaggio's Sant'Agostino altarpiece (fig. 8) that remains in situ, also in a rich marble frame, in the first altar on the left nave near the main entrance to the church. It was ordered sometime after July 1602 when Ermes Cavalletti left money for the purchase of the chapel dedicated to the Madonna of Loreto, which in 1603 was formally assigned to the family.[19] The style of the work suggests it does not date that much later, so its execution may have overlapped in part with the Chiesa Nuova altarpiece. For Caravaggio the paint surface is unusually highly finished, almost polished and marmoreal as the artist clearly took great care in completing the work. The space is grainy and mysterious, not explained in realistic terms – a clear metaphor for the divine. The Virgin and Child emerge on the low step of a doorway of a recognizably Roman palace in a setting that is certainly not impoverished. The peeling wall indicates that we are here outdoors and so the appearance of the divine pair is meant to be understood as miraculous, evoking the Madonna at Loreto who was reputed to come occasionally to life. Yet while the Virgin's black hair and simple ribbon indicates a beautiful if contemporary figure type, the red velvet and purple dress – the only colours present in the entire work – denote a wealth beyond mortal reach, despite the frayed edges of the white cloth. The figure of the Madonna is thin, elegant, poised and enviable in an arabesque pose sourced from classical antiquity, but again in contradiction: the bare feet establish an accessible model for the pilgrims to emulate. The two travellers at the bottom corner of the canvas are portrayed not just with dirty feet but their clothes too are in threadbare condition. The Christ Child's face is in shadow, rendering him rather anonymous and thus subtly diminished in importance compared with the Virgin. The mother strains realistically to support his large body – he is no longer a baby. The sensitive placement of the child's hand on the breast is certainly a gesture observed from the life, as is the way her neck lengthens and

Fig. 8 Michelangelo Merisi da Caravaggio, *Madonna of Loreto*, 1604–05, oil on canvas, 260 × 150 cm. Sant'Agostino, Rome

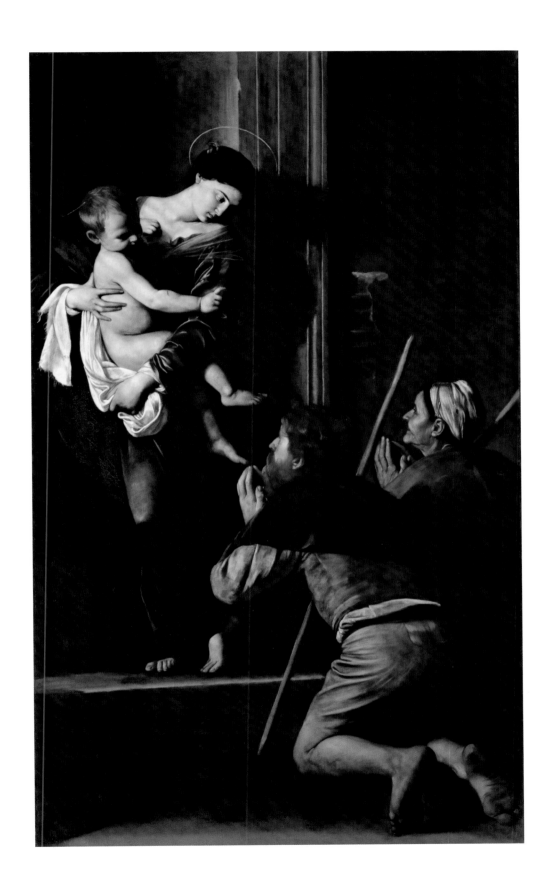

strains under the weight and the stretched thumb of her hand is flexed. As in all Caravaggio, an honest beauty appears with more severe elements, in this case the dirty feet of the pilgrims. The figures are viewed from an oblique angle in a powerful light falling from left to right suggesting another opening fictively presented on the real facade of the church.

The period of the autumn 1604 was, if possible, more complicated for the artist's very public private life. Caravaggio was jailed in October for assaulting a policeman who asked him if he had a license for his sword – a pattern of accusation and arrest that followed in the next months as the artist was clearly well known to the authorities.[20] In July 1605 he was imprisoned for forced entry and damages to the home of some women.[21] Following his release later that month, he was accused in the assault on the notary Mariano Pasqualone in Piazza Navona because he was jealous of the relationship between the painter and Lena, who was referred to as the "donna" of Caravaggio and was one of his known models.[22] Pasqualone taunted the painter who reacted violently. Whether a result of these events or not, Caravaggio was briefly in Genoa in August 1605, where he refused the considerable sum of 6000 scudi to paint in the Casino di Marcantonio Doria at Sampierdarena, just outside the city.[23] He was documented back in Rome by the end of the month involved still with the case brought by Pasqualone, following which Caravaggio formally apologized. He appears then to have completed his last two altarpieces for Rome in this period leading up to his stormy departure from the city less than a year later.

As early as 14 June 1601 Caravaggio had signed a contract with Laerzio Cherubini for the *Death of the Virgin*, for Santa Maria della Scala. This new church controlled by the Carmelites had been initiated by Clement VIII in 1592. Because the painting was rejected in 1606, it can be assumed it was not executed until around 1605–06 for reasons that are unclear, though it might simply be related to the chapel's physical construction.[24] There is no evidence that the painting of the *Death of the Virgin* (fig. 9) surviving in the Louvre was ever installed on its original altar. The painting's rejection relates to the artist's daring use of a drowned prostitute as a model for the Virgin. Her exposed bare feet were also likely, in the context of an altarpiece, an issue even though the Order of Barefoot Carmelites controlled the church. The theme was a complex one in the wake of the Counter-Reformation and confusion over how its appropriate portrayal may have also been to blame. In Carlo

Fig. 9 Michelangelo Merisi da Caravaggio, *Death of the Virgin*, 1605–06, oil on canvas, 369 × 245 cm. Musée du Louvre, Paris

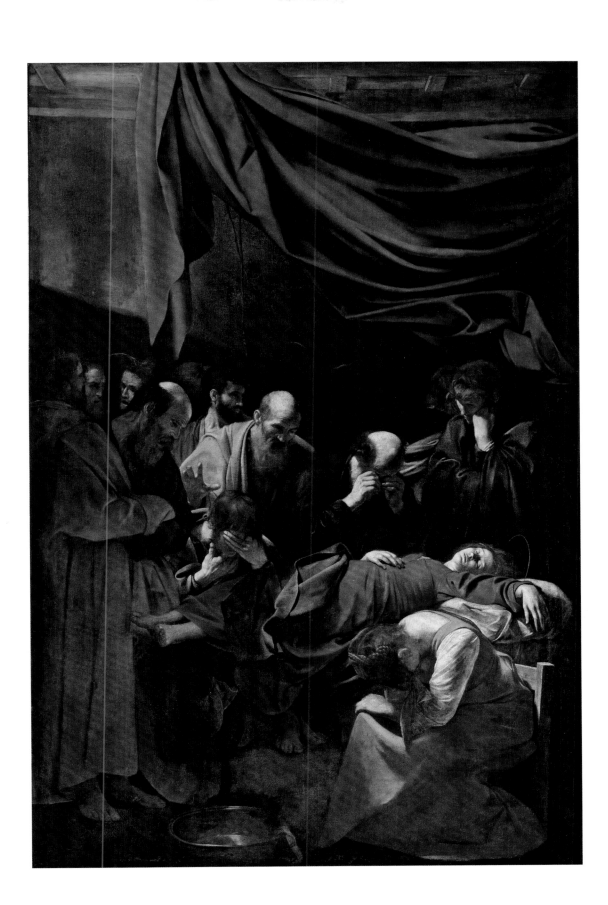

Saraceni's eventual replacement, the Virgin is shown not as dead but in process of dying. In this instance Caravaggio, even if he was considered, was not available to produce a substitute as he left Rome in the summer of 1606. His painting left the city having been purchased for the still substantial sum of 280 *scudi* early in 1607 by the Duke of Mantua on the advice of Rubens following a brief public exhibition in Rome.[25] The stylistic and emotional qualities of this majestic and mournful painting without a trace of the sentimental were overshadowed by its own dramatic history. The futile pessimism of his art was starting to connect precisely with this life.

Caravaggio's last public commission in Rome was ordered on 31 October 1605 when negotiations began between the painter and the confraternity of Sant'Anna dei Palafrenieri for an altarpiece for no less a location than Saint Peter's.[26] On 19 May 1606 the balance due was paid off by the confraternity but there is documentary evidence that the work was executed even more quickly. Given the prominent location, it should have been one of the pinnacles of the artist's career. Yet it remained on its altar for only a week or so in April 1606 when it was rejected by the patron for reasons that are not certain, though are perhaps related to the usual issues of excess nudity in the artist's treatment of religious characters. It was transferred for safekeeping to the church of the Palafrenieri in the Vatican nearby, then almost suspiciously quickly sold to Cardinal Scipione Borghese in the summer of 1606 for the same 100 *scudi* they apparently had paid Caravaggio after he had already left Rome, as the object went from public altarpiece to private treasure.[27] At 100 *scudi* this work was certainly a bargain.

The canvas *Madonna and Child with Saint Anne* (fig. 10) survives in the Museo Borghese. The huge, larger than life-size figures are placed in an indistinct architectural space resembling a square niche so, as with the Sant'Agostino altarpiece, their appearance may be understood as miraculous and occurring in the street as the female figures are clearly dressed for the outdoors. The Virgin is depicted with a non-canonical green skirt and with a bow smartly tied to prevent her superabundant crimson drapery from touching the ground. The pensive Christ Child grimaces in disgust as he helps to crush the snake, while the Virgin calmly leans over him not just to verify the miracle but as a protagonist in the action, fully collaborative, foot on foot. The action refers to the passage in Genesis 3 which describes the "New Eve" crushing the serpent's head. The serpent writhes in death throes

Fig. 10 Michelangelo Merisi da Caravaggio, *Madonna and Child with Saint Anne*, 1605–06, oil on canvas, 292 × 211 cm. Galleria Borghese, Rome

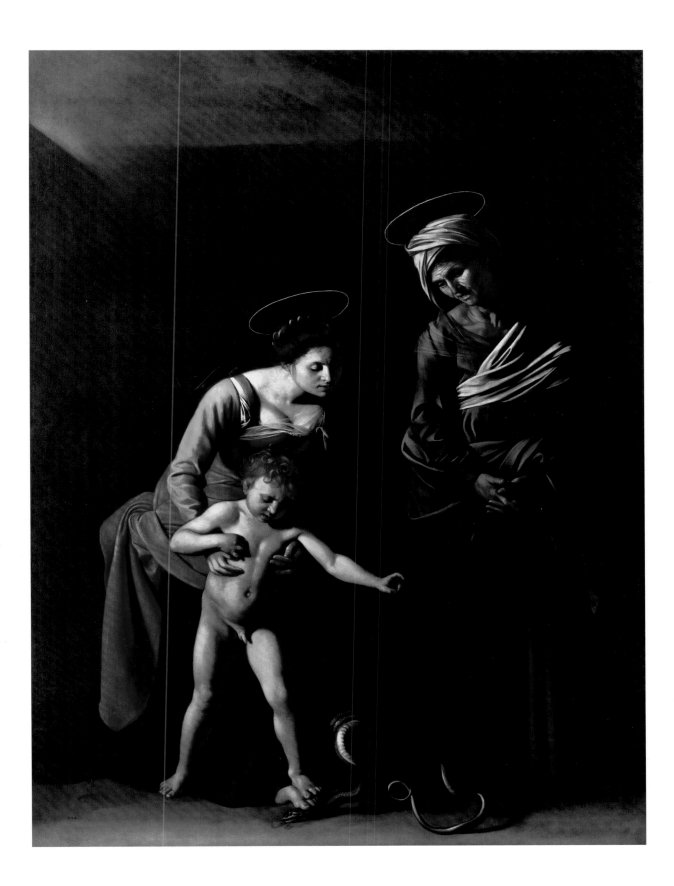

but forms a striking shape of great linear eloquence – a relatively unusual gesture towards the decorative in Caravaggio's later work, almost out of character in what is a severely imposing image. While her mother, Saint Anne, who was the patron of the confraternity that first commissioned the work appears more prosaically in a brown skirt and metallic blue–grey dress – her statuesque pose stabilized by columnar folds of drapery. The figure seems to speak as a witness and her traditional gesture of the crossed hands recalls early Renaissance precedents as in the art of Perugino, sounding a retroactive note as befitted the conservative location originally intended for the picture. The heads still cascade from the upper right to the lower left as in the preceding Chiesa Nuova altarpiece – one of the artist's favoured organizing principles when operating on a large scale, just somewhat less compact and regular as the artist started to lose structure in his designs. The fatalism and imposing severity of the image in which any virtuosity is replaced by resignation and humility were qualities Caravaggio would now explore for the rest of his ill-fated career – solitary, sad revelation without drama.

Fatefully, on 28 May 1606 during the celebrations of the first anniversary of the election of Pope Paul V, Caravaggio killed Ranuccio Tomassoni near the Pantheon. Sensing the seriousness of his actions for once, the artist fled Rome and went south into hiding on the Colonna estates on the Alban Hills.[28] The artist is then first recorded in Naples on 6 October 1606. His story takes yet a more dramatic turn leading eventually to his death during his attempt to return to Rome following a papal pardon in 1610. Thanks in part to his celebrity death, the market for paintings in his style was immediately filled by numerous followers and imitators and that provides the theme for this exhibition.

NOTES

1 The bibliography on this artist is immense;
 for a complete account with catalogue see,
 most recently, Ebert-Schifferer 2009, Schütze
 2009, and Vodret 2010. All the known
 documents related to the artist are found
 in Macioce 2010.
2 Macioce 2010, doc. 97.
3 Ibid., doc. 279.
4 Ibid., doc. 787.
5 Ibid., doc. 423.
6 For his papacy see Ottawa 2009.
7 Macioce 2010, docs. 476, 477, 495.
8 Ibid., docs. 539 and 547.
9 Ibid., doc. 502.
10 Ibid., doc. 532.
11 Ibid., doc. 456.
12 Ibid., doc. 466.
13 Ibid., doc. 511.
14 Ibid., doc. 518.
15 Ibid., docs. 560, 562–569, 571, 575.
16 Ibid., doc. 579.
17 Ibid., doc. 584.
18 Ibid., doc. 597.
19 Ibid., doc. 561.
20 Ibid., docs. 601, 604, 626.
21 Ibid., doc. 633.
22 Ibid., docs. 636 and 652.
23 Ibid., doc. 643.
24 Ibid., doc. 526.
25 Ibid., doc. 780.
26 Ibid., doc. 672.
27 Ibid., docs. 704 and 716.
28 Ibid., doc. 705.

Caravaggism in Europe:
A Planetary System and its Gravitational Laws

SEBASTIAN SCHÜTZE

In the history of European painting, few artists had an effect comparable in scale and depth to that of Michelangelo Merisi da Caravaggio (fig. 11), whose radical pictorial innovations induced dozens of painters from all over Italy, as well as Spain, France, Germany, and the Low Countries to follow his example.[1] These painters are commonly described as Caravaggisti or Caravaggesque painters, and the artist's impact seems all the more remarkable considering his relatively short career and the dramatic circumstances of his final years. Caravaggio never formed a proper school, unlike his most important contemporary Annibale Carracci, and he never had a large workshop such as the highly specialized one of the Cavaliere d'Arpino. The remarkable success of international Caravaggism calls for more circumstantial explanation and an in-depth analysis of the historical, economic and artistic conditions that favoured it. Precisely where, when and how did certain artists discover Caravaggio's art and become engaged in a critical dialogue? Did this encounter occur directly or indirectly? How was it transmitted? And, most importantly, which particular qualities caught their attention: the use of light and the strong chiaroscuro, the naturalistic modelling, the foregrounding of action, the highly theatrical construction of pictorial narratives, or the choice of certain subject matters?

International Caravaggism circumscribes a multi-faceted phenomenon, and like any other such term provides but a general frame of reference within which specific works and individual artists need to be positioned and defined. During the first decades of the seventeenth century, famous artists as diverse as Peter Paul Rubens, Guido Reni and Pietro da Cortona, or Diego Velázquez, Francisco Zurbarán and Rembrandt, responded to Caravaggio through individual works or during a specific period of their careers, yet none of them can certainly be described as Caravaggesque painter. Even later generations of artists, up to Gaspare Traversi in eighteenth-century Naples or Augustine Théodule Ribot in nineteenth-century Paris, continued to adopt aspects of Caravaggio's art, but it is the intensity and duration – the dominance and lasting impact of his art – that distinguishes a Caravaggesque painter. And while such categories need to be applied and interpreted with elasticity, the main protagonists of international Caravaggism, as well as its chronological progression and overall geography can certainly be defined.

Rome was the centre of Caravaggio's artistic career. He arrived there in the summer of 1592, at the age of twenty, from his native Lombardy with great

Fig. 11 (*facing page*) Michelangelo Merisi da Caravaggio, *Martyrdom of Saint Matthew* (detail of fig. 2, with self-portait)

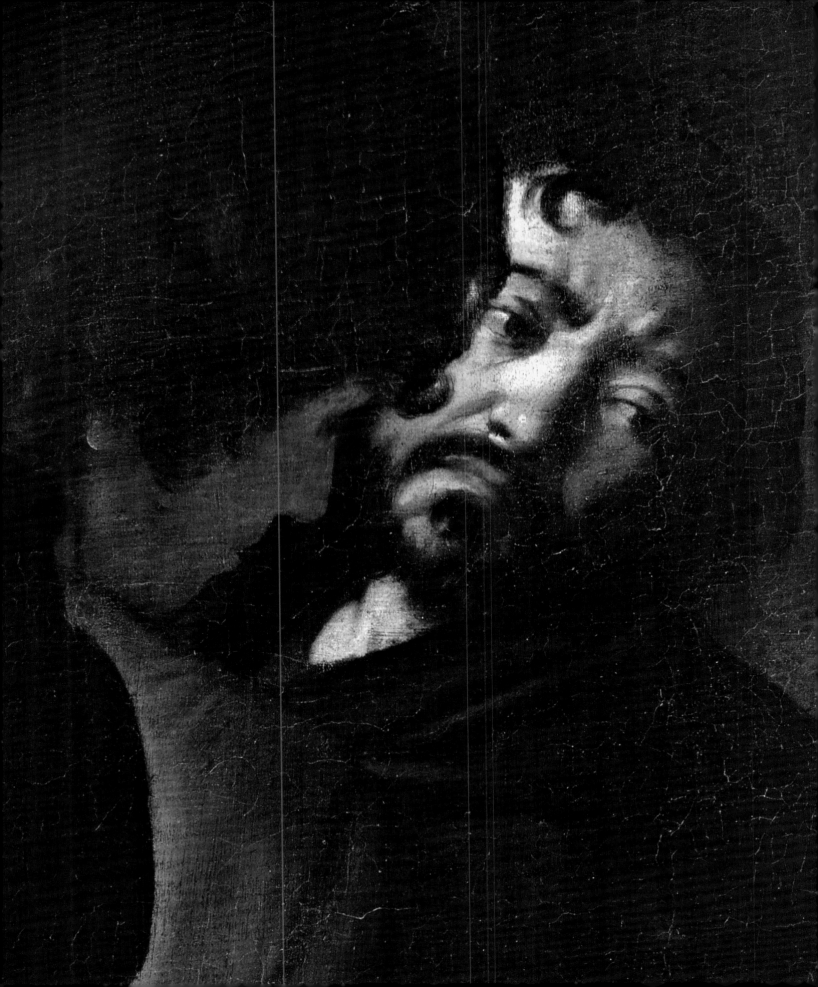

hopes and high-reaching ambitions. Within a few years he attracted the patronage of bankers, princes and cardinals, some of the most powerful collectors of his day, including Francesco Maria del Monte, Benedetto and Vincenzo Giustiniani, Maffeo Barberini, Ottavio Costa, Olimpia Aldobrandini, Ciriaco Mattei, and Scipione Borghese. By 1600 with his first public works for the Contarelli Chapel in San Luigi dei Francesi, he had become a universally acclaimed master of the contemporary art scene. In Rome until late May 1606 – the date of his fatal duel with Ranuccio Tomassoni and his resulting exile from the Papal States – he executed a spectacular series of public and private works that would forever change the course of European painting. Throughout his final days leading to his mysterious death at Porto Ercole on 18 July 1610, Caravaggio hoped to return to the Papal city.

If the turmoil of the Reformation and the growing dominance of the European nation states, Spain and France in particular, diminished the political and economic power of the papacy by 1600, Rome continued to be the most important stage of international diplomacy and the unrivalled artistic capital of Europe. After the rather austere pontificates from Paul IV (1555–59) to Pius V (1566–72), with Gregory XIII (1572–85), Sixtus V (1585–90), Clement VIII (1592–1605) and Paul V (1605–21) the church triumphant was back on stage and eager to display the splendour of the arts to advocate their claim for universal power, both temporal and spiritual. Rome was not only an open air academy, offering the greatest assembly of canonical master pieces from Antiquity to the Renaissance, but the hottest spot in European contemporary art and a must for any artist of ambition. Caravaggio's arrival in Rome coincided with the election of Clement VIII, and the papal city was destined to soon become the centre of international Caravaggism. Most of his followers would study his art in Rome, while a relative few would travel farther south to see his late works in Naples, Malta and Sicily. Seventeenth-century Rome housed by far the greatest number of Caravaggio paintings, as it does today. With its focus on Caravaggism in papal Rome, this exhibition aims to reconstruct in visual terms a truly unique artistic constellation and the creative energies it generated for roughly four decades.

Caravaggesque painters are scarcely documented. Contemporary biographies, when they are available, are cursory in nature and limited to a

few lines in passing. Even a basic grid of biographical data or a documented chronology of works is often hard to establish; information on artistic education and cultural background remains sketchy and for the most part based on stylistic analogies alone. Very few pictures are signed and dated or otherwise precisely documented. Powerful and clearly distinguishable artistic personalities continue to be identified with such auxiliary names as the Pensionante del Saraceni, the Master of the Annunciation of the Shepherds, the Master of the Acquavella Still Life, or the Candlelight Master.[2] The mysterious Cecco del Caravaggio, described by Mancini as one of Caravaggio's earliest followers, has only very recently been identified with the painter Francesco Buoneri. Even the early stylistic profile of such a giant of seventeenth-century painting as the Spaniard Jusepe de Ribera remains highly controversial, particularly the recent attempt to identify the Master of the Judgement of Salomon *tout court* with the early Ribera. Under such circumstances, it is no wonder that a lot of research on the Caravaggisti is concentrated on stylistic analysis, and questions of attribution and chronology, while close readings of individual pictures along with comprehensive studies regarding the development of still-lifes and genre-scenes or the social and economic conditions that fostered Caravaggism have only begun to emerge.

To reconstruct the careers of individual Caravaggisti and their role within the Caravaggesque movement as a whole, it is essential to establish when they arrived in Rome, the duration of their stay, their social circles and the kinds of patronage they enjoyed. In recent years the systematic examination of the *Stati delle Anime* – the annual lists of residents in Roman parishes – as well as records of marriage and baptisms, have produced a wealth of new information in this regard. Juan Bautista Maíno is now firmly documented in Rome in 1604–10 and Luis Tristán in 1607–09, while Bartolomeo Manfredi and Valentin de Boulogne appear in the records as early as 1607 and 1609 respectively.[3] These simple facts nonetheless change dramatically the early topography of international Caravaggism and its internal checks and balances. On the other hand, research on the history of collecting and on the art market in early modern Rome has not only provided information on individual patrons and early provenances, but also a better understanding of market structures and economic conditions behind the Caravaggesque movement and its pan-European success.[4]

Caravaggism developed over time and in distinct stages. With his first public works, the spectacular side panels for the Contarelli chapel representing the *Calling of Saint Matthew* (fig. 1, p. 6) and the *Martyrdom of Saint Matthew* (fig. 2, p. 7), Caravaggio instantly attracted broad attention as well as the inescapable envy of some fellow artists. The contract for his next public commission, the side panels for the Cerasi chapel in Santa Maria del Popolo, dated 24 September 1600, shortly after the inauguration of the Contarelli chapel, addressed him as *egregius in Urbe pictor*, "renowned master in the City."[5] An Avviso, a kind of almost daily diplomatic newsletter with the latest events from Rome, reported on 2 June 1601 the unveiling of Annibale Carracci's Farnese ceiling and celebrated the revival of the art of painting, suggesting that with the imminent finalization of the Cavaliere d'Arpino's frescos in the Palazzo dei Conservatori and Caravaggio's panels for the Cerasi chapel the new height of Roman art would become even more evident.[6] As this extraordinary document illustrates, contemporaries in 1601 were perfectly aware that these three painters represented the key currents in Rome. D'Arpino was the most successful representative of late Mannerism under the pontificate of Clement VIII. He dominated the field of public commissions and with his large, highly specialized workshop, decorated the churches and palaces of Rome (fig. 12). Carracci and his brother Agostino had been called in 1595 by Cardinal Odoardo Franese to decorate the magnificent family palace in Rome. With their cousin Ludovico, the two brothers had founded the famous Carracci Academy in Bologna in the early 1580s with the intent to reform the art of painting. Annibale, who stayed in Rome until his death in 1609, formed an extraordinary group of pupils including Domenichino, Giovanni Lanfranco, Guido Reni, Sisto Badalocchio and Francesco Albani. And while later historiography has tended to describe d'Arpino, Carracci and Caravaggio as rather antithetic phenomena, they also present important points of contact. The young Caravaggio attended d'Arpino's workshop briefly in 1593–94. The side panels in the Contarelli chapel had been originally commissioned to Girolamo Muziano and subsequently to d'Arpino. The latter owned a number of early Caravaggio paintings, including the *Bacchus* and the *Boy with a Fruit Basket* (both now in Rome, Villa Borghese), and in his 1598 *David*, executed for Cardinal Pietro Aldobrandini (Milan, Koelliker collection), d'Arpino himself began to respond to Caravaggio's bold naturalism. The Carracci Academy's emphasis on life studies as well as their

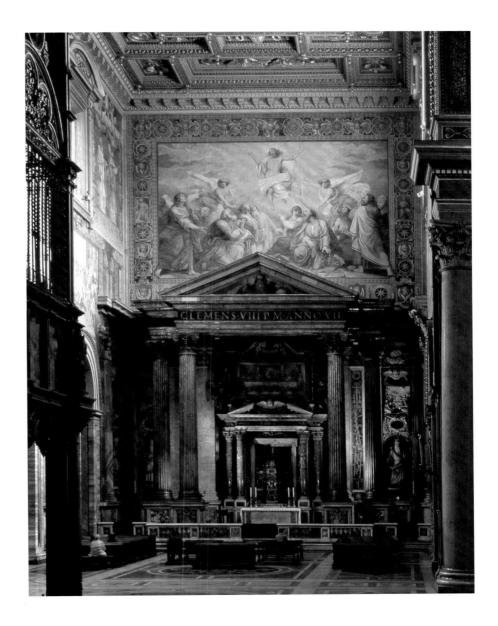

Fig. 12 View of the Transept of San Giovanni in Laterano, with Giuseppe Cesari called Cavaliere d'Arpino, *Resurrection of Christ*, San Giovanni in Laterano, Rome

interest in genre painting, parallel, in many ways, Caravaggio's approach. In 1600 Tiberio Cerasi staged a veritable competition and commissioned Annibale to paint the *Assumption* altarpiece for his chapel in Santa Maria del Popolo while Caravaggio was awarded the two side panels (fig. 13). Artistically, Annibale's monumental *Pieta* for Odoardo Farnese (Naples, Museo Nazionale di Capodimonte) and Caravaggio's almost contemporary *Entombment* (fig. 7, p. 17) for the Vittrici chapel in Santa Maria in Vallicella (Rome, Vatican Museums) are each both an ostentatious homage to and a self-confident *paragone* with Michelangelo's early sculptural *Pietà* in Saint Peter's. It is highly significant that in 1603 Caravaggio himself described his fellow artists

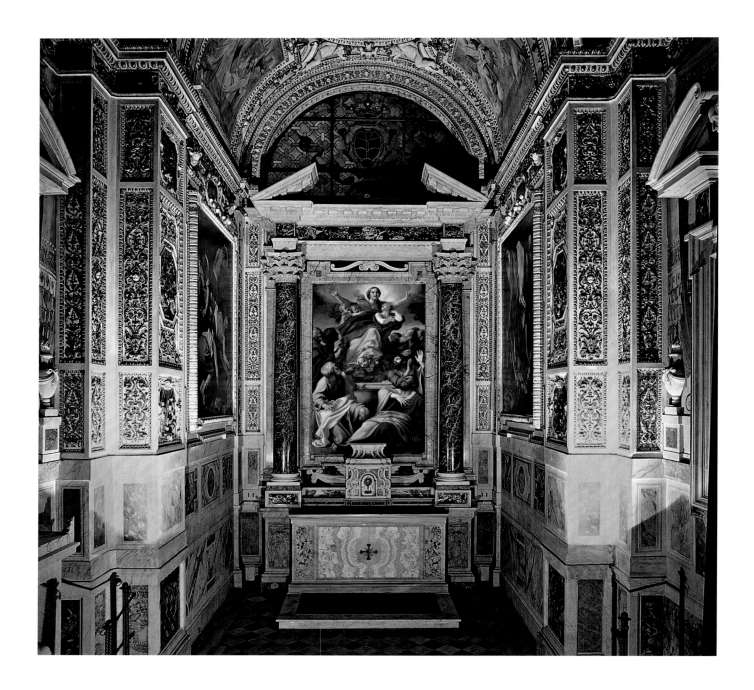

Fig. 13 View of the Cerasi Chapel, with
Annibale Carracci's *Assumption of the Virgin*
and Caravaggio's side panels with the
Martyrdom of Saint Peter and the *Conversion
of Saint Paul*, Santa Maria del Popolo, Rome

d'Arpino, Federico Zuccari, Cristoforo Roncalli and Annibale Carracci as *valent'huomini*, that is, painters who were "capable of painting well and imitating nature."[7] For Vincenzo Giustiniani both Caravaggio and Annibale belonged to the highest category of painters, those of the 12th class, which combined the qualities of the 10th and 11th classes, "to paint *di maniera*" and "to paint from life," that is, the painters who employed both their fantasy and the study of nature in their artistic inventions.[8] The Roman art scene around

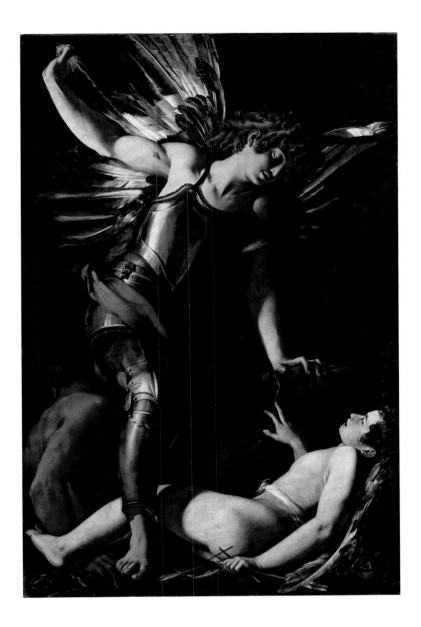

Fig. 14 Giovanni Baglione, *Divine Love Conquering Earthly Love*, 1602–03, oil on canvas, 183.4 × 121.4 cm. Gemäldegalerie, Staatliche Museen, Berlin

1600 offered extremely rich and multi-faceted options, and it is imperative to keep in mind that Caravaggio's first followers operated in such pluralistic and permeable context. Certain artists employed different stylistic options at the same time while others converted to Caravaggism in stages or only for a certain period of time.

Giovanni Baglione was born in 1566, five years before Caravaggio, and started to adopt his strong *chiaroscuro* and naturalistic modelling in the early years of the new century in such paintings as *Saint Sebastian* (University Park, The Palmer Art Museum) and *The Ecstasy of Saint Francis* (cat. 29). In 1602 he executed his two versions of *Divine Love Conquering Earthly Love* (fig. 14,

see also fig. 23, p. 61) for Benedetto Giustiniani in direct competition with Caravaggio's famous *Triumph of Earthly Love* (fig. 22, p. 56) painted for the cardinal's brother, Marchese Vincenzo Giustiniani. Caravaggio strongly disapproved of what he must have considered a pale and "unauthorized" imitation of his manner. Shortly thereafter a series of verses circulated in Rome ridiculing his rival. A conflict, which led to the famous law suit Baglione brought against Caravaggio in 1603 and ultimately resulted in Baglione's notoriously biased Caravaggio biography published in 1642.[9] At the same time, Baglione distanced himself artistically and after 1603 turned only sporadically to a Caravaggesque style. The well-documented trial speaks volumes to Caravaggio's low esteem for Baglione as well as to his protective behaviour regarding his "brand." Among Caravaggio's friends involved in the law suit and interrogated in its course was Orazio Gentileschi. Eight years Caravaggio's senior and trained in a late mannerist style, Gentileschi rapidly assimilated his naturalistic manner and became one of his earliest and most prominent followers. He was well acquainted with Caravaggio, and during the Baglione trial affirmed that had lent the Lombard master a Capuchin habit and a pair of wings as props.[10] A series of representations of *Saint Francis in Ecstasy*, today in private collections and in the Prado (cat. 28) in Madrid, perfectly illustrate Orazio's gradual process of appropriation over the first decade. Among his first truly Caravaggesque paintings are the *Christ on His Way to Calvary* (fig. 15) and the *Madonna and Child* (Rome, Palazzo Corsini). Both are datable to the second half of the first decade and display a brilliant use of colour as well as a strong modelling from life. For his 1610–11 *Saint Jerome* (Turin, Museo Civico) Orazio hired Giovan Pietro Molli, a seventy-three-year-old Sicilian pilgrim, as model for several weeks.[11] Through his highly original interpretation of Caravaggio's art and his cosmopolitan career, leading from Rome to Genova, Paris and finally, as court painter for Charles I, to London, Gentileschi played a decisive role in promoting Caravaggism on a grand scale. This effect was further amplified through the brushes of his daughter Artemisia, who initially followed his example but soon developed her own theatrical "brand" of Caravaggism, most notably in her representations of female heroes from Susanna, Judith and Magdalen to Cleopatra, Lucretia and Danae. Antiveduto Gramatica was, like Baglione and Gentileschi, slightly older than Caravaggio and trained in a late-Mannerist tradition. For a brief period during his first Roman years, Caravaggio even

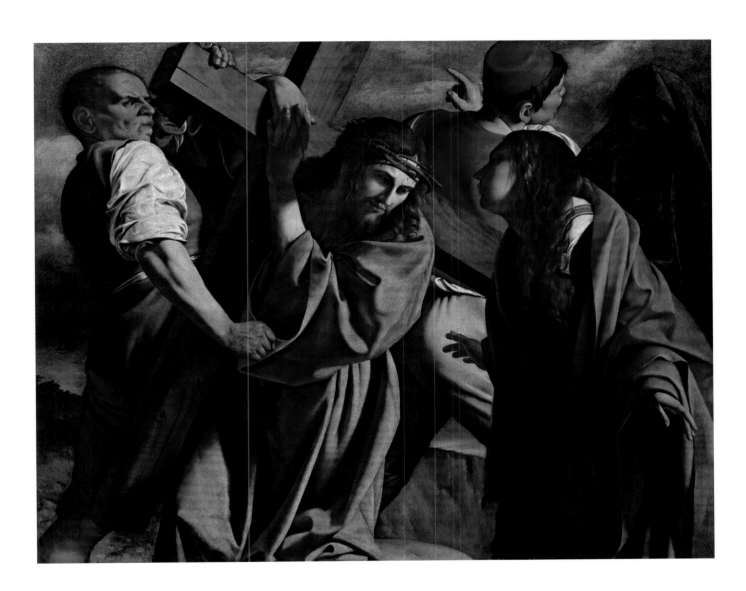

Fig. 15 Orazio Gentileschi, *Christ on his Way to Calvary*, 1605–07, oil on canvas, 138.5 × 173 cm. Kunsthistorisches Museum, Vienna

joined Gramatica's workshop, but it was only around 1610 that Gramatica started to adopt a more naturalistic modelling and stronger chiaroscuro, most convincingly in such lyrical paintings as *Saint Cecilia with Two Angels* (cat. 10) or *Saint Dorothy* (London, private collection). Baglione, Gentileschi and Gramatica represent three early responses to the art of Caravaggio. They each assimilated it to a very different degree, and only Gentileschi fully converted to his naturalistic credo.

In those early Roman years Prospero Orsi, a painter specializing in grotesque decorations, was Caravaggio's preferred companion, and more than once the two were involved together in nightly brawls. Orsi acted as a kind of promoter and factotum for Caravaggio. He procured commissions, but also executed "authorized" copies of his works. Such copies were in high demand among collectors and started to circulate early on. In 1606, on a visit to Genova, Vincenzo Giustiniani discovered, to his own surprise, a copy of Caravaggio's famous *Incredulity of Saint Thomas* (1601–02) from his own collection in the palace of Orazio Del Negri.[12] The French ambassador in Rome, Philippe de Bethune, asked Cardinal Maffeo Barberini in 1610 for permission to have his *Sacrifice of Isaac*, today in Florence (cat. 52), copied.[13] Mancini's correspondence with his brother Diofebo in Siena eloquently speaks to the prosperous market for such copies as well as to the restrictive politics on the part of those in possession of Caravaggio's precious originals.[14] Copies were executed for a variety of motives: to "double" an original on the occasion of hereditary divisions, to replace a painting that had been disposed or donated, to substitute a work that could not be acquired or was too expensive and, of course, to be sold as Caravaggio originals on the market. Copies varied greatly in quality, ranging from those executed by eminent painters early on and directly from the originals to rather modest copies after copies or from a later date. Many such works are still preserved and have to be regarded as primary sources for the study of Caravaggio and his critical reception. They can offer valuable information about lost works or the original state of damaged or altered Caravaggio paintings. Bartolomeo Manfredi's *Mars Punishing Cupid* (fig. 24, p. 65), for example, almost certainly reflects Caravaggio's now-lost painting of the same subject for Cardinal Francesco Maria del Monte, while Cecco del Caravaggio's *Resurrection* (fig. 48, p. 122) might document aspects of Caravaggio's also lost altarpiece for the Fenaroli chapel in Sant'Anna dei Lombardi in Naples. Indeed, Roberto Longhi, the doyen of twentieth-century Caravaggio studies, identified numerous important Caravaggio compositions based on copies, long before the originals resurfaced. Whether or not Caravaggio himself replicated his own paintings is a matter of heated debate. He certainly executed variants of successful compositions, as in the case of the *Lute Player* (see figs. 49 and 50, pp. 130–131) or the *Fortune Teller* (fig. 51, p. 158). Yet, no contemporary documents attest that he executed direct copies of his own works, nor does

the remarkable difference in quality between originals and copies suggest such practice. Copies are, in any case, of fundamental importance to the *fortuna critica* of Caravaggio and the rapid diffusion of Caravaggism. They were the major medium for the transfer and multiplication of Caravaggio's creations, while drawings and prints played only a marginal role. There are but a few drawings after Caravaggio preserved – such as Gerrit van Honthorst's dated 1616 study after the *Martyrdom of Saint Peter* in the Cerasi chapel (Oslo, Nasjonalmuseet) – and there are virtually no early prints *d'apres*, which, no doubt, also reflects the marginal role drawing played in general for the theory and practice of Caravaggesque painting.[15]

If Caravaggio initially controlled and protected his "brand" rather successfully, following his flight from Rome late in May 1606 and even more so after his death in July 1610, an increasing number of painters adopted his manner as they attempted to fill the vacuum and take advantage of the demand for Caravaggesque works. Karel van Mander, Caravaggio's first biographer, lauded his powerful naturalism and recommended younger artists to follow his example as early as 1604.[16] Mancini named Bartolomeo Manfredi, Cecco del Caravaggio, Spadarino, Jusepe de Ribera, and Carlo Saraceni among Caravaggio's first followers.[17] Spadarino was born in Rome, while Saraceni is firmly documented in the papal city in 1601–20, Manfredi in 1607–22, Ribera in 1612–16 and Cecco del Caravaggio in 1613–20. With varying artistic temperaments and different cultural backgrounds, each of these painters had a different take on Caravaggio. Some might have worked with Caravaggio as apprentices, while others likely met him during his late Roman years. Manfredi was born in the small village of Ostiano, at the time part of the diocese of Brescia. He is first documented in Rome in 1607, but might be identified with Caravaggio's servant "Bartolomeo" mentioned during the Baglione trial in 1603.[18] The mysterious Cecco del Caravaggio, instead, could well be the "Francesco garzone," the apprentice living in Caravaggio's household in 1605, who has recently been identified with the painter Francesco Buoneri, who executed the monumental *Resurrection* in 1619–20 for the Guicciardini chapel in Santa Felicita in Florence.[19] Giovanni Antonio Galli, called lo Spadarino, was born in Rome in 1585 and lived for almost two decades in the Palazzo di San Marco under the protection of the Venetian cardinal Giovanni Dolfin. His early period remains difficult to reconstruct, but it is only over the course of the second decade of the seventeenth century

that he emerged as a Caravaggesque painter with such works as the *Saint Francesca Romana and the Angel* (Rome, Banca Nazionale del Lavoro) or the *Saint Anthony of Padua with the Christ Child* (Rome, Basilica dei SS. Cosma e Damiano). Saraceni must have arrived from Venice shortly before 1600, but continued to specialize in small-format paintings in the style of Adam Elsheimer for several years before he started to assimilate Caravaggio's grand manner. Ribera, on the other hand, was trained in Valencia, possibly by Francisco Ribalta, and demonstrated strong Caravaggesque qualities in his very first Roman paintings. Saraceni's lyric Caravaggism has indeed very little in common – stylistically or conceptually – with Ribera's violent naturalism and *tremendo impasto*, and both artists represent emblematically the diversity among those early followers.

Soon other Italian, Spanish, Netherlandish, and French masters joined the ranks of the Caravaggisti in Rome: Orazio Borgianni, Angelo Caroselli, Tommaso Salini and Bartolomeo Cavarozzi, Juan Bautista Maíno and Luis Tristán, Gerrit van Honthorst, Hendrick ter Brugghen and Dirck van Baburen, Valentin de Boulogne, Simon Vouet, Nicolas Tournier, Nicolas Régnier, Claude Vignon, and Trophime Bigot. Most of them lived in close proximity in the parishes of Santa Maria del Popolo, San Lorenzo in Lucina, and Sant'Andrea delle Fratte; many had familial bonds and strong affiliations with their respective national communities in Rome. In 1620 a group of artists mostly from the Low Countries and Germany formed the Bentvueghels, a kind of professional association alternative to the official Accademia di San Luca. Shortly specialized "brands" of Caravaggism developed, and here Bartolomeo Manfredi played a central role. Mancini, Baglione, and Giovan Pietro Bellori all underscore Manfredi's empathy and his capacity to almost deceivingly assimilate Caravaggio's art, while the German painter Joachim von Sandrart famously characterized Manfredi's way of interpreting Caravaggio as the "Manfrediana methodus."[20] Manfredi specialized in half-length gallery pictures, both religious and genre scenes. Among his earlier paintings are the *Allegory of the Four Seasons* (see fig. 63, p. 190) and the *Ecce Homo* (cat. 54), the former re-reading Caravaggio's early half-length figures such as the *Sick Bacchus* (cat. 2), the latter Caravaggio's religious narratives such as *Crowning with Thorns* (see fig. 42, p. 115). Manfredi's nightly tavern scenes (fig. 16), where the protagonists engage in drinking and playing, in amorous affairs, musical entertainment,

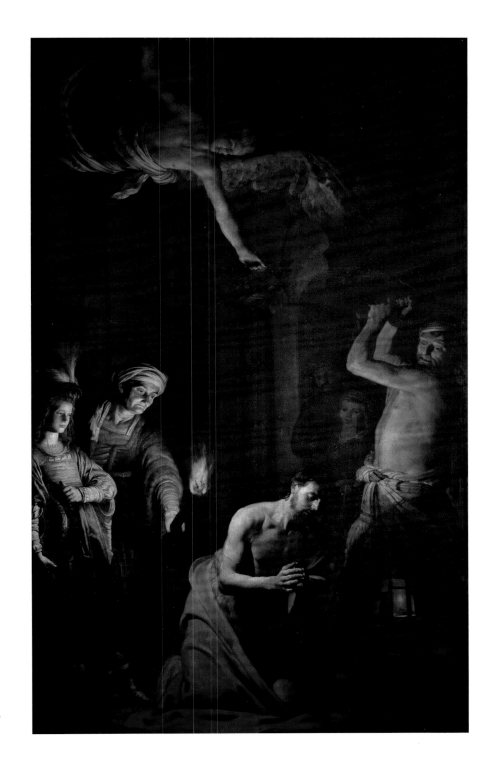

Fig. 18 Gerrit van Honthorst, *Beheading of Saint John the Baptist,* 1618, oil on canvas, 345 × 215 cm. Santa Maria della Scala, Rome

it was generally only later in the second decade that the Caravaggesque painters were able to compete successfully for those highly prestigious public commissions. Saraceni executed two altarpieces for Santa Maria dell'Anima in 1617–18, representing *The Miracle of Saint Benno* and the *Martyrdom of Saint Lambert*, while Honthorst painted in the same years the *Saint Paul Taken to the Third Heaven* for Santa Maria della Vittoria, and the *Beheading of Saint John* for Santa Maria della Scala (fig. 18). In 1619–20 Baburen and David de Haen decorated the Cussida Chapel in San Pietro in Montorio, and in 1623–24 Vouet the Alaleoni Chapel in San Lorenzo in Lucina. The later years of the pontificate of Paul V marked indeed in many ways the apex of Caravaggism in Rome. Soon leading artists of the first generation died – Saraceni in 1620; Manfredi in 1622 – and others left for good and established strong Caravaggesque traditions elsewhere. Ribera went to Naples in 1616, Régnier to Venice in 1626, while ter Brugghen, Honthorst and Baburen all returned to Utrecht between 1620 and 1622.

The following pope, Gregory XV (1621–23), programmatically favoured painters from his native Emilia, the Carracci pupils Guercino and Domenichino in particular, and his pontificate has been described as the "Indian summer" of Bolognese painting. Under Urban VIII (1623–44) there was a temporary revival of Caravaggism, which reflects the pluralistic artistic politics of the early Barberini pontificate, not to mention the capacity of painters like Vouet and Valentin to update and renew their style. Vouet was nominated Principe of the Roman Accademia di San Luca in 1624, and both Vouet and Valentin would execute altarpieces for the Vatican Basilica (fig. 36, p. 93) in the later 1620s, as well as numerous commissions for the Barberini entourage. The Barberini pope himself had been among Caravaggio's early patrons, commissioning his portrait (Florence, Private Collection) and the *Sacrifice of Isaac* (cat. 52). His nephew, Cardinal Antonio Barberini the Younger, in 1628 acquired important works from the estate of Cardinal Francesco Maria del Monte, including the *Cardsharps*, the *Lute Player* and the *Saint Catherine of Alexandria* (fig. 70, p. 228). Other key patrons of Caravaggio, like the Giustiniani, Crescenzi and Mattei, also continued to favour and patronize the Caravaggisti. Vincenzo Giustiniani, in particular, added magnificent paintings by Manfredi, Ribera, Caroselli, Honthorst, Baburen, Valentin, and Régnier to his collections. He encouraged younger painters to study his Caravaggio masterpieces, and Honthorst, Régnier, and

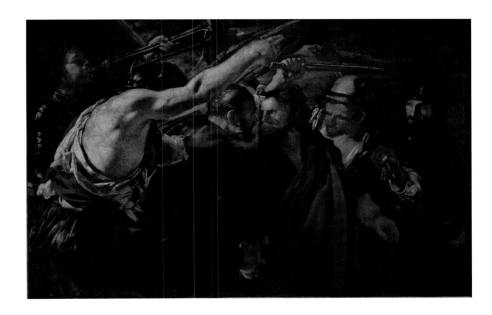

Fig. 19 Giovanni Serodine, *Parting of Saints Peter and Paul Led to Martyrdom*, 1624–25, oil on canvas, 144 × 220 cm. Galleria Nazionale d'Arte Antica, Palazzo Barberini, Rome

later Sandrart, actually lived and worked for years in his palace situated just opposite to San Luigi dei Francesi. The Crescenzi patronized notably Bartolomeo Cavarozzi. The painter, called also Bartolomeo dei Crescenzi, lived in their palace near the Pantheon and owed his commissions mostly, directly or indirectly, to their patronage. He formed a kind of unique artistic partnership with the Marchese Giovanni Battista Crescenzi, a well-known amateur and art consultant, and accompanied him to Spain in 1617. In the mid-1620s Asdrubale Mattei commissioned a series of monumental pictures for his gallery, where a rather heterogeneous group of painters, including Valentin, Alessandro Turchi, Orazio Riminaldi, Giovanni Serodine (fig. 19), and the young Pietro da Cortona, produced one of the most impressive ensembles of Caravaggesque half-length pictures. But these were rather late heydays. The departure of Vouet for Paris in 1627 and the death of Valentin in 1632 marked, in many ways, the end of Caravaggism in Rome. The high baroque of Pietro da Cortona and the classicism of Andrea Sacchi and Nicolas Poussin would dominate the Roman scene for the rest of the century up to Giovanni Battista Gaulli and Carlo Maratti. Around 1630, it is true, new arrivals such as Matthias Stom and Mattia Preti continued the Caravaggesque manner but, significantly, both masters would achieve their greatest success

and lasting impact only once they moved southward to Naples, Sicily and Malta.

Caravaggism in Rome encompasses an amazing diversity of artists, who explored different aspects of Caravaggio's art. At the same time, a closer look at the Caravaggisti, and an attempt to define their individual relations to Caravaggio in more precise terms, decisively sharpens the profile of the master himself. Hundreds of Carravaggesque paintings offer indeed a valuable but often rather neglected source for the study of Caravaggio and a privileged perspective on his art that is strictly pictorial and contemporary at the same time. For example, Cavarozzi's two versions of the *Saint Jerome*, today in Florence (cat. 34) and at the American Embassy in Rome, present most tangible proof of the widespread use of Dürer prints among Caravaggio and his followers. Ter Brugghen's readings of Caravaggio's *Calling of Saint Matthew*, today in the Centraal Museum in Utrecht (fig. 20) and at the Musée des Beaux-Arts in Le Havre, leave no doubt in regards to the apostle's much-debated identity and offer most authoritative evidence that Matthew is indeed the elderly bearded man seated at centre. On the whole, Caravaggesque pictures constitute a highly sensitive resonance board, indicating with seismographic precision not only how Caravagggio's pictures were perceived and which of his pictorial innovations had the greatest impact, but also where he infringed the limits of decorum or even intelligibility and his fellow painters felt the need to temper, decelerate or clarify his inventions.

Caravaggesque painters have responded to Caravaggio with specific and, at times, radically differing intentions ranging from emulation and homage to partial appropriation and even alienation. The exhibition *Caravaggio and His Followers in Rome* offers the exciting opportunity to visualize those critical dialogues in all their complexity. A selection of Caravaggisti is arranged around a particular painting or a group of paintings by Caravaggio. Pictures are combined, as in an experimental lab, to provoke reactions in a range from sympathetic dialogue and synergetic blending to contrasting opposition and straight rejection. All the pictures on stage communicate simultaneously with each other and propose challenging perspectives on Caravaggio's art. Each picture in the installation creates and absorbs contemporarily a multitude of reflections and, as a whole, such artificial system of mirrors produces a highly complex and truly multi-faceted view of Caravaggio precisely because every mirror is of a different type, plane, convex or concave, clear, tinted, blurred or

18 Macioce 2010, doc. 567.

19 Ibid., doc. 628.

20 Mancini 1956–57, p. 251: "E, veduto il colori-
 to del Caravaggio, si messe ad operar per
 quella strada, ma con più diligenza e fine,
 nel qual modo ha fatto progresso tale che
 adesso le sue opere sono in grandissima
 stima." Baglione 1642, p. 159: "Ma poi fatto
 grande si diede ad imitare la maniera di
 Michelagnolo di Caravaggio, & arrivò a tal
 segno, che molte opere sue furono tenute di
 mano di Michelagnolo, ed infin gli stessi pit-
 tori, in giudicarle, s'ingannavano." Bellori
 1672, p. 215, trans. in Bellori 2005, p. 186:
 "Bartolomeo Manfredi of Mantua was not a
 mere imitator but transformed himself into
 Caravaggio, and when he painted it seemed
 as though he were looking at nature through
 that man's eyes. He adopted the same
 stylistic modes and deepened the darks, but
 with somewhat greater diligence and
 freshness, and he too used predominantly
 half-length figures, of which he was wont to
 compose his *istorie.*" Sandrart 1675, p. 301
 (Latin edition 1683, p. 294).

CARAVAGGIO'S ROMAN COLLECTORS

SANDRA RICHARDS

The profession of painting today is at the peak of esteem, not only for the usual things that come onto the Roman market, but also for what is sent forth to Spain, France, Flanders, England, and elsewhere. In truth it is marvellous to contemplate the great number of ordinary painters, and many persons who maintain large and populous studios, who also get ahead, solely on the basis of being able to paint in various ways and with inventiveness. And this is not only in Rome and in Venice, but in other parts of Italy. Also in Flanders and in France recently they have begun to adorn palaces with paintings as a variation from the sumptuous wall hangings that were used in the past. This new usage provides very favourable opportunities for the sale of the painters' works.[1]

Marchese Vincenzo Giustiniani, letter to Teodoro Ameyden, c. 1610s

So CONCLUDES VINCENZO GIUSTINIANI'S RESPONSE to his friend's request for advice on matters of painting. As he breathlessly enthuses, remarkable changes were taking place in the Roman art world in the early decades of the seventeenth century. It was a period of transition, in which long-standing hierarchies of painting that had been dominated by the monumental works commissioned under religious and court patronage were yielding to new genres of easel paintings produced for collectors to display in their galleries, a seismic shift towards ideas that continue to inform the way art is produced and consumed today. His words are especially resonant because, together with his brother, Cardinal Benedetto, Vincenzo amassed more paintings by Caravaggio than anyone at that time or since. Indeed Caravaggio's career in Rome was firmly, and dichotomously, tied to these developments: he associated with the most progressive collectors and connoisseurs of the day; but with status and success, his career ultimately adhered to established models of private and public patronage.

CONNOISSEURS

Following more than half a century of retrenchment that began in the wake of the Sack of Rome in 1527 and continued through the Reformation crisis, the 1592 election of the Florentine pope, Clement VIII Aldobrandini, who reigned until 1605, marked a prolonged period of political stability and economic prosperity.[2] The city itself had been transformed by massive urban

facing page Michelangelo Merisi da Caravaggio, *Triumph of Earthly Love* (detail of fig. 22)

planning projects undertaken by Sixtus V between 1585 and 1590, while sweeping decorative campaigns were underway to renovate the city's old pilgrimage churches and to complete the interiors of the newly completed churches of the new religious orders in anticipation of the 1600 Jubilee.

The post-Tridentine censure of extravagance enforced under Pius IV and Gregory XIII gave way to more permissive attitudes towards private consumption among Rome's thriving monied class. The conspicuous wealth of the ecclesiastics, bureaucrats, lawyers, diplomats and bankers who converged on the city in support of the burgeoning curia prompted the Venetian diplomat, Paolo Paruta to comment in a dispatch that ". . . the pomp and splendour, which in other periods had been restricted to only a few, especially cardinals and barons, is now enjoyed by so many that it is truly a wonder."[3] As family palaces were expanded and built, paintings played an increasingly prominent role in domestic interiors, both for display in galleries and salons as well as embellishments throughout rooms and corridors.[4] In Rome, more so than Florence and Venice, the demand for paintings was especially acute due to the fact that the preoccupation with antiquarianism and preference for fresco painting that characterized private spending throughout much of the sixteenth century meant that many collections of paintings had to be built almost entirely from scratch. The city's expanding art market offered something for every budget; even members of the merchant and artisan classes had ready access to modestly priced paintings to decorate their homes.[5]

To help navigate this changing artistic landscape, a new breed of expert emerged: the connoisseur, referred to alternatively as *intenditore, amatore,* or *dilletante.*[6] Existing traditions of artistic discourse had become increasingly challenged. On one hand, late-sixteenth-century painters such as Giovanni Paolo Lomazzo[7] and Federico Zuccaro[8] teased long-standing tenets of art theory into ever more elaborate and esoteric formulations. And on the other hand, post-Tridentine reformers such as Giovanni Andrea Gilio[9] and Cardinal Carlo Borromeo[10] promulgated the decrees of the Council of Trent in terms of proscriptions against indecorous content or conspicuous displays of invention, which, they argued, distracted viewers from the spiritual vocation of religious art. Giorgio Vasari's monumental compilation of artists' biographies, *Lives of the Painters, Sculptors, and Architects,* published in 1550 (and in an expanded

edition in 1568)[11] remained unsurpassed as a resource for information on art of the past, notwithstanding the biases and exclusions dictated by his overriding Florentine patriotism, but was of diminishing utility for contemporary art, which saw the introduction of new genres of painting along with a marked influx of foreign artists.

Connoisseurs were typically middle-ranking members of Roman society, who combined social influence with expertise in the arts. Their authority arose not from the patronage of monumental public art as it had in the past, but from the collections they assembled, the collectors they advised, and the artists they promoted. Their financial limitations meant that they engaged more actively in the art market of ready-made paintings – seeking less well-known artists to champion – than those who could afford to collect the increasingly rare works by past masters or commission costly works from well-established contemporary artists. This was evidently the case with Caravaggio, when, according to Giovanni Baglione, his rival and biographer, Cardinal Francesco Maria del Monte bought two of the artist's paintings from a dealer's shop in his neighbourhood in San Luigi dei Francesi in Rome, and shortly thereafter invited the artist to live in his household, a common practice among Rome's cultured elite.[12]

Caravaggio had recently left the busy studio of the papal favourite, Giuseppe Cesari, where he had worked as a still-life specialist, and during which time he supplemented his income, as did many workshop painters, by making small paintings for sale for the market. He had enjoyed some measure of success with his allusive half-length portraits of youths dressed in classical garb, known through several examples which remained in Cesari's workshop. Del Monte purchased the *Cardsharps* (cat. 17) and the *Fortune Teller* (cat. 13), which offered a fresh take on the "low-life" genre paintings that had recently become popular in Rome.[13] The characters were rendered in a refined but emphatically realistic style that stood somewhere between the coarse caricatures found in moralizing Flemish prints of gamblers and the genteel aristocrats that populated Northern Italian paintings of salon games. During his stay with Del Monte, Caravaggio would paint several more works for his patron, including the *Lute Player* (fig. 50, p. 130) and the *Musicians* (cat. 1), both of which appealed to his well-known passion for music; a still-life *Vase of Flowers* (lost); a painting of *Mars Punishing Cupid* (lost); full-length paintings

of *Saint Catherine* (fig. 70, p. 228) and *Saint Francis of Assisi in Ecstasy* (lost); and a ceiling painting of *Jove, Neptune, and Pluto* for his villa near the Porta Pinciana.

Del Monte quickly set about promoting his protegé's career, and was perfectly positioned to do so. Hailing from a family of career functionaries at the della Rovere court in Urbino, Del Monte arrived in Rome in the early 1570s equipped with a full complement of humanistic and legal training.[14] His role as mediator in the sale of the fief of Sora led to a lasting friendship and alliance with Cardinal Ferdinando de' Medici. When Ferdinando returned to Florence in 1587 to assume leadership of the Grand Duchy of Tuscany, Del Monte was made cardinal and installed in the Palazzo Madama to help promote Medicean interests. Although Del Monte's direct political power was circumscribed, he became a fixture in Rome's most influential circles as a cultivated host of salons and musical concerts among the city's powerbrokers. Even with the support of the Medici, however, his living arrangements were by no means extravagant; rather it was his taste and refinement that set him apart. In a letter to Ferdinando, his friend the nobleman and musician Emilio de' Cavalieri, remarked that "Del Monte amazes me in regard to spending that he can live on what he has and do it so honorably," and adds that "he is courted by more Romans than cardinals [and] his antechamber is always filled with people . . . he is not involved in important transactions and those that come do so only to visit."[15]

Del Monte's exceptional knowledge of painting was widely recognized among his peers. He acted as an intermediary on behalf of the Medici, as amply documented in his correspondence to Florence, and later served as first point of contact and provisional residence for state-sponsored French artists arriving in Rome (Ferdinando's niece, Marie de' Medici, had become Queen of France in 1600).[16] Del Monte accrued official distinctions as well: in 1595 he was appointed, alongside Cardinal Gabriele Paleotti, co-patron of the Accademia di San Luca following the departure of the founding patron Cardinal Federico Borromeo, who had been named Archbishop of Milan; and, in 1606 he was named to the Fabbrica, the committee of cardinals entrusted to oversee the decoration of the newly completed interior of Saint Peter's Basilica.

Unfortunately, there is little documentary evidence of Del Monte's expressed views on art; his post-mortem inventory of 1627, which lists 599

paintings (almost half, however, belonged to a decorative series of *viri illustri*), sheds little light on his early years at the Palazzo Madama, although it does boast a robust proportion of works by contemporary artists to be sure.[17] Nevertheless, Del Monte's patronage of an untested and unconventional artist such as Caravaggio clearly testifies to the progressiveness of his tastes. Admiration for Caravaggio was by no means universal. The insistent realism of his paintings challenged classicist ideals, which continued to dominate church and private patronage. For example, Giovanni Battista Agucchi, secretary to the papal nephew Cardinal Pietro Aldobrandini, omitted Caravaggio altogether from his unpublished treatise on painting, written between 1607 and 1615, in which he exalted the classicizing aesthetic of Annibale Carracci and the Bolognese school.[18] Likewise, the inventory of the celebrated collection of Cardinal Ludovico Ludovisi reveals a conspicuous absence of paintings by Caravaggio and his followers.[19]

Despite Del Monte's professional connections, he initially championed Caravaggio through more informal channels, which were less restrictive than the official taste of Clementine Rome. Del Monte sent out carefully considered gifts to his most illustrious contacts. He probably gave Cardinal Federico Borromeo, his predecessor at the Accademia, the *Still Life with a Basket of Fruit* (fig. 21), a subject surely devised to appeal to Borromeo's belief that paintings of nature and landscape could inspire spiritual contemplation.[20] The painting was exceptional for being among the earliest known independent still lifes in Italy, and evidently pleased the cardinal who later praised its "beauty and incomparable excellence" in his treatise on religious painting, *De pictura sacra* (Milan, 1624). By contrast, for the more worldly Grand Duke Ferdinando, Del Monte selected the startlingly violent, but equally innovative, *Head of Medusa*, which is painted on a shield with virtuoso *trompe l'oeil* illusionism that would have rivalled the Medici's prized Medusa painted by Leonardo da Vinci (since lost).[21]

In the late 1590s, Del Monte facilitated Caravaggio's early commissions, almost all of which came from the ambit around his close friends, Cardinal Alessandro Peretti Montalto, nephew of Sixtus V and Vice-Chancellor of the Church, and Cardinal Pietro Aldobrandini, the current papal nephew.[22] Members of this elite circle were acquainted through professional involvements, political alliances, religious associations and social activities. Pietro's sister, Olimpia Aldobrandini, commissioned the *Martha and Mary*

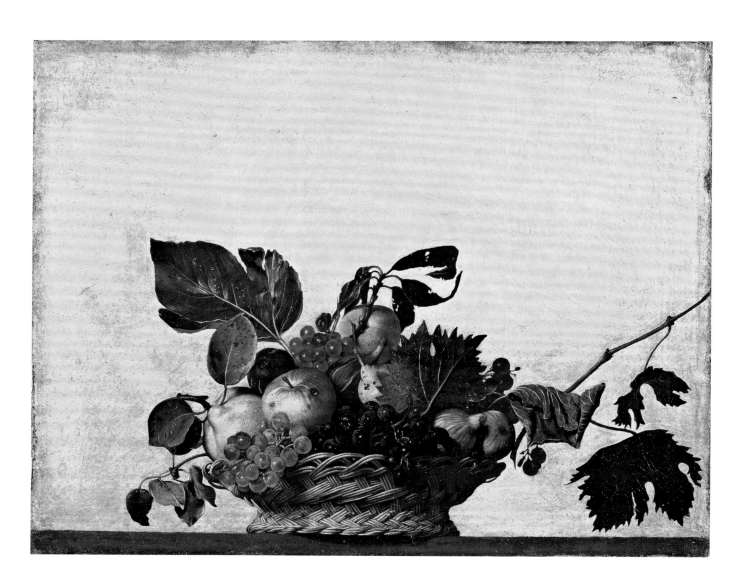

Fig. 21 Michelangelo Merisi da Caravaggio, *Still Life with Basket of Fruit*, 1597–1601, oil on canvas, 31 × 47 cm. Pinacoteca Ambrosiana, Milan

Magdalene (cat. 47). The Ligurian banker Ottavio Costa, a friend of Montalto's secretary, Ruggero Tritonio, acquired a painting of *Judith Beheading Holofernes* (fig. 76, p. 267), as well the *Saint Francis in Ecstasy* (cat. 27). Francesco Rustici, an associate of Montalto, bought a painting of *Saint Francis in Meditation* (c. 1603, Santa Maria della Concezione, Rome). And Vincenzo Giustiniani, Del Monte's neighbour and fellow music afficionado, acquired a close variant of Del Monte's *Lute Player*.

But even with such a notable clientele, wider acclaim for Caravaggio came only with the distinction of a prestigious public commission. In 1599 he began work on a pair of canvases for the lateral walls of the Contarelli Chapel in the church of San Luigi dei Francesi in final fulfilment of the will of the French cardinal Matthieu Cointrel. Del Monte surely had a hand in securing the commission once the legacy of the delay-plagued project had been

transferred to the Fabbrica in 1597 at the behest of the increasingly impatient French clergy.[23] The two paintings – the *Calling of Saint Matthew* and the *Martyrdom of Saint Matthew* – were large-scale, multi-figured compositions entirely unprecedented in Caravaggio's career and as such presented the artist with considerable challenges. While the *Martyrdom* saw Caravaggio tackling the pictorial complexities entailed in large-scale history painting – not without considerable difficulties as evident in its substantial pentimenti – his approach to the *Calling of Saint Matthew* (fig. 1, p. 6) was entirely unconventional. He situated the event, in which Christ summons Matthew from among his fellow tax collectors, in a stark and darkened room populated with roguish types imported from contemporary low-life genre paintings. By illuminating the scene with a sharp shaft of light beaming through an unseen window from behind the figure of Christ, Caravaggio conveyed the dramatic moment before Matthew's revelation.

When the Contarelli Chapel paintings were unveiled in late 1600, they drew a large and enthusiastic audience of connoisseurs and fellow artists, and other altarpiece commissions followed in quick succession. With professional recognition, in 1601 Caravaggio moved into the more ample and luxurious accommodations of Marchese Ciriaco and Cardinal Girolamo Mattei, the elder two brothers of an extremely well-connected ancient Roman family of civic administrators.[24] Cardinal Girolamo had been an elector, along with cardinals Montalto and Benedetto Giustiniani in the election of Clement VIII, and succeeded Ferdinando de' Medici as Cardinal Protector of the Observant Franciscans in 1588. The brothers commissioned two scenes from the life of Christ – the *Supper at Emmaus* (1601, now in the National Gallery, London), and the recently discovered *Taking of Christ* (1602, National Gallery of Ireland, Dublin) – a painting of *Saint Sebastian* (lost), and a sensual image of *John the Baptist* (1602, Galleria Capitolina, Rome) as a nude youth, which was eventually bequeathed to Del Monte by Ciriaco's son. Although Del Monte remained on good terms with his former protegé, he did not acquire any further paintings from the artist. With a steady stream of high-profile commissions, Caravaggio's prices had exceeded the cardinal's modest means.

Caravaggio also began to attract the attention of Rome's most elite collectors. Monsignor Maffeo Barberini, the papal nuncio at the French court (and the future Pope Urban VIII), commissioned him to paint his portrait as

well as a large painting of the *Sacrifice of Isaac* (cat. 52). When Camillo Borghese was elected Paul V in May 1605, Caravaggio was commissioned to paint his portrait. His nephew, Scipione Borghese, who had received the *Supper at Emmaus* as a gift from the Mattei, also ordered a painting of *Saint Jerome Writing* (c. 1606, Galleria Borghese). For Ottavio Costa the artist created a *John the Baptist* (cat. 25), for Cardinal Benedetto Giustiniani, the *Agony in the Garden* (destroyed), a *Saint Jerome* (lost), a *Penitent Magdalene* (lost) and, possibly, the newly discovered *Saint Augustine* (cat. 37), as well as a portrait of the cardinal (lost), and for Vincenzo Giustiniani the *Crowning with Thorns* (fig. 42, p. 115) and the *Incredulity of Thomas* (fig. 78, p. 270). He also completed two scenes from the Passion – the *Crowning with Thorns* (fig. 83, p. 276) and probably an *Ecce Homo* – for Massimo Massimi. Thus, with the notable exception of a brazen image of *Triumph of Earthly Love* (fig. 22), painted for Vincenzo Giustiniani in 1601, the remainder of his Roman career was occupied with altarpieces, religious subjects, and a handful of portraits. Caravaggio had abandoned the innovative genre paintings that first drew the attention of Rome's connoisseurs in favour of more traditional forms of patronage.

VIEWERS

Given the intense spiritual climate of Clementine Rome, which coincided almost exactly with his activity in the city, the question of the specific influence of religious currents on Caravaggio's art continues to provoke debate.[25] With a steady stream of commissions, his style matured rapidly within the span of a few productive years. Caravaggio's realistic aesthetic had certainly proven amenable to the devotionalism and humility embraced by such new religious orders as the Jesuits and Oratorians. He moved towards a darker palette in which he sharply illuminated his conspicuously un-idealized subjects from an external source, using light rather than "artificial" symbols or saintly attributes to thematize their inner spirituality. But even if the question remains inconclusive – especially given the prevailing conservatism of Church patronage and the absence of any concrete information about Caravaggio's own religious views – surely the spiritual attitudes of the new orders had permeated Caravaggio's Roman world in a more pervasive sense. In a letter

Fig. 22 Michelangelo Merisi da Caravaggio, *Triumph of Earthly Love*, 1601–02, oil on canvas, 156 × 113 cm. Gemäldegalerie, Staatliche Museen, Berlin

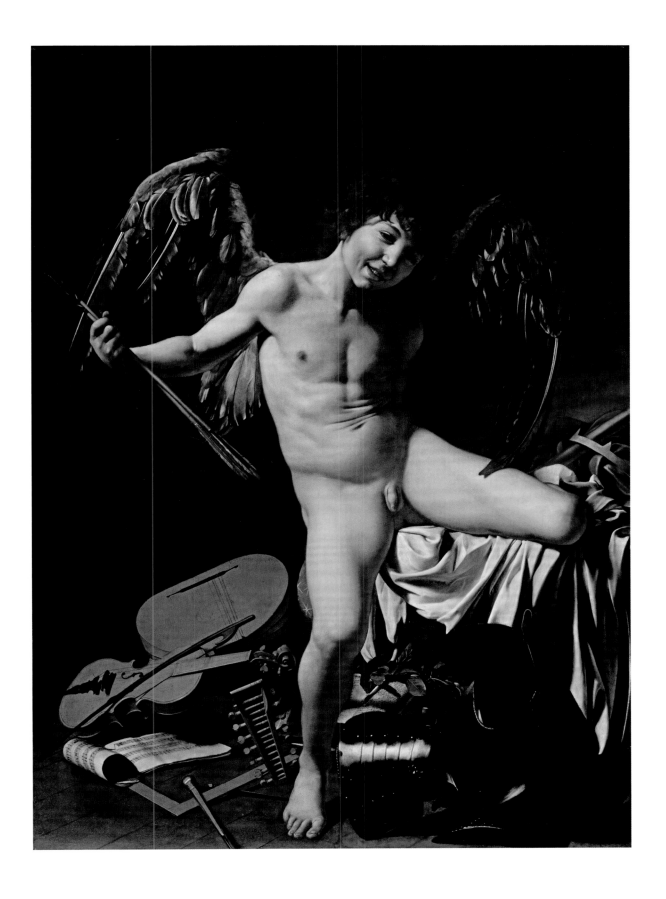

of August 1603, Cardinal Ottavio Parravicino famously commented that Caravaggio's paintings were "halfway between sacred and profane," an enigmatic description that continues to inspire debate as to his precise meaning.[26] Yet his words aptly summarize the ambiguities in understanding Caravaggio's oeuvre during this crucial period in the development of collecting, a time when more traditional attitudes toward the function of paintings existed alongside newer ideas of connoisseurship and collecting.

It is important to remember that during the 1590s, private galleries were still a novel and fairly uncommon addition to domestic spaces. Since the late fourteenth century, the interior spaces of wealthy Italian households had been filling up with all manner of furnishings and luxury objects;[27] however, paintings typically fulfilled a function: as devotional images that could be found in almost any room of the residence; as portrait displays of family members, ancestors, historical, and contemporary personages in public halls; as intellectual devices in private studies; and, as religious and moralizing images for private chambers that were often incorporated into the furnishings themselves. Although there is ample evidence that by the late fifteenth century paintings were being accumulated for their own sake – particularly if they were by a well-known artist – there were, in fact, few proper collections during the first half of the sixteenth century. The idea of an art collection entailed new habits for acquiring, displaying and viewing paintings – conditions that were hampered by near-continual political and religious turbulence – which disrupted economic and social conditions favourable to private consumption. Picture galleries, as specially dedicated spaces for the delectation of painting and sculpture, only began to appear in the final decades of the century in response to the increasing self-sufficiency of practices of collecting vis-à-vis more functional modes of ownership as much as the practical requirements of housing the sheer accumulation of art.[28]

At the same time, however, in the years following the Council of Trent, Counter-Reformation writers such as cardinals Gabriele Paleotti and Federico Borromeo proclaimed that all paintings, even those in the private domain, should depict religious subjects or act as moralizing exempla.[29] They argued that the purpose of all forms of painting – both sacred and profane – is to stimulate devotion and provide moral instruction and inveighed against demonstrations of virtuosity by artists and aesthetic delectation by collectors.

These restrictive guidelines nevertheless enjoyed great currency in Clementine Rome. Guided by Filippo Neri (d. 1593), founder of the Oratorians who was canonized in 1622, Clement VIII promoted a model of spirituality based on an almost nostalgic conception of the purity of the Early Christian Church. Clement was well known for his abstemious personal conduct and rigorous devotional practices and expected his court to follow his example.

Indeed, most of Caravaggio's early patrons in Rome were actively involved with the Santissima Trinità dei Pellegrini, a confraternity closely affliated with the Oratorians and dedicated to assisting poor pilgrims, which enjoyed great prominence due to the pope's close ties with Filippo Neri, and his successor, Cardinal Cesare Baronio.[30] Ferdinando de' Medici had been protector of the confraternity before he returned to Florence, and was succeeded by Cardinal Montalto. Cardinal del Monte, the Giustiniani brothers, the Mattei brothers, Olimpia and Cardinal Pietro Aldobrandini, Francesco Rustici, and Ottavio Costa were all involved, either as members, benefactors, or protectors, with the confraternity.[31] The inventories of the collections of Olimpia Aldobrandini,[32] Ottavio Costa,[33] and the Mattei family,[34] in particular, list religious subjects almost exclusively (as well as the usual assortment of portraits), mostly fitted throughout the residence as to suggest that these paintings continued to fulfill a more traditional role as morally instructive decoration. Significantly, in the inventories of the Palazzo Mattei dating to the first three decades of the seventeenth century, the paintings throughout the palace are simply grouped into two categories: "*Quadri di devotione*" (devotional paintings); and "*Quadri di ritratti et altre cose*" (portraits and other subjects). In other words, at a time when art collecting was very much still in its infancy, it is not always certain when dealing with Caravaggio's patrons whether they are better understood within the new schema of art collecting or according to more traditional practices of domestic display.

These two modes of spectatorship are especially apparent in the collections of the Giustiniani brothers, which are recorded in the post-mortem inventories of Cardinal Benedetto and Vincenzo dated 1621 and 1638, respectively.[35] Benedetto's collection of almost 300 paintings and prints featured religious subjects almost exclusively. Benedetto owned numerous works by both old masters and contemporary artists including, of course, works by Caravaggio as well as the Carracci, Giovanni Lanfranco, Jan Brueghel the Elder, and Jusepe de Ribera.[36] However, Benedetto's most

valuable works were not necessarily concentrated in his small gallery but were instead disposed throughout his apartments, suggesting that devotional criteria took precedence in the formation of his collection. His predilection for the early-sixteenth-century Bolognese artist, Francesco Francia, for example, who is represented by eight paintings in the collection, was idiosyncratic for the time; but Francia's characteristically placid devotional paintings were nevertheless reflective of the propriety of Benedetto's tastes. Even a rare secular subject, such as Giovanni Baglione's *Divine Love Conquering Earthly Love* (fig. 23), probably commissioned in competition with his brother's *Triumph of Earthly Love*, is overwhelmingly chaste and overtly moralizing in its content.[37] In marked contrast to Caravaggio's provocatively smiling, nude youth, who subverts the ostensibly neoplatonic theme of the triumph of Love over worldly pursuits, Baglione's Cupid rather cowers beneath a highly manneristic and prudishly dressed figure of Divine Love. Although Baglione's painting was roundly mocked by Caravaggio and his cohorts, it nevertheless earned him a prestigious gold chain from the cardinal.

Vincenzo, on the other hand, was among the few virtuosi who could match Del Monte's expertise. As scion of the family of papal bankers, Vincenzo was wealthy enough to pursue his interest in painting through personal endeavours. In 1606, for example, he undertook a tour of Germany, Flanders, England and France accompanied by the painter Cristoforo Roncalli, to view the most celebrated works of Northern Europe. During the 1610s and 1620s, he housed northern artists associated with the Caravaggist movement including Nicholas Regnier, David De Haen, and Dirck Baburen, where the artists would be able to study from the works in his collection.[38] And from the 1630s until his death in 1637, he was preoccupied with the publication on the *Galleria Giustiniani*, a monumental two-volume compilation of engravings after his famous sculpture collection.[39]

Vincenzo, like Del Monte, was also well known for his progressive tastes. Nowhere is this more apparent than in the letter quoted at the beginning of this essay. In guiding his reader through the subjects and methods found in contemporary painting, he presents a perspective that was wholly independent from the staid traditions of art theory. He was not concerned with theoretical ideals, but rather painting as he saw it, in which every style and genre of painting – not just the lofty themes of "history" painting in the classical tradition – was praiseworthy. His injunction that "we must not be prejudiced

Fig. 23 Giovanni Baglione, *Divine Love Conquering Earthly Love*, 1602, oil on canvas, 240 × 143 cm. Galleria Nazionale d'Arte Antica, Palazzo Barberini, Rome

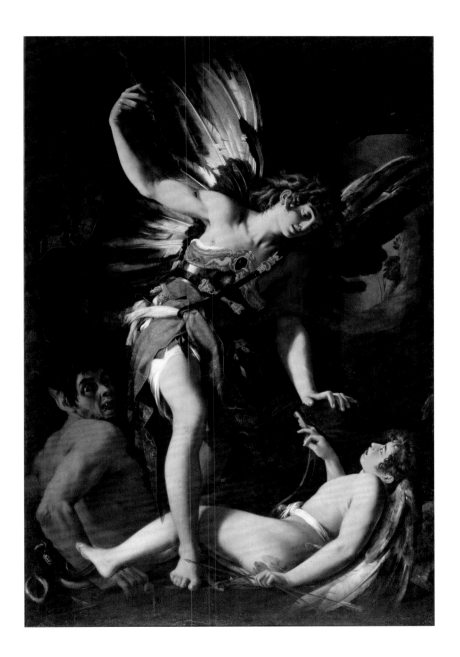

against those who failed to work in certain areas although in others they were excellent" is surely aimed at the narrow purview of the tastes of Agucchi among others.[40]

Accordingly, the 1638 inventory of Vincenzo's collection, which lists more than 600 paintings including those owned by Benedetto bequeathed to Vincenzo, reveals a more decisive orientation towards art collecting. Vincenzo concentrated his holdings in the three rooms devoted to paintings, with the most celebrated grouped in the Grand Gallery. Benedetto's paintings by Caravaggio, which had been scattered among the rest of his holdings, were gathered together with Vincenzo's and hung – regardless of subject – alongside his collection of old master paintings by Raphael, Titian, and Veronese as well as contemporary paintings by the Carracci. As the German artist Joachim Sandrart, who lived at the Palazzo Giustiniani during the 1630s, would later recollect, Caravaggio's *Victorious Cupid* was so highly esteemed that it was kept behind a green curtain to be revealed to visitors only once they had seen the rest of the collection so as not to overshadow the other works.[41] Baglione's *Divine Love*, which had been so prized by Benedetto, was consigned to a minor gallery.

Such was Vincenzo's admiration for Caravaggio, that in 1602 he stepped in to salvage the potentially disastrous situation when the *Saint Matthew and the Angel* (fig. 3b, p. 9), which had been commissioned for the altar of the Contarelli Chapel, was rejected by the congregation. According to the much later account of Giovanni Pietro Bellori, "the figure [of Saint Matthew] with his legs crossed and his feet crudely exposed to the public had neither decorum nor the appearance of a saint."[42] Giustiniani not only bought the *Saint Matthew*, but also funded a revised version to replace it ensuring that Caravaggio retained the commission.[43] The altarpiece was not installed in the palace chapel, but instead assumed pride of place in the Grand Gallery.[44] In this context, Caravaggio's alleged lapses of decorum made no difference to its artistic worth; rather its grand proportions made it the most monumental of Caravaggio's privately owned paintings at that time. As Baglione later scoffed, though the painting "pleased nobody," Giustiniani took it "because it was by Michelangelo."[45]

Thus, for some owners his works could be decorous exempla and reflections of their piety, while for others they were objects of aesthetic virtue and demonstrations of their taste. Caravaggio's Roman oeuvre precariously straddled these two contexts. Despite his considerable successes, his almost-polemical brand of realism also existed in intrinsic conflict with the conservative values of religious patronage. Although his pictorial and

thematic innovations had led to new modes of spiritual expression in private devotional art, his continued experimentation had become problematic when it came to public religious art. Church art not only relied heavily on established iconographic traditions by design, but, in Clementine Rome, there was little tolerance for even perceived improprieties.

Caravaggio's professional reputation in Rome suffered further setbacks. The altarpiece known as the *Madonna dei Palafrenieri*, painted for the Confraternity of the Pontifical Grooms for their altar in Saint Peter's, was removed in May 1606 just days after it was installed under curious circumstances. It is possible, as some have suggested, that this was necessitated by the grooms' loss of rights to their altar;[46] but Caravaggio's detractors nevertheless seized upon the loss of what would have been his most prestigious commission as confirmation of the inappropriateness of his art.[47] Worse still, his altarpiece of the *Death of the Virgin* (fig. 9, p. 20), which was painted for Laerzio Cherubini's chapel in Santa Maria della Scala was outright rejected sometime before October 1606 by the Carmelite fathers, allegedly – according to Caravaggio's biographers – due to its indecorous portrayal of the Virgin, who all too realistically resembled a bloated corpse.[48]

Both paintings, however, were promptly sold for a tidy profit to two of Italy's most prominent collectors: Cardinal Scipione Borghese, who bought the *Madonna dei Palafrenieri* for 100 *scudi*;[49] and Duke Vincenzo I Gonzaga of Mantua, who purchased the *Death of the Virgin* for 280 *scudi*.[50] If these altarpieces were unsuitable for a religious context, they posed no problems for such notoriously acquisitive collectors such as Borghese and Gonzaga. No less an authority than Peter Paul Rubens, the famous Flemish painter, had advised Gonzaga to buy the *Death of the Virgin*. The correspondence of the Mantuan envoy, Giovanni Magno, is explicit about Gonzaga's interest in it as a collector. In a letter of February 1607, Magno recounts the acclaim it had received from other painters and advises that it "is one of the most famous for collectors of modern things, and the picture is held to be one of the best of the works he has done."[51] In subsequent letters, he reports that he had refused to allow copies to be made of the prized painting, and that, due to its fame, the former altarpiece had been put on display in the house of the Mantuan ambassador where artists flocked to see the painting.[52] By this time, Caravaggio had been gone from Rome for almost a year, having fled the city on charges of the murder of Ranuccio Tomassoni. Caravaggio's departure

from Rome must have been acutely felt by collectors and artists alike who realized that paintings by his hand had suddenly become a much rarer commodity, and the art market responded in kind.

DEALERS

That altarpieces were transformed into gallery paintings reveals that for whatever purpose Caravaggio's paintings may have been intended, they had also become highly desirable among collectors. Rarely were his paintings offered for sale; rather, they circulated as gifts or bequests among his patrons. In 1607 Cardinal Scipione Borghese, armed with his newfound power as papal nephew to build his collection, notoriously imprisoned Giuseppe Cesari, whose status had plummeted with the death of Clement VIII, on charges of tax fraud and seized his covetable collection, which included several of Caravaggio's early works.[53] But for the rest of Rome, the immediate demand for his works was sated by the production of copies.[54] With collectors vying for a comparatively small pool of works by sixteenth- and seventeenth-century artists, high-quality copies that faithfully replicated an invention were acceptable substitutes for the real thing.

The aftermath of Caravaggio's Roman career was documented by Giulio Mancini in his extensive correspondence with his brother, Deifebo Mancini.[55] These letters, some 3000 of which are preserved in the Mancini family archives in Siena, offer a rich chronicle of the art market in early seventeenth-century Rome. Like Del Monte, Mancini arrived in the city in 1592 in the service of his patron, Agostino Chigi, the rector of the Hospital of Siena; he was trained as a doctor, and was eventually appointed as the personal physician to Urban VIII in 1623.[56] Mancini however, does not appear to have frequented the same lofty circles as Del Monte. On the contrary, their acquaintance seems to have been distant at best. In letters from February and March 1613, Mancini complained to his brother that Caravaggio had originally promised him the painting of *Mars Punishing Cupid*, which ultimately went to Del Monte.[57] The Cardinal further refused Mancini's requests to have another version of the painting made for Chigi, prompting Mancini to commission a variant of the same subject from Bartolomeo Manfredi (fig. 24), perhaps the best known of Caravaggio's followers at that

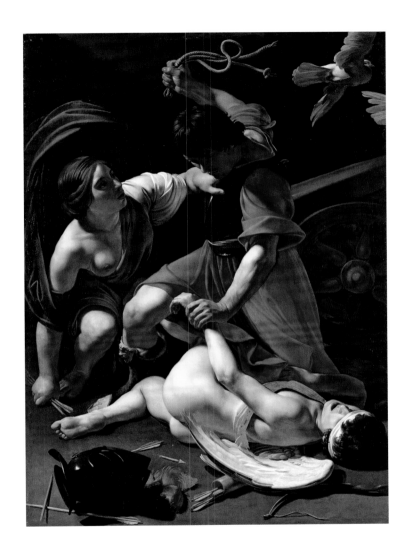

Fig. 24 Bartolomeo Manfredi, *Mars Punishing Cupid*, 1613, oil on canvas, 175.3 × 130.6 cm. The Art Institute of Chicago, Charles H. and Mary F.S. Worcester Collection, 1947.58

time. In a letter of February 1615 Mancini reported having commissioned copies of Del Monte's *Cardsharps*, the *Fortune Teller*, and the *Musicians* without the Cardinal's permission, having gained access for his copyist from the Guardaroba.[58]

Mancini does not appear to have personally supported an artist as had Del Monte and Giustiniani, preferring instead to buy and sell paintings on the market. He shrewdly kept his paintings in Siena to prevent his collection from being picked over by acquisitive and more titled collectors who could

take advantage of his obeisance. Tellingly, there is no recorded inventory of Mancini's own collection, only a cursory list of approximately two dozen paintings recorded in the 1620 sale of his paintings to the Sienese painter and art dealer, Michelangelo Vanni.[59] With business-minded acumen, Mancini paid careful attention to the prices of works bought and sold on the market, and the rising prices of Caravaggio's paintings, in particular. In a letter of June 1613, for example, he reports Caravaggio's *Fortune Teller*, a later variant of the Del Monte painting owned by the Vittrice family, had been sold for 300 scudi, a hefty sum for such a modestly sized genre painting.[60] Based on this amount, he adds, his own painting by Caravaggio, the Saint John the Evangelist, which he had acquired for 5 *scudi* sometime before 1606 when the painting was shipped to Siena for safekeeping, should be worth 150 *scudi*.[61]

The value and prestige of Caravaggio's works was irresistible to Mancini, both as a connoisseur and entrepreneur. It comes as little surprise then to find that in late 1606 he had also attempted to buy the *Death of the Virgin* – ostensibly to install in the family's chapel in Siena – before it was offered to Gonzaga. What is surprising, however, is that Mancini also counted among the painting's detractors. In proposing the purchase of the painting to his brother, he describes it as being "without decorum or invention or cleanliness," but added that it was "even better than the *Saint John*."[62] Mancini was apprehensive, not dismissive, of Caravaggio's naturalism, which he found praiseworthy but ill-suited to complex, multi-figured compositions (rather, he unequivocally preferred the classicism of the Bolognese school). Yet his appreciation of the painting as a superior and rare example of Caravaggio's art, evidently trumped any cavilling over its style or content.

But Mancini was not motivated strictly by status or profit. His pragmatic attitude toward the *Death of the Virgin* also belies an art-historical orientation that was distinctly modern for the time. He was perhaps not the first collector to take an interest in a painting on account of its fame, but he was the first theorist to put forth an appreciation for art that was informed by a desire for representativeness rather than taste. Between 1618 and 1621, he compiled *Considerazioni sulla pittura* ("Considerations on Painting"), the first treatise written expressly to deal with collecting, a topic of some urgency at a time when there was little in the way of precedent to guide collectors in managing their burgeoning holdings.[63] Although it was never published, several manuscript copies circulated among Roman aristocracy, including

the renowned collectors Ludovico Ludovisi and Cassiano dal Pozzo, a close associate of Del Monte and aide in the court of Urban VIII.

Giulio Mancini states the purpose of the "Considerations" at the outset: "My intention is not to propose precepts pertinent to painting or its production . . . since this is not my profession; rather I propose to consider the various means by which a dilettante of similar learning as myself can easily pass judgment on paintings, collect them and display them."[64] Although the bulk of the treatise deals with artists' biographies – a much-needed update to Vasari, which was now over fifty years out of date – the most original chapters concern such practical topics as pricing, framing, hanging, and distinguishing counterfeits.

In the "Rules for Buying, Locating, and Conserving Paintings," Mancini largely follows traditional practices of organizing paintings according to their subject and the function of the room.[65] When there is an abundance of paintings, he proposes the gallery, "a convenient place of light and good air," as a location where paintings of any subject could be hung. However, Mancini also introduces a new element: in arranging the collection, he encourages his readers to first classify their paintings, and then hang them according to period, with the major schools – Northern, Lombard, Tuscan and Roman – mixed together so that they can be compared with each other according to their pictorial qualities. This provided viewers with the opportunity to demonstrate their judgment, an enjoyable activity in itself, and to hone their connoisseurial skill, a necessity when dealing with the often-unscrupulous art market. This was a pastime that Mancini practiced himself. In November 1608, Mancini organized a *paragone* between his *Saint John the Evangelist* by Caravaggio and a recently acquired painting of *Saint John the Baptist* by Annibale Carracci, the foremost proponents of what Mancini would identify elsewhere in the "Considerations" as the leading schools of contemporary art in Rome.[66] Indeed, after Karel van Mander, Mancini was the first writer firmly to identify and describe the style of Caravaggio and his followers in terms of its tenebrism and realism.

"Painting," as Mancini declared in the introduction of his treatise, "has no utility, it is pleasure."[67] In his ability to evaluate Caravaggio without prejudice, Mancini eschewed the regional and stylistic biases characteristic of the Vasarian tradition of art writing, which persisted throughout the seventeenth century. Similarly, he was also one of the first collectors to demonstrate a

sincere aesthetic sensibility toward medieval painting, which previously had been of interest only to church historians.[68] In short, Mancini believed collections should incorporate all periods and all schools, an ideal that anticipates the creation of the first public galleries in the late eighteenth century. Unfortunately, it appears few of Mancini's contemporaries in Rome followed his precepts; evidence indicates that paintings were usually grouped to form symmetrical arrangements on the walls, and it would take almost two more centuries before medieval painting was collected in significant numbers. But it is Mancini's conception of the gallery – as an autonomous venue where considerations of function and decorum were irrelevant, a place where scenes taken from Roman street life were hung alongside images of saints, all for the delectation of discerning viewers – that continues to inform our ideas about art collecting to this day.

NOTES

1 Bottari and Ticozzi 1922–25, vol. 6, pp. 121–129; trans. in Enggass and Brown 1970, p. 20.

2 Magnusson 1982, vol. 1, pp. 40–99.

3 Quoted and trans. in A. Zuccari, "The Rome of Orazio Gentileschi," in New York 2001, p. 44.

4 On the planning and decoration of seventeenth-century Roman palaces, see Waddy 1990; Ago 2006; F. Petrucci, "La collezioni romane dal private al pubblico," in Rome 2008, pp. 17–41.

5 For recent studies on the Roman art market, see Ago 2002; L. Lorizzo, "Il mercato dell'arte a Roma nel XVII secolo: 'pittori bottegari' e 'rivenditori di quadri' nei documenti dell'Archivio Storico dell'Accademia di San Luca," in Fantoni et al. 2003, pp. 325–333; Cavazzini 2004; R.A. Goldthwaite, "L'economia del collezionismo," in Genoa 2004, pp. 13–21; Cavazzini 2008.

6 De Benedictis 1998, pp. 108–116. For the rise of the "connoisseur" in early seventeenth-century Rome, see the excellent essay by M. Fumaroli, "Rome 1630: entreé en scène du spectateur," in Rome 1994, pp. 53–82.

7 Giovanni Paolo Lomazzo, Trattato dell'arte della pittura, scoltura et architettura (Milan, 1584).

8 F. Zuccaro, L'Idea de' pittori, scultori ed architetti (Turin, 1607).

9 G.A. Gilio, *Dialogo nel quale si ragiona degli errori e degli abusi de' pittori circa l'istorie. Con molte annotatione fatte sopra il Giudizio di Michelangelo e altre figure, tanto de la nova, quanto de la vecchia capella del Capella del Papa* (Camerino, 1564).

10 C. Borromeo, *Instructionum fabricae et supellectilis ecclesiasticae libri duo* (Milan, 1577).

11 G. Vasari, *Le vite de' più eccellenti pittori, scultori, e architettori* (Florence, 1550; Florence, 1568).

12 G. Baglione, *Le vite de' pittori, scultori, et architetti* (Rome, 1642), trans. in Hibbard 1983, p. 352.

13 On the development and popularity of genre

painting in seventeenth-century Rome, see G. Feigenbaum, "Gamblers, Cheats, and Fortune-Tellers," in Rome 1996, pp. 150–178; H. Langdon, "Cardsharps, Gypsies and Street Vendors," in London 2001, pp. 42–65.

14 For biographical information on Del Monte, see, above all, Waźbiński 1994.

15 Quoted and trans. in Trinchieri Camiz 1991, p. 213.

16 For Del Monte's relations with French artists in Rome, see Z. Waźbiński, "Simon Vouet et le cardinal Francesco Maria del Monte: une hypothèse sur le mécénat d'Henri IV à Rome," in Loire 1992, pp. 149–167.

17 Del Monte's inventory is transcribed in Frommel 1971; see also the addendum in Kirwin 1971. For an analysis of his collection vis-à-vis other contemporary collectors, see Jones 2004b.

18 Giovanni Battista Agucchi Trattato della pittura (c. 1607–15), published and trans. in Mahon 1971.

19 Garas 1967.

20 Jones 1988.

21 Varriano 1997.

22 On the close relationship between the three cardinals, see Waźbiński 1994, vol. 1, pp. 137–140.

23 M. Pupillo, "I Crescenzi, Francesco Contarelli e Michelangelo da Caravaggio: contesti e documenti per la commissione in S. Luigi dei Francesi," in Macioce 1996, pp. 148–166; Zuccari 1999.

24 For Caravaggio and the Mattei family, see Cappelletti and Testa 1994; M. Calvesi, "Michelangelo da Caravaggio: il suo rapporto con i Mattei e con altri collezionisti a Roma," in Rome 1995, pp. 17–28; Gilbert 1995, ch. 10, "A Religious Cardinal Host: Del Monte."

25 See, for example, Friedlaender 1955, ch. 4 "Caravaggio's Character and Religion"; Chorpenning 1987; Troy 1988; J. Varriano, "Caravaggio and Religion," in Boston 1999, pp. 191–207.

26 The quotation comes from a letter sent from Cardinal Ottavio Parravicino to Monsignor Paolo Gualdo on 2 August 1603, first published in Cozzi 1961. For further discussion of the letter, as well as the debate surrounding its meaning, see Pupillo 1999; B.L. Brown, "Between the Sacred and Profane," pp. 274–303 in London 2001; M. Calvesi, "Fautori e avversari del Caravaggio," in Volpi 2002.

27 For the decoration of fifteenth- and sixteenth-century interiors in central Italy, see Lydecker 1987; Thornton 1991; Goldthwaite 1993, pp. 212–243; Thornton 1997; London 2006.

28 On the development of the gallery in Italy, see Settis 1983; Prinz 1988; C. Cieri Via, "I luoghi del mito fra decorazione e collezionismo," in Lecce 1996, pp. 29–48; De Benedictis 1998, pp. 79–96.

29 Cardinal Gabriele Paleotti, *Discorso intorno alle immagini sacre e profane* (Rome, 1582); Cardinal Federico Borromeo, *De pictura sacra* (Milan, 1624). For Paleotti, see Boschloo 1974, vol. 1, ch. 7, "Paleotti's 'Discorso intorno alle iamgini sacre e profane'; Jones 1995. For Borromeo, see Jones 1993.

30 For Oratorian circles in Rome, see Zuccari 1981a; Zuccari 1981b; Zuccari 1984; Verstegen 2003. For the history of the Santissima Trinità dei Pellegrini, see O'Regan 1994.

31 For the involvement of Caravaggio's patrons in the confraternity, see R. Cannatà and H. Röttgen, "Un quadro per la SS. Trinità dei Pellegrini affidato al Caravaggio, ma eseguito dal Cavalier d'Arpino," in Macioce 1996, pp. 80–93; Pupillo 1997; Pupillo 2001; M. Pupillo, "La Madonna di Loreto di Caravaggio: gli scenari di una committenza," in Volpi 2002, pp. 105–121.

32 For the May 1606 inventory of Olimpia Aldobrandini's collection, see L. Testa, "'. . . In ogni modo domatina uscimo': Caravaggio e gli Aldobrandini," in Volpi

2002, pp. 145–146; for subsequent inventories taken in 1611, c. 1615, and 1634, see Testa 2004, pp. 157–167.

33 Ottavio Costa's inventory of his palace in Rome, taken in January 1639, is transcribed in Costa Restagno 2004, pp. 98–102. For Costa's collection, see also Terzaghi 2007, pp. 118–133.

34 The collections of Cardinal Girolamo and Ciriaco Mattei are known principally through the inventories of Ciriaco's son, Giovan Battista Mattei, taken in 1616, two years after Ciriaco's death, and his own post-mortem inventory of 1624. The inventories are transcribed in Cappelletti and Testa 1994, pp. 173–176, and pp. 181–187.

35 Cardinal Benedetto Giustiniani's post-mortem inventory of his apartments in the family palace, which was drawn up in March 1621, is transcribed in Danesi Squarzina 1997–98; Vincenzo Giustiniani's post-mortem inventory of February 1638 appears in Salerno 1960. For the relationship between Caravaggio and the Giustiniani, see S. Danesi Squarzina, "Caravaggio e i Giustiniani," in Macioce 1996, pp. 94–111. and S. Danesi Squarzina, "La collezione Giustiniani. Benedetto, Vincenzo, Andrea nostri contemporanei," in Rome 2001, pp. 17–45.

36 For an analysis of Cardinal Benedetto's tastes as deduced from the inventory of collection, see Danesi Squarzina 1997–98; Jones 2004a.

37 For the rivalrous relationship between the Caravaggio's and Baglione's paintings, see Röttgen 1993 and R. Vodret, "Giovanni Baglione, nuovi elementi per le due versioni dell'Amor sacro e amor profano," in Volpi 2002.

38 On Giustiniani's patronage of Northern artists, see Danesi Squarzina, "Caravaggio e i Giustiniani" in Macioce 1996; Lemoine 1999–2000; Lemoine 2007.

39 The first volume was prepared between 1631 and 1635, and circulated in a limited

"private" edition in 1636. The second volume, which must have been well underway by that time, was released sometime between 1636 and 1637. On the *Galleria Giustiniani*, see Cropper 1992.

40 Quoted in Bottari and Ticozzi 1922–25, vol. 6, pp. 121–129; trans. in Enggass and Brown 1970, pp. 19.

41 Enggass 1967, p. 13.

42 G.P. Bellori, *Le vite de' pittori, scultori e architectti moderni* (Rome 1972), trans. in Hibbard 1983, p. 365.

43 Pupillo, "Contarelli e Caravaggio," 1996.

44 The painting is listed first in the inventory of Giustiniani's Grand Gallery; cf. Salerno 1960, p. 135.

45 Baglione 1642, trans. in Hibbard 1983, p. 353.

46 Rice 1997, pp. 44–45; Spezzaferro 1998; Beltramme 2001.

47 Baglione 1642, trans. in Hibbard 1983, p. 354; Bellori 1672, trans. in Hibbard 1983, p. 372.

48 Mancini 1956–57, vol. 2, pp. 120, 132; Baglione 1642, trans. in Hibbard 1983, p. 354; Bellori 1672, trans. in Hibbard 1983, p. 372.

49 Della Pergola 1959, vol. 2, pp. 81–83.

50 Giovanni Magno to Annibale Chieppo, 24 February 1607, in Furlotti 2003, doc. 717.

51 Giovanni Magno to Annibale Chieppo, 17 February 1607, in Furlotti 2003, doc. 714. correspondence regarding the painting, see Furlotti 2003, docs. 714, 717, 720, 721, 723.

52 Giovanni Magno to Annibale Chieppo, 31 March 1607, 7 April 1607, in Furlotti 2003, docs. 720, 721.

53 For Scipione Borghese's activities as a collector, see Calvesi 1994.

54 As evidenced by the numerous copies after Caravaggio's works catalogued in Moir 1976.

55 For Mancini's correspondence, see Maccherini 1990–93; Maccherini 1997; Maccherini 1999.

56 For Mancini's biography, see L. Salerno, "Vita e opera di Giulio Mancini," in Mancini 1956–57; Maccherini 2004; Sparti 2008.

57 Maccherini 1997, p. 71, docs. 23, 24.

58 Ibid., p. 79, doc. 28.

59 Ibid., doc. 36.

60 Ibid., pp. 79–80, doc. 25.

61 Ibid., pp. 73, doc. 36.

62 Ibid., pp. 76–78, docs. 2, 5, 6.

63 G. Mancini, *Considerazioni sulla pittura* (c. 1618–21), published in Mancini 1956–57; trans. in Bowcutt Butler 1972.

64 Mancini 1956–57, vol. 1, p. 5.

65 Mancini 1956–57, vol. 1, pp. 139–148.

66 For the paragone, see Maccherini 1997, p. 74, doc. 13. The other two schools Mancini identifies are that of Giuseppe Cesari and a miscellaneous group of late Mannerist painters; see Mancini 1956–57, vol. I, pp. 108–111.

67 Mancini 1956–57, vol. 1, p. 9.

68 G. Previtali, *La fortuna dei primitivi: dal Vasari ai neoclassici* (Turin, 1989), pp. 44–48.

Notes on Caravaggio's Early Followers Recorded in Roman Parish Registers from 1600 to 1630[1]

ROSSELLA VODRET

The Archivio Storico del Vicariato is one of the most important archival centres in Rome today. Its vast and extensive collection of documentary holdings bears extraordinary significance in respect of the city's religious history. Along with a rich store of historical ecclesiastical material, the archive also preserves a remarkable core of documents that make possible a meticulously detailed reconstruction of the history of the Roman population and the vicissitudes of its evolution from the time of the Council of Trent in the mid sixteenth century to the end of the temporal government of the Catholic Church in the late nineteenth century. Among other functions during this period, the Vicariate of Rome – essentially a prototype registrar's office that developed along lines similar to Italy's present-day Uffici di Stato Civile – was responsible for taking a census of the Roman population and maintaining registers of the births, marriages and deaths that occurred in each of the many parishes that constituted subdivisions of the urban territory. These duties came under the authority of the Cardinal Vicar, who was responsible for the pastoral administration of the diocese of Rome, while parish priests were tasked with undertaking an annual house-by-house head count just before Easter to record pertinent information for each member of the parish and to ascertain whether religious duties had been performed. Known as the *Stati delle Anime* ["Status of the Souls"], these registers contained the given name, family name, age, place of origin, profession and kinship of each resident and were filed with the Uffici del Vicario for inspection (to verify the moral and religious conduct of the population). Roman parish priests were also responsible for compiling special registries known as the *Libri dei Battesimi*, *Libri dei Morti* and *Libri dei Matrimoni* (books of baptism, death and marriage).

Together, the *Stati delle Anime* and the books of baptisms, marriages and deaths constitute a valuable source for reconstructing Rome's demographic, social and economic history, as well as the history of its architecture and urban development. These records are also important to art history, as they naturally contain the names and particulars of many artists who were born, lived or died in Rome, or stayed there for a limited time: a faithful reflection of real lived lives.

In 2001 the Soprintendenza per il Patrimonio Storico–Artistico di Roma [Office for the Historical and Artistic Heritage of Rome] began collecting, analyzing and cataloguing every document related to artists residing in Rome

facing page Carlo Saraceni, *Saint Bennone Receives the Keys of Meissen* (detail of fig. 29)

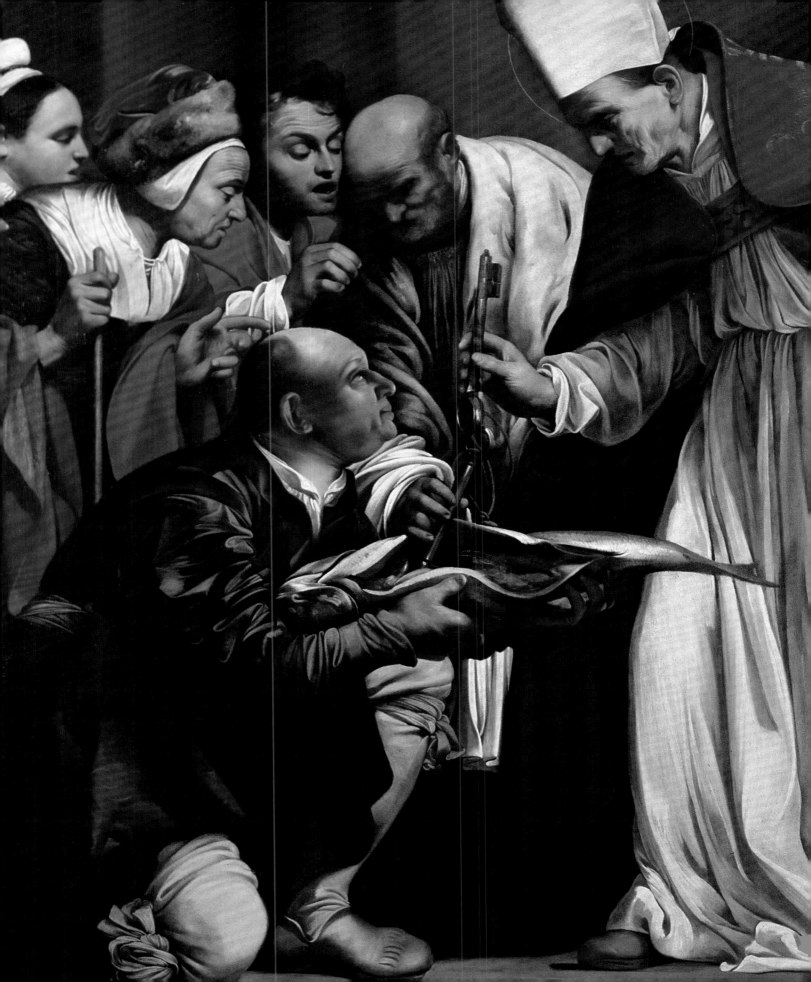

between 1600 and 1630. This was a critical period in art history; the papal city was becoming a cosmopolitan crossroads of diverse artistic trends that would soon bear enormous influence on the successive course of both Italian and European artistic culture.

While it is difficult to draw definitive conclusions or identify potential avenues of research from the volume of facts examined, it is certain that a great number of artists resided in Rome's seventy parishes during the first three decades of the seventeenth century. More than 2700 names are recorded in some 6500 documents related to artists. Of these, fewer than 300 are well known, cited in the sources or have works attributed to them. They are the tip of a huge iceberg. The rest, roughly 2400, form a crowd of "unknowns" difficult to categorize as minor or secondary artists, apprentices or workshop assistants without further research. However, many social aspects surface following a close inspection of the documents; many artists – both well known and minor – are associated with the names of important personalities of the day: wealthy collectors, powerful cardinals, or influential members of the nobility often figure in the registers as witnesses at weddings or godparents at baptisms. Furthermore, networks of kinship, friendship and family ties linking artists of different origins, ages and professions are evident upon study. These are only a few examples of the many lines of inquiry that the archival documents bring to our attention, raising unexpected implications. Faced with the endless ways of interpreting this material, it is difficult to map out a path, suggest avenues of pursuit, or summarize the plethora of information, much less offer a comprehensive account. For this reason, I will limit myself here to citing only some of the more significant data that emerged in the course of this complex and fascinating research.

MARIO MINNITI

Two parish documents refer to Mario Minniti, Caravaggio's first companion in Rome. In 1600, he lived at an inn on Via Gregoriana in the parish of Sant'Andrea delle Fratte,[2] with his brother Andrea, cited as a painter, and Alessandra, listed as his wife (although the two did not actually marry until the following year[3]), neither of whom have been previously mentioned.[4] An annotation in the same document – referring to the following year –

indicates the three "departed," apparently soon after Mario and Alessandra married. The records identify the painter simply as Mario Siracosano ("Mario of Syracuse"). The omission of the family name in the 1601 document poses no obstacle to identifying the artist, since even in the proceedings of a 1603 trial, he is referred to as the painter Mario "resident of the Corso." Furthermore the second document, the certificate of marriage between Mario and Alessandra, lists the painter as the son of a certain Gerolamo of Syracuse (*Hieronimi Saracusani*), which matches the name of Minniti's father, who died in 1592.[5] The certificate shows that Mario and Alessandra, daughter of the late Gio Batt. Mediola, were married on 2 February 1601, apparently making their relationship official in the parish of San Martino ai Monti.

It is known that Mario Minniti moved to Rome at age fifteen or sixteen, in the 1590s and that following an apprenticeship with "a Sicilian painter" (likely Lorenzo Carlo, who had apprenticed the young Merisi), he became friends with Caravaggio. While it is not clear whether Minniti or Caravaggio arrived in Carlo's workshop first, it is generally accepted that they left at the same time. Caravaggio went to the workshop of the Sienese Antiveduto Grammatica (1571–1626), but we do not know what Minniti did.

Proceedings of the lawsuit of 1603,[6] indicate the friendship between the two painters ended in 1600, so it is no coincidence that Mario Siracosano appears in the parish books in that year – that is, having left Caravaggio, he was living with his brother Andrea and future wife, Alessandra Mediola. It is not clear why the friendship ended, but Minniti's biographer Francesco Susinno reports that Mario "decided to marry in order to live more quietly, because he had become troubled by the turbidity of his friend"[7] – a passage that is substantiated by the discovery of these two documents. Subsequently, as Susinno reports, the two appeared to have salvaged their relationship in 1608 in Syracuse where Minniti, who had an active workshop received Caravaggio, who was fleeing Malta, and perhaps obtained for him the commission for *The Burial of Saint Lucy* (today in Syracuse, Palazzo Bellomo).[8]

After his stay in Rome, Minniti's presence is confirmed in Sicily in 1606, when he was commissioned to paint a Madonna del Soccorso (now lost) for the church of San Giovanni Battista, Vizzini. Minniti pursued his artistic activity between Syracuse and Messina, with periods in Malta and Palermo as well.

PAOLO GUIDOTTI (LUCCA, C.1560–1629)

The scant documentary information on this artist is linked mainly to his appearance on the lists of the Accademia di San Luca and some receipts for payment. Therefore, the three documents that have emerged hold great importance because they provide additional facts valuable in the reconstruction of his biography.[9]

The first hint of Guidotti's presence in Rome dates to 1589, when his name appears on a *lista delle candele* in the Accademia di San Luca as "m[esse]r il Cavalier Paulo Guidotto lucchese."[10] In 1593 he was in Naples, where he painted frescoes depicting Stories of Mary in the apse of Santa Maria del Parto (signed and dated), but was back in Rome by October of the same year, as he is recorded at meetings of the Accademia di San Luca. From October to November 1599, he received payment for frescoes in the dome of Santa Maria dei Monti (fig. 25).

The first document, dated 17 August 1600, registers the death of the painter's "infant" daughter Maria, recorded in the book of deaths of Santo Spirito in Sassia where she was buried.[11] This document cites Guidotti as a *cavaliere*, likely by virtue of his noble origins because it is too early to allude to his title of Cavaliere della Milizia di Cristo [Knight in the Army of Christ] that would be granted upon him by Paul V in 1608.[12] In July 1605, the same year the painter was appointed secretary of the Accademia di San Luca,[13] his name appears in the registers of the basilica of Santa Maria in Trastevere as the godfather of Paolo, the son of Gregorio di Giacomo Umiltà and Margherita Ladi, both of Rome. Their names are not otherwise known, but they were likely related to Guidotti in some way since they gave their son his name. Two years later, on 22 July 1607, Guidotti baptized his daughter Benedetta in the same parish. The mother, Ursula, daughter of Bastiano Turrini Romana, is not listed as his wife. The infant had an illustrious godfather, the "Ill.mo et R.mo Mons.r Benedetto Ala Governatore di Roma" (the most illustrious Right Reverend Monsignor Benedetto Ala, Governor of Rome), for whom she was named (Benedetta) – an unmistakable sign that not only had the painter attained prestige in the city,[14] he also had a relationship with the Governor of Rome.[15] It is currently unknown as to whether he had any further connection with Monsignor Benedetto Ala, who was of a noted Lombardy family that had quite probably[16] commissioned from Caravaggio the *Saint Francis*, today at the Museo Ala Ponzone in

Fig. 25 Dome of Santa Maria dei Monti, Rome, with frescoes by Paolo Guidotti

Fig. 26 Paolo Guidotti, called Il Cavaliere, *David with the Head of Goliath*, 1608, oil on canvas, 80 × 67 cm. Basilica of San Paolo fuori le Mura, Rome

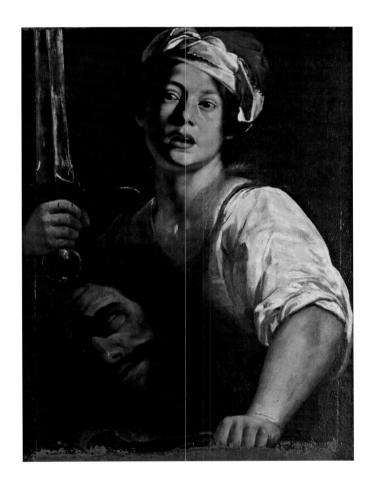

Cremona (cat. 26).[17] This document will be beneficial to further research on the presumably prestigious activity of the painter from Lucca for the then Governor of Rome. The Ala were from Cremona, a diocese that also included the village of Caravaggio. It is no coincidence that Benedetto had a penchant for the works of Caravaggio. Not only was the artist one of the most sought after painters in Rome at the time, he also came from Benedetto's own diocese. And perhaps it was not by chance that shortly after the date on which this document establishes a link to Monsignor Benedetto Ala, Guidotti painted his first known easel painting, a splendid early example of the assimilation of the Caravaggesque manner, the *David with the Head of Goliath*, now at the basilica of San Paolo fuori le Mura, signed and dated 1608 (fig. 26), clearly derived from Caravaggio's Borghese *David*.

SARACENI AND HIS CIRCLE: PIETRO PAOLO CONDIVI, GIOVAN BATTISTA PARENTUCCI, JEAN LE CLERC, AND ANTONIO GIAROLA

While Carlo Saraceni's presence in Rome from the final years of the sixteenth century has been established, two documents allow us to expand the painter's chronology with more certainty.[18]

Bonfait mentions the painter briefly in regard to his relationship with French artists, and notes his name in the parish registers only as early as 1616.[19] However, the documents, dated 1610 and 1611, establish the painter's residence on Via Ripetta,[20] in the parish of Santa Maria del Popolo, where he remained until his departure for Venice in 1619. The Stato delle Anime of 1610, indicates that Saraceni declared he was twenty-seven years old, which, if true, would shift his date of birth from 1579 to 1583, as previously accepted. However, this date is conflicts with that in subsequent statements, generally themselves inconsistent until the records of the Stati delle Anime for 1614 (age thirty-five), 1615 (thirty-six) and 1616 (thirty-seven), at which point the declarations appear to become more reliable and coincide with 1579. In 1610, the words *pittore concubinario* ["painter in a common-law marriage"] are added after his name and age, despite the fact that he lived alone. Massimo Pomponi observes that the painter was obviously guilty of unlawful cohabitation, since in the Stati delle Anime after 1610 a certain Prudenzia Bighi from Chiusi, described as a servant, lived with Saraceni until at least 1618 when the painter married the Neapolitan Grazia di Luna.[21]

By 1611, however, he was living with two persons described as servants, a sure sign of his increased social status: along with the twenty-year-old Prudenzia (his common-law wife), the record shows a Pietro Paolo, age nineteen. The latter is identified in successive documents (the Stato delle Anime for 1614) as the painter Pietro Paolo Condivi of Ripatransone, in the Marches, who stayed with Saraceni until 1617. In 1612 Saraceni was also living with a ten-year-old servant by the name Giovan Battista – also from the Marches and perhaps "recommended" by Condivi – who is none other than the very young Giovan Battista Parentucci, called Il Galluccio, clearly a workshop apprentice who would become a skilled copyist.[22] His full name does not appear in the Stati delle Anime until 1614 when he is recorded as age sixteen. Parentucci soon launched upon a career, so quickly in fact, that in 1616, at a mere eighteen years of age he made his official entry into the

Accademia di San Luca, perhaps with the help of his master who had entered in 1607.

The book of baptisms at San Marco for 1612 contains another record of great interest to Saraceni's biography: on 11 December Carlo stood as godfather at the baptism of Anna and Faustina, apparently twin daughters of Marzio Ganassini (Rome 1580? – before 1626) and Maddalena Lavinia Picardi,[23] both of Rome. That Ganassini chose Saraceni as godfather to his daughters clearly indicates the deep bond between the two painters; their relationship was previously unknown, at least at such an early a date. We know that the two painters worked together between 1616 and 1617 in the Sala Regia (now the Salone dei Corazzieri) at the Quirinale, where Ganassini was among those who collaborated with Agostino Tassi on *Allegory of Glory* and *Allegory of Nobility* (figs. 27a and b).[24] With these new documents,

Fig. 27a (*below left*) Agostino Tassi, *Allegory of Glory*, 1616–17, Sala dei Corazzieri, Palazzo del Quirinale, Rome

Fig. 27b (*below right*) Agostino Tassi, *Allegory of Nobility*, 1616–17, Sala dei Corazzieri, Palazzo del Quirinale, Rome

Ganassini's participation[25] in the important commissions from Pope Paul V at the Quirinale takes on a new meaning: he was certainly engaged by his friend Saraceni, one of the three masters[26] entrusted with the immense decoration of the pontifical palace.

In confirmation of Saraceni's close relationship with other painters active in Rome – entirely understandable given the large workshop he directed at that time – two years later, in April 1614, in San Marcello, Saraceni again stood as godfather at the baptism of Caterina, the daughter of Antonio Andreini – subsequently described as a Roman painter but not otherwise known – and Marta Picionni of Rome.[27]

In parallel with Saraceni's remarkable professional growth with his participation in the grand papal project at the Quirinale,[28] the artist achieved considerable maturity between 1617 and 1619, culminating in splendid masterpieces such as *Saint Bennone Receives the Keys of Meissen* and *The Martyrdom of Saint Lambert* for the entrance chapel of the German church of Santa Maria dell'Anima (figs. 28 and 29), where the drama of Caravaggio's language is heightened on a monumental scale. The artist's workshop had grown to become one of the most important in Rome.

In addition to the two painters from the Marches living in Saraceni's house, the Stato delle Anime of 1617[29] introduces the Frenchman Jean Le Clerc, who became his most important collaborator, and the Veronese Antonio Giarola (1595–1665),[30] who first encountered Caravaggism in Saraceni's workshop at the age of about twenty-two.[31] These are the years of the great undertaking of the Sala Regia (1616–17), and, given the demanding time limits imposed by the papal commission, Saraceni needed reliable collaborators like Le Clerc and Giarola. Two women also joined the household that year: the Neapolitan Grazia di Luna, cited as his wife but whom he married only the following year,[32] and her mother, Angela.

Saraceni left for Venice in mid 1619 with Le Clerc and Giarola and died there on 16 June the following year. However, the Stato delle Anime for 1620 contains a surprise: all members of the Saraceni household, including Carlo and Giovan Battista Parentucci, are present in that year's Easter census. But the entry is crossed out, as if the family no longer lived in the house. Apparently the entire clan had moved to Venice with the painter. However, this was not a permanent departure: soon after Carlo's death his wife, Grazia di Luna, returned to Rome. On 8 December 1620,[33] not yet six months after

Fig. 28 Carlo Saraceni, *Saint Bennone Receives the Keys of Meissen*, 1617–18, oil on canvas, 239 × 178 cm. Santa Maria dell'Anima, Rome

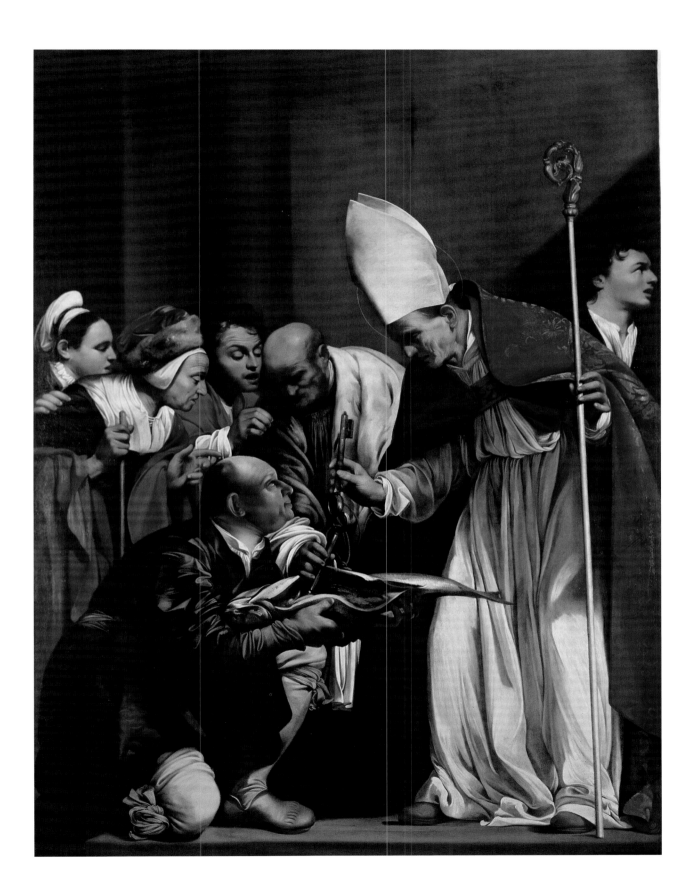

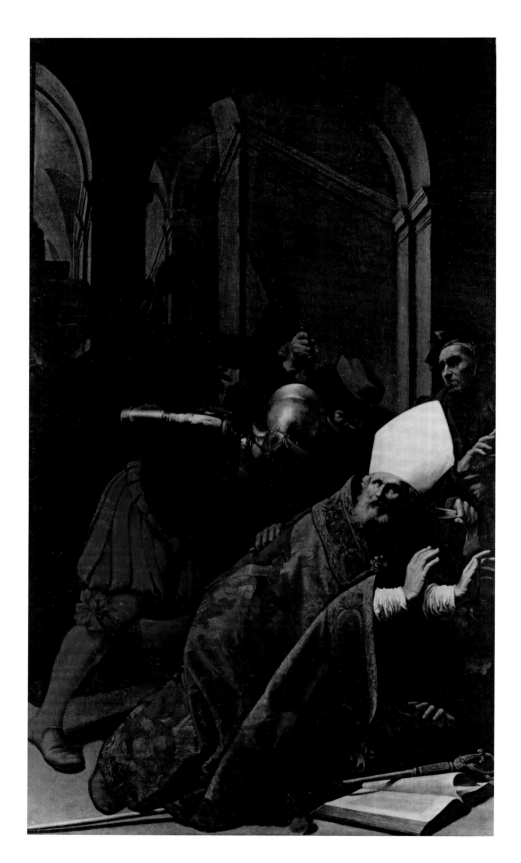

Fig. 29 Carlo Saraceni, *Martyrdom of Saint Lambert*, 1617–18, oil on canvas, 239 × 178 cm. Santa Maria dell'Anima, Rome

her husband's death, she married the French shipping agent Giovanni Bauldari in the church of Sant'Andrea delle Fratte. Among the witnesses at her second marriage was Saraceni's old acquaintance, Antonio Andreini, the Roman painter who had asked Carlo to stand as godfather at the baptism of his daughter Caterina in 1614 and who appears in the parish registers until 1623 with his wife and children. Grazia di Luna's marriage to the French shipping agent so soon after her husband's death implies that they knew each other before she left for Venice. Moreover, the presence of the Frenchman Le Clerc in the Saraceni household confirms that the Venetian painter's family had contact with the French colony in Rome.

FOREIGN CARAVAGGISTS IN ROME: THE SPANIARDS MAÍNO AND TRISTÁN, AND THE FRENCHMEN VALENTIN AND LHOMME

As papal power was consolidated throughout the sixteenth and seventeenth centuries, Rome began to emerge as mecca for European painters. The influx of foreigners peaked in the second decade of the seventeenth century, with the arrival of many French and Flemish artists, drawn by the novelty of Caravaggio's art. They thronged the parishes of Santa Maria del Popolo and San Lorenzo in Lucina, generally distributing themselves between Via Babuino, Via della Scrofa and Via Margutta. They became regular participants in the meetings and official activities of the Accademia di San Luca, where records of their payments for alms or taxes confirmed, in addition to the parish registers, of their residence in the city. Indeed many of these artists chose to settle permanently in Rome; Valentin, Stom and then Lorrain, Poussin and Dughet are perhaps the most famous. Alongside the French and Flemish colonies, research has ascertained the existence of a small Spanish colony that flourished in the first three decades of the century, concentrated mainly around Via Margutta. German artists were rare, perhaps owing to religious and political difficulties, and in the decoration of Santa Maria dell'Anima, the national German church, their absence is particularly notable. Finally, the lack of English artists is remarkable.

The period during which artists flocked to Rome from every part of Europe, saw the introduction of secular painting – easel paintings for a

private clientele. The Northern artists, generally excluded from public commissions, more easily found space for their paintings in the picture galleries of cultivated and refined collectors. As the presence of Spanish artists in Rome was limited (fourteen in all) during that period,[34] the documents on two major Caravaggist painters – Juan Bautista Maíno[35] and Luis Tristán – hold particular interest.

Juan Bautista Maíno

A record[36] of the baptism of Maíno's son, Francesco, at San Lorenzo in Lucina on 17 October 1605, unquestionably establishes the Spanish painter's presence in Rome at this early date. The certificate states that little Francesco Maíno is the painter's illegitimate son, indicating that his parents were not married. His mother, Ana de Bargas, was Spanish, possibly from the region of Toledo, where, according to Gabriele Finaldi,[37] the family name Bargas is common. The godparents, Francisco Arias Picardo and Isabella de Castiglione, were both Spanish, but it is not clear at this time just who they were. The fact that both godparents are Spanish suggests that Maíno had not yet become integrated into his Roman milieu.

Maíno's son was born 6 October and baptized eleven days after his birth. This would have been quite unusual, since owing to the high mortality rate for infants, it was customary to baptize them the day after delivery. The birth date indicates that the pregnancy began in late December or early January. It is not clear where Maíno met Ana, but if it was in Spain (as it would seem, given the absence of Italian names on this certificate), it is highly unlikely she could have withstood the arduous journey in advanced pregnancy, thus Finaldi's hypothesis that Maíno arrived in Rome in 1604, when Caravaggio still lived there, seems sound. Unfortunately, the Stato delle Anime of San Lorenzo in Lucina for that year, which could confirm this hypothesis, is missing.[38]

There is no other information about Ana and little Francesco. While they do not appear in the Stati delle Anime at San Lorenzo in Lucina for 1609 and 1610, there were many gaps in the parish records in those days. It is possible that they returned to Spain or they may have died – mortality rates in childbirth or early infancy were high at the time, as the books of deaths in various parishes demonstrate.

Fig. 30 Juan Bautista Maíno, altarpiece of the *Cuatro Pascuas* (1612–14). San Pedro Mátir, Toledo

Fig. 31 Juan Bautista Maíno, altarpiece of the *Cuatro Pascuas* (detail of fig. 30)

Two additional documents concerning Juan Bautista Maíno are from the Stati delle Anime of the parish of Sant'Andrea delle Fratte for 1609 and 1610.[39] In 1609 Maíno was living with two people, one of whom was Matteo Serrari, cited as a painter; he is perhaps Spanish, identifiable, according to Finaldi with the family named of Serran.[40] A letter C in front of the names indicates that all three were regular communicants. The living arrangement changes the following year; Serrari is replaced by an apprentice named Gio Maria Treguagni,[41] suggesting that Maíno's social status is on the rise. However, the presence of the Spanish student Pietro Nagli indicates that Maíno remained closely linked to his native land and may have even become an inspiration for young Spanish students in Rome.

The parish records indicate that Maíno lived in the papal city from 1604 to at least 1610, which means he would have come into direct contact with Caravaggio himself. Maíno is recorded in Toledo in 1612,[42] where he executed the magnificent paintings for the altarpiece of the "Cuatro Pascuas" (figs. 30, 31), in which he reworks the complex influences he had assimilated during his long stay in Rome, foremost among them Gentileschi and Caravaggio.

The date of Maíno's arrival in Rome, 1604, also suggests another hypothesis: that the trip might have been connected with Orazio Borgianni's return from Spain, which could have taken place that year. Borgianni may

be a link between the young Spanish painters and their arrival in Rome to finish their training.

Until now it has been impossible to trace works by Maíno dating to these years, but confirmation of the period of his stay in Rome could be a fundamental aid in identifying them, especially in the areas near the Spanish churches and communities in Rome.

Luigi [Spanish?] Painter (Luis Tristán?) (1607 and 1609) and a Hypothesis regarding Ribera(?)

Evidence supporting the presence of Luis Tristán in Rome is more complex, yet convincing. We know that the painter was born in Toledo in 1586 and studied under El Greco from 1603 to 1607. Information related to his training in Rome exists, but we have had no idea when it took place.

The Spaniard José Martínez[43] – considered a highly reliable source as he obtained information from Ribera himself in Naples in 1625 – reports that Tristán had spent "much time in Italy in the company of our great Jusepe Ribera," another painter whose presence in Rome still has uncertain boundaries in time.

The Stato delle Anime of the parish of San Lorenzo in Lucina for 1607 contains some significant information: a "Luisi pictore,"[44] a regular communicant, was living at the home of Luigi Ubiedo, the canon of Toledo, on Via Condotti. He reappears in the same house in the Stato delle Anime for 1609[45] but disappears from this parish as of 1610. From 1613 Tristán is recorded in Toledo, where, after El Greco's death in 1614, he became the leading figure in that city's artistic culture. Confirmation that "Luisi pictore" is indeed Luis Tristán lies in the fact that the painter was a guest in the home of the canon of Toledo, his native city – which would have been a normal and frequent gesture of hospitality – during the period for which his presence in his homeland is not documented.

Furthermore, as Martinez reliably indicates that Ribera was in Italy with Tristán, it is reasonable to hypothesize – even in the absence of concrete documentary evidence – that Ribera's arrival in Rome, until now recorded only from 1613,[46] was in fact as early as 1607. In this context, Martínez's comment that the two painters were together in Italy "for a long time" is all the more understandable.

Fig. 32 (*below left*) Luis Tristán, *Holy Family with Saint Anne*, after 1613, oil on canvas, 149 × 105 cm. Private collection, Seville

Fig. 33 (*below right*) Orazio Borgianni, *Holy Family with Saint Anne*, c. 1613, oil on canvas, 97.5 × 79.8 cm. Longhi Collection, Florence

As with Maíno, no Roman works by Tristán are known, but these new documents provide a vital link in the research on his activity in the papal city. It appears that Tristán assimilated the Caravaggesque effect much more deeply than did Maíno, and that he was also influenced by the work of Orazio Borgianni (figs. 32 and 33), whom he likely met in Spain, where the Roman painter had stayed at least until early 1603.[47]

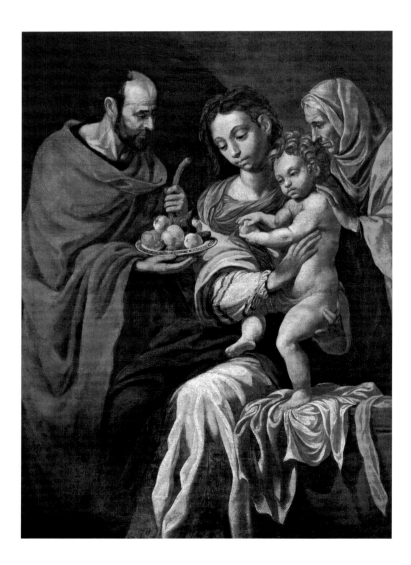

Valentin de Boulogne

The case of Valentin de Boulogne is emblematic of the challenge of determining dates for the period many foreign artists spent in Rome in the early seventeenth century with certainty. The arrival date is usually the harder to establish. Early in their sojourns, foreign artists could not easily obtain official commissions for churches or from noble patrons, and literary sources are often vague regarding dates. While the parish registers can provide valuable information, they are not without their shortcomings in confirming the presence of specific artists. Changes of residence, variations in the type of dwelling (often rented rooms in inns), and especially inaccurate recordings of foreign family names can be problematic in ascertaining an individual's presence in place and time. Often it is a chance intersection of facts and circumstances that provides any certainty.

The arrival in Rome of Valentin de Boulogne, born 3 January 1591 or 1594[48] in Coulommiers (near Paris), to Valentin de Boulogne and Jeanne de Monthyon, is also veiled in mystery. According to Sandrart (1675) the painter was in the papal city when Simon Vouet arrived 10 March 1613.[49] Yet, his presence was not recorded with any continuity in the Stati delle Anime of the parish of Santa Maria del Popolo until 1620.

Recent evidence may place the painter in Rome before 1620. An interesting entry in the 1609 Stato delle Anime of Sant'Andrea delle Fratte, shows a "Valentin garzone pittore" [Valentin apprentice painter] at the house of "messer Pietro Veri fiorentino."[50] This may be the first trace of the painter in Rome in the first decade of the century, thus confirming Sandrart's information. Bousquet has suggested the painter was the "Valentino francese" who lived in the painter Polidoro's house in the parish of San Nicola dei Prefetti in 1611.[51] Although we cannot be sure it is actually Valentin, Mojana's main objection – that at the time, the painter would have been too young to make the journey – collapses with the confirmation of his birth date in 1591.[52] In 1609 Valentin was eighteen years old, an ideal age for a young painter to train in a stimulating environment such as the papal city, which in those years was so universally considered the art capital of Europe that King Louis XIII of France sent Simon Vouet – later to become the official French court painter – to Rome to finish his training.

Danesi Squarzina identifies the artist with a certain "Monsù da Colombiera" (not cited as a painter) in the parish registers of San Lorenzo

Fig. 34 Valentin de Boulogne, *Cleansing of the Temple*, 1618, oil on canvas, 195 × 260 cm. Galleria Nazionale d'Arte Antica, Palazzo Barberini, Rome

in Lucina for 1615,[53] living in an inn on Via Ferratina. Beyond the omission of a profession, this identification conflicts with another unpublished document for the same year that records a "Valentino francese pittore" in a house with many other residents, in the same parish on Via Ripetta.[54]

Advancing the artist's presence in Rome to the second decade of the century provides a more comfortable timeframe in which to place him in the workshop of Bartolomeo Manfredi (d. 1622), his recognized master, whose teaching Valentin would follow the rest of his life and from whom the subject matter and compositional choices in the great French painter's early works clearly derive, works dated by critics to the years 1615–18. Among these are *The Cardsharp* in Dresden (Staatliche Kunstsammlungen, Gemäldegalerie Alte Meister), *The Fortune Teller with Soldiers* in Toledo, Ohio (cat. 16), and *The Cleansing of the Temple* (Rome, Galleria Nazionale d'Arte Antica di Palazzo Barberini, fig. 34).

It has long been known[55] that as of 1620 Valentin is recorded at a house in the parish of Santa Maria del Popolo, near Via Margutta, where he remained (except for 1621 and 1629) until his death in 1632. In 1620 and 1622

the Flemish painter Gérard Douffet, the Walloon Timoteo Oto, and David La Riche, a sculptor from Lorraine, are recorded with him. La Riche, present in the parish in 1619 along with Nicolas Tournier,[56] would also share Valentin's lodgings in 1624 and 1625. These are the years when Valentin joined the Bentveughels,[57] with the nickname of Amador (the Lover). On 29 September 1626, the artist participated as *festarolo* in the celebration of the festivities in honour of Saint Luke, at which time Simon Vouet was the president of the Academy. From 1627 on, Valentin lived in the same house with a servant, indicating that he had attained a higher standard of living. That year he received his first commission from Cardinal Francesco Barberini, one of his main patrons, who had "adopted" him among his favourite painters, replacing Vouet, who had returned to Paris in 1627. The Barberini records show an increase in commissions[58] beginning in 1627 when the cardinal ordered the immense and marvellous *Allegory of Italy* (fig. 35) from the artist, a "dress rehearsal" before entrusting him in 1628 with the prestigious assignment to paint the altarpiece with the *Martyrdom of Saint Processus and Saint Martinian* (1629) for Saint Peter's Basilica (fig. 36), the ultimate recognition of the French painter's success. The painter's close relationship with Cardinal Barberini is evidenced in the document published by Mazzetta di Pietralata, which reveals that the prelate assumed the expenses of Valentin's illness, the result of excessive eating and drinking, that led to the painter's tragic death in 1632. The *Computisteria Barberini* [Barberini Account Books] record *Adì 30 d.o a Gio:batta Fatio scudi 12:50 cioe scudi 10 per tanti spesi da lui nella malatia e morte di Monsu Valent. Pittore d'ordine di S.E.*[59] [October 30 (1632), to Giovanni Battista Fatio 12.5 *scudi*, that is 10 *scudi* for his many expenses in the illness and death of Monsu Valentin, painter in service to His Excellency]

❧ ❧ ❧

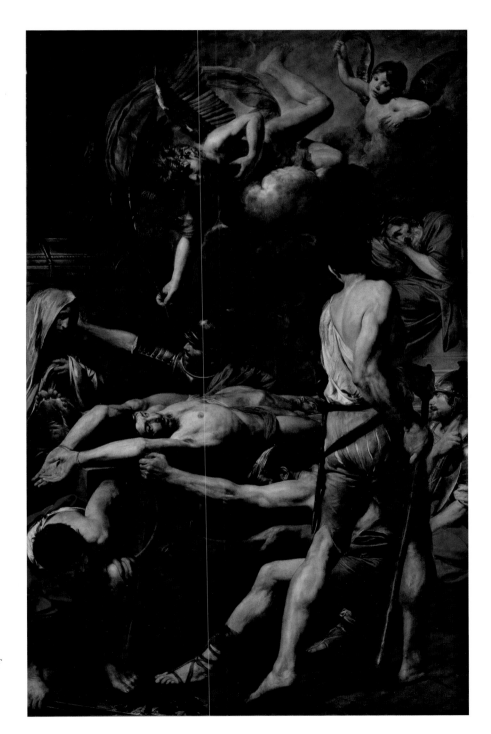

Fig. 35 (*facing page*) Valentin de Boulogne,
Allegory of Italy, c. 1628, oil on canvas,
333 × 345 cm. Istituto Finlandese,
Villa Lante, Rome

Fig. 36 Valentin de Boulogne, *Martyrdom of
Saint Processus and Saint Martinian*, 1629,
oil on canvas, 302 × 192 cm. Pinacoteca
Vaticana, Rome

Jean Lhomme

The known documents on the painter Jean Lhomme place his Roman activity between 1623 and January 1632, the year he died at age forty.[60] Together with his brother Jacques, a student of Vouet documented in Rome between 1623 and 1624, Jean was present at the famous meeting of 1624 in the house of the French master, who that year returned to the position of principal of the Accademia di San Luca.[61] The parish registers have divulged new information and identifications that deviate from those proposed by Bousquet[62] and provide some necessary clarification.

The 1622 parish register cites a "Giovanni Lombo pittore," identifiable as Jean Lhomme, in a house on the Corso (parish of San Lorenzo in Lucina) with other foreigners. This document, which seems to have escaped Bousquet's notice, advances Lhomme's presence in Rome by one year, adding an important link to the reconstruction of his presence in Rome.[63] From 1623, "Giovanni pittore" and "Riccardo," also a painter, are recorded in a dwelling on Strada Laurina, which crosses the Corso. Interpreting this later document, Bousquet suggests Giovanni as the painter Jean Monier and identifies Lhomme with the "Giovanni pittore" living next door with three other French artists. Along with Lhomme – this time unmistakable ("Gioani Lhome") – the scholar notes the presence in 1625 of other artists, among them a "Giovanni pittore francese," whom he still identifies with Monier, and "Depenier francese," probably François Pernier.[64]

A comparison of these documents with the Stati delle Anime for subsequent years – for which the parish priest provides additional names – confirms that the Giovanni and Riccardo who shared the same house from 1623 to 1628, are Jean Lhomme (Gio Lomi, Gioani Lhome or just Giovanni francese) and Riccardo Bissonet. In 1630 Lhomme moved to Via Margutta with painter Cornelio "Roxier" (that is, Rogier) and, filling a gap between 1628 and 1630, a baptismal certificate from 1629 indicates that the artist was the godfather of Lorenzo, the son of Antonio del Turco, of Florence, and Barbara, of Rome.[65]

Lhomme is known almost exclusively through documents, but one signed and dated painting discovered in Umbria a few years ago, at "a small settlement in the Norcia mountains that was part of the diocese of Spoleto,"[66] can be definitely attributed to him. On an altar in the church of Santo Stefano, there is an altarpiece of an "excellent level of quality"

Fig. 37 Jean Lhomme, *The Pardon of Assisi*, 1631, oil on canvas, 193 × 142 cm. Santo Stefano, Nottoria di Norcia, Perugia

depicting *The Pardon of Assisi*, signed and dated 1631 (IOANNES LHOMO GALLUS I.F.1631) [fig. 37]. However, all trace has been lost of the altarpiece originally in the church of San Luigi dei Francesi, representing *Saint Andrew and Saint John*, transferred after 1840. It is known through receipts located by Bousquet, dated between 10 December 1629, and 19 December 1631[67] (when the painter last appears in the parish registers), and a passing reference by Titi,[68] who calls it a "somewhat naturalist work." Finally, it should be noted that at the painter's death (December 1632, only a few months after Valentin

died in August) his studio contained more than 150 canvases on various subjects. Among these were many portraits of the family of Urban VIII, confirming a connection between the painter and the Barberini circle, which may account for the otherwise puzzling explanation for the commission in Umbria.[69]

To conclude this brief overview of some of the many artists cited in the records of the Archivo Storico del Vicariato in Rome, these documents have permitted us to draw some interesting inferences, although further study is required. They also provide much methodological guidance for those wishing to study this subject in more depth.

Based on general observations on the material put forth in this essay, these documents have made it possible to clarify biographical data on some of the artists under study and to correct some inaccuracies that, until recently, misled the study of early seventeenth-century Rome.

New links with patrons have come to light, as in the case of, for example Guidotti's connection to Monsignor Benedetto Ala, who was at that time (1607) the Governor of Rome, or Tristán's relationship to Luigi Ubiedo, Canon of Toledo.

Furthermore, these documents have shed light on hitherto unknown relationships between artists such as those in Saraceni's workshop. We can now trace the formation and growth of his studio almost year by year, beginning with the presence of Pietro Paolo Condivi (from 1611) and Giovan Battista Parentucci (from 1612), when they were young apprentices from the Marches, and then, from 1617 on, when commissions became more demanding, with the arrival of such reputed painters as Jean Le Clerc and the Veronese Antonio Giarola, both of whom followed Saraceni to Venice in 1619. But most remarkable is the baptismal certificate dated 1612, which confirms the relationship between Saraceni and Marzio Ganassini – a discovery that is certain to open new perspectives on this interesting artist for whom we do not yet have a clear picture.

And finally, in respect of some of the major foreign artists, we can accept that Valentin, Maíno, Tristán and probably Ribera arrived in Rome earlier than was previously known. This fact is perhaps most important to the study of how the lesson of Caravaggio was disseminated in Rome. Contrary to what art historians have believed until now,[70] many of the most original main figures of Caravaggism were already in Rome in the first decade of the

seventeenth century, when Caravaggio himself was still there. Along with Saraceni, Gentileschi, Borgianni, Manfredi – to name only the most important of those already present – we must add Valentin, who had, in all likelihood, been in Rome from at least 1609, Maíno from 1604, Tristán from at least 1607 or even 1606 and, probably with Tristán, the great Ribera. This information necessitates a careful and thorough review of the chronology of the early days of Caravaggism in Rome.

NOTES

1 This essay is a preview of R. Vodret, ed., *Alla ricerca di Ghiongrat. Gli artisti citati nei libri parrocchiali romani dal 1600 al 1630*, forthcoming.

2 Stati delle Anime of the parish of Sant'Andrea delle Fratte, 1600, c. 43v: "[f. 41v: Strada Gregoriana dal ca.tone a mano sinistra p. latrinita]

 15 in casa propria
 +C Bartolomeo da Pesaro mezarolo
 +C Chaterina Romana sua moglie
 Alissa.dro suo figliolo
 gioa. battista figliolo
 +C Marino ———-
 +C Perino partito ——— peggiorante
 C Mario Siracosano pittore ———
 C Alessandra sua moglie **partiti**
 C Andrea suo fr.ello pittore"

3 See the *Libro dei Matrimoni* of San Martino ai Monti, 1601, c. 29v: "Die 2 Februarij An.o 1601. Denunciationibus premissis tribus diebus continuis festivis quor. p.a die 6. 2.a die 17. 3.a die 17 Januarij intermisse Parochialis sole.nia habita est nulloq. impedimento detecto ex facultate scripto concessa a R.mo D. D. B. Gypsio Pro Vices Gerente. sub datum die 2 Februarij (quam penes meretineo). Ego F. Angelus Minicucius Ordinis Cor.u. Parrochus Cu. SS. Silvestri et Martini in Montibus **Marium f. q.**

Hieronimi Saracusani Pictore., et Alexandra. f. q. Jo. Bap. Mediola: de Bertoldis in dicta Cu.a interrogavi eor. q. mutuo consensu habito sole.niter per verba de presenti matrimonio coniuxi, presentib. testibus D: Jo. Jacobo Bonomi Romano et Jacobo f. q. Dominici Benvenuti."

4 Neither Mario Minniti's brother nor his wife figure in the recent bibliography of the painter: G. Coniglio, "Fonti e regesto biografico," pp. 142–143 in Syracuse 2004; B. Mancuso, "'Parlarli, bisogna' : un' 'Immacolata' di Mario Minniti,' in F. Abbate, ed., *Ottant'anni di un Maestro. Omaggio a Ferdinando Bologna*, 2 vols. II (Naples 2006), pp. 385–395; C.F. Parisi, "Mario Minniti e suoi affini nella chiesa madre di Vizzini," in *AmpeloScordia bollettino di storia e cultura*, 8:1 (2007), pp. 71–81.

5 See Syracuse 2004, pp. 142–143.

6 See Macioce 2010, p. 152 f.

7 F. Susinno, *Le vite de' pittori messinesi e di altri che fiorirono in Messina* [1724] (Florence, 1960), pp. 116–117.

8 Macioce 2010, p. 185.

9 On Paolo Guidotti, see O. Melasecchi, "Dizionario Biografico degli Italiani," *Istituto Treccani*, 61 (2003), pp. 442–466; O. Melasecchi, "Paolo Guidotti," in *Roma di Sisto V. Le arti e la cultura*, ed. M.L. Madonna (Rome 1993), pp. 533ff

10 Melasecchi, ibid., p. 533.

11 Santo Spirito in Sassia, *Libro dei Morti*, 1600, f. 28v: "[1600 Agosto] Adì 17 [Agosto 1600] Maria infante figl.la del **Cav.re Guidotti luchese Pittore** la q.le fanciullina stava à balia al portone di s. sp.o, morì adì d.o et fu seppellita nella n.ra Chiesa." S. Maria in Trastevere, Batt., 1605, f. 239r: "Adi 7 di Luglio Paulo f. l. et nat. di Gregorio di Giacomo humilta Romano et di Margherita ladi Romana, nato il primo Furno Comp.e **S.r Paulo Guidotti Lucensis**. Coma.re m.a Faustina manini Romana." S. Maria in Trastevere, Batt., 1607, f. 31v: "A'di 22 Luglio 1607 Benedetta f. l. et n. di **Paolo Guidotti Lucchese** et d'Ursula figlia di Bastiano Turrini Romana, nata alli 20. furono co.pari l'Ill.mo et **R.mo Mons.r Benedetto Ala** Governatore di Roma, et la S.ra Imperia figlia del s.r Cosimo Incasati Romana."

12 The honorific was granted by the pope in return for a "group of six figures in a piece of white marble, all complete," given by Guidotti to Cardinal Scipione Borghese. See Baglione 1642, p. 303, and M. Vaes, "Appunti di Carel van Mander su vari pittori italiani suoi contemporanei" (1604), in *Roma*, IX (1931), p. 203; the work must have had some importance if the pope also granted the artist the privilege of taking the last name Borghese. See Melasecchi, "Dizionario Biografico," p. 463.

13 F. D'Amico, "Su Paolo Guidotti Borghese e su una congiuntura di tardo manierismo romano," in *Architettura e società nel secolo dei lumi* (Rome 1984), pp. 71–102.

14 In 1607 he was also among the artists enrolled in the prestigious Congregazione dei Virtuosi al Pantheon: V. Tiberia, *La Compagnia di S. Giuseppe di Terrasanta Nei Pontificati di Clemente VIII, Leone XI e Paolo V: 1595–1621* (Galatina 2002), p. 56.

15 Monsignor Benedetto Ala was Governor of Rome from 1604 to 1610. From 1610 to 1620 he was the Archbishop of the diocese of Urbino, where he died on 27 April 1620.

16 See most recently M. Gregori, "La modernità di Caravaggio: lectio magistralis di Mina Gregori," *Piazza Grande*, 20 May 2010, pp. 30–31; Schutze 2009; Vodret forthcoming.

17 As is known, Monsignor Benedetto Ala's family arms appear on the frame of the Cremona *Saint Francis*.

18 According to V. Martinelli, "Le date di nascita e dell'arrivo a Roma di Carlo Saraceni, in *Studi romani* 7 (1959), p. 684, his marriage license of 23 February 1618 states that he had been in the city for twenty years. However, the original document contains no such information: S. Maria del Popolo, Matr., 1618, f. 182r, 1618 febbraio] Anno et me.se ut supra [1618 Februarii] die 26 denuntiationibus p.missis ut supra nulloq. legittimo impedimento rep.to cu. lice.tia R.mi V.es G.is que est in filo ego Fr. Gabriel ut supra p. **Carolum Saracinu. Venetu. Pictore.** et Gratia de Lunis siculam huius Parochie in eccl.a interrogavi eor.q. mutuo co.se.su habito p. verba de p.senti sole.niter matrimonio coniunxi p.sentibus testibus notis Andrea Bianchetto Bononiense ceme.tario et laurentio Romano huius filio huius Parochia

19 O. Bonfait, "'Molti franzesi e fiammenghi che vanno e vengono non li si puol dar regola': Mobilité géographique, mode d'habitat et innovation artistique dans la Rome de Nicolas Tournier," in Bertrand and Trouvé 2003, pp. 65–75, see esp. p. 72. On Saraceni, see also A. Ottani Cavina, *Carlo Saraceni* (Milan 1968), and A. Ottani Cavina, "Saraceni: tre dipinti qualche dato," in *Scritti in onore di Giuliano Briganti*, exh. cat., ed., M. Bona Castellotti, L. Laureati, A. Ottani Cavina, and L. Trezzani (Milan 1990), pp. 161–167.

20 Santa Maria del Popolo, Stato delle Anime, 1610, f. 5r: "[Nella Via di Ripetta Verso il Corso] Nella casa di Domenico Bassi di sopra Carlo saracini Venetiano di anni 27 Pittore co.cubinario." Santa Maria del Popolo, Stato delle Anime, 1611, f. 24v, f. 21r: "[per ripetta verso il sacramento di sa.to giacomo] in casa della sig.ra penelope aragona co. cre Habita il sig.r Carlo saraceni vinicano di anni n 36 co. cre prudentia bica sua serva di anni n 20 co. cre pietro paulo suo servitore di anni n. 19."

21 See Pomponi in R. Vodret, ed., *Alla ricerca di Ghiongrat ...* (forthcoming).

22 J. Bousquet, "Valentin et ses compagnons : réflexions sur les caravagesques français à partir des archives paroissiales romaines," in *Gazette des beaux-arts* 92 (1978), pp. 101–114, especially p. 105; J. Bousquet, *Recherches sur le séjour des peintres français à Rome au XVIIème siècle* (Montpellier, 1980), p. 205.

23 San Marco, *Libro dei Battesimi*, 1612, f. 514r; "eod. die [11 X.bre 1612] Anna et Faustina figli di Martio Ganasini **Ganassini [sic] et di Mad.na Lavinia Picardi R.mi nata adi 6 d.to nella Parrochia di San Lorenzolo il** compare il S.re Carlo Saraceni."

24 Ganassini's presence may be ascertained on the basis of stylistic comparison with frescoes he executed at Bagnaia, in the Casino of Cardinal Montalto. See R. Vodret, "Agostino Tassi e il fregio della Sala Regia al Quirinale," in *Agostino Tassi*, exh. cat., ed., P. Cavazzini (Rome 2008), pp. 127–150, esp. p. 132.

25 On Marzio Ganassini, see the study by F. Nicolai, "Novità sul pittore Marzio Ganassini," in *Bollettino d'Arte* 146 (2008), pp. 67–87.

26 As is well known, the other two were Agostino Tassi and Giovanni Lanfranco.

27 "[Aprile 1614] [...] Adi 7. [...] Catarina. Adi d.o fù bat.a da me d.o Catarina nata alli 6 di P.re ms Antonio Andreini Romano, et di m.a Marta Picionni Romana sua moglie, il

comp.e il s.r Carlo Saraceni Venetiano, La mam.a Appollonia d'Ancona, P. S. M.a Invia."

28 During this period he also executed *Saint Charles Borromeo Administering the Sacrament to a Plague Victim* (1618–19) for the church of the Servi di Cesena and St. Charles Borromeo and the Holy Nail for San Lorenzo in Lucina, datable to around 1619.

29 See V. Martinelli, "Le date della nascita e dell'arrivo a Roma di Carlo Saraceni, pittore veneziano," *Studi Romani* VII (1959), 6, pp. 679–684, p. 684 for this reference; Bousquet, "Valentin et ses compagnons," p. 106.; Bousquet, *Séjour des peintres français*," p. 205, including a transcription.

30 Santa Maria del Popolo, S.A., 1617, f. 11v. [strada di Ripetta A mano sinistra p. andare a Ripetta] nella casa del S.r **Carlo Saracini Venetiano Pittore**
Pietro Paolo Condivi da Ripatransona [crossed out]
Giovanni Cleo francese
Giambatt.a Parentucci da Camerino
Prudentia Bighi da Chiusi serva [entire line crossed out]
Gratia di Luna Napoletana moglie
Antonio Girella Veronese
Angela madre di Gratia.

31 S. Marinelli, "Su Antonio Giarola e altri fatti veronesi del suo tempo," *Paragone* 33 (1982), 387, pp. 33–43; D. Benati, "Antonio Giarola per Modena," *Paragone* 38 (1987), 447, pp. 37–42, and most recently A. Mazza, "San Giuseppe in gloria e i santi Costanzo e Filippo Benizzi di Antonio Giarola," in *Per conoscere il patrimonio di Sassuolo, studi su dipinti e arredi di proprietà pubblica* (Sassuolo 2004), pp. 75–80.

32 Martinelli, "Le date della nascita," esp. p. 684.

33 Sant' Andrea delle Fratte, *Libro dei Matrimoni*, 1620, f. 118v: "[1620 December] Anno D.ni 1620 Die vero

8 X.bris Prehabitis denuntiis t.b. festivis dieb. v[idelicet] die 29 et 30 9.bris et 6.a X.bris nullo rep.to impedime.to ego fr. Bonifati. Curat. interrogavi de consensu D. Ioannem q. Ioannis Bauldarii Gallum Andegaver speditionario ex parr.a S. Laure.tii i. Lucina et D. Gratiam q. Caroli Saraceni dicti Venetiano pictoris, habitoq. ambor. consensu cum dispensatione R.mi D. Vicesger. predictos matrimonio coiunxi p. verba de p.nti vis et volo cu. anuli benedictione et impositione, legitimumq. inter illos contractu. fuit matrimoniu. iuxta decretum S. Conc. Trid. ac ritum S.te Romane Ecclesie, presentib. testib. fr.e Thomaso q. Dominici Sanctini flore.tino sacrista, Antonio q. Ioannis Andriini Romano pictore et M. Petro q. Marsilii Pardini de Lucca in quor. fidem. Ita est fr. Bonifati. Curat. manu p.p.a."

34 The following is a brief list of dates at which the Spanish painters are documented in Rome in the parish books: Egidio spagnolo garzone di Giacomo de Asa pittore fiammingo (1604) – Gaspare Strada spagnolo, padre di Vespasiano Strada (1604); Vespasiano Strada, figlio maschio maggiore di Gaspare (from 1604); Pietro Riero/a spagnolo (1604–09); Egidio Ximenes (1605); Lorenzo Gonzales dalla Galizia spagnolo (1605–1610); Domenico Tresegni [Trasegni] da Valladolid spagnolo (1607–09); Francesco di Giovanni Calvo Samonens (?) spagnolo (1607); Giuseppe Padules spagnolo (1607), Lorenzo de Silva spagnolo (1607 and 1609); Diego Machado spagnolo (1609); Diego pittore (1609, spagnolo partito); Juan Batista Maino (1605, 1609–10); Luigi [spagnolo?] pittore (Luis Tristán?) (1607 and 1609).

35 Information on Maino, provided by the author, was published in G. Finaldi, "Sobre Maino e Italia," in Madrid 2009, pp. 41–55.

36 San Lorenzo in Lucina, Libro dei Battesimi, 1605, f. 52r: "Die 17 dicti [octobris 1605] Franciscus filius naturalis **D. Jo: Baptiste.**

Maini Hispani et d. Anne. de bargas Hispane degen. in n.ra par.a natus die 6 dicti baptizatus fuit a me Petro Angelino curato et susceptus a d. francisco arias picardo Hispano et a d. Isabella de Castiglione Hispana."

37 G. Finaldi, "Sobre Maino," pp. 41–55.

38 The Stati delle Anime of San Lorenzo in Lucina are missing from 1600 to 1606.

39 Sant'Andrea delle Fratte, Stato delle Anime, 1609, f. 136v:
"C Gio: B.tta Mainò pittore
C Matteo Serrari pittore
C Ascanio Cappello."

40 G. Finaldi, "Sobre Maino," pp. 41–55.

41 Sant'Andrea delle Fratte, Stato delle Anime, 1610, f. 113r:
"Gio Batta Maioni pittore spagnolo
Gio Maria Treguagni garzone
Pietro nagli studente spagnolo
Agostino
pirro da poglio La... [illeg.]."

42 M.C. Boitani, *Juan Bautista Maino* (Rome 1995); A. E. Pérez Sánchez, "Sobre Juan Bautista Maíno," in *Archivo español de arte* 70 (1997), pp. 113–125.

43 José Martinez, see Naples 1992, pp. 57–80, esp. p. 60.

44 [Condotti]:
Luisi de Ubiedo canonico da Toleto C
Luisi pictore C
... [illegible: Giuntanighi?] C
Agnese Perez partita

45 [Condotti]:
+ D. Luisi Ubiedo canonico C
Luisi pittore C
Bart.eo partito C
Pietro de mattei C
Constanza de bonmarzo serva partita col marito

46 V. Macro, "Gli anni romani di Jusepe Ribera : due nuovi documenti, il rapporto con i Giustiniani e una proposta attributiva," in *Decorazione e collezionismo a Roma nel*

Seicento : vicende di artisti, committenti, mercanti, ed. F. Cappelletti (Rome 2003), pp. 75–80, especially pp. 75–76. Ribera is recorded in Parma in 1611. See also Spinosa 2006.

47 Orazio Borgianni was in Spain until 1603 but probably not the entire year, because that year he painted the portrait of the Sicilian Tommaso Laureti, who had died in 1602, which is now kept at the Accademia di San Luca, and in 1604 he presided over a meeting there.

48 Valentin's birth date had been traditionally established as 1591 by a now-lost certificate of baptism discovered by A. Dauvergne in the archives of the parits of Saint Denis in Coulomniers (Bibliothèque Municipale, Coulommiers) and published in "Notes sur le Valentin," in *Gazette des Beaux-Arts*. I (1879), p. 205. However, this date has come under doubt since Roberto Longhi published the artist's death certificate, dated August 1632, which stated he was 38 years old; see "Ultimi studi sul Caravaggio e la sua cerchia," in *Proporzioni* 1 (1943), p. 58. This latter date has also been embraced by Mojana 1989, p. 18, and more recently by O. Melasecchi, "Valentin de Boulogne," in Zuccari 2010, p. 733.

49 F. Solinas, "Ferrante Carlo, Simon Vouet et Cassiano dal Pozzo : notes et document inédits sur la période romaine," in Loire 1992, pp. 135–147.

50 S. Andrea delle Fratte, 1609: nella casa di messer Pietro pictore, Pietro pittore Veri fiore.tino, Dianora moglie, Giuliano figlio, Luca figlio putti, Verginia zitella, Valentino garzone pittore. Many pupils and apprentices passed through the Florentine painter's workshop on Via Gregoriana, which is documented from 1598 to 1612. See the essay by M. Pomponi in *Alla ricerca di Ghiongrat …* (forthcoming).

51 S. Nicola dei Prefetti, S.A., 1611, f. 54r, casa n. 83. Bousquet, "Valentin et ses compagnons," pp. 101–114, p. 107 for this reference.

52 Mojana 1989, p. 4.

53 San Lorenzo in Lucina, S.A., 1615, f. 44r
S. Lorenzo in Lucina, S.A, 1615, f. 44r
"Via Ferratina
Stefano crivelli c
Paola moglie
Battistina di franchi serva c
Giulio di Ruschi c
Franc.co Riccionico da Como c
Paolo mappello c
Monsù da Colombiera dal papa
Monsù di balena dal papa
Pietro servo camariero c
Franc.co camariero c
Sr. b. Gasparo de blaschi siciliano c
Gio: Dom. co di Ricchi bene siciliano"

54 The document is unpublished: San Lorenzo in Lucina, *Stato delle Anime*, f. 82r:
"[Ripetta parte di sop.a]
Peregrino de nepi cocchiero del S.r fr.
Cefar
Margarita moglie C
Isabetta perugina C
S.r Ant.o crudele C
S.r D. Pietro Vaijs C
S.r Ger.mo Lombardo C
S.r Pietro C
S.r mastro Rosso C
+ S.r fabiano can.co C
+ S.r Gio: Can.co
S.re Michele spagno[lacuna]
Valentino francese pittore C."

55 See Bousquet, *Séjour des peintres français*, pp. 214–215.

56 Ibid.

57 G.J. Hoogewerff, *De Bentvueghels* (The Hague, 1952), p. 145.

58 M. Aronberg Lavin, *Seventeenth-century Barberini Documents and Inventories of Art* (New York, 1975), p. 402. In 1627, the acquisition of a *David with the Head of Goliath* (formerly New York, Christie's 1991, 9 October) was cited in the inventory of Cardinal Antonio Barberini in 1633 along with a pendant *Samson* (today in Cleveland). Moreover, Valentin executed a portrait of Cardinal Francesco Barberini (lost) and a *Beheading of John the Baptist* (missing since 1854).

59 C. Mazzetti Di Pietralata, "Joachim von Sandrart e la Roma dei Barberini," in *I Barberini e la cultura europea del Seicento*, ed. L. Mochi Onori and S. Schütze (Rome 2007), pp. 403–410, note 49.

60 J. Bousquet, "Un compagnon des caravagesques français à Rome, Jean Lhomme," in *Gazette des Beaux-arts*, 101 (1959), pp. 79–96. See also Bousquet, "Valentin et ses compagnons," pp. 101–114.

61 Cfr. D. Jacquot, *Repères biographiques* in Nantes 2008, pp. 92–98: San Lorenzo in Lucina, Stati delle Anime,
f. 19r: "[Ferratina]
S.r Simone Vuetti pittore C
S.r Horatio pisano C
S.r Gio: Batta va.ni C
S.r Giac.o Deletin C
S.r Gio: Batt.a pisano C
S.r Giac.o dupre C
S.r Felice santelli C
S.r Nicolò giani C
S.r Aless.o Horion C
S.r Nicolò Pusin C
S.r Gio: Lomi C
S.r Giac.o Lomi
S.r Nicolò Lagu
S.r Pietro votrel C
S.r Gio Lumer C
S.r Giac.o Novel C
S.r Carlo Savelli C
S.r Egidio Horion C
S.r Ascanio Cinni C
S.r Placido costa C
S.r Pietro mel C

S.r Gabriello Natiis C

S.r Fran.co Dansi C

62 J. Bousquet, *Séjour des peintres français.*

63 San Lorenzo in Lucina, *Stato delle Anime,* f.3r.

64 Santa Maria del Popolo, *Stato delle Anime,* 1623, p. 31; 1624 f. 23v; 1625 f. 21r.

65 Santa Maria del Popolo, *Libro dei Battesimi,* 1629, f. 100v. Nothing is known of the child's parents.

66 V. Casale, G. Falcidia, F. Panesecchi, and B. Toscano, *Pittura del '600 e '700. Ricerche in Umbria,* 1 (Treviso 1976), pp. 31–32, no. 119 and pl. XXI.

67 J. Bousquet, *Séjour des peintres français,* p. 123.

68 F. Titi, *Ammaestramento utile, e curioso di pittura, scoltura et architettura nelle chiese di Roma, palazzi Vaticano, di Monte Cavallo, & altri, che s'incontrano nel cammino facile, che si fa per ritrovarle con l'indice delle chiese, e de' virtuosi, che si nominano; et in fine un'aggiunta, dove è descritto il Duomo di Città di Castello dell'Abbate Filippo Titi ... overo Nuovo studio per sapere l'opere de' professori delle virtù sudette...* (Rome 1686), p. 124.

69 J. Bousquet, "Un compagnon des caravagesques," p. 79.

70 Zuccari 2010, vol. I, pp. 31–59.

Notes toward a Caravaggisti Pictorial Poetics

Michael Fried

Let me begin by looking briefly at Valentin de Boulogne's *Fortune Teller* from the 1620s in the Louvre (fig. 38) , which I take to be a representative work by the artist and also, equally to the point of this essay, a representative work of a certain sort of Caravaggesque painting.[1] In what follows I want to use Valentin's canvas as an initial (and indeed a recurrent) point of reference for a series of remarks about what I take to be a particular Caravaggesque pictorial "system" or – perhaps better – pictorial poetics, one which I suggest possesses an internal consistency and rationale such as have never, to my knowledge, been fully appreciated.

Valentin's canvas, nearly 153 cm high by about 158 cm wide, depicts in a naturalistic manner derived from post-1600 Caravaggio – which is also to say in a style based at once on strong local colour and powerful chiaroscuro – six figures (four men, two women) in a shadowy but otherwise unspecified interior space. The central figures are a standing young woman – by her dress and colouring, as well as by her actions, a gypsy – who is reading the palm of a seated young man in expensive clothes and a feathered hat. At the right, a young woman plays a guitar while a seated older man with an unruly grey beard and piercing eyes plays a smallish harp. The harpist appears to be singing and the young woman may be doing so as well. Neither looks either at the two principal figures or toward the viewer standing before the painting. Instead the young woman gazes off into space to her right (our left), and the bearded man gazes abstractly, albeit intensely, before him as if lost in the music. Between the two principal figures and a few feet beyond them a boy sits at a table covered with an oriental carpet, his left elbow resting on the table as he supports his head with the back of his left hand; he too looks neither at the gypsy and her client nor at the viewer, but instead gazes off toward his right. (Possibly, though, he should be seen as looking toward the gypsy – it wasn't always easy for artists at this moment to get the directions of gazes on target.) At left, behind the gypsy a shady character in a cloak and hat carefully extracts – that is to say steals – a chicken from the pocket or sack at her side. (A similar action occurs in the Toledo *Fortune Teller with Soldiers* [c. 1620, cat. 16] in the present exhibition, with the added detail of the man picking the gypsy's pocket with his right hand being aided by a young boy and enjoining the viewer to silence with his left.) The depicted space is shallow and all the figures appear to be situated in close proximity to the picture plane, including the boy: the table under its rug has almost no depth.

So much seems plain. What is not so plain is whether or not art historians – whether or not *we* – have taken the Louvre canvas and others like it with full critical and intellectual seriousness. What I mean is this. It is true that Valentin is today widely recognized as a painter of impressive achievement, one of the key figures in Roman Caravaggism. At the same time, there has been a widespread tendency to underrate the pictorial interest of paintings such as this one. The subject is inevitably regarded as hackneyed (not just the theme of fortune-telling but also the related themes of music-making and pocket-picking); no strong narrative or dramatic thread binds the various characters together, and each individual conveys the sense of having been

Fig. 38 Valentin de Boulogne, *Fortune Teller*, c. 1628, oil on canvas, 125 × 175 cm. Musée du Louvre, Paris

drawn from a common repertoire of stock figures of a "genre" sort
(Caravaggio's two *Fortune Teller* canvases, in the Capitoline Museum and
in the Louvre, are of course decisive here). As for the organization of the
painting as a whole (its composition, to use a somewhat tricky term), it lacks
any all-encompassing principle of coherence (in fact that isn't quite right,
but I'll put off saying why until further on), largely because, as already
mentioned, there is no single, dramatic or otherwise meaningful action or
narrative in which all the figures participate. The overall impression – I am
seeking to express a consensus among Valentin's commentators – is that of an
anthology of stock figures, motifs, and anecdotes (to use a loaded term that
I shall disparage shortly) somewhat crammed together in a shallow, minimally
articulated space. What is impressive about the painting in this view is simply
how it is painted: Valentin is a superb colourist, his touch is invariably strong,
his figures have remarkable realistic or naturalistic "presence"; in short, one is
aware of his pictorial gifts virtually in every brushstroke. All this makes him a
greater painter than Manfredi, say. But there is, in the standard account,
nothing particularly interesting or arresting about the *kind* of painting he
or indeed Manfredi – or Nicolas Régnier, Nicolas Tournier, or the young
Simon Vouet – typically produced. (The term "Manfrediana methodus"
was introduced early on to characterize such painting.) More broadly, the
teens and twenties of the seventeenth century, the twenty years following
Caravaggio's death, are usually viewed as a kind of interregnum before, on
the one hand, the spectacular flowering of the Roman Baroque in the art of
Pietro da Cortona, Bernini, Borromini et al. and, on the other, the advent of
Nicolas Poussin, whose smaller-figure, lucidly structured, quietly dramatic
compositions not only embodied but emblematized a mode of pictorial unity
in comparison with which the seemingly "additive" compositional mode of
Valentin, Manfredi, and the others appeared outmoded and maladroit.
Poussin, it is recognized, marked the return of a certain classicism in
European painting, or perhaps one should say that he sealed that return
following the lead of Annibale Carracci's Roman production starting around
1595. The most famous utterance attributed to him is the statement that
Caravaggio was born "pour détruire la peinture," to destroy painting. And of
course, the extent of Poussin's influence on painting in his native France, not
just during the mid and later seventeenth century but recommencing around
the middle of the eighteenth, can scarcely be exaggerated.

My point in what follows will be to offer an alternative account of this sort of Caravaggesque picture. To begin with my conclusion, because space is limited, I want to emphasize such a painting's status as what has helpfully been termed a "gallery" picture, that is, a framed canvas of limited dimensions – not enormous but not too small, either – made for wealthy and important collectors to hang in exhibition spaces in their homes and palaces, where they were made available to friends and visitors under conditions which at the time would have been regarded as ideal.[2] Such a picture, therefore, could count on being looked at closely by men of taste who prided themselves on being able to discern artistic quality; but precisely because that was the case, it was also faced with need to establish, by virtue of its forcefulness or refinement or, ideally, both, a distinctive and authoritative "presence" on the gallery wall. At least as far as Rome was concerned, I understand this as a fairly recent development. Such a tendency marked a clear difference from the norms of the High Renaissance, the greatest Roman monuments of which were of course fresco projects on the walls and ceilings of important buildings. The decline of the art of painting in Rome and other central Italian cities as the sixteenth century wore on largely involved the failure of decorative painting in fresco even remotely to approach the artistic standards set by the earlier masters. But this did not mean that the emergence of the gallery picture was not in its own way fraught with difficulties, the key question it had continually to resolve being whether or not paintings of limited dimensions, often depicting figures not shown in their full height, could possibly rival in force or importance – in pictorial authority – the earlier canonical achievements by arguably the greatest painters who had ever lived. Such gallery pictures, moreover, unlike the famous Renaissance altarpieces by Fra Bartolommeo, Raphael, Correggio, Titian, et al., no longer had the support of a traditional religious setting; rather, their conditions of viewing were essentially secular, as they competed for admiration in rich men's spaces with paintings by other masters who were just as favourably exhibited and illuminated. In my recent book, *The Moment of Caravaggio*, I argue that the key figure in this development was none other than Caravaggio, and that crucial aspects of his art, including his predilection for scenes of violence and its aftermath – indeed for scenes of decapitation and its aftermath – are ultimately to be understood in this light, as thematizing the sort of effort that was required to (in effect) cut the gallery picture free of its surroundings, that

is, to establish it in its aesthetic autonomy as a self-sufficient whole. Another factor under particular pressure in Caravaggio's art concerned the relation of the painting-in-progress to its maker, Caravaggio himself. Under the emerging pictorial dispensation (including the emergence of a new sort of market for art) the painter was, more nakedly than ever, his painting's sole begetter and aesthetic guarantor, but precisely because that was the case it was also necessary, it turned out, to seek to cut the finished work free from the painter also, to launch it into history as an independent artifact, to establish its autonomy in that respect as well. At any rate, in my book I suggest that various paintings by Caravaggio can be understood as all but spelling out the conflicts and contradictions involved in such a project. What may well be Caravaggio's most admired picture, *David and Goliath* (fig. 86, p. 283), in the Borghese, with its youthful David gazing with an ineffable amalgam of aversion and regret at the severed head bearing Caravaggio's own features, exemplifies this state of affairs.

With Caravaggio's death in 1610 a certain consolidation of principles seems to have taken place. In fact the subject matter of decapitation remains basic to an entire generation of artists, but in other respects the extreme affective tonality of Caravaggio's art is replaced by something much more like a consistent practice, a style or manner or say, a set of conventions that nevertheless continues to have the same end in view: the achievement of a new sort and degree of pictorial autonomy on the gallery wall.

Returning to Valentin's *Fortune Teller*, note especially how the young man having his palm read has been depicted largely from the rear. This by itself is at least a little surprising, but what should be should be stressed is that the same motif is widespread in Caravaggesque painting of the period, not only in other works by Valentin such as the Toledo *Fortune Teller with Soldiers* in which the central (also the nearmost) figure has his head turned wholly away from the viewer, but also for example in Manfredi's *Bacchus and a Drinker* (c. 1608–10, fig. 39) in the Barberini, in which the close juxtaposition – the intertwining, almost the melding – of the two figures, one facing the viewer and the other largely facing away, seems the very point of the work. Another painting by Manfredi, *Allegory of the Four Seasons* (fig. 63, p. 190) deploys four figures, two male, two female, also in a vertical format to much the same effect, a further complication being that the two figures nearest us, Spring and Summer, between them offer complementary views of backs and shoulders.

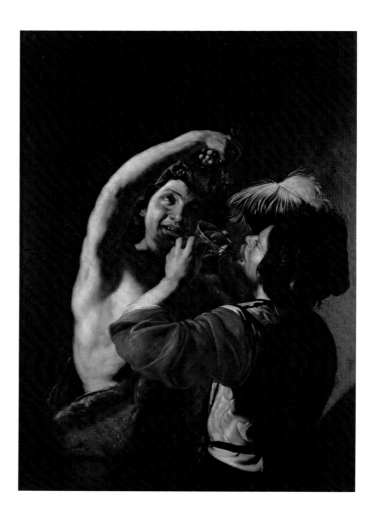

Fig. 39 Bartolomeo Manfredi, *Bacchus and a Drinker*, c. 1608–10, oil on canvas, 132 × 96 cm. Galleria Nazionale d'Arte Antica, Palazzo Barberini, Rome

The immediate precedent for this is doubtless certain paintings by Caravaggio of the 1590s, such as *The Cardsharps* (cat. 17) in Fort Worth, a work with obvious thematic affinities to Valentin's canvas; the *Rest on the Flight into Egypt* (c. 1595–97) in the Doria Pamphili; and *The Musicians* (cat. 1) in the Metropolitan Museum of Art. I see these paintings as belonging to a highly labile moment in the evolution of Caravaggio's art, one which raises the question: which way – toward the beholder or away – does a painting face? In one sense, of course, the answer is obvious: as material artifacts paintings face their beholders. But if one thinks of a painting less as an artifact and more as a representation, then there is an important sense in

which the depicted space opens in response to the beholder's act of looking, which is to say that it opens *into* the painting, or to put this slightly differently, it is oriented similarly to the beholder – and before the beholder, to the painter. In all the paintings we have just looked at, the figure seen largely from the rear in the extreme foreground "keys" the entire scene to that relationship. (I need hardly remark that the personage holding a cornetto and looking out of the *Musicians from* beyond the two foreground figures is Caravaggio "himself.") All this has to do, I have suggested, with a particular moment in the history of Italian painting (in Bologna and Rome, at any rate),[3] and by the time we get to the second and third decades of the seventeenth century the moment is over in the sense that I do not take the prevalence of figures depicted from the rear in Manfredi, Valentin, and their colleagues to represent that sort of questioning of a painting's fundamental orientation. Rather, I see such figures as seeking to elicit the viewer's conviction as to their sheer bodily being, their physical and ontological density, in the first place by virtue of the combination of their implied nearness to the picture plane (they often seem on the verge of having been forced into the viewer's space by their location "this" side of whatever table the image contains) and in the second by making a point of their corporeal orientation, which in effect enlists, empathically, the beholder's sense of his or her own corporeality as he or she stands facing the picture. (In Manfredi's *Bacchus and a Drinker* and *Allegory* the intertwining of the figures, not to mention in the latter the virtual intertwining of genders, gives rise to a sense of bodiliness – of bodily "presence" – that is positively hyperbolic.).

Another previously unremarked factor reinforcing an effect of "presence" on the gallery wall concerns the just alluded to tables, or rather the conspicuous placement in Valentin- or Manfredi-type painting after painting of block-like elements serving as tables, often massive, carved, and set at an angle to the picture plane. This last point is especially important. In the Louvre *Fortune Teller* the crucial such element is the bench (stone or wood?) on which the gypsy's client sits. More characteristic, though, is the *Concert with Bas-Relief* (fig. 40) in the same museum, one of Valentin's masterpieces, with its music-makers and drinkers gathered around a massive antique marble block bearing a classical bas-relief on its nearest oblique face. The illumination of the block – the top face most strongly lit, the left-hand face in a raking light that brings

out the bas-relief, the right-hand face in darkness – all but thrusts the block itself on the viewer, or at least gives it a salience that cannot be ignored. In other canvases of this sort – the Toledo *Fortune Teller*, for example, in which the angle of the stone table relative to the picture plane is unusually slight – it is easier to overlook such elements, or, if they are noticed, to minimize their importance. But they are in almost all cases *the* decisive structural (and structuring) element in the painting – that is patently the case in the *Concert*

Fig. 40 Valentin de Boulogne, *Concert with Bas-Relief*, c. 1624, oil on canvas, 173 × 214 cm. Musée du Louvre, Paris

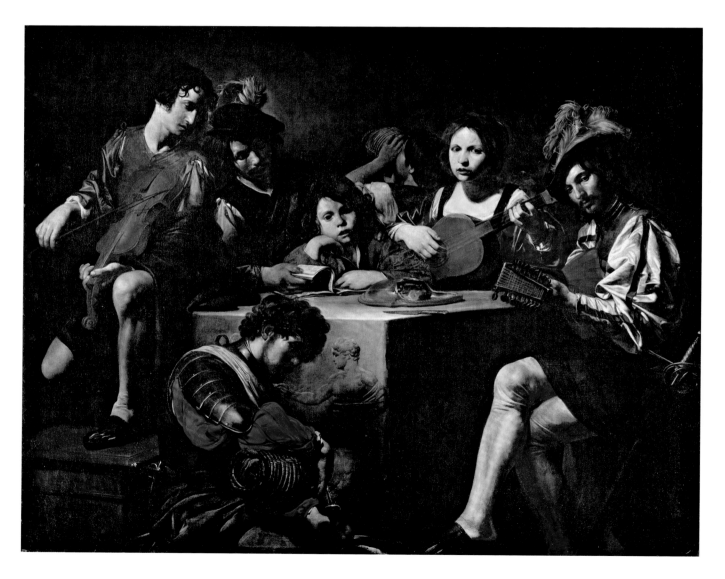

with Bas-Relief – and by virtue of their angledness they also stand in implicit contrast to the emerging classical system of composition based on parallel planes, as in the later "Roman" Annibale Carracci and – still in the future – post-1630 Poussin. (If one were looking for a precedent for such angled elements in Caravaggio, it would surely be the great stone slab toward the bottom of his *Deposition* in the Vatican.) Indeed I want to go further and suggest that marble blocks and tables of this sort provide a kind of internal ideal of obtrusive and substantial physicality, as if a truly satisfying density of "presence" on the gallery wall could not be achieved except in felt relation to a central depiction – amounting to an invocation – of massiveness and density as such. The *Concert with Bas-Relief* has something of the force of a manifesto in this regard, owing not only to the impressiveness of this particular angled and carved marble block but also to the strong sense of direct address of the viewer on the part of the central boy and perhaps also the lutenist at the right (the gaze of the young woman guitar player seems, in comparison, just slightly "off"). Notice, however, how in the Toledo canvas attention is subtly drawn to the table by both by its length and by the roughly chipped area at its leftmost end, and in any case the bench on which the nearmost soldier is seated is angled somewhat as in the Louvre *Fortune Teller*. (More on the notion of "address" shortly.)

It is in this connection too that I understand much of the motivation behind Valentin's and Manfredi's predilection for tavern scenes and specifically for depictions of persons pouring and drinking wine, playing and cheating at cards or dice, playing musical instruments and singing, pocket-picking and having one's pocket picked (sometimes at the same moment), and so on. (Three more characteristic examples: Manfredi's *A Group of Revellers* (fig. 62, p. 188) currently at the National Gallery of Art; Valentin's *Gathering in a Cabaret* (fig. 41) in the Louvre; and Nicolas Tournier's *Drinking Party with a Lute Player* (fig. 64, p. 191) in Bourges. Note the stone table in each. A fourth example, Manfredi's *Denial of Saint Peter* (fig. 67, p. 200) in Braunschweig, shows how the general subject matter I have just cited is compatible with certain religious themes.) It is in relation to such subject matter that the misleading term "anecdote" has been deployed repeatedly, usually by way of explicit or implicit denigration. But it is possible to see this feature of the paintings in an altogether different light, keyed, again, to a project of maximizing pictorial "presence." In the *Gathering in a Cabaret*, for example,

Fig. 41 Valentin de Boulogne, *Gathering in a Cabaret*, c. 1625, oil on canvas, 96 × 133 cm. Musée du Louvre, Paris

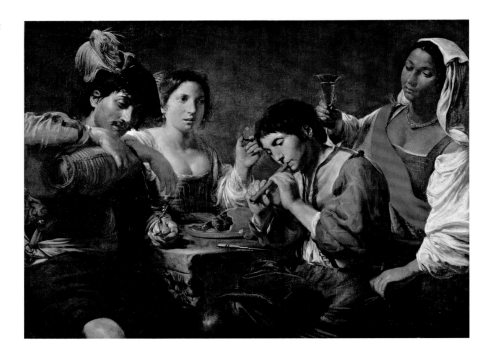

what takes the place of a single all-encompassing dramatic *mise-en-scène* – such as will shortly come to the fore in the art of Poussin – is a congeries of small and conspicuously undramatic actions, either carried out by individual figures independently of each other (the man at the left pouring wine into a glass, the boy to his left playing the flageolet) or in some sort of immediate, often non-reciprocal relation to another figure (the woman in decolleté resting her right arm on the pouring man's shoulder, the gypsy at the right picking the flute-player's pocket). Or, in the Louvre *Fortune Teller* the man at the left victimizing the gypsy, who is surely gulling her all-too-trusting client. The effect of this strategy – reaching a peak of effectiveness, perhaps, in Manfredi's *Denial of Saint Peter*, where the main event, Peter's moral collapse, takes place to the left rear – is to disperse the viewer's attention across much of the surface of the canvas, though here it is necessary to add that we must not take that verb, "disperse," to suggest an attenuation of interest or attention. On the contrary, precisely because the beholder cannot readily grasp the action or structure of such a painting as a whole, he or she is led almost effortfully to shift focus from one part of the canvas to another, often in response to the

actions, the doings, of the depicted persons' *hands*. In the Louvre *Fortune Teller*, for example, note how the busy hands of the pickpocket at the left are illuminated whereas his face with its wary eye is in deep shadow. The fortune teller's hands are also active in their quiet way, her poised right hand seeming to hold something (a coin, a ring?) between thumb and forefinger. As for the seated client, we are shown not only his open right hand but also his left hand gripping the seat of the bench as if helping to support the weight of his upper body. Plus there are the active, music-making hands of the man and woman at the right.

Another feature of both the Louvre and the Toledo canvases is that the open right hand of the man whose palm is being read is presented as if in visual isolation from the rest of his arm, an impression that is all the stronger in the Toledo picture in that the body blocking the seated soldier's extended arm from view is that of another figure entirely, one, moreover, whose face we do not see. Something similar takes place in the soldiers-playing-dice portion of the *Denial of Saint Peter*, a pointing hand belonging not to the soldier nearest it but to the one behind him. The result, in these and other pictures like them, is a further moment of cognitive uncertainty on the part of the viewer, who has to look hard and closely to work out precisely who is doing what. Here too my sense is that this is not a fault; rather, I understand it as a consistently applied strategy to compel the viewer to engage actively with the depicted scene and thereby to consolidate his or her relation to the painting in a highly motivated way. I should add that the emphasis on a multiplicity of small, particular, essentially *manual* acts also has the effect of allowing the various figures to adjoin one another extremely closely, which in turn contributes to the sheer density of "presence" of the painting as a whole.

Another point remains to be stressed: the role in these paintings of the depiction of what I have elsewhere called "absorption." This is an extremely rich topic, one to which I cannot begin to do justice in this essay, but for present purposes what must be noted is, first, that the invention of absorption as a pictorial resource took place in the 1590s largely, though not exclusively, in the art of Caravaggio (at any rate, this is my claim in *The Moment of Caravaggio*); and second, that whereas in Caravaggio's art absorptive states and motifs were largely mobilized in connection with religious subject matter to suggest emotional and spiritual depth, in paintings such as the ones we have been looking at absorption assumes a very different significance.

The works by Caravaggio I have in mind include his *Penitent Magdalene* (cat. 31) in the Doria Pamphilj; the *Death of the Virgin* (fig. 9, p. 20) today in the Louvre (in both of which absorption does the work of the *affetti*); the *Incredulity of Saint Thomas* (fig. 78, p. 270) in Potsdam (in which absorption does the work of composition, holding a picture together); and the magisterial *Crowning with Thorns* (fig. 42) in Vienna (I am thinking particularly of the presumed state of mind of the man in armour and feathered hat at the left, whom I see as utterly absorbed in close range contemplation of Christ's passion). As hardly needs to be said, the secondary literature on Caravaggio is crammed with praise for him for having plumbed the emotional and spiritual depths of his personages like no painter before him – and very few after (perhaps only Rembrandt gets mentioned in the same breath). And yet if one looks closely at, for example, the man in armour in the Vienna *Crowning*, whose face is largely turned away from us, or indeed the disciples in the *Death of the Virgin*, whose features are for the most part lost in dark shadow, it becomes apparent that the intensities of feeling that commentators at least since 1950 have routinely discovered in Caravaggio's art can only have a single source – the psyche of the viewer, the beholder standing before the painting, who is repeatedly induced by minimally expressive but distinctly absorptive motifs to unstintingly "project" his or her own subjectivity "into" the painted figures in question. Absorptive painting thus engages the beholder in a highly particular way: one might say it "absorbs" the beholder precisely by inducing him or her to spontaneously and unreflectively *flood* the canvas in question with intensities of feeling that he or she at once proceeds to "discover" in the picture, quite as if the beholder had nothing whatever to do with such feeling having come to "be" there in the first place.

In Valentin, Manfredi, and other painters of their general orientation, the emotional temperature is for the most part far cooler than in Caravaggio's religious canvases, but it obviously matters that all the figures in the Louvre *Fortune Teller* and indeed the Toledo canvas (with two exceptions, the pickpocket at the left and the soldier holding a wine glass at the right, both of whom look directly at the viewer) appear absorbed in what they are doing, thinking, or feeling – indeed one basic marker of a personage's absorption is his or her obliviousness to everything else, which is why in both pictures the gypsy's absorption in the act of reading her client's palm sets her up so

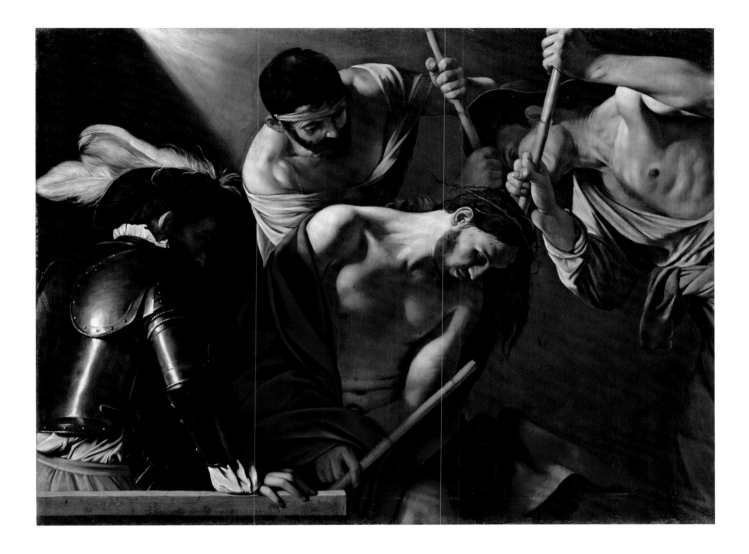

Fig. 42 Michelangelo Merisi da Caravaggio,
The Crowning with Thorns, 1602–05, oil on
canvas, 127 × 165 cm. Kunsthistorisches
Museum, Vienna

effectively for the depredations of the pickpocket. Another feature of the
depiction of absorption concerns the issue of temporality, in the sense that
absorbed figures often appear relatively static (an absorptive state, virtually by
definition, is one that is *held*), which again is true of the personages in the
Louvre *Fortune Teller* and, to a lesser extent, the Toledo canvas as well (the
standing soldier toward the right pouring wine into a glass is a tour de force
of quiet concentration, as are the soldiers playing dice toward the right of the
Denial of Saint Peter). By now I hope it will not seem tendentious to suggest
that the combined effect in these and similar paintings of the depiction of
absorbed states of mind and body and of the sense of temporal protraction or
dilation that goes with those states also serves the end of pictorial "presence";
the effect, one might say, is of a sustained density of being that is more than
simply physical.

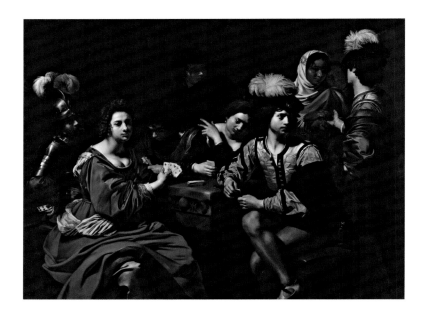

I remarked earlier that I would have more to say about what I called
address, and here I will add that in certain works by Caravaggio, such as
The Musicians or the ravishing *Rest on the Flight*, absorption and address go
hand in hand – which makes perfect sense in that both devices have for their
ultimate rationale the transfixing of the viewer before the painting (they are,
one might say, two faces of the same ontological coin). And if we look again
at Valentin's *Concert with Bas-Relief*, we find the two motifs even more
"equally" conjoined, four of the figures appearing caught up in what they
are doing to the extent of giving no thought to the beholder (none more
persuasively than the man pouring wine toward the bottom of the canvas),
the other three – the two musicians at the right and the central boy – looking
directly out of the canvas. (Much the same is true, I have suggested, of the
Toledo *Fortune Teller*, to which I would also add the Manfredi *A Group of
Revellers* at the National Gallery of Art) In a brief section on the Caravaggisti
in *The Moment of Caravaggio* I observe that a deliberate if not quite
systematic juxtaposition of absorbed and beholder-addressing figures forms a
basic element in the "presence"-seeking pictorial poetics I attribute to
Valentin, Manfredi, and the others. Consider, in this connection, Nicolas
Régnier's masterly *Cardsharps* (fig. 43) in Budapest, the internal "narrative" of

which depends on the contrast between the expensively dressed young card player in yellow and black and with crossed legs in tights who gazes distractedly out of the picture toward the right and the woman cardsharp in red at the left who turns toward the viewer to display her hand. Note too the other woman cardsharp who appears absorbed in stealing a look at the young man's cards, an operation that subtly points up the extent of *his* absorption/distraction. Indeed it is just possible that the overtness with which the woman in red addresses the viewer is designed momentarily to distract the latter's attention from what her colleague is up to, as if to involve the viewer in the fictional situation. More broadly, whereas what I have called the absorption-plus-address system largely disappeared from Caravaggio's art after the early 1600s, it subsequently became a basic resource of that of some of his closest followers. (Another feature of Régnier's *Cardplayers*, of course, is the massive carved and angled stone block thrusting toward the viewer at the picture's centre. We are dealing with an all but ubiquitous convention here.)

In summary, I interpret the efforts of Manfredi, Valentin, Régnier, and others of their school as a collective effort to formulate a new paradigm for gallery painting keyed to the values of density and "presence," one extrapolated from Caravaggio's canvases of the 1590s and early 1600s but not, in the most developed instances, parasitic upon them. Another watchword of the new paradigm I think of as *autonomy without unity*, a notion that seems to me to capture perhaps *the* guiding impulse behind some of the most ambitious painting in Rome during the first decades of the seventeenth century. Indeed the evident lack of interest in pictorial unity on the part of many of the Caravaggisti is one reason modern scholars have tended to underestimate the significance of their artistic project. The sole exception in this regard among those painters is the strongest of them, Valentin, who repeatedly composed his pictures on the basis of corner-to-corner diagonals that cross at or near the centre of the canvas and thereby counteract the multiplicity of "actional" foci in a strictly surface-structural way. This too has been hard to recognize for what it is, though the later seventeenth-century theorist and historian Giovanni Bellori astutely commented, "[Valentin] made more progress than any other naturalist in the deployment of figures."[4] Both the Louvre and Toledo *Fortune Tellers* and, more perspicuously, the *Concert with Bas-Relief* demonstrate this approach, as does a canvas not yet mentioned, the ambitious and original *Last Supper* (fig. 44) in the Barberini,

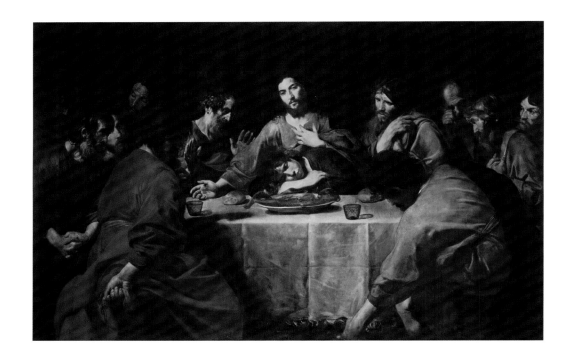

with its nearest disciples viewed from the rear (Judas at the left, clutching his bag of silver in his right hand). The pursuit of autonomy not just with but *through* pictorial unity of an essentially dramatic sort will be basic to Poussin's enterprise throughout his career.

In *The Moment of Caravaggio* I went on to mention briefly an additional point, one that I said I would develop further on a future occasion (a promise I renew on this one): in certain characteristic paintings by (especially) Valentin and Régnier individual male figures appear possessed by what might be described as an "excessive" mode of embodied subjectivity, as if their own physicality were not wholly "transparent" to them, something to be taken for granted and in that sense not registered as such. The strongly built young man being gulled in Régnier's *Cardsharps* is an instance of this, as is the lute-player – also in tights and with crossed legs – in Valentin's *Concert with Bas-Relief*. Other exemplary figures in this vein are the seemingly distracted bearded shepherd making a wicker basket in Valentin's *Erminia and the Three Shepherds* (fig. 45) in Munich (based on the same model as the bearded man in the Louvre *Fortune Teller*), and the protagonist of the stupendous single-

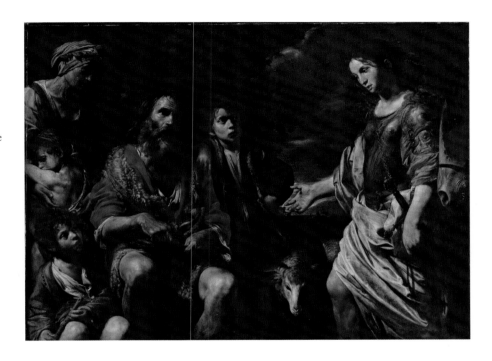

Fig. 44 (*facing page*) Valentin de Boulogne,
The Last Supper, 1625–26, oil on canvas,
139 × 230 cm. Galleria Nazionale d'Arte
Antica, Palazzo Barberini, Rome

Fig. 45 Valentin de Boulogne, *Erminia and
the Three Shepherds*, 1629–30, oil on canvas,
134.6 × 185.6 cm. Alte Pinakothek, Bayerische
Staatsgemäldesammlungen, Munich

figure *Samson* (fig. 46) in Cleveland. There is also the protagonist of the
superb *Lute Player* (fig. 47) by Valentin in the Metropolitan Museum of Art,
with his rose-pink silk shirt, steel gorget, feathered hat, and – once more –
crossed legs in tights, who sits in extreme proximity to the picture plane,
looks almost broodingly at the viewer as he plucks his lute, and, possibly or
possibly not, sings. (I should have said earlier that a multi-sensory or at least
visual-tactile-aural thematics contributes to the effect of "presence" in many
of these works.) Or, to close with a different sort of picture by a painter who
more than any other was intimate with Caravaggio, consider Cecco del
Caravaggio's remarkable *The Resurrection* (fig. 48) in the Chicago Art
Institute, with its physically imposing soldier in tights and with partly drawn
sword asleep in the near foreground and his stricken fellows variously reacting
to the divine event. Each of the soldiers, in my view, is "excessive" in his own
distinctive way, thanks not only to the nature of the action in which each is
engaged but also to the carefully delineated interplay between clothing and
body, as in the preternaturally sharp-focus treatment of the sandals and
legging-bottoms on the feet of the "stepping" soldier to the left or the skin-

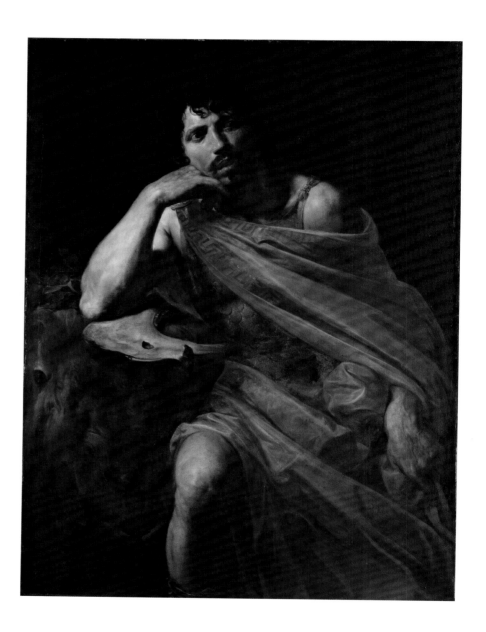

Fig. 46 Valentin de Boulogne, *Samson*,
c. 1630, oil on canvas, 135.6 × 102.8 cm.
The Cleveland Museum of Art,
Mr. and Mrs. William H. Marlatt Fund,
1972.50

tight blue leggings on the soldier to the right. (A proposal: tights or leggings
on muscular, often crossed legs function in all these pictures as markers of
what a later age will call self-affection.)

The question is what to make of such figures, and although a detailed
answer is beyond the scope of this essay I want at least to observe that the

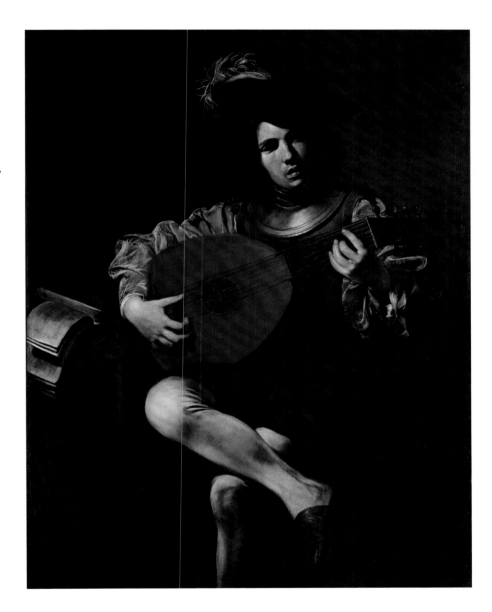

Fig. 47 Valentin de Boulogne, *The Lute Player*, c. 1626, oil on canvas, 128.3 × 99.1 cm. Metropolitan Museum of Art, New York, Purchase, Walter and Leonore Annenberg Acquisitions Endowment Fund; funds from various donors; Acquisitions Fund; James and Diane Burke and Mr. and Mrs. Mark Fisch Gifts; Louis V. Bell, Harris Brisbane Dick, Fletcher, and Rogers Funds and Joseph Pulitzer Bequest, 2008.459

dates of all these paintings, the 1620s, place them a generation before the publication of Descartes' *Meditations* (1641), in which the problem of the relation of mind or soul to body leads famously to the linked assertions that "my essence consists solely in being a body which thinks [or a substance whose whole essence is only to think]" and that my mind or soul "is entirely

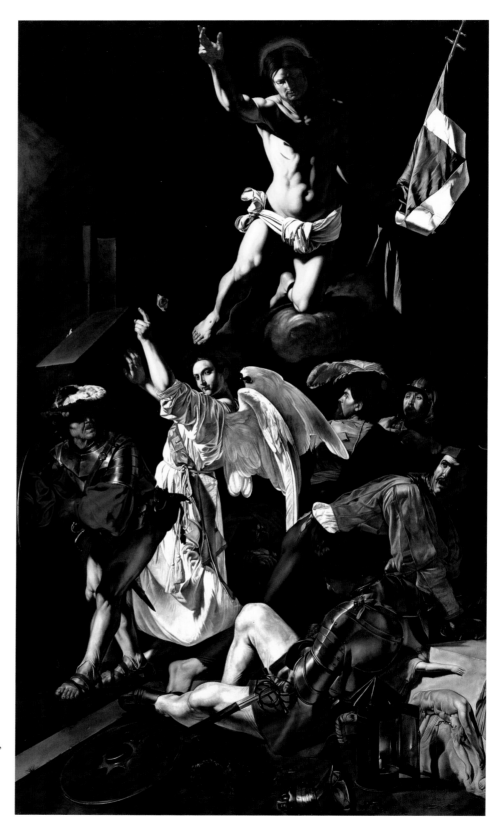

Fig. 48 Francesco Buoneri, called Cecco del Caravaggio, *The Resurrection*, 1619–20, oil on canvas, 330.1 × 199.5 cm. The Art Institute of Chicago, Charles H. and Mary F.S. Worcester Collection, 1934.390

[and truly] distinct from my body and . . . can [be or] exist without it."[5] It is also the case, Descartes insists, that ordinarily mind and body are "intimately connected," even, in a sense, "blended."[6] But the blend or union is merely apparent, and the hierarchy of mind over body is for Descartes absolute: thus in his view all "feelings of hunger, thirst, pain, and so on are nothing else but certain confused modes of thinking, which have their origin in the . . . apparent fusion of the mind with the body."[7] A certain "confusion" does indeed seem to mark the condition of some of the figures we have just glanced at, most obviously the soldiers in Cecco's *Resurrection*, but it is as if Descartes' strategy in the *Meditations* was ultimately to portray *all* bodily feelings in this light, and more broadly to counter the radically embodied vision of human subjectivity that lies very near the heart of the Caravaggisti's collective achievement.

NOTES

1 The present essay should be read in the context of the larger argument of my recent book, *The Moment of Caravaggio*, The A.W. Mellon Lectures in the Fine Arts (Princeton and Oxford, 2010). Among the many works I have found helpful in connection with the Caravaggisti discussed in these pages I want particularly to mention Beverly Louise Brown, ed., *The Genius of Rome: 1592–1623*, exh. cat. (London and Rome, 2000–01).

2 The emergence of the full-blown "gallery" picture in Caravaggio's Rome is a central theme in *The Moment of Caravaggio* (see esp. chap. 5, "Severed Representations"). In that chapter I cite and discuss V.I. Stoichita's important book, *L'Instauration du tableau: Métapeinture à l'aube des temps modernes* (Paris, 1993); in English *The Self-Aware Image: An Insight into Early Modern Meta-Painting*, trans. A.-M. Glasheen (Cambridge and New York, 1997).

3 I mention Bologna along with Rome because

in *The Moment of Caravaggio* I devote considerable attention to the collective achievement in that city of the Carracci – Ludovico, Agostino, and Annibale – starting in the early 1580s. In particular I try to show how one of the masterpieces of the late sixteenth century, Annibale's *The Bean Eater* (c. 1583–85) in the Galleria Colona also exemplifies the double-facingness I have attributed to certain works by Caravaggio (pp. 145–46).

4 Bellori 2005, p. 186. This is said toward the end of his *Life of Caravaggio*. H. Langdon has remarked that "[t]hroughout the 1620s, in [Valentin's] increasingly ambitious compositions . . . figures are often linked in a deep space by bold diagonals" (London 2001, p. 60).

5 R. Descartes, "The Meditations Concerning First Philosophy," in *Discourse on Method and Meditations*, trans. L.J. Lafleur (Upper Saddle River, N.J., 1997), p. 132.

6 Ibid., p. 134.

7 Ibid., p. 135

following pages Michelangelo Merisi da Caravaggio, *Saint Francis* (detail of cat. 26)

pages 152–53 Michelangelo Merisi da Caravaggio, *The Musicians* (detail of cat. 1)

CATALOGUE

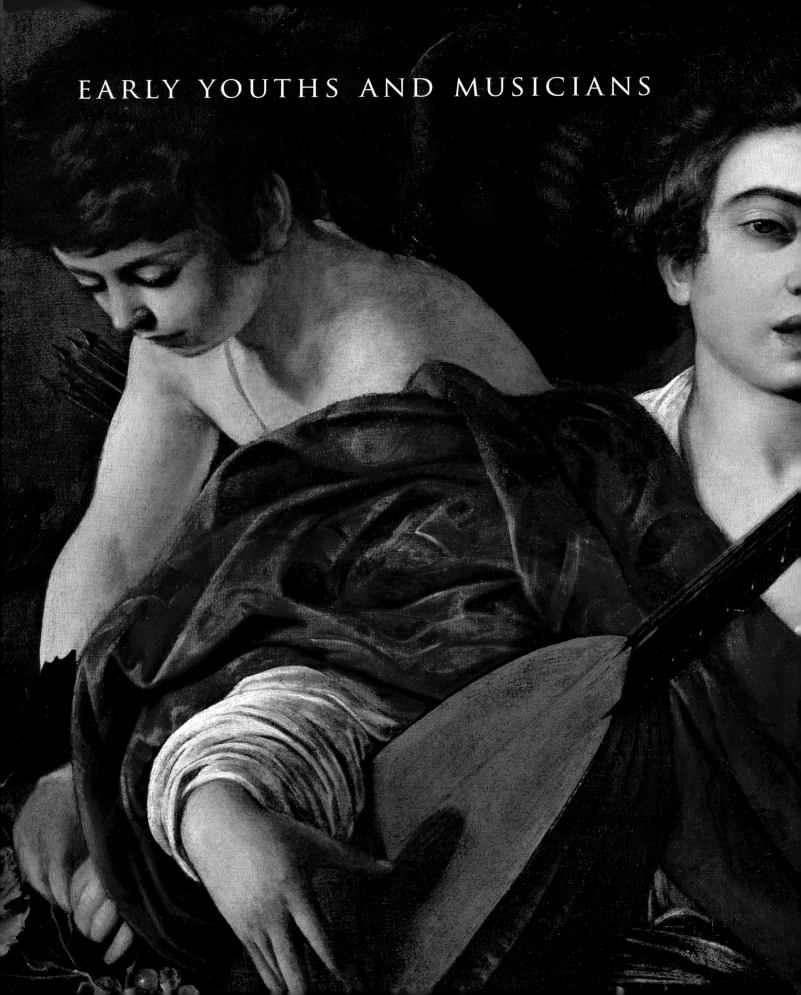

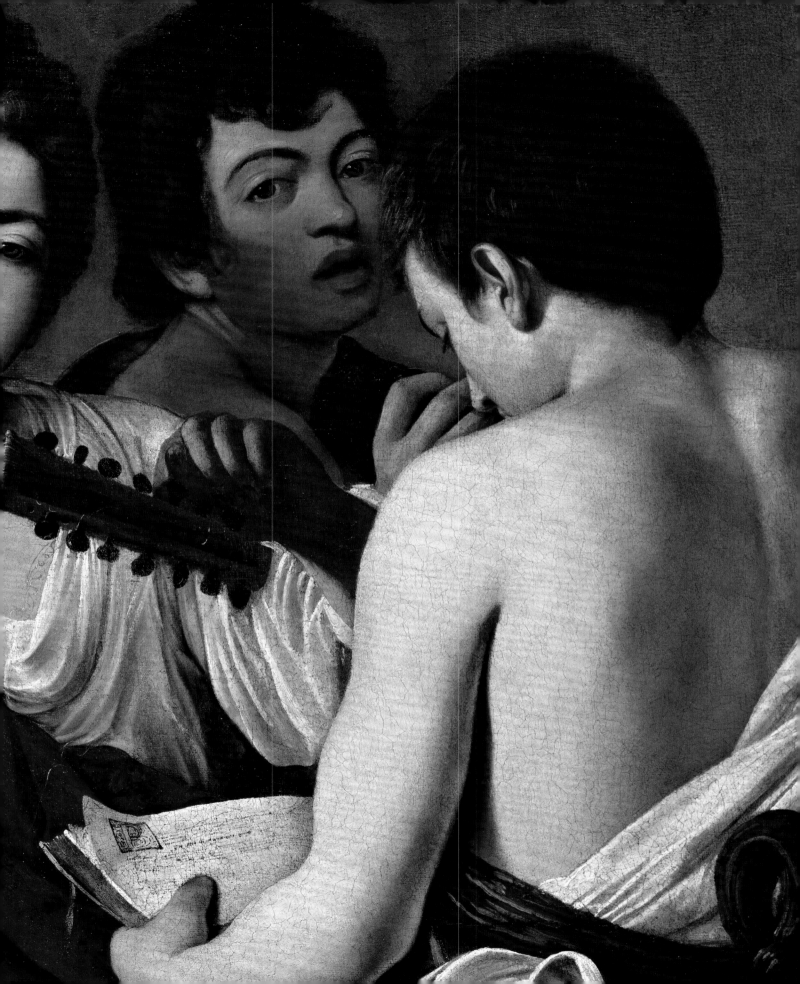

"You Know that I Love You": Music and Youth in Caravaggio

DAVID FRANKLIN

MUSIC WAS ONE OF THE THEMES THAT MOST PREOCCUPIED Caravaggio in Rome during the 1590s and around which he revolutionized painting of the time.[1] Of course, the link between music and the visual arts was a long-standing one by this date. Yet it was doubtless a useful strategy for the young painter to treat music as his subject matter and thereby implicate another art form with his own – one that many contemporaries would have judged superior and so he established an intriguing dialectic to stimulate educated debate. This period saw not only the creation in 1585, by order of Pope Sixtus V, of a professional musical organization in Rome based at the Pantheon, it also corresponded with the rise of passionate amateur interest in writing about music and performance, as with, for example, Vincenzo Giustiniani, one of Caravaggio's major Roman patrons. The paintings undoubtedly depicted actual events and participating musicians. Likewise, many of these collectors of art objects owned the very instruments and original manuscripts commemorated in the works. All of this contributed further to the popularity of Caravaggio's paintings, which were likely created to decorate rooms used for performance.

The painting of *Musicians* in the Metropolitan Museum in New York (cat. 1) is the key early work produced by Caravaggio involving music.[2] Generally dated on stylistic grounds to around 1594–95, it is among the artist's earliest independent efforts. According to Giovanni Baglione, it was Caravaggio's first painting commissioned by his major patron the Venetian-born Cardinal Francesco Maria del Monte (1549–1627), resident in a palace close to Piazza Navona very near to the Giustiniani. It was also classified as *una Musica* in a letter from Giulio Mancini, one of Caravaggio's earliest biographers, to his brother Deifebo in 1615.[3] Del Monte's musical knowledge was equal to Giustiniani's: he was, for example, the protector of the choir of the Sistine chapel.

The painting, which has been trimmed slightly, appears to have been signed by Caravaggio but the letters are erased owing to the poor condition of the canvas. The work is damaged and thus difficult to analyze in detail. However, the main aspects are apparent enough. The Metropolitan painting is dedicated to the themes of music and love, but with a pervasive sense of melancholy rather than idyllic pleasure. The canvas features a trio of musicians with the additional, anachronistic (and completely self-possessed) figure of Cupid, the God of Love, child of Venus and Mars, with his attribute of the quiver, handling a cluster of grapes in the background. Caravaggio would naturally have painted and studied angels in religious art and the physiognomy of this one evokes the paintings of Giovanni Bellini and Mantegna, thus he has imported this knowledge into a secular context with his depiction of this additional character. The artist represented the figures seated almost casually and intimately

Cat. 1 (*facing page*) Michelangelo Merisi da Caravaggio, *The Musicians*, c. 1595

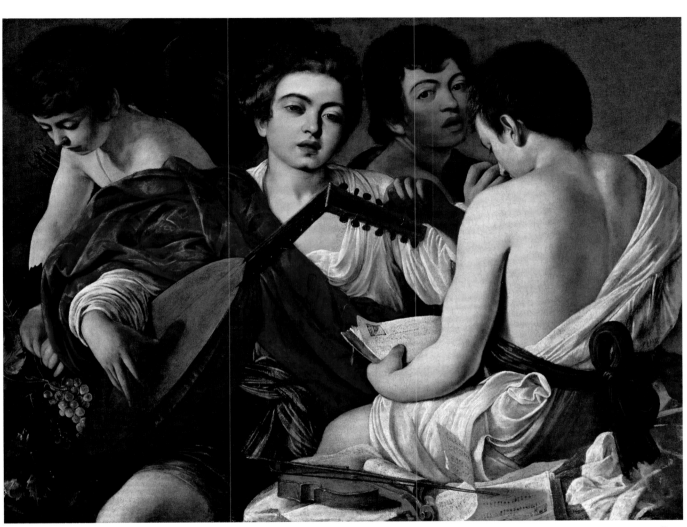

preparing for a concert rather than the performance itself – an unusual narrative choice. The main player seems captured in a wave of emotion as he tunes the seven-course lute pressed against his thigh, while another appears to be studiously familiarizing himself with the musical score; the youth at the back with the speaking mouth holds a curved horn or *cornetto,* which provided the treble part of the music in concert. The music visible in the immediate foreground hints at a specific meaning, even a particular concert or repertoire, or perhaps performers that the painter was required to commemorate for Cardinal del Monte. The violin present in the foreground suggests a professional performance, as it was not known as an amateur instrument in this period. The direct visual contact with the viewer by the two central faces is deliberate and indicates a specific intent to break down the picture plane for the sake of immediacy. The image seems addressed to a lover, presumably unrequited, who is invited to participate through the music. The main interlocutor wears a brocade of crimson – in this context reminding us too that luxury and wealth are like music, pleasure and love, all illusory.

This painting was one of the first multi-figured compositions that Caravaggio ever undertook, and evidence for his tentative approach shows. The overall design has a dense, composite quality and seems to lack adequate space or a ground plan. The

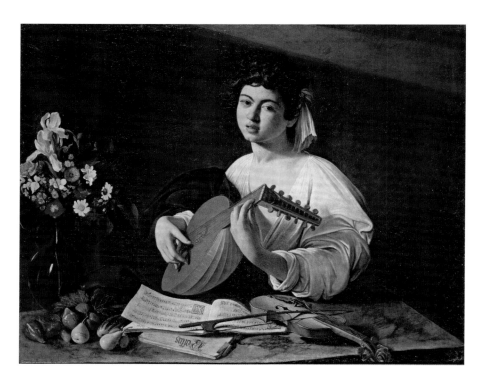

Fig. 49 Michelangelo Merisi da Caravaggio, *The Lute Player*, 1595–96, oil on canvas, 94 × 119 cm. Hermitage, Saint Petersburg

figures are in turn depicted in front, back and partial side views to establish a sense of dynamic rotation – a standard compositional device introduced here to powerful effect. The placement of the main figure with his thigh trimmed by the lower margin of the canvas provides a smooth access for the viewer into the pictorial space.

The imagery of the Metropolitan work has roots in Northern Italian painting so it looks retrospectively to the artist's own experience. Caravaggio frequently exploited the general ignorance of the Romans to his artistic upbringing yet, paradoxically, it inspired some of the most progressive works in Rome. A main difference, of course, from the source material in works by such artists as Titian is that rather than any allegory is remote from the viewer's experience of the painting, whereas Caravaggio captures a single moment in all its complexities. By introducing the Cupid into a scene from contemporary life (and one with portraiture), the painter combines genres in an unusual way.

Caravaggio's painting of a solitary musician survives in two versions (figs. 49 and 50).[4] One in the Hermitage Museum was painted for Vincenzo Giustiniani and a variant, in a private collection on deposit to the Metropolitan, was executed for Cardinal del Monte, the owner of the *Musicians*. The latter work is directly relevant to a discussion of the *Lute Player* works as they share many of the same concerns,

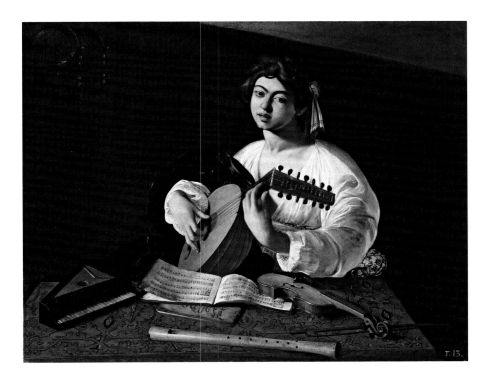

Fig. 50 Michelangelo Merisi da Caravaggio, *The Lute Player*, probably c. 1597, oil on canvas, 102.2 × 129.9 cm. Private collection, on extended loan to the Metropolitan Museum of Art, New York. L.2003.30

subject-wise and pictorially. To judge on the basis of style, both paintings appear to date slightly later than the *Musicians* canvas to the latter part of the 1590s. Here we witness more of a live, simulated performance with a seven-course lute (Hermitage) and a twelve-string lute (private collection), in contrast to the *Musicians*, which for being more informal and ambiguous evokes a much greater tension. The lute was also used in solo performance in this period and the image could be respectfully commemorating one such event (the heavier end of the lute is realistically supported on a table) or a person one assumes is wearing a costume for performance. Indeed, the androgynous figure appears not only to be an identifiable contemporary but plays a transcribed piece of music. He has been identified as the castrato Pedro Montoia who was in Rome from about 1592–1600 and was part of the Del Monte circle, presumably performing at private concerts for him.[5] One of the partbooks depicted in the foreground of the Hermitage painting is a madrigal first published in 1539 by the Franco-Flemish composer Jacques Arcadelt (died 1568), who was known for his secular vocal compositions that became regarded as prototypes of the genre. The text labelled for the bass part – "Bassus" – is most easily decipherable on the cover of the closed score underneath, so symbolic too of how we lower ourselves in the pursuit of love. The open score includes the lines "You know that I love you," so directly addressing the viewer, the beloved for whom the performer has intense longing.[6] This bold reference suggests one possible interpretation for the *Musicians* too, where the musical score is illegible.

The *Rest on the Flight into Egypt* in the Doria-Pamphilj in Rome – another major painting of the 1590s – contains reference to another specific piece of music and deepens our knowledge of this facet of Caravaggio's art. The musical score awkwardly held up by Joseph for the angel who plays on a violin has been identified as a motet by another Franco-Flemish composer Noel Bauldewijn (d. 1529/30): *Quam pulchra es et quam decora*, borrowed from the Song of Solomon, then commonly interpreted to speak to the Virgin Mary and her love for Christ as like that between a bride and groom.[7] It was a popular source for composers of the period to set to sacred music and Caravaggio treats it as the very subject of the painting. As the motet was a polyphonic type of choral music, the performance here would suggest that the angel is accompanied by a divine choir. As in many of Caravaggio's paintings – not just those involving music – the artist clearly strove to add an audible aspect to our experience of the work and yet he seems to insist upon the permanence of visual representation compared to the evanescent nature of music.

Caravaggio's adept handling of the foreshortening of the instrument in the *Lute Player* paintings obviously demonstrates his formal ability, just as the nude shoulder

of the most foreground youth in the Metropolitan picture reveals the artist's skill in the representation of anatomy. The still-life aspect in these paintings is crucial too for how meaning is generated. The flowers and fruits perish just as life and such pleasures as music and love are fleeting and ultimately frustrating. The illusionistic accuracy of the depiction adds to the seductive power of this message.

A dominant aspect of these early paintings on musical themes by Caravaggio are the presence of handsome youths partially draped in white costumes and this type was repeated in many works of the artist's followers. The *Bacchino Malato* or *Sick Bacchus* (cat. 2) in the Museo Borghese was one of the first of these provocative males in a canvas dating to around 1593–94.[8] The figure is notably Asiatic looking, though some scholars consider him a self-portrait. The reference to the origins of Bacchus on the island Chios in Greece near Asia Minor, though this suggestion is far from irrefutable. Another prominent still life appears in the lower right, not merely as an accoutrement but as much part of the subject matter as the figure. Indeed, the entire work could almost be described as a still life given its airless exactitude. The image is distinguished by the unsettling, furtive look of the character reinforced by the rising stone plinth and overall taut construction. The figure of Bacchus sports a garland wreath and clutches at the grapes in an almost animalistic manner. The high viewpoint is contrived to allow the spectator to look down on the under-life-size figure as if to possess him in an intimate way. The slightly off-centre placement to the viewer's left also adds to the sense of spontaneity and immediacy of the picture.

This type of image was developed further in other works that Caravaggio produced in Rome, including the *Boy Bitten by a Lizard* (cat. 3), now in the Longhi Foundation in Florence, a second version of which survives in the National Gallery, London.[9] The figure wears the same *all'antica* white shirt that appears in the Hermitage and private collection Musician paintings, provocatively worn to reveal some of the nude body, and the unusual hairstyle suggests a wig. Whether the artist intended the figure to be mythological or contemporary is not clear, but it shares the strong portrayal of the features with *Sick Bacchus*. The work follows portrait conventions in the striking portrayal of the face and hands, but some restraint is maintained as the figure placed sideways in space resists the viewer and the off-centre placement indicates a narrative. Yet the figure is just under life size and this delicate scale seems an invitation to the viewer to possess the character. The articulate, highly expressive hand gestures, particularly that of the open left hand, may have a source in religious art, but appear almost comical in this context. The character emerges as almost animalistic, with no apparent self-control, similar to the *Sick Bacchus*. The emotional content is also expressed by the vertiginous cascade of streaming folds in the boy's clothing.

Cat. 2 (*following page*) Michelangelo Merisi da Caravaggio, *Sick Bacchus,* 1593–94

Cat. 3 (*page 135*) Michelangelo Merisi da Caravaggio, *Boy Bitten by a Lizard,* 1594–96

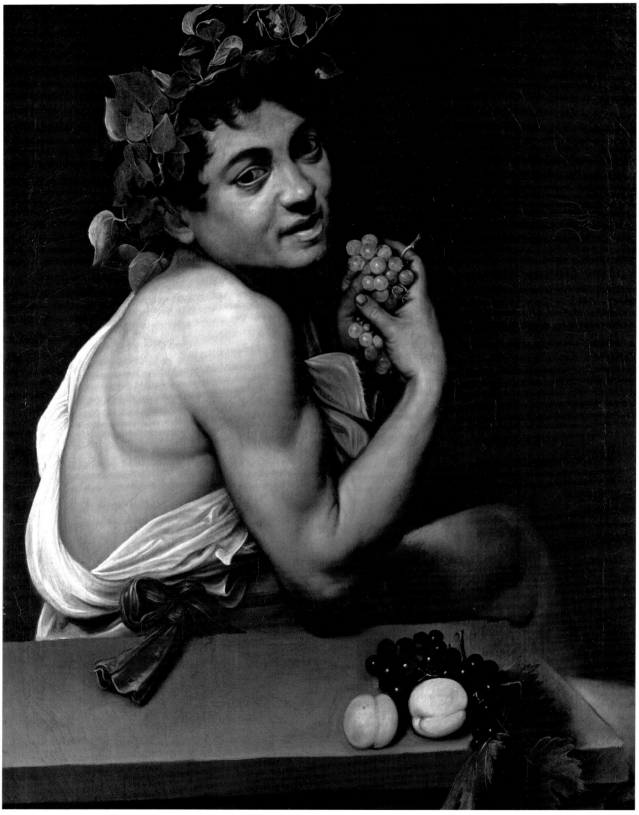

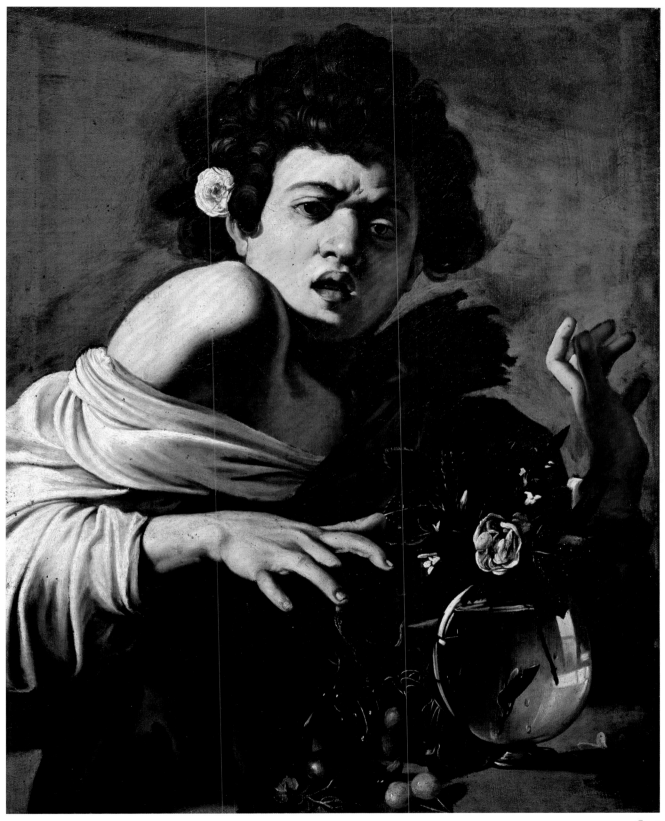

The precise meaning is much debated but the main sense is clear enough: Love will hurt you when you least expect it. According to Alciati's emblem book, first published in 1531, the lizard made reference to corruption and deceit – meanings clearly at play here.[10] While the rose is a symbol of Venus and love so this reference also adds a veneer of classical learning and significance, similar to that in the Metropolitan canvas, thus deepening the viewer's response and experience of the image, while unsettling any traditional sense of the separation of genres.

Typically for Caravaggio's early work there is a prominent still-life element, virtually a *trompe l'oeil*. Here this is placed in the lower right corner of the support and adds an accent of strong colour to an otherwise monochrome image, as it invites the viewer to marvel at the high degree of illusionism. A window full of sunlight and Roman warmth is reflected in the carafe opening the image out, a detail that places the observer in physical relation to the image. It is otherwise a taut and turbulent picture where tension is never far from visual pleasure. All of Caravaggio's works of the 1590s demand a direct response from the viewer and in this way are almost confrontational. They present a world in which pleasure is irresistible but simultaneously treacherous and ultimately produce only sadness and absence.

As with all the cases of the influence of Caravaggio's private paintings, his treatment of musical themes had an impact on the work of other artists following his departure from Rome. So in part it seems apparent that there was an attempt to fill a market after his death, in addition to a genuine inspiration, though this cynical attitude towards the art market suits the artist's own sensibility. The depiction of male youths comparable to the Borghese and Longhi pictures for whatever reason were far less prevalent, but one example is Gerrit van Honthorst's *Smiling Young Man Squeezing Grapes* (cat. 4) in Worcester Massachussetts.[11] Signed and dated 1622, it was likely executed not long after the artist's return to the Netherlands following an extended period in Rome. It features a comparable half-length youth directly (and rather repulsively) addressing the viewer with an inebriated grin. He is likewise captured in a strong raking light against the sort of "negative' background found in most of Caravaggio's work, and wears a white shirt with a flagrantly bared shoulder. The still-life treatment of the leaves, grapes and earthenware cup is as prominent and virtuoso as in any Caravaggio. But Honthorst's image has a simplified, more robust interpretation without much complexity or subtlety, as in the over-tight squeezing of the grapes. The figure seems also more caricatured, lacking the ambiguity of Caravaggio's treatments in this format, which veer between the mythological and contemporary, while at the same time faithfully preserving all the dramatic formal aspects of the master's style.

Cat. 4 (*facing page*) Gerrit van Honthorst, *A Smiling Young Man Squeezing Grapes,* c. 1622

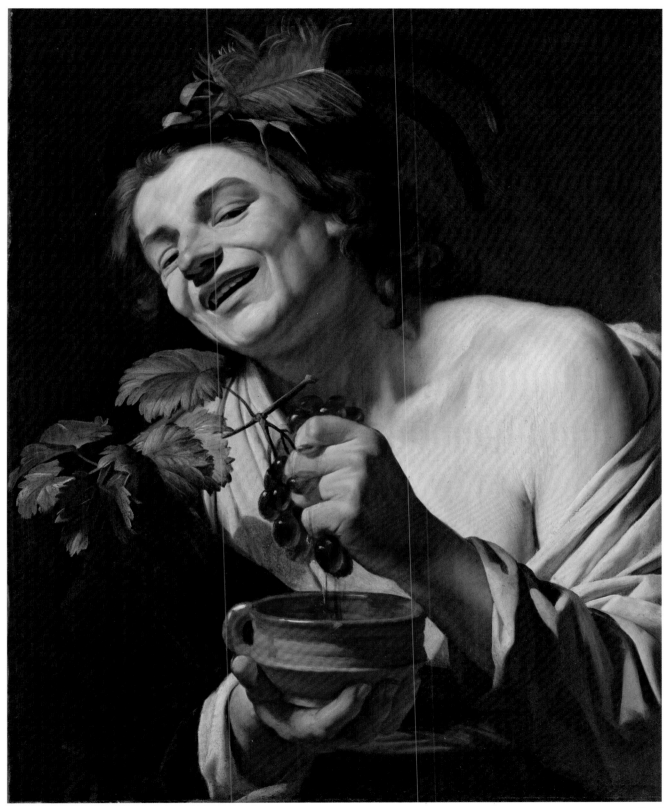

Cat. 4

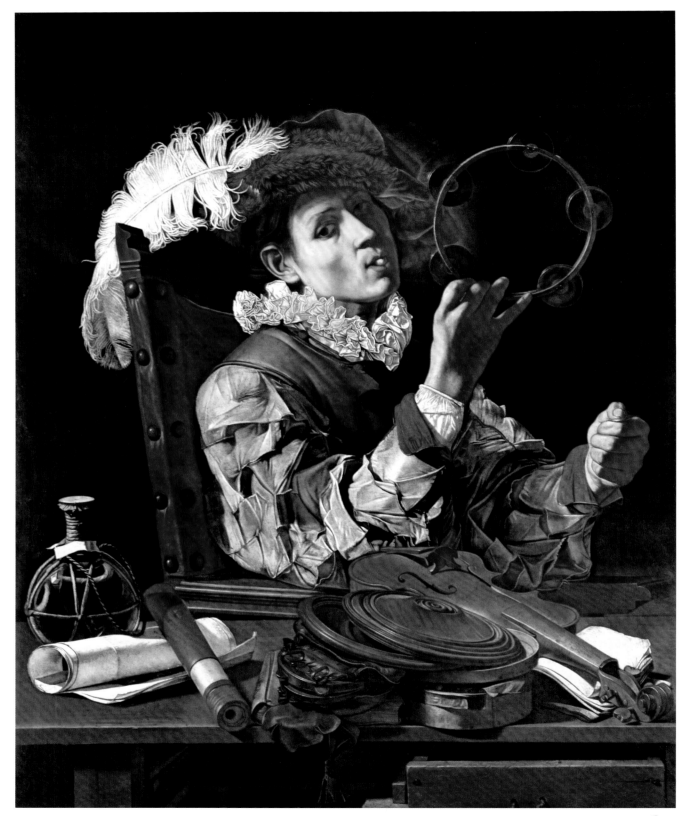

Among the first musically themed paintings produced respecting Caravaggio's example are found in works by Francesco Buoneri, alias Cecco del Caravaggio, including a single musician (cat. 5) in the Wellington Museum, Apsley House, London.[12] The painting is treated with the distinct crisp and linear handling of Cecco's in a typically restricted palette of red, brown, gold and white. Cecco, a short form of "Francesco," recently identified as Francesco Buoneri, who was a Tuscan-born painter. He is documented as living with Caravaggio himself in 1605 in Rome in the parish of San Nicola dei Prefetti. He apparently died around 1620. So Cecco was among the first wave of Caravaggio followers, one of the few who knew him personally prior to his departure from Rome in 1606.

The London painting has been dated around 1610–15 and although this is simply a hypothesis in the absence of documents, it is certainly among the earliest derivations after Caravaggio's secular art. The work was formerly titled *Conjurer*, but as Richard Spear has pointed out, the character has a whistle in his mouth and a clacker with a tambourine so this is a single musician caught in the literal act of performing,[13] as in Caravaggio's *Lute Player*, or perhaps demonstrating for sale the wares otherwise laid out on the table in front of him. In this regard the prominent still-life element makes for a hypnotic, virtuoso focus of attention. There seems the possibility of a deeper meaning in the tambourine held up to create a circle – a metaphor for eternity, though, conversely, the playing of percussive instruments also suggests a comic element and it is difficult to know how cryptic these images were intended to be. It cannot be ruled out it represents a known contemporary, given the portrait-like character of the sitter. The costume is particularly rich and elaborate, including an abundant collar and plumed hat. The odd viewpoint with the low table and triangulated design reflects an awkward attempt for a less competent painter to recreate Caravaggio's pictorial solutions. But the heightened, almost uncomfortable emotional engagement and emphatic gestures also suggest the influence of early Roman works not explicitly musical in theme such as the Longhi *Boy Bitten by a Lizard,* in contrast to the more tender *Musicians.* The London picture is a complex hybrid befitting Cecco's known close relationship with Caravaggio.

Another example featuring a single musician is Theodor Rombouts' *Lute Player* in (cat. 6) the Philadelphia Museum of Art, of about 1620.[14] Rombouts returned from Rome to Antwerp by 1625 (like Honthorst, he had been there the decade prior). As with most of these private secular paintings, it is difficult to date but this one is very Italianate and speaks directly to that experience for Rombouts. The presence of the artist's monogram provides the attribution. He formed part of a second wave of Caravaggio followers and the distance from original source material can be felt in this

Cat. 5 (*facing page*) Cecco del Caravaggio, *A Musician or Maker of Musical Instruments,* c. 1610–15

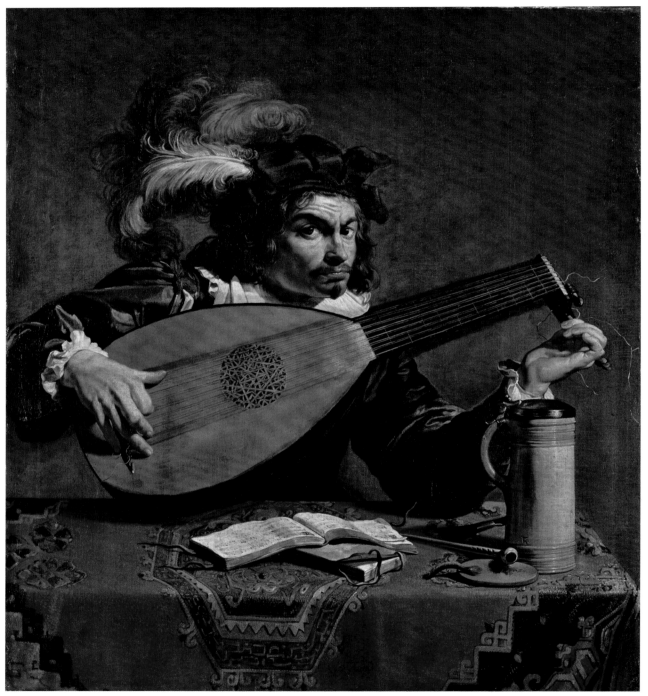

example, as the influence becomes more allusive and second-hand. The general conception is certainly recognisable from Caravaggio's paintings of musicians. Even significant details such as the musician tuning his instrument are also present in the Metropolitan painting. Even if it here it has a more overtly sexual connotation. In general terms, the outwardly comical character of the image recalls too Caravaggio paintings like the *Boy Bitten by a Lizard* because of the heightened dramatic element and direct engagement with the spectator. This connection reminds us again of Caravaggio's Northern Italian roots and one source for his novelty in Rome that he himself consistently mined. Rombouts finally alters the spirit of the image compared with Caravaggio's, however, by including specific genre elements unrelated to music like the tankard and pipe that add a moralizing quality and the colourful treatment of the musician's costume. Meaning is less subtly emotional, more overt and rather easily evokes the older, rather hackneyed theme of the Five Senses.

It is not certain if paintings like the Cecco and Rombouts were commissioned or done on spec but moving to a painting like Bartolomeo Cavarozzi's *Sorrows of Aminta* (cat. 7) in the Louvre, we are certainly in the realm of sophisticated patronage given the rarefied, narrative subject with little or no pictorial precedent. Cavarozzi was born outside Rome in Viterbo around 1587 and securely recorded in the Eternal City by 1622, though he is presumed to have arrived earlier (he died in 1625). This work possibly dates from around 1608.

His elegiac painting of the *Sorrows* is known in several versions, but this example in the Louvre appears to be the best quality. The character wearing a laurel is captured in the act of performing on the recorder, while the other, resting his head on a tambourine, is dressed in a loose white shirt derived from several examples in Caravaggio. It is closest to the Metropolitan picture for its quiet, enigmatic quality and celebration of androgynous male beauty. Yet the inclusion of just two figures naturally allows for greater intimacy than the Metropolitan work and the still life on the table is if anything more prominent. The design is imbalanced – almost casual in its arrangement – with a weighting to the viewer's left. Cavarozzi's picture is unlike any of the prototypes in Caravaggio, however, in making reference to a literary source. The identification of the text turned towards the spectator allows us to add a more specific layer of meaning. It corresponds to a madrigal by Erasmo Marotta published in 1600 inspired by act three, scene two of Torquato Tasso's popular pastoral *Aminta* first performed in 1573.[15] The play celebrated the power of love, but the text leads to the observation that Aminta is portrayed playing music to console himself following the death of his beloved Sylvia, while his companion Thyrsis listens, refusing to make a sound with the tambourine associated with joyous occasions. As

Cat. 6 (*facing page*) Theodoor Rombouts, *A Lute Player*, c. 1620

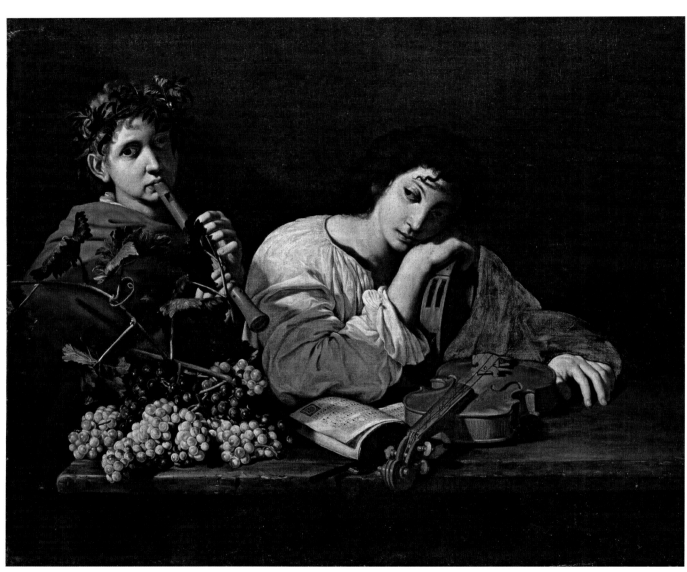

with the Metropolitan *Musicians* and the two *Lutists*, a suspicion arises that the Louvre picture commemorates an actual performance, almost in the manner of a frontispiece.

Also representing an identifiable literary subject but different in its ambitions is another Honthorst – the *Orpheus* (cat. 9) in the Palazzo Reale in Naples.[16] A rare early mythological painting by the artist, it seems to date from around the middle of the 1610s while Honthorst was in Rome, but its patronage is uncertain. The sophisticated subject matter and large scale also suggest a specific commission of which we remain ignorant. The Honthorst is different than these other works featuring music and musical instruments in that the mythological figure is treated like a monumental full-length single saint and has some of that same almost religious pathos. The mythological hero – the greatest musician of the ancient world – appears visibly inspired as he glances heavenward while playing his instrument – a modern one as opposed to his traditional lyre. A menagerie of animals calmly listens to the music that has charmed them into submission on Arcadia. The powerful foreshortening reminds us that the influence on the pose comes from Michelangelo's Sistine Chapel ceiling, but characterization otherwise takes its cues from the public Caravaggio, such as the prominent dirty foot. The saturated red drapery, smooth handling, modular treatment of the figure, enclosed by a screen of trees, are all derived from Caravaggio's general example in each, grafted onto a distinctly northern instinct best symbolized by the inclusion of a menagerie of accurately portrayed animals.

In terms of single figures, Orazio Riminaldi's *Triumph of Earthly Love* (cat. 8), in the Galleria Palatina in Florence – also fits into this general category of youth and musical themes involving cupid inspired by Caravaggio.[17] Music is not the main subject of Riminaldi's work but it is a protagonist. In this case, the more direct inspiration came from Caravaggio's painting of *Triumph of Earthly Love* owned by Vincenzo Giustiniani, now in Berlin, dating from just after 1600. The patron of Riminaldi's work was doubtless aware and encouraged the link as well. He was documented in Rome roughly from 1615 to 1625 (he died in 1630) and so belongs with the second wave of Caravaggio followers – those who could not have known the master in person but were attracted to his art and reputation in Rome. This painting dates perhaps around 1625. In addition to Cecco del Caravaggio, Riminaldi was one of the few Tuscan-born painters who came close to Caravaggio's style, the others being more tangential, including relatively little-known names like Rutilio Manetti, Francesco Rustici, Astolfo Petrazzi, Pietro Paolini, and Domenico Fiasella.

The painting resists precise interpretation but the main theme is clear enough with the handsome male nude representing the god of Love sitting in triumph above all

Cat. 7 (*facing page*) Bartolomeo Cavarozzi,
The Sorrows of Aminta, c. 1625

Cat. 8 (*following page*) Orazio Riminaldi,
Triumph of Earthly Love, c. 1624–25

Cat. 9 (*page 145*) Gerrit van Honthorst,
Orpheus, c. 1615–20

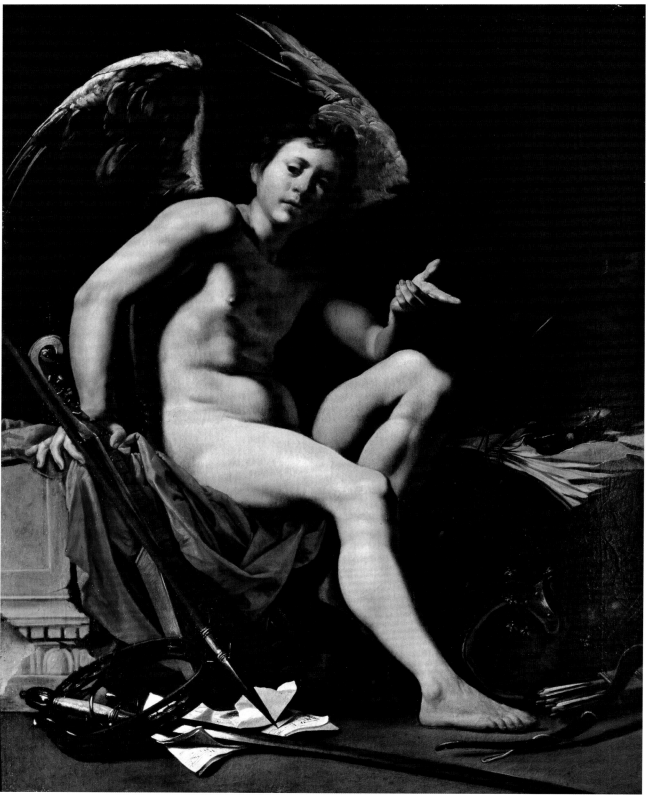

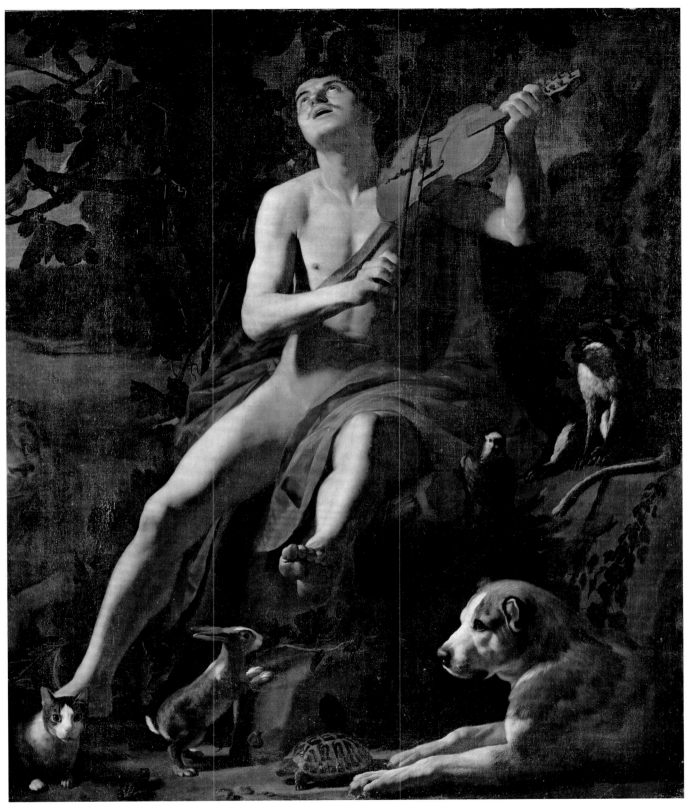

Cat. 9

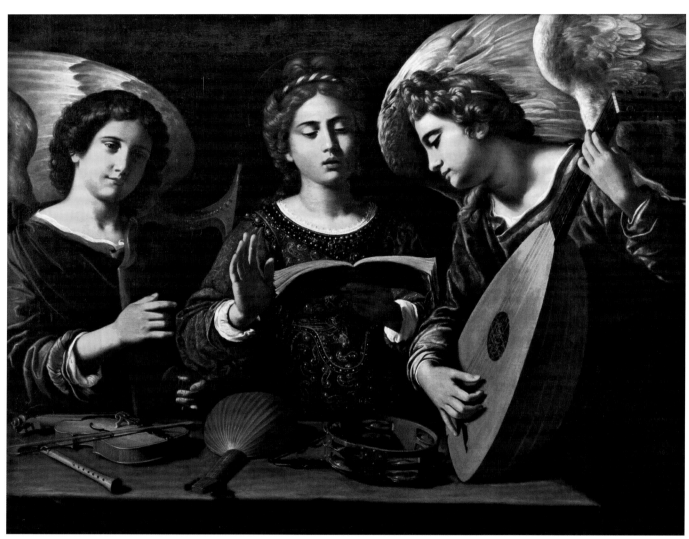

the arts recognized by their attributes, including music symbolized by a tambourine and the lute he holds, as well as the accoutrements of warfare. The basis of images like this is ultimately the celebrated passage in Virgil's *Eclogues* (X, line 68): *Omnia vincit amor, et nos cedamus amori* (love triumphs over everything and we accede to love). Riminaldi successfully followed Caravaggio's example of the Berlin picture in blending the rather elaborate literary subject matter with the same explicit naturalism that produced an image of great power and immediacy but certainly less provocative than the art of the master and with a more superficially attractive smoothness and elegance.

Finally, this interest in music combined with other aspects of Caravaggio's style and appeared in certain religious paintings by his followers, so revealing the yet more fertile nature of his art. One case in point is Antiveduto Gramatica's *Saint Cecilia with Two Angels*, in Lisbon (cat. 10), which takes Caravaggio's example into a more traditional, dignified space.[18] Saint Cecilia – the third-century Roman martyr who was considered the patron saint of music – sings from a music book accompanied by angels on the lute and harp, the presence of which, as an ancient instrument, hints at an attempt at historical accuracy. Her popularity grew in this period when her decapitated body was discovered miraculously well preserved in her own church in Trastevere in Rome in 1599. The saint in the Lisbon painting concentrates intensely on her performance and looks down at her score shared with the lute-playing angel and acknowledges the viewer with a gesture of a flat handed that catches the light from behind. Cecilia recited a prayer, according to a fifth-century account, while listening to the music during her ill-fated marriage to a pagan Roman but here she herself sings, perhaps from that a liturgical book containing that very text, and the divine music performed foreshadows her demise and reception into heaven. Her emotional remoteness and bejewelled costume indicate a divine status in a style that is ever so explicitly expressed in Caravaggio's work and points to other more restrained influences on Gramatica's work such as Annibale Carracci. This rather more cerebral and balanced approach was something that distinguished Gramatica from most other painters associated with Caravaggio. The basic composition with the table truncating the figures in the foreground, the dark palette, the androgynous types and still life featuring a selection of individual instruments prominently arranged on the table in the foreground was clearly developed with a direct knowledge of Caravaggio's paintings such as the *Lute Player*. Like most Caravaggio followers, Gramatica painted the still-life elements to a level of high competence, equal if not superior to the representation of the figure.

An indicator of its importance for the artist's career - the painting was signed by the artist in Rome. The Lisbon canvas has been dated on the basis of style to

Cat. 10 (*facing page*) Antiveduto Gramatica, *Saint Cecilia with Two Angels*, c. 1620

Cat. 11 (*following page*) Carlo Saraceni, *The Martyrdom of Saint Cecilia*, c. 1610

Cat. 12 (*page 149*) Guy François, *Martyrdom of Saint Cecilia*, c. 1608–13

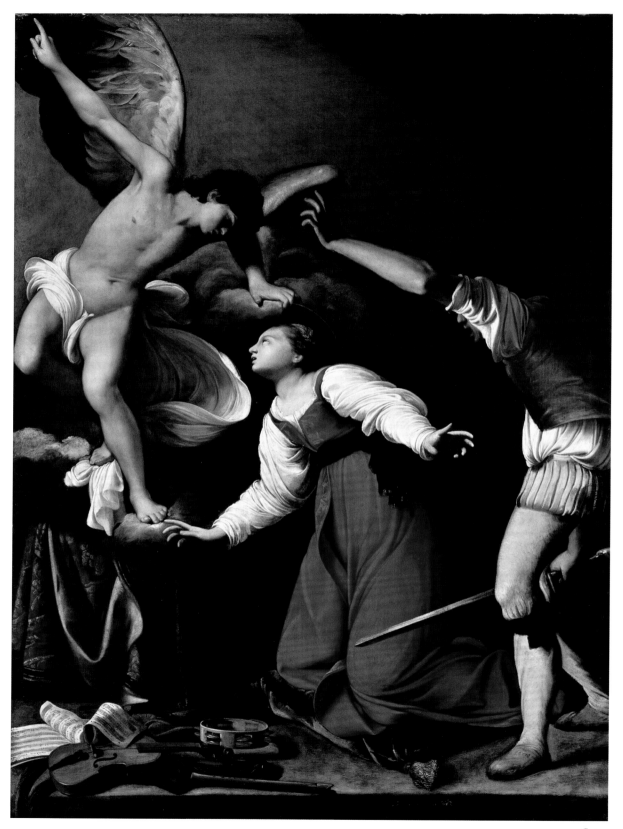

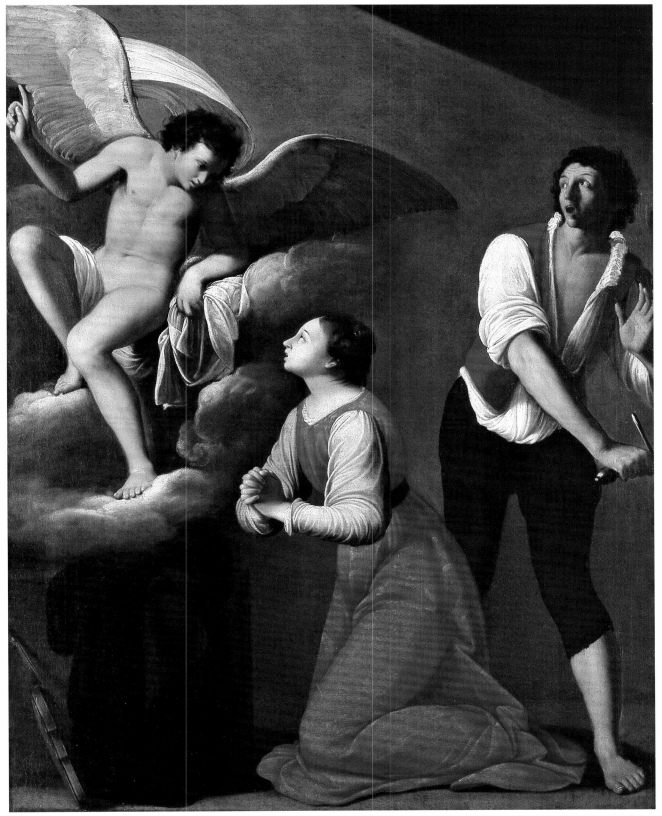

Cat. 12

c. 1610–15. Born in Siena, Antiveduto Gramatica was recorded in Rome in the Anime continuously from 1601–25, virtually until his death in 1626. He was already in the Academy of Saint Luke in Rome by 1593 and his relationship with Caravaggio began soon after. Considering that he was born in 1569, their relationship was more that between colleagues or collaborators than master and apprentice.

Carlo Saraceni was another one of the few artists who knew Caravaggio personally. Along with Orazio Gentileschi and Orazio Borgianni, they were described in 1606 as the *aderenti al Caravaggio*. Born around 1579 Saraceni arrived in Rome from his native Venice around 1598 when he was almost immediately swayed by Caravaggio's example even though his own sensibility tended towards something far sweeter and more restrained. Saraceni is documented continuously from 1601–20 in Rome, though he did return to Venice in the last year of his life. In 1610 he produced the *Death of the Virgin* as a replacement altarpiece for Caravaggio in the church of Santa Maria della Scala. And then through the 1610s Saraceni was one of the few to produce public altarpieces in Rome in a style unashamedly evoking Caravaggio's, though in a gentler manner also recalling the work of Orazio Gentileschi.

The theme of Saint Cecilia was also developed into larger and more dramatic scenes of martyrdom as in Saraceni's *Martyrdom of Saint Cecilia*, in the Los Angeles County Museum, dating to circa 1610.[19] Like the work in Lisbon, this picture was doubtless produced for private devotion, though, again, the patronage is not yet traced. The Los Angeles canvas (cat. 11) features the saint strenuously flexed and kneeling at the moment of her execution, while a youthful angel appears in the upper left corner to comfort her and guide her heavenward. Although its original purpose is unclear, it is treated a narrative as opposed to an icon, with a full range of dramatic detail caught in a raking light before an indistinct dark backdrop. An assortment of accurately portrayed musical instruments, including a violin, recorder and tambourine, along with a roughly treated musical score appear scattered before her as attributes on the ground in a full arrangement by now familiar from Caravaggio's works, public and private. The vulgar handling of the instruments in this case stands a metaphor for the brutal treatment of the saint who literally kneels before music at the moment of her demise. At the same time the presence of these musical instruments stand not only as a metaphor for the instrument of torture itself but remind us that music in general provided a living reminder to the sanctity of the saints and supplied the soundtrack to all types of religious devotion in the period. The casual handling of these instruments, so charmingly treated in secular themes by Caravaggio and his followers, now become charged with very specific emotional content. The carpet with ermine border on the table suggests a richly decorated altar.

facing page Carlo Saraceni, *The Martyrdom of Saint Cecilia* (detail of cat. 11)

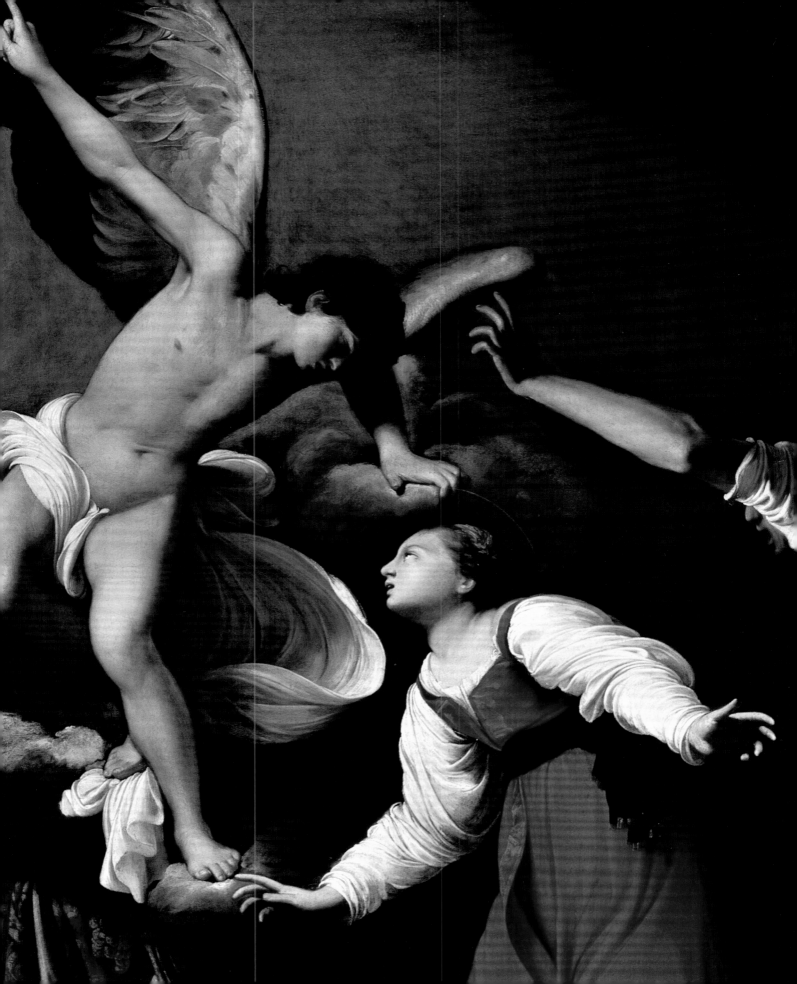

The tender boyish angel captured in a contorted, frontal pose is a direct quotation from his counterpart in the Contarelli Chapel *Martyrdom of Saint Matthew*. The abundant, creased and circulatory white drapery, evoking in this case a winding sheet, is also familiar from Caravaggio paintings like the Metropolitan *Musicians*, as is the ephebic body type.

Saraceni also influenced the French and Flemish painters who gravitated to his workshop, so followers could absorb aspects of Caravaggio's art and thus create another hybrid, intermediary style, rather like Bartolomeo Manfredi did for a different group of secondary followers. Saraceni's painting is directly related to a work attributed to Guy François of the same subject of the *Martyrdom of Saint Cecilia* (cat. 12) now in the Blanton Museum, Austin, Texas.[20] This artist is documented in Rome as early as 1608 but returned to Le Puy in France by 1613. Where this canvas was produced is uncertain. This puzzling painting is treated on a similar scale, but is cruder with less subtlety in the handling. Although the executioner is more dramatically treated as he reacts to the divine light, the angel is comparable in every detail to the Los Angeles painting, if more relaxed and lacking complexities. The instruments here are reduced to a single violin propped up vertically in the lower left corner of the picture – also a useful metaphor but one which avoids the complex formal artistic challenge welcomed in every other painting discussed here. While François seems to interpret Caravaggio's art in a highly personal way, he also indicates the incredibly broad reach the master had among his contemporaries.

NOTES

1 On the theme of Caravaggio and music see especially the following: S. Macioce, "Variazioni su tema musicale da Caravaggio ai Caravaggeschi," in *I Colori della Musica*, ed. F. Buzzi and M. Navoni (Milan, 2004–05), pp. 95–104; R. Vodret and C. Strinati, "Painted Music: A New and Affecting Manner." in London 2001, pp. 92–115; F. Trinchieri Camiz, "Music and Painting in Cardinal del Monte's Household," *Metropolitan Museum Journal* 26 (1991), pp. 213–226; H.C. Slim, "Musical Inscriptions in Paintings by Caravaggio and his Followers," in *Music and Context: Essays in Honor of John Milton Ward*, ed. A. Shapiro (Cambridge, MA., 1985), pp. 241–263; and, F. Trinchieri Camiz and A. Ziino, "Caravaggio: Aspetti musicali e committenza," *Studi musicali* 12 (1983), pp. 67–90.

2 See Schütze 2009, pp. 245–246, no. 4, with bibliography.

3 Maccherini, 1997, p. 80, nos. 99–100.

4 Schütze 2009, pp. 246- 48, nos.5 and 6.

5 Trinchieri Camiz 1991, pp. 219.

6 See Slim, "Musical Inscriptions," pp. 243–244. The music in the private collection painting is of a similar period but by different composers, but Slim argues that it was possibly thought also to represent the work of Arcadelt, pp. 246–247.

7 Slim, Ibid., pp. 244–245.

8 Schütze 2009, p. 244, no. 1.

9 Schütze 2009, p. 245, nos. 3 and 3a.

10 J. Gash, *Caravaggio* (London, 2003), p. 41.

11 Judson and Ekkart 1999, pp. 194–195, no. 249.

12 C.M. Kauffmann, *Catalogue of the Paintings of the Wellington Museum*, rev. by S. Jenkins (London, 2009), pp. 75–77.

13 Spear, 1971, p. 87.

14 C. Braet, *Theodor Rombouts (1597–1637).* Een monografie. Ghent, 1987, p. 72, no. B8. London 2001, p. 105, no. 35.

15 See most recently, G. Papi, "Il primo 'Lamento di Aminta' e altri approfondimenti su Bartolomeo Caravozzi," *Paragone* 59 (2008), pp. 39–51. See also Slim, "Musical Inscriptions," 1985, pp. 249–251.

16 Papi 1999, pp. 145–146, no. P8.

17 See *La Galleria Palatina e gli Appartamenti Reali di Palazzo Pitti: Catalogo dei Dipinti*, ed. M. Chiarini and S. Padovani (Florence 2003), entry by S. Casciu, p. 234, no. 59.

18 Papi 1995, pp. 90–91, no. 10.

19 See the entry in London 2001, p. 101, no. 32.

20 J. Bober, "The Suida-Manning Collection in the Jack S. Blanton Museum of Art of the University of Texas, Austin," *The Burlington Magazine* CXLI (1999), p. 449.

following pages Michelangelo Merisi da Caravaggio, *The Gypsy Fortune Teller* (detail of cat. 13)

THE FORTUNE TELLER

CHRISTOPHER ETHERIDGE

I don't know which is the greater sorceress:
the woman who dissembles,
or you, who painted her.
She with her sweet spells
ravishes our hearts and blood.
You have painted her so that she seems alive;
so that, living and breathing, others believe her.

Gaspare Murtola, on a gypsy by Caravaggio[1]

W̲E CAN ONLY GUESS AT THE EVENTS that have brought the gypsy fortune teller and the young man together on a city street, and the words they have exchanged to stop them in mid-action. The fortune teller's odd gesture – delicately grasping her client's hand, while running her fingers over his palm – is perhaps part of her secret art. Yet neither looks at his hand; both are instead absorbed in each other. Caravaggio painted this scene twice.[2] The first version, now in the Capitoline Museum, depicts the man as wary, assessing the gypsy with some detachment (cat. 13). The second (fig. 51) is subtly different: the result of their meeting is now less in doubt, the patron no longer on his guard. Mancini cynically described the encounter between the sly gypsy with her false smile and the young man "who shows his naiveté and the effects of his amorous response to the beauty of the little gypsy who tells his fortune and steals his ring."[3]

Bellori tells the story behind the making of the picture, rather than the event shown in the painting itself. He imagines how it was painted: Caravaggio, when challenged with the accomplishments of the Ancients, dismisses them. "His only answer was to point toward a crowd of people, saying that nature had given him an abundance of masters."[4] He then takes a gypsy off the street as his model and paints the work we see. His action is defiant, polemical: Caravaggio rejects the authority of Antiquity and the example of his Renaissance predecessors, instead turning to the world itself.

Bellori's account addresses the reality of making the work – a tale about how and why it was painted – and is simultaneously fictitious. Yet his story is grounded in what he understood to be the painter's practice. For him, the essential fact of Caravaggio's art was his use of models. Contemporaries spoke of painting "after the life," meaning that the object was before the artist as he painted. The expression implies a certain relationship between what we see and what the painter saw before him. This art was never entirely free from its origin in the studio, the place where

Cat. 13 (*facing page*) Michelangelo Merisi da Caravaggio, *The Gypsy Fortune Teller*, 1595

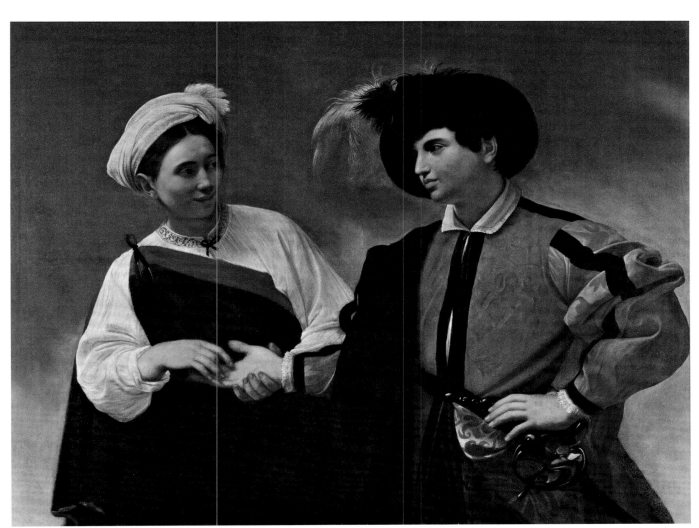

Cat. 13

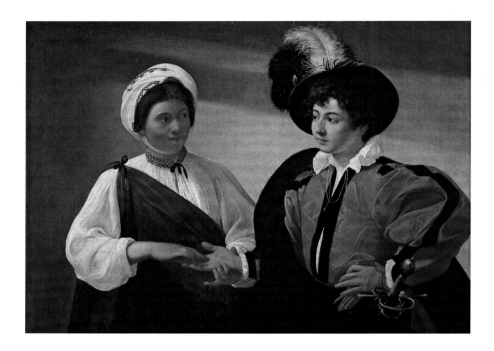

Fig. 51 Michelangelo Merisi da Caravaggio, *The Fortune Teller*, c. 1594–95, oil on canvas, 99 × 131 cm. Musée du Louvre, Paris

painter and model met. For Caravaggio's contemporaries, copying the visible world meant an inherent confusion between art and life.

THE PAINTER'S GYPSY

The painter's gypsy was part real, part stereotype – a mixture of prejudice, fantasy and close observation. She was immediately recognizable: headscarf, cloak-like mantel slung over the shoulder, hands reaching out to grasp the client's coin and palm. The first images date to the fifteenth century and changed little over the next centuries. While these precedents informed Caravaggio's work and its reception, the novelty and power of his example was overwhelming. The fortune teller entered the repertory of painters with Caravaggio, and they would explore the subject for several decades to follow, even coming to exhaust its possibilities.[5]

Caravaggio's contemporaries would have considered gypsies as a subject of curiosity and as a potential threat. Of their identifiable signs, one is particularly telling: the gridiron, sometimes shown hanging from their cloaks. It literally signified hearth-less, a wanderer lacking stable ties. Gypsies were only one part of a vast body of rootless

poor, imagined to lie at or beyond the margins of society. Contemporaries created a compelling image of this underworld, still part of our collective imagination – a world populated by thieves, false beggars and cripples, quacks, cardsharps, kingpins, gangs, confidence men, and the like. Attempts at suppression alternated with indifference. Gypsies were certainly present in Rome, but we can only guess at how Romans perceived or negotiated any gap between image and reality.[6]

Yet the reality of gypsy life is simply an undercurrent, invisible in the paintings. The portrayed incident occurs over and over again, and the cast of characters is small: a fortune teller, young and beautiful, sometimes paired with an old gypsy woman and, at times, accompanied by a child; gypsy men are invisible. Painters' gypsies are strange beauties practising a suspect art; but their strangeness is fundamentally exotic and their deceptions diverting, not threatening to the viewer.[7] We are, in fact, invited to share the joke: the paintings are constructed to ensure we see the theft, and our complicity is assumed.

The subject of the gypsy and the duped client resonated in contemporary culture, popular and elite. It was simultaneously new yet old – a story of deception, tinged with gullibility and lust, the parts played by stock characters. Caravaggio's dupe and his beautiful young gypsy were cliché, even in his day, and the story he depicted must have been as familiar to its first viewers as it is to us. Contemporary entertainment traded in exactly these familiar situations, and the dupes, wily servants, beautiful women, cuckolds and bombastic soldiers of the *commedia dell'arte* formed the foundation for the appreciation of similarly conceived fortune tellers. One particular genre of comic performance came to prominence at exactly this time: the *Zingaresca*, from the word *zingara,* meaning "gypsy woman." who plays the role of comic anti-hero.[8]

Paintings and texts reflected and encouraged contemporaries' fascination with the world of the streets, seen as both banal and comic. The picaresque novel, a new genre exploring the same territory, came to enjoy Europe-wide popularity in the early seventeenth century. It had deep roots, developing aspects of the early vernacular *novelle* and more recent fiction, which mixed the bawdy, humble subjects, and trickery. Less familiar now is the large body of literature, circulating in both manuscript and print, which addressed frauds – part amusing, part monitory, the genre came to a new prominence at this time. Some of this material is marked by a strong ethnographic and documentary sensibility. Writers explored the practises of thieves, cheats, beggars, false cripples and pilgrims, explaining how they deceived the unwary. It was possible to read these works as manuals of the art of deception: after reading one of the most famous, the painter Lionello Spada supposedly disguised

himself in succession as a beggar, a blind man and a destitute widow to trick his friends.[9]

The subject of the deceitful and beautiful fortune teller resonated with contemporaries, but its pictorial fortune depended upon Caravaggio's example. We can imagine the events that led up to the encounter of gypsy and her client – the raillery, the flattery and any number of outcomes – the deception revealed, the threat of violence, the chase or, more likely, the successful theft. Never shown, these merely remain potential. Artists who took up the subject after Caravaggio were as fascinated as he by the exchange between fortune teller and client, the meeting of hands, which is at the centre of these pictures. The fortune teller has, or will soon, reveal her prophecy but the paintings are mute witnesses and the future remains unrevealed. Caravaggio never returned to the subject, and its future lay with other painters who would explore the possibilities inherent in his example.

PAINTING AFTER CARAVAGGIO

The woman to the left turns to us; smiling, she invites us to enjoy the joke. A dumb show of gesturing hands and conspiratorial glances tells the story in Vouet's *Fortune Teller* (cat. 14), now at the National Gallery of Canada in Ottawa: the gypsy is herself being robbed. She performs her part both slyly and seriously, and seems strangely out of place in this company – as if she has lost the thread of the plot. A professional actor repeating a familiar role, she is lost in the new scenario.[10]

What did it mean to paint in Rome after Caravaggio? To paint a subject identified with him? Contemporaries recognized a school following his example, understanding it as marked by a strong sensitivity towards the natural world. It was defined by the practice of painting after the life. On canvas, this naturalism was tempered by dependence upon Caravaggio's works, the exaggerated play of light and shadow, a certain sensibility for colour, motifs and conventions that had become a second nature.[11] Caravaggio's legacy was complex, and if his followers adopted the subject of the Fortune Teller as a result of to his example, they also interpreted it freely.

Dependent upon, yet distant from Caravaggio's example, Vouet's painting reflects the Roman art world of the late 'teens. Trained in Paris, the artist arrived in Rome in 1613.[12] His model was not Caravaggio's work, but a painting by Manfredi, effective heir to the master and the school's leading representative (fig. 52). Whereas Caravaggio's couple hold each other's gaze, assessing each other, Manfredi instead plays with the now-multiple foci of attention among the four figures, the open or

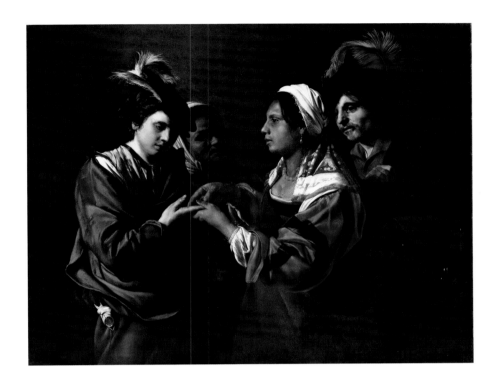

Fig. 52 Bartolomeo Manfredi, *The Fortune Teller*, c. 1616/17, oil on canvas. Detroit Institute of Arts, Founders Society Purchase, Acquisitions Fund, 79.30

furtive subjects that command their interest. The gypsy has turned inwards for inspiration; her only link to her client is the palm she holds. He is absorbed with the sight of his fate traced out on his flesh. The gypsy is acting, as likely is her client. Their assumed roles leave them vulnerable, and each is robbed by the other's accomplice. The chiastic composition pairs the two men and women, implying reciprocity and so collusion. However, there must be some doubt: we expect her to be false, but he seems naive, too perfect an actor. The interpretation depends upon the degree of our cynicism.[13]

In the Ottawa canvas, Vouet adapts the tightly plotted composition, isolating the now-friendless gypsy and her male counterpart (the client's friend), neither of whom has grasped what is happening. Alternately, the woman's awful grin could suggest that, rather than inviting us to share the joke, she herself has been taken in by the gypsy. As viewers, we are invited to play the comic game of distinguishing the apparent from the actual. This problem is central to the literature on frauds, which warned readers to be on their guard, that anything could be faked. And when read against the grain, this issue was also fundamental to the writings on behaviour that

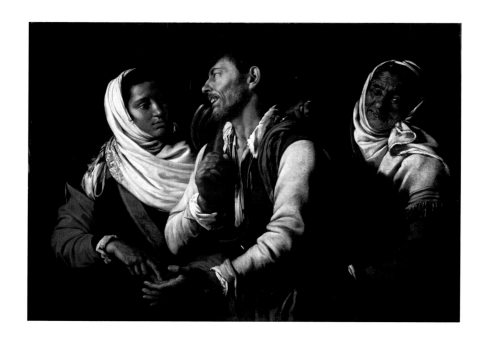

Fig. 53 Simon Vouet, *The Fortune Teller*, 1617, oil on canvas, 95 × 135 cm. Galleria Nazionale d'Arte Antica, Palazzo Barberini, Rome

Cat. 14 (*facing page*) Simon Vouet, *The Fortune-teller*, c. 1620

helped to create the ideal man and woman of the Renaissance courts – the courtier as performer of an assumed character. If we immerse ourselves in the fiction of the image, we must distinguish the imitation of emotion or a mental state – sincerity, attention – from the real thing, perhaps shown side-by-side. Both are fictitious: the painter must show and pretend to show within his painting.

The Ottawa canvas was not Vouet's first work on this subject; a painting now at the Palazzo Barberini in Rome precedes it (fig. 53). A labourer has his palm read as the older gypsy woman makes the sign of the fig to show her contempt. The very ordinariness of the characters, exaggerated to the point of caricature, and the explicitness of the action and of their mental states seems a deliberate rejection of Caravaggio's example.[14]

The Roman canvas was described succinctly by its first owner, the collector Cassiano dal Pozzo as "an Egyptian, in the vulgar 'Gypsy,' who tells the fortune of a foolish artisan, depicted after the life by Simon Vouet, 1617."[15] The new painting polemically linked together making and viewing – creation in the studio and the viewers' response to the completed work. We can see the term "after the life" as describing both a process (the use of models) and the result (naturalistic or veristic). Cassiano's "after the life" is a claim as to the relationship of painting to model, and perhaps also of model to reality.[16] The work could be seen to capture a higher truth –

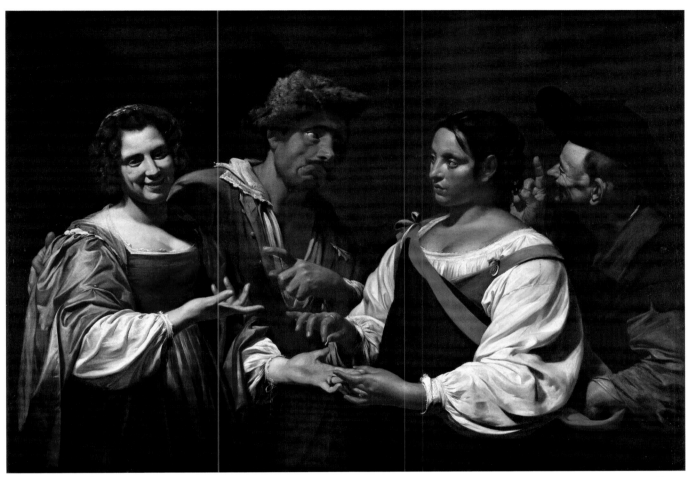

method and result are appropriate for a subject that is by its very nature comic, gross. Painting after the life could be condemned for its dependence upon the accidental (confusing *this* artisan with *the* artisan) and for its literalness. However, here the practice captures both the appearance of its subjects and their true, base natures – or perhaps, more appropriately, their assumed natures, as they are models playing roles.

We should return to the practice of painting. For contemporary viewers, the identification of Caravaggio's school with painting after the life implied a set of events: posing, looking, copying. The result was understood to capture the conditions under which the artist saw the models and worked. Of Caravaggio's painting Mancini wrote that it seemed to be staged in "a very dark room with one window and the walls painted black."[17] This passage, a description of the setting of the image, has been interpreted as a description of how the works were painted. The *ekphrastic* has been confused with a literal account of the artist's practice. It is a critic's account, not a painter's, made for rhetorical effect. Vouet's art was more complex, and it was far less easy to determine where art and life met in the studio.

Vouet began by laying out the composition of the Ottawa canvas, drawing with a dark coloured paint over the red-brown ground. This underdrawing left traces, and what is visible shows no hesitation and few changes. Vouet left reserves where elements – arms, hands – overlap, and the composition would have been established through preliminary drawings.

Vouet was open to adapting and refining his plan as he painted. As revealed in infrared reflectography, at an early stage, the gypsy had a head scarf. The loss of this expected prop was compensated by the ethnographic attention the artist brought to the woman: her distinctive physiognomy sets her apart from Caravaggio's gypsy. An x-ray shows that the play of hands at the painting's heart was revised extensively (fig. 54). Some changes, such as the position of a finger, were subtle refinements. The man's hand, pointing to the woman, was a late addition. Vouet painted it twice to arrive at the final result. At first, he showed all the fingers extended; he then sharpened the gesture, the man now pointing with his index to the gypsy's client. With the addition of the hand, his expression is now tied to her, and its meaning delimited: he reacts to her apparent gullibility in trusting the gypsy. He, like the gypsy, has been left out of the joke. With this addition, the fortune teller is now ringed by a circle of gestures and gazes. And the hands of all the figures can be seen clearly: there can no secrets from us.

We must be struck by the very oddness of the work: the woman's rictus; her friend's expression of disappointment, and his absurd mouth and moustache; the thief's broad grin. Only the fortune teller plays her role with care, without overacting.

Fig. 54 Detail of x-ray of Simon Vouet, *The Fortune Teller*, c. 1620, oil on canvas, 120 × 170.2 cm. National Gallery of Canada, Ottawa

The characters' inner lives were to be revealed through their gestures, expressions and postures, but here this body language is too demonstrative (if seen as appropriate to their status). It has been compared to a theatrical performance. It is also a kind of playing-out of an element that could be seen as essential to the new painting – the performance being that of the models posed for study.

How did art and life meet in the studio? Vouet used models as part of a process that included the progressive refinement of the composition on paper before beginning to paint. He may also have returned to them during painting, although the generic quality of the figures is troubling. Judging whether a painting depends upon models is inherently subjective: is this painting from a model, or the imitation of the practice? Arguably, only a distant echo of the studio is what remains here of painting after the life. Scholars write of the "reality effect," the close description, specificity of detail, and narrative conventions that produce the appearance of the real. Caravaggio's contemporaries might have instead spoken of verisimilitude, although some would have claimed the painter had confused reality and art. For Vouet, painting after Caravaggio meant not so much the effect of the real, but the effect of the studio – the conventions of the posed model in a darkened room.

"THE APE OF CARAVAGGIO"

The gypsy, about to tell her client's fortune, has stopped. The man's companion has intervened, seemingly too late to help, even supposing the other understands. We recognize the dupe, the friend, the gypsy and her family, all performing their familiar roles. The subject and cast of characters would seem to be all that Spada's painting, *The Gypsy Fortune Teller* (cat. 15) shares with the work of his contemporaries in Rome.

Lionello Spada (1576–1622) offers us a more distant response to Caravaggio's art.[18] Trained in Bologna, Spada was active for most of his life in Emilia and Parma, schools in which Caravaggio's example remained marginal. This, his only work on the theme of the fortune teller, shows us the new movement as seen by an outsider. Yet it was painted for a Roman patron, and through it, Spada participated in the Roman art world, although at a distance.[19]

Spada's Fortune Teller must date to before 1618.[20] The artist was no stranger to Caravaggio's work at this time. While deeply indebted to it, his art was distinctly his own: there is no sense of the residual presence of the model's reality in the fiction of the image, no tension between the illusion of the painted scene and the memory of its creation in the studio. Spada understood Caravaggio's art as a repertory of motifs

and conventions and treated his gypsy more as a pretext than a model. Yet even in these terms, Spada's canvas is distinct.

We are struck by the difference between Caravaggio and Spada. Others saw similarity; Spada's biographer Malvasia, the seventeenth-century historian of the Bolognese school derisively called him Caravaggio's "ape."[21] The insult was charged with meaning, alluding to the practice of emulation basic to artistic training. Emulation created the new painting which, for all its supposed dependence upon the world, was a response to Caravaggio's work. Malvasia understood this as more than simply a question of adopting a shared practice, painting after the life, and a set of stylistic ticks. For him, the new painting was fundamentally identified with Caravaggio himself. Art and the painter's life were one and the same: style was a product of character – a commonplace then and now. Spada's emulation of Caravaggio's art sprang from a shared nature.

In Malvasia's story, Spada's conversion to the new painting was sparked by seeing Caravaggio's *Incredulity of Thomas* (fig. 78, p. 270). He wished to emulate it, and went to Rome to join his new hero. Caravaggio, "who had finally found a man after his own heart" took him into his household. Yet, unlike the saint's, it was only a partial conversion; Spada was soon disappointed in his new master. Rather than practicing his profession, he became the object of Caravaggio's art – made to pose by a master who needed a model before him to paint. Malvasia recognized Spada as one of the soldiers of fortune (*bravi*) in *The Calling of Saint Matthew* (fig. 1, p. 6). He lets this pass without comment, but the potential confusion between art and life, the rebellious, insolent and vain young painter modelling as a *bravo*, is perfect.

Identifying the models in his work was spurred by the paintings themselves: the anonymous men and women retain something of their own selves even when given roles to play, succinctly expressed in Bellori's "he painted a girl … pretending that she is the Magdalene."[22] Refusing to accept the fiction of the image, viewers sought the reality of the model and identified the figures. Following Malvasia's lead, the young Spada would later be recognized as the dupe in Caravaggio's *Fortune Teller*, his prominent sword ("spada" in Italian) a pun.[23]

Spada was forced to literally flee from the long sessions of posing. While now free, Spada found he was still tied to Caravaggio. Seeking the same honours, he later travelled to Malta which, inevitably, he too was forced to flee in disgrace for his insolence. Spada returned to Bologna as kind of second Caravaggio, "dressed like him in a slashed jerkin, with a sword, a strange cape, and with a cur."[24] (Caravaggio's dog, named Raven, could do "the most beautiful tricks." The painter Saraceni, another of the master's followers, gave his own dog the same name in another act of emulation.[25])

Cat. 15 (*facing page*) Leonello Spada, *The Gypsy Fortune Teller*, c. 1614–16

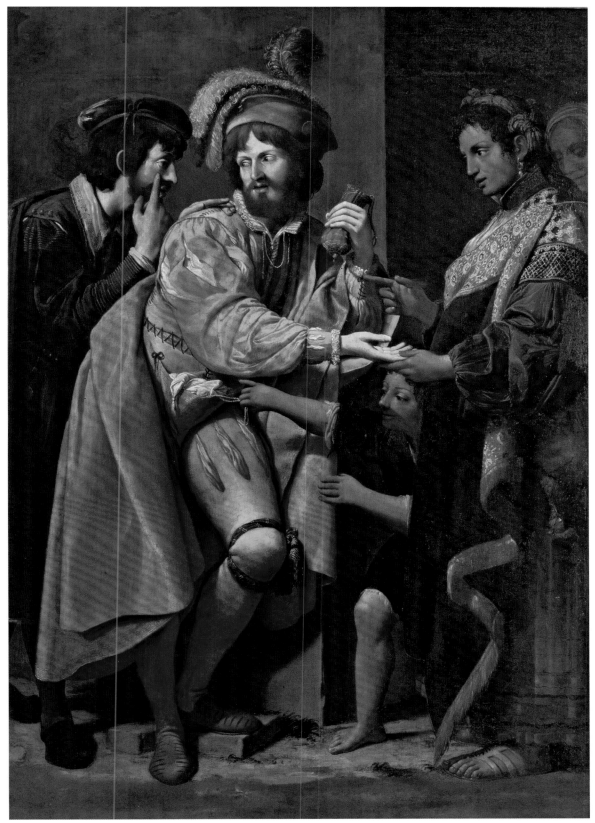

In reality, Spada and Caravaggio seem to have never met, and little of Malvasia's hostile account can be true. Spada's first works to acknowledge the new painting date after a short, undocumented stay in Rome.[26] Malvasia's biography likely reflects local legend (perhaps encouraged by Spada himself), but it is primarily a fictional device to explain the painter's life, to give it shape.

Malvasia's distaste for Spada's betrayal in choosing Caravaggio and Rome over the example of Bologna is clear. It is more difficult to know how *The Gypsy Fortune Teller* would have been perceived in Rome. Cardinal d'Este, Spada's patron and an avid collector, had a taste for the bizarre and may well have appreciated the work for its humour. He acquired works in the new idiom such as Tournier's *Young Man with a Flask* (cat. 19), as part of a wide-ranging collection in which Caravaggio's followers were secondary to other artistic currents, past and present.[27] An attentive viewer would have seen in Spada's work something distinctive, but whether this placed Spada at or beyond the margins of Caravaggio's school, itself fluid, is less clear.

Something of the Roman context for Spada's Fortune Teller is revealed in two anonymous works on the same subject, a print and a small panel painting (figs. 55 and 56). It is difficult to translate the point–counterpoint of the three works into a narrative of looking and response by the artists. However, Spada likely follows the print. His other works in the idiom of the new painting are much closer to their models; the print may well have been a trigger for change.

Fig. 55 (*below left*) Anonymous (previously attributed to Caravaggio), *La buona ventura*, n.d., etching, 31.5 × 41.5 cm. Istituto Nazionale per la Grafica, Rome

Fig. 56 (*below center*) Anonymous follower of Caravaggio, *La buona ventura*, n.d., oil on panel, 45.5 × 32.8 cm. Galleria Pallavicini, Rome

Fig. 57 (*below right*) Anonymous follower of Caravaggio, *Concerto*, n.d., oil on panel, 45.7 × 33.8 cm. Galleria Pallavicini, Rome

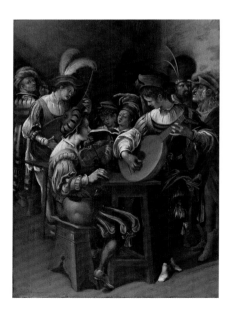

The print is dedicated (effectively, offered as a gift) to the Cavaliere d'Arpino, perhaps the city's leading painter. The artist and dedicator, the unidentified "MM" was perhaps his student.[28] In the small Roman art world, the relationship between giver and receiver – real or anticipated – would have been clear; we are missing this dimension of the gift. Arpino's art showed little sympathy for the new painting. However, his early employment of Caravaggio and the presence of works by the artist (among others in a similar idiom) in his collection must have given the gift particular resonance. And if the subject was not the exclusive preserve of Caravaggio's successors, it would have been impossible to ignore the close association of the fortune teller with caravaggesque painting.

The panel is one of a pair; the other shows a concert (fig. 57).[29] Together with the card sharps, these were the key genre subjects for Caravaggio's followers. (Spada himself painted a number of caravaggesque concerts.) The artists of the print and panels make pointed reference to Caravaggio's example, and thus comment on the new painting, both the subject of emulation and of satire in contemporary Rome.[30] Both the print and the panel are the work of artists outside of Caravaggio's school, who look at his and his followers' work with some detachment. This aesthetic is perhaps clearest in the trivial, the paper apparently pasted to the surface of the images. An old convention, here perhaps drawn from popular prints, it is at odds with the illusionism favoured by Caravaggio, yet simultaneously calls attention to the fiction of the image, so strongly felt in his works. The warning text, "Beware Theft, the Devil, and Worldly Things," seems out of sympathy with the joking ambiguity of Caravaggio's model and the often broad comedy of the followers. Arguably, it fails to capture the humour of the scene on which it comments – and it does not speak in the vernacular, the language of the streets, but in the Latin of a more distant and elite observer. While the warning text reveals one contemporary response to this subject, its clarity is reductive.[31]

The fall of the light and the sharp shadow cast on the wall are emblematic of the new painting. The older man with the eyeglass in the Fortune Teller, blind to the true course of events is taken from *The Calling of Saint Matthew*.[32] The more charged reference is found in the Concert, where Christ's gesture summoning the apostle is mimicked by the man to the right, who reaches out to nothing. Unmotivated – if he marks time, no one watches him – its inclusion can only be parodic. The fashionable *bravi* in *The Calling* and their subsequent adoption by the master's successors also caught the anonymous painter's attention. His response was to emphasize the plumes, pleating and slashes – just as Spada had made his gentleman into an absurdly dressed fop, the child unlashing his codpiece to steal from this unlikely pocket.[33] Parody of

Caravaggio's *Fortune Teller* is perhaps as early as its emulation. Spada shares something of the same sensibility, but he avoids the more charged references seen in the Roman works to Caravaggio's examples, preferring broader comedy.

Yet Spada's distant response to Caravaggio's work is exceptional in his oeuvre, and this itself is perhaps a critique. In some sense, Spada is attempting to "re-naturalize" Caravaggio's art, returning to a more traditional model for painting. The anonymous artists of the print and panel felt the same need, and Spada found a sympathetic model in this image. Spada's gypsy is more elegantly dressed than those favoured by Caravaggio's followers, and her pose is almost statuesque. She has been compared to a statue of a Gypsy commissioned by the Borghese, an adaptation from the antique.[34] The painters' gypsy is telling of their interests: Caravaggio's young, corrupt beauty, Vouet's distinctly gypsy fortune tellers, and Spada's reference to a classicizing precedent. The work's composition is more conventional, rejecting a subjective vantage point that implies our proximity. We do not stand in front of the work as the painter would in front of his canvas and models. The lighting is closer to that seen in Caravaggio's early Fortune Tellers, praised by critics for their naturalism, unlike the artificially strong contrasts he later favoured and which his followers adopted. Even the trivial details of the setting – the ground, grass and stones – serve to anchor the improbable encounter on the street. It is not the minimally described setting of the new painting, the non-place of the infamous dark room.

PAINTED SCENES

Valentin's young *bravo* leans across the table, tense with interest (cat. 16). We sense the figures' attention, both auditory and physical, and can almost hear the fortune teller's words, the hush, the gasps. Perhaps, for once, she may not be a cheat, repeating the same old lines to her naïve clients, but rather truly able to see the young man's future. She cannot, however, see her own. Yet the comedy of thefts – the man robbing the gypsy, the child robbing the man – seems almost extraneous to the business at hand. Like the other works discussed here, we are spectators to a theft, witnesses enjoined to silence by the cloaked cutpurse. Complicit, we are unable to intervene: it is, after all, only a picture.

This work, and similar scenes, are compilations of the pleasures, vices and dangers of the world of the streets. Valentin de Boulogne's painting is also a compilation of pictorial motifs. The figures, some culled from other paintings, perform their stereotyped actions – the thief, dark cloak pulled to his face, the young bravo on the

Cat. 16 (*facing page*) Valentin de Boulogne, *Fortune Teller with Soldiers*, c. 1620

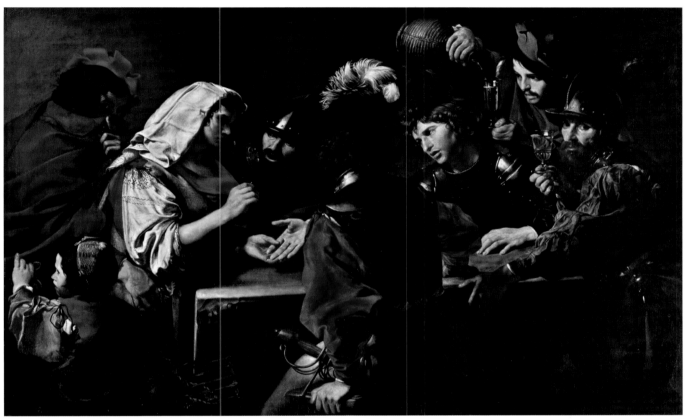

stool, his back to us. The fragment of stone (or cornice or sculpted frieze in other works) improvised as a table, will become a popular motif.

How are we are to interpret what the painter shows us, and how it is shown? Valentin would describe another of his fortune tellers in these terms: "I made a large painting, peopling it with a gypsy, soldiers, and other women who play instruments."[35] He speaks of this assembly matter-of-factly, listing its parts, but not describing the whole. Valentin's factual – literal – description stands in contrast to the painter Sandrart's response to the same work. He gave the subject as the Four Senses, a traditional allegory.[36] The two descriptions capture different ways of seeing and different conceptions of the function and nature of art. These differing interpretations are not exclusive, but we must be alive to the tension between them. This tension is particularly acute thanks to the naturalism of the new painting, which is itself undermined by the sense of artifice, studio practice (the idiom of painting in the famed dark room), and the individuality of the artist's personal vision.

A critic such as Bellori was sensitive to this tension, but chose to deny that these works could have any meaning: Caravaggio's paintings, and by implication those of his followers, simply showed what the painter saw and copied. They do not bear meaning, tell a story or capture a higher truth, but are simply the literal representation of the stuff of this world, as assembled by the painter in his studio.[37] Mancini felt this as well, arguing that the absurdities of painting after the life were clearly visible in such works, which were assemblages, not coherent wholes, of posed figures, who were studied individually and painted.[38]

The aesthetic of this painted world is, if sometimes tempered by the intangible melancholy of a Valentin, about things, as many of the works in this exhibition attest: about the clothes, weapons, packs of cards, wine flasks, and the bodies of the figures who inhabit the images. The new painting privileges the tangible: painting after the life implies a referent in our world, and the object reality of the models finds an echo in the image. Yet it is far from literal, matter-of-fact.

What do we see in these paintings? Men sit at table, drink, sing, brawl, play at cards or at music in taverns and guardrooms. The potential for violence is everywhere, and men go armed or in armour – some, like Caravaggio's young dupe, with hand by their sword. It was a powerful symbol, and the right to bear a sword was assumed by certain artists, Caravaggio included. Worn by the ubiquitous *bravi* and rarer gentlemen who appear in these scenes, the sword is an almost essential prop of the new painting. Remarkably, the dupe in Spada's Fortune Teller lacks a sword. Painters in Rome show a particular sensitivity to the weapon, and its omission distinguishes an outsider such as Spada, whose men go unarmed.[39] This is a world created and defined

by male sociability. Women are not intruders here, but the female prostitutes, companions, or servants are the more at risk. The gypsy fortune teller ventures the most, an outsider directly engaging the men (more rarely, the women) of this world.

Silks, plumes, pleats and slashed clothing catch our eye.[40] At least pictorially, such clothing was part of a *bravo's* identity, fashion signalling his potential for violence. Yet the men in these paintings are dressed in clothing, perhaps a generation or two out of fashion. The slashed or pleated fabrics are archaic and the rich silks and fabrics seem implausible. There is now a general consensus that this clothing is anachronistic, yet it is difficult to be certain without more extensive studies of inventories. Other hypotheses are possible: once fashionable clothing, now handed down and circulating among hangers-on to some noble or cardinal's court; references to stereotyped stage costumes; livery. Or it may reflect and embellish a kind of punk aesthetic found among the Roman demimonde – a counter-culture of *bravi*, soldiers, gamblers, prostitutes and perhaps, painters.[41]

Caravaggio's *Calling of Saint Matthew* served as model. The modern, if older and implausibly rich costume and the tavern setting were intended to make the familiar scene new and immediate to its viewers. (Significantly, this interpretive freedom is applied to the secondary figures, not to Christ.) Caravaggio's anachronism works by displacement, creating a space for the viewer to freely interpret traditional subjects. (Caravaggio here owes much to older examples where such anachronism was common, and to Northern art, where it remained in use later than in Central Italy.) The device was adopted by his successors, and the paintings that we call scenes of contemporary life – tavern scenes, card games, life among the demimonde – are rather out of time, perhaps best described as disassociated from both the past and the present. The new painting is simultaneously distant and immediate in subject matter, as it is as art both artificial and natural.

This sense of distance – in Caravaggio's hands, of interpretive freedom, for many of his emulators, of fantasy – was precarious and easily lost. Bellori, writing a few decades later, misunderstands: for him, such clothing does not seem out of time, but rather indecorous. "Now began the imitation of common and vulgar things, seeking out filth and deformity, as some popular artists do so assiduously. . . The costumes they paint consist of stockings, breeches, and big caps. . . ." In the same passage he itemizes the motifs of the new painting, condemning the choice to paint the worst of things – the rustiest armour, "if a vase, they would not complete it except to show it broken and without a spout . . . they pay attention only to wrinkles, defects of the skin and exterior, depicting knotted fingers and limbs disfigured by disease."[42] The poetry of the new painting, its fantasy, allusiveness, its ambiguity – between the

reality of the world and the painter's imagination, our imagination – and its humour, was invisible to him.

These paintings are fantasies. Nothing is less surprising. Yet what of Bellori's story of Caravaggio taking a gypsy off the street to serve as his model? The claim of painting after the life? "He claimed that he imitated his models so closely that he never made a single brushstroke that he called his own, but said rather that it was nature's."[43] It is stating the obvious that Caravaggio and his follower's work is not the literal imitation of life, but its imaginative recreation. His studio, the infamous dark room, was a place for recreating the world through looking and making, not a window open onto the world.

NOTES

1 G. Mutola, *Rime* (Venice, 1603), trans. by K. Christiansen, "A Caravaggio Rediscovered: The Lute Player," p. 17 in Christiansen 1990, pp. 9–52.

2 For the two versions, see the entries in Guarino and Masini 2006, pp. 334–337, and Loire 2006, sv. Caravaggio. Their early history is unclear: the first was in the collection of Cardinal del Monte, Caravaggio's first and among his most important patrons; the second in the collection of the Vittrice family, likely from at least 1609. Del Monte may not have acquired his directly from the artist, judging from the somewhat oblique comments in Macini's ms. notes and correspondence. The second version would then have been painted directly for a collector – possibly Gerolamo Vittrice. For this alternate history see esp. Maccherini 1997, pp. 75 ff.; Sickel 2003, ch. 2; and the comments in Loire 2006.

3 Mancini's *Life* of Caravaggio, as trans. in Hibbard 1983, p. 350 referring to the second version.

4 Bellori's *Life* of Caravaggio, as trans. in Hibbard 1983, p. 362.

5 The most complete study of Caravaggio's *Fortune Teller* and its sources remains Cuzin 1977. It should be supplemented by the works listed in the following notes and in particular by H. Langdon, "Cardsharps, Gypsies and Street Vendors," in London 2001 (upon which this essay depends); O. Bonfait, "Commedia dell'arte et scène de genre caravagesques: 'Les Diseuses de bonne venture' de Simon Vouet," pp. 56–65 in Nantes 2008; Hartje 2004, ch. 3. See also T. Olson, "The Street has its Masters: Caravaggio and the Socially Marginal," in Warwick 2006, for a significantly different interpretation of the context. Little substantive has been written on gypsies in seventeenth-century Rome and attempts at linking the painters' gypsy with the reality of the subject have been unsuccessful.

6 See Burke 1987, chap. 6 for a classic examination of how society conceptualized the marginal and deviant. For gypsies, as with any such group, bouts of repression alternated with indifference, typical of Ancien Régime government. J. Bousquet, "Valentin et ses compagnons. Réflexions sur les caravagesques français à partir des archives paroissiales romaines," in *Gazette des Beaux-Arts* 92 (October 1978), pp. 101–114.

1978, cites a "family of three gypsies" [p. 102] in the *stati d'anime* of 1617 – the reference is unsurprising, showing how even marginal groups such as the gypsies could be caught up in bureaucratic exercises such as the *stati d'anime*, a census of those who took annual communion.

7 On the art of palmistry as interpreted and practised in Early Modern Europe see esp. B.P. Copenhaver, "A Show of Hands," in Sherman 2000, pp. 46–59 and the associated entries. It seems unlikely that painters of this subject focused on precise details of the art; their interest instead lies in the more general play of hands.

8 For an introduction to this material see Langdon in London 2001; Bonfait in Nantes 2008.

9 Malvasia 1678, vol. 2, pt. 4, p. 116. See T. Olson in Warwick 2006 for examples of the Europe-wide fashion for this literature on deception.

10 For the painting see Laskin and Pantazzi 1987, sv. Vouet; see also Nantes 2008, entry 13 for a summary of recent literature. Generally dated to c. 1620 or earlier, i.e. close to the version in Rome discussed below. In a larger discussion as to the dating of Vouet's Roman works, G. Fiegenbaum, in Conisbee 2009, note 23, p. 460, argues for a later date, comparing it with the *Saint Jerome* in Washington from the early to mid 1620s. Although Vouet may have felt that the two works required different treatments – matching the style to subject – the Washington work is more sophisticated in respect of handling and conception and is arguably later.

11 For different definitions of Caravaggio's "school" see Mancini in Hibbard 1983, pp. 350–351; Bellori in Hibbard 1983, esp. p. 372.

12 See the essays in Nantes 2008.

13 For Manfredi's work now in Detroit see J.-P. Cuzin, "Manfredi's *Fortune Teller* and some Problems of 'Manfrediana methodus'," *Bulletin of the Detroit Institute of the Arts* 58:1 (1980), pp. 1–25; Bissell in Bissell et al. 2005, pp. 126–129, argues for the importance of this work to Vouet's Rome and Ottawa canvases. Both writers correctly emphasize the importance of Manfredi's *Fortune Teller* for the new painting; they see it as having effectively come to supplant Caravaggio's work as a model. Hartje 2004, cat. no. A20 for the question of the date, prefers 1615–18.

14 See especially R. Vodret, "Simon Vouet, 1617. Una 'Buona ventura' per Cassiano dal Pozzo," *Bollettino d'arte* 40 (Oct.–Dec.1996), pp. 89–94. Another version, likely a copy and not an autograph variant, is in Florence; for this see Florence 2010, entry 80 who, however, argues for its execution by Vouet.

15 For the inscription on the verso of the canvas, see R. Vodret, "Simon Vouet, 1617," pp. 89–94.

16 Cassiano's fame and his particular interests as a collector have coloured interpretations of the individual works he owned. His known taste for the documentary (in this case, almost ethnographic) could explain his interest in Vouet's unusually banal, if comic interpretation of the fortune teller. However, we should avoid any reductive interpretation of Cassiano's interests; furthermore, the location of Vouet's painting in the 1689 inventory of the collection does not seem particularly charged, appearing among disparate works. For a description of the inventory, see D. Sparti, "The dal Pozzo Collection Again: the Inventories of 1689 and 1695 and the Family Archive," *The Burlington Magazine* 132 (1990, August), pp. 551–570; the entry is fol. 223r, #335. For Cassiano's collections of costume and genre prints (often similarly combining the documentary and comic), see the perceptive analysis in A. Griffiths, "The Print Collection of Cassiano dal Pozzo." *Print Quarterly* 6:1 (1989), pp. 2–10.

17 Mancini in Hibbard 1983, p. 350.

18 See especially Pirondini et al. 2002. See also F. Frisoni, "Lionello Spada," pp. 265–276 in Negro and Pirondini 1994; S. Macioce, "Leonello Spada," pp. 688–695 in Zuccari 2010.

19 In the collection of Cardinal d'Este in Rome. For the work, see Pirondini et al. 2002, entry 143. Frisoni in Negro and Pirondini 1994, note 39 cites a letter written in 1620 by Spada to Cardinal d'Este implying that his works were accessible to visitors to the Cardinal's palace in Rome; Spada thanks the Cardinal for the honour it brings him. For the letter see Venturi 1882, p. 173; no specific works are mentioned.

20 The date ante-quem of 1618 has now been established by C. Cremonini, "Le raccolte d'arte del cardinale Alessandro d'Este. Vicende collezionistiche tra Modena e Reggio," in *Sovrane Passioni: Studi sul collezcionismo estense*, ed. J. Bentini (Milan 1998), pp. 115–117, who publishes an inventory of 1618 listing works sent to Rome from Modena; Spada's is clearly identified. Spada's chronology is difficult; until recently, this work was thought to date later in his career. A terminus post-quem is difficult to establish: Spada's association with the Cardinal dates back some years before this.

21 Malvasia 1678, vol. 2, pt. 4, pp. 103–120; p. 106 for the quote.

22 Bellori in Hibbard 1983, p. 362, commenting on the Doria-Pamphilij Magdalene.

23 Hess 1967, p. 282 referring to the Louvre version.

24 L. Marzocchi, *Scritti originali del Conte Carlo Cesare Malvasia spettanti alla sua* Felsina Pittrice (Bologna, 1983), p. 273, cited by Frisoni in Negro and Pirondini 1994, note 1, p. 270.

25 Baglione 2008, p. 147.

26 See especially S. Macioce, "Leonello Spada a Malta: nuovi documenti," *Storia dell'arte*, 80 (1994), pp. 54–58, for Spada's movements between Emilia, Rome and Malta during his formative years.

27 For the inventory of his collection see Cremonini, "Le raccolte d'arte del cardinale Alessandro d'Este," pp. 117 ff.

28 Zeri 1959 catalogue entries 107 and 108 with a proposed attribution to Vignon; correctly rejected by Bassani 1992, catalogue entry R-145. The print is signed "MM," perhaps for "Marco Merolle" as suggested by Röttgen 2002, p. 206. Given the dedication, which identifies the painter as cavaliere, it must date to after 1600.

29 Zeri 1959 also tentatively attributed the panels to Vignon, again correctly rejected by Bassani 1992, cat. entries R-75 and R-76. Röttgen 2002 attributes both panels to Merolle. Zeri noted a possible connection to the frescos in a chapel of S. Giovanni dei Fiorentini, which Röttgen followed. For these see S.M. Germond, "Orazio Gentileschi and S. Giovanni dei Fiorentini," *The Burlington Magazine* 135 (November 1993), pp. 754–759 and K. Christiansen "Orazio Gentileschi and S. Giovanni dei Fiorentini," *The Burlington Magazine* 136 (September 1994), p. 621. The author continues to remain anonymous. They presumably date to shortly after Caravaggio's models.

30 For a different argument, see Volpi's essay in Zuccari 2010, vol. 2, esp. pp. 779 ff.; she argues that the print and Pallavacini panel reflect the interests of Arpino's circle, and were a model for Caravaggio's own Fortune Teller. This would seem to invert the order: panel and print are a response to Caravaggio. However, her choice to emphasize the artificial elements of Caravaggio's *Fortune Teller* – seeing it as reflecting the world of the theatre (an ambience she associates with these works) rather than a manifesto of realism – remains valid.

31 The full inscriptions translates from the Latin as "Theft, the Devil, the World (and

the deceptions the Old make for the Young), these are the three things man must beware." As a guide to the image, the text seems superfluous, but it is an important indicator of one contemporary response to the subject of the Fortune Teller – one which, however, would misinterpret the work of Caravaggio and his successors.

32 For a response by Simon Peter Tilmann to this detail of the painting or print, see Nicolson 1990, no. 1458.

33 Vecellio 2008, p. 98, showing a soldier from the time of Charles V, notes the use of the codpiece ("brachetta") as pocket. For the bbrachetta and the lacing of breeches to jerkin see J. Arnold, "Preliminary Investigation into the Medici Grave Clothes," in Liscia Bemporad 1988, p. 153 for surviving comparative material.

34 Langdon in London 2001, p. 59. For the statue by N. Cordier, identified by contemporaries as either a Gypsy woman or a Mooress, see Pressouyre 1984, cat. no. 22. This was one of two statues of gypsy fortune tellers owned by the Borghese; for the other, anonymous work see Haskell and Penny 1981, cat. no. 95. The popularity of the exotic and beautiful subject is not surprising, but that both works reused fragments of Antique statues for the figures' trunks is more so; the association of Antiquity and the gypsy is unexpected. For examples of Antique sculptures interpreted as gypsies on account of their outstretched hands and unusual dress (interpreted as servile, or seen as reminiscent of the gypsy cloak) see also Bober and Rubenstein 1986, cat. no. 192.

35 Valentin is describing a Fortune Teller likely that now in the Liechtenstein Museum.

Freely translated from the painter's testimony transcribed on p. 278 by Jane Costello, "The Twelve Pictures 'Ordered by Velasquez' and the Trial of Valguarnera," *Journal of the Warburg and Courtauld Institutes* 12 (1950, no. 3/4), pp. 237–284.

36 Costello, p. 251: Sandrart is describing Valentin's canvas decades later, and his memory is not exact, but his elevation of the subject matter is at issue. My comparison, setting Valentin against Sandrart, is somewhat forced. In addition, Valentin's Liechtenstein *Fortune Teller* is more an assemblage of figures than a coherent scene; the composition (the figures apparently oblivious to each other, the space somewhat incoherent) has little regard for narrative plausibility. This sense of oddness – that it is not a realistic scene – may elicit other responses such as Sandrart's. This lack of interest in narrative and composition plausibility is not uncommon in Caravaggesque genre scenes, where it seems to be a function of composing the works from units and from repetition.

37 See Bellori's comments on Caravaggio's *Penitent Magdalene* in Hibbard 1983, p. 362.

38 Mancini in Hibbard 1983, pp. 350–351.

39 This is not an isolated case; cf. Spada's two Concert scenes (Museo Borghese & Louvre) where the men also go unarmed.

40 Vouet is the rare artist who rejects such finery, instead offering an equally fictitious vision of a different, more banal world.

41 As is suggested by critics' responses to Caravaggio's costume and social life.

42 Bellori in Hibbard 1983, p. 372.

43 Ibid., p. 371.

following pages Michelangelo Merisi da Caravaggio, *The Cardsharps* (detail of cat. 17)

CARDSHARPS AND
TAVERN SCENES

THE CARDSHARPS

NANCY E. EDWARDS

No other painting by Caravaggio inspired more copies and variants than did *The Cardsharps* (cat. 17). This fresh, youthful painting, produced before Caravaggio had reached the height of his powers, was nevertheless coveted by collectors and connoisseurs for decades – even centuries – beyond its creation. *The Cardsharps* helped to launch the artist's fast-rising career and captured the imagination of several generations of artists working in Rome.[1]

A drama unfolds as two young men stake their luck and wits in a game of cards. A fresh-faced boy studies his hand, unaware that his slightly older adversary is preparing to pull out one of the cards hidden in his breeches in response to a signal from his sinister accomplice. The allure of the painting is immediate due to the deceptively simple way that Caravaggio insinuates the viewer into the game. We are seduced by the boy's flushed cheek and silken fabrics, startled by the gesture of the grimacing rogue and ultimately complicit with the underhanded action of the young cheat. The eye is amazed by feats of illusion such as the apricot and cream-coloured ostrich feathers. The setting is indeterminate. We are brought close to the table, a backgammon board pushed past its edge, and although there is no view of the room we know it to be a tavern, the venerable locale of iniquity and corruption.

According to Caravaggio's early biographer Giovanni Pietro Bellori, *The Cardsharps* was not painted on commission, but produced after he left the workshop of Giuseppe Cesari d'Arpino. His older friend, the painter Prospero Orsi, helped promote Caravaggio's new style of painting to the leading families and members of the papal court. Bellori writes that *The Cardsharps* was purchased by Cardinal Francesco Maria del Monte, who gave the young artist an honoured place in his household.[2] Although penniless, Caravaggio forged other significant friendships. Among them, according to Giovanni Baglione, was a "Maestro Valentino," a dealer near San Luigi dei Francesi, who sold some of Caravaggio's paintings.[3] "Maestro Valentino" has been identified as Costantino Spata, a paintings dealer – and it is plausible, but not verifiable, that the cardinal purchased the painting from him, since his shop was near Del Monte's residence.[4] Likewise, he may have brokered the cardinal's purchase of *The Gypsy Fortune Teller* (cat. 13), which is closely related in subject and style, but not a true pendant, since it differs somewhat in size.

❧ ❧ ❧

Cat. 17 (*facing page*) Michelangelo Merisi da Caravaggio, *The Cardsharps*, c. 1595

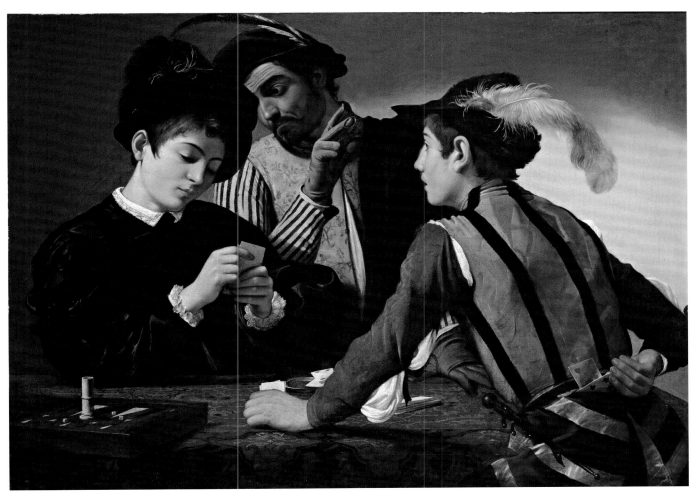

Cat. 17

If *The Cardsharps* was not a commissioned work, it is intriguing to speculate how Caravaggio seized upon the novel subject. Through Arpino and other contacts, Caravaggio would have been introduced to the rich literary culture of Rome. Arpino was associated with the Perugian Accademia degli Insensati, whose meetings in Rome were hosted by Maffeo Barberini (later Pope Urban VIII). Barberini had been tutored by the poet Aurelio Orsi, Prospero's uncle with whom Prospero seems to have shared an interest in literature and poetry.[5] This network of contacts no doubt filtered to Caravaggio and was instrumental in formulating the *concetti* underlying his early works. *The Cardsharps* and *The Fortune Teller* depicted themes that triumph as embodiments of deception, showcasing the naturalistic effects that astounded his contemporaries.

To realize his deception and gull the viewer in *The Cardsharps*, Caravaggio appealed to sight and touch, meticulously describing such material goods as the Ushak carpet covering the table. He would have had access to such luxury items through his circle of cultivated acquaintances and perhaps through his friend Costantino Spata.[6] The dupe wears a fine plum-coloured doublet of velvet and a soft black cap with a feather. The rolled collar and gathered cuffs of his white linen shirt bear a finely embroidered floral pattern identical to that of the young man's shirt in the Capitoline *Fortune Teller*, suggesting that some of the articles of clothing were painted after items in Caravaggio's possession. A savvy youth – which the dupe is not – would have been wary of his companions because of their dress. The younger cheat sports a golden damask doublet with black bands and breeches of red and yellow fabric with a *stiletto*, a type of dagger, tucked into his belt. This menacing and often outlawed weapon was unlikely to be carried by a gentleman, who would wear a sword and parrying dagger.[7] His attire identifies him as a *bravo,* or mercenary. In his compendium of costume annotating an illustration of the Venetian *bravo*, Cesare Veccellio noted that *bravi* "frequently vary their dress, and are always dueling… They serve this or that [master] for money, swearing and bullying without provocation, and committing all kind of scandals and murders."[8] The older rogue wears a doublet with floral motifs and detachable yellow and black striped sleeves, and a cloak over one shoulder. His dark complexion, scruffy hair and long moustache complete his nefarious appearance. The mismatched and striped clothing signals the ruffians' disreputable character. Ribbons and bands, bright colours, and feathers adorning livery and soldiers' uniforms helped to identify the family or factions for whom they worked, but striped and brightly coloured dress also marked or stigmatized those on the margins of society such as servants, entertainers, and criminals and mercenaries.[9] The contrast between the

dupe's tasteful dark clothing and the gaudier attire of the ruffians in *The Cardsharps* is striking. Luxury clothing was highly valued and a common currency during this period, available in the second-hand market. Indeed, the rogues' costumes give the impression that they won their attire, item by item, through gambling. The older rogue's torn gloves exposing his fingertips and thumb would have raised suspicion among those wise to the tricks of cardsharps.

The game played here is likely *primero*, a forerunner of poker. The physician, mathematician and gambler Gerolamo Cardano explained the rules in his *Book on Games of Chance* (1565). The game entailed five types of bid. The second, called *primero,* consisted of cards of different suits. The cheat has concealed the seven of hearts and the six of clubs, worth twenty-one and eighteen points respectively, the two highest possible scores for individual cards, which could secure a win.[10] Cardano and other writers on roguery detail the ingenious ways in which cheats marked their cards. Needles were used to prick the cards with small holes that could be felt with the fingers, and decks were prepared with thick pigments so that the relief of the points – especially clubs and face cards – could be felt with a fingertip, which might be shaved to expose the sensitive skin. Cards were also marked with ink or cut at the edges, or doctored in other subtle ways to indicate the different suits.[11]

Cardsharps frequented the taverns of Caravaggio's Rome – a pilgrimage city that also attracted large numbers of vagabonds and villains – in hopes of defrauding foolish youths. But his rogues are drawn less from real life than from any number of popular dramatic and literary sources of the period. Broadsides and pamphlets warning about the ruses of beggars, charlatans and other tricksters, including cardsharps, abounded. A sizeable literature satisfied the public's fascination with rogues and their swindles, an indication of social anxieties as well as an interest in human folly.[12]

Caravaggio's cardsharps could also have been plucked from contemporary dramatic performances. The parable of the prodigal son (Luke 15:11–32), had been told since the medieval era in dramatic poems, *tableaux vivants*, and religious plays, embellished to show the prodigal in a tavern wasting his inheritance and being seduced by wine, women and gambling. The opening scene of the *Prodigal Son Play* by Pierozzo Castellano de Castellani, performed from the early sixteenth century, bears comparison to the staging of Caravaggio's *Cardsharps.* The vivid slang dialogue follows a lively card game as the Prodigal, lured by bad companions into gambling, loses his bet, prompting him to ask his father for his inheritance.[13] The famed *commedia dell'arte* actor Francesco Andreini played the stock role of the *bravo* or *Capitano*; in one scenario he plays a game of *primero* with Time, Fortune and Death,

with Death placing the winning hand.[14] The picaresque novel *The Life of Guzman de Alfarache,* also known as *The Spanish Rogue,* was immensely popular in Italy. The adventurer and gamester Guzman, who settled in Rome, divulges some of his tricks such as sleight of hand: "I was skill'd above all at *Primera* . . . and knew how to give my self Three Cards when I should have but Two if I was to Deal, and afterwards Two instead of one; so that having Five in my Hand, I would let Two slide gently under my Feet, and play with the other Three that to be sure were the best . . . Never was Man more adroit than I in slipping a Card. . . ."[15]

If inspiration for *The Cardsharps* came from the popular theatre, *commedia dell'arte* and picaresque literature, the *mise en scène* had various pictorial precedents, including Northern prints. Joachim von Sandrart, who was in Rome in the early 1630s, noted that Caravaggio was familiar with Hans Holbein's prints, citing a figure from *The Calling of Saint Matthew* in the Contarelli Chapel that derived from a woodcut depicting gamblers in the *Pictures of Death* (figs. 58 and 59).[16] Indeed, the card player

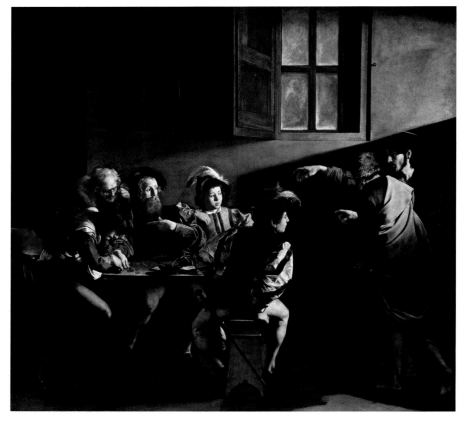

Fig. 60 Lucas van Leyden, *Card Players*, c. 1514–17, oil on panel, 35.6 × 45.7 cm. Collection of the Earl of Pembroke, Wilton House, Salisbury, UK

seated at the right must have inspired the young cheat in *The Cardsharps* as well. The woodcut's moralizing intent is explicit, for Death and the Devil attack one of the players. Sebastian Brant's *Ship of Fools* (1494) inveighed against "Some foolish idiots I could name/ They love the cards, the dice, the game . . . And day and night they game and rattle /With Cards and dice, and drink and prattle." Brant particularly condemned women playing in mixed company.[17] Associated with greed, sloth and violence, gaming was condemned and periodically prohibited or restricted – to little avail – by civic and religious authorities throughout Europe.[18]

Lucas van Leyden's paintings of men and women gambling appear to be the earliest of this genre. *Card Players* at Wilton House invites the viewer to puzzle out the machinations involved in winning the game (fig. 60). A man places his bid and a woman discards, while onlookers offer advice or collusion. The figures at upper right appear to censure the gambling; one looks toward the viewer and the man makes a gesture signifying idleness: "A slothful man hideth his hand in his bosom" (Proverbs 19:24). This group of paintings has been interpreted in the context of "The Power of Women" (*Weibermacht*), a favourite theme in Lucas' work wherein women use their feminine charms and deceit to entrap men, victims of their own folly.[19] The subject finds its way to Caravaggio's native Lombardy in Giulio Campi's *Game of Chess* (Museo Civico d'Arte Antica e Palazzo Madama, Turin, c. 1530–34) in which the

players are a sumptuously dressed woman and a soldier in armour. The rose on the table suggests that the stakes are love. As in some of Lucas' works, a brightly dressed fool appears among the onlookers.[20]

Another Lombard precedent for Caravaggio's *Cardsharps* is a detached fresco of card players by Girolamo Romanino (previously Rome, Villa Feltrinelli, mid-sixteenth century) that formerly decorated a palace in the region of Brescia, Bergamo, or possibly Trent.[21] Romanino's painting recalls earlier frescoes of courtly pastimes, such as *Men and Women Playing Cards* in the Casa Borromeo, Milan, but the figures' sly glances evoke Lucas'. Three men hover behind three women playing cards. The centre man in a plumed hat gestures, apparently signalling an accomplice about the neighbouring woman's cards. The role of kibitzers in cheating was described in *The Spanish Rogue*: "I had a Person that would be continually walking around the room where we play'd, who by Singing, Whistling, Dumb Signs, or some other such like Token agreed on between us, would give me notice how the Game stood."[22]

CLAIMING *THE CARDSHARPS*

Caravaggio's representation of cheating in *The Cardsharps* is key to its popularity as an inspiration for artists who produced *pitture ridicole* in the comic moralizing mode as well as those who explored themes of deception, dissimulation and transgression in a deeper way. The intrigue derived from the psychological interaction among the figures and the involvement of the viewer. Cardinal del Monte guarded his collection carefully. In 1615 – a few years after the artist's death – the connoisseur Giulio Mancini (one of Caravaggio's early biographers) arranged surreptitiously to have copied three paintings in Del Monte's collection by Caravaggio, including *The Cardsharps*. In 1621, a fascinating court case chronicled the theft of a painting of *The Cardsharps* in Marchese Sannesi's collection, which was stolen while it was being copied. Expert witnesses, including Mancini, testified that Sannesi's painting was not autograph (as Sannesi apparently believed), but a very good copy of Caravaggio's work and valued it nonetheless at the considerable sum of 200 *scudi*. Such incidents confirm an enormous interest in possessing Caravaggio's creation.[23]

The Frenchman Valentin de Boulogne knew Caravaggio's painting well. His *Cardsharps* in Dresden brilliantly appropriates aspects of the prototype (fig. 61). Luring the viewer into the action by the highlighted deck of cards beyond the table's edge, Valentin creates a moment of tension: the alert cheat, eyes fixed on his prey, prepares to strike with his palmed card as his unwitting opponent contemplates his

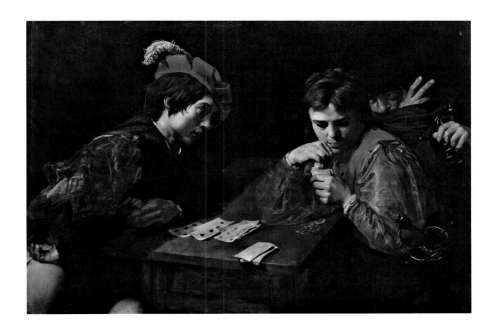

Fig. 61 Valentin de Boulogne, *Cardsharps*, c. 1615–17, oil on canvas, 94.5 × 137 cm. Gemäldegalerie Alte Meister, Staatliche Kunstsammlungen Dresden

next play. The young men are barely distinguishable by their dress, underlining the lesson that appearances are deceiving. Valentin repositioned the older accomplice to a more discreet vantage point for signalling the dupe's cards. This scoundrel, swaddled in a dark cloak up to his chin, would be much emulated by other artists.

Valentin was among the artists under the sway of Bartolomeo Manfredi, who applied Caravaggio's later, tenebrist style to his early subject matter. *The Cardsharps* was painted on a light grey ground, rather than the brownish ground Caravaggio soon adopted that enhanced the dramatic lights and shadows for which he is celebrated. Manfredi's tavern scenes are broadly derived from Caravaggio's works of men seated at a table – *The Cardsharps*, *The Supper at Emmaus* and, especially, *The Calling of Saint Matthew*. Manfredi's refined adaption of Caravaggio's style was embraced by both collectors and artists alike, filling a void following the master's death. One of Manfredi's earliest paintings of this genre, the *Group of Revellers* (fig. 62) typifies this "Manfrediana methodus," as Sandrart famously called Manfredi's widely emulated style of paintings.[24] The revellers are shown at close vantage point in a dark, indeterminate setting, arranged in a staggered frieze with the standing figures almost in the same plane as those seated. Each figure performs an action such as pouring wine or playing a lute. The bilateral groupings intersect in the boy lifting a crystal wineglass. Strong highlights and deep shadows organize the shallow space of the picture and create a poetic mood.

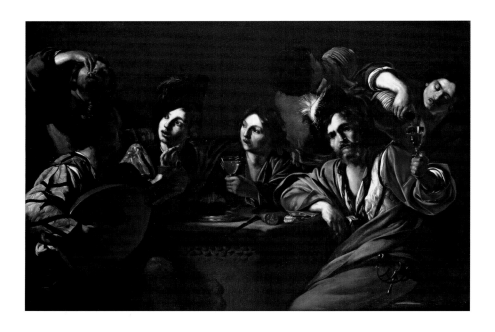

The French artist Nicolas Tournier was possibly a mature twenty-nine years of age when he arrived in Rome from Montbéliard, but like younger artists he likely learned Manfredi's techniques by copying his works, for which there was a ready market.[25] His copy of Manfredi's *Revellers*, today in the Musée de Tessé, Le Mans (cat. 18), is cooler and more sharply observed, with abstracted faces and decorative treatment of drapery. The emotional tenor of Tournier's canvas is similar to that in Valentin's work – a dignified melancholy or *tristesse*. In effect, the predominant subject of the tavern scenes, like the merry companies in the Netherlands, is the use of the senses. Allegories of the five senses, especially in Northern art, made the point that although the senses were a gift if used to advantage, overindulgence in sensual pleasures should be avoided. Representations of the five senses also allude to the emptiness of transitory sensory pleasures and the fragility of worldly existence.[26] The ancient stone table, with a carved relief of the Triumph of Bacchus, evokes the past glories of antiquity.[27] The allusion to Bacchus may also refer to the deleterious effects of overindulgence in wine – the loss of *ratio* or reason, as in Honthorst's *A Smiling Young Man Squeezing Grapes* (cat. 4).[28]

Conceiving the natural world in terms of the senses was a commonplace during this time. Upon viewing *Boy Bitten by a Lizard* (cat. 3), Caravaggio's contemporaries would have readily associated the painting with touch. Early genre painting, ostensibly a mirror of nature, was closely associated with such emblematic concepts.

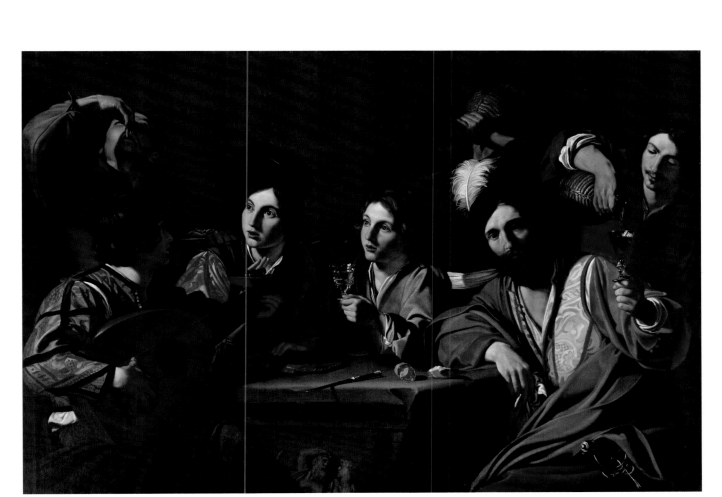

Cat. 18

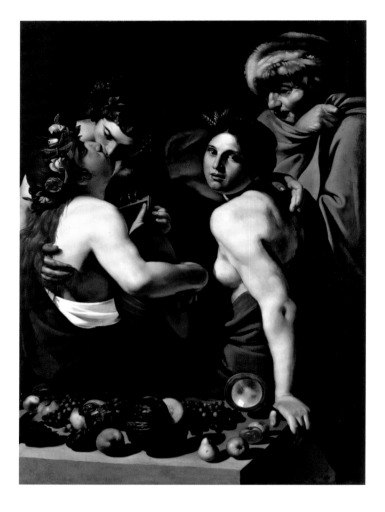

Fig. 63 Bartolomeo Manfredi, *Allegory of the Four Seasons*, c. 1610, oil on canvas, 134 × 91.5 cm. The Dayton Art Institute, Gift of Mr. and Mrs. Elton F. MacDonald, 1960.27

Caravaggio's boy has learned a lesson – he has been bitten by a reptile that emerged from the flowers and fruit associated with love. In the picture Caravaggio declares the primacy of sight, which invokes all the other senses so palpably that we are amazed by the window's reflection on the vase (sight), startled by the boy's cry of astonishment (hearing), seduced by the scent of the flowers (smell) and the sweetness of the cherries (taste), and stung by the bite of the lizard (touch). He commandeers our senses, the means by which we experience the world.[29]

Caravaggio's contemporaries would have also noted that the duplicity pictured in *The Fortune Teller* and *The Cardsharps* parlayed the two most important senses: sight and touch. The gypsy foresees the future while her client is blind to her subterfuge of slipping the ring from his finger. Reading his palm, she touches his hand and looks into his eyes, acts freighted with eroticism. These two senses were especially thought to arouse lust.[30] Similarly, the cardsharps' trickery depends on both sight and touch: hand signs, marked cards, sleight of hand; again, the gull is blind to the deception. The bulging eye and gloved hand with bared fingertips of the older ruffian are sight and touch incarnate.[31]

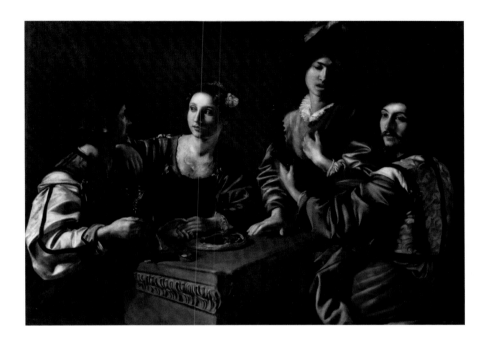

Caravaggio's marshalling of the senses in his early genre painting reinforces his narrative and asserts his artistry. But some of his followers pursued the idea of the senses in more explicit, allegorical or quasi-allegorical terms. Manfredi's *Allegory of the Four Seasons* affirms how attentively he studied the master (fig. 63). Within a narrative of the birth of love the painting also alludes to the senses: the flowers represent smell, the mirror sight, the lute hearing, the fruit taste, and the embracing figures touch.[32] Followers of Caravaggio such as Jan van Bijlert and Theodor Rombouts represented allegories of the Five Senses in a single picture; others, including Jusepe de Ribera, in a series. Pictures like Tournier's *Drinking Party with a Lute Player* (fig. 64) were more subtle: a reserved amorous couple holding hands and gazing into each others eyes alludes to touch and sight; the wine to taste, the filled pastry and sausage to smell, and the lute player and singer to hearing. Toward the end of his career, Valentin produced allegorical paintings of the Four Ages and the Five Senses. Among the dozen paintings that Sandrart describes seeing in an exhibition during his sojourn in Rome, before 1635, was a painting by Valentin of the five senses represented by a group at table: "Some eat and drink, others play chess, draughts, and cards, and others attend to the coins, inhale the scent of the flowers, and others play the flute or lute. Finally, some strike each other and come to blows."[33] Sandrart's description may be faulty or even imaginary, but it conforms in parts to a painting that is today in the

Fig. 65 Nicolas Tournier, *Man Raising a Glass*, before 1624, oil on canvas, 130 × 93 cm. Galleria Estense, Modena

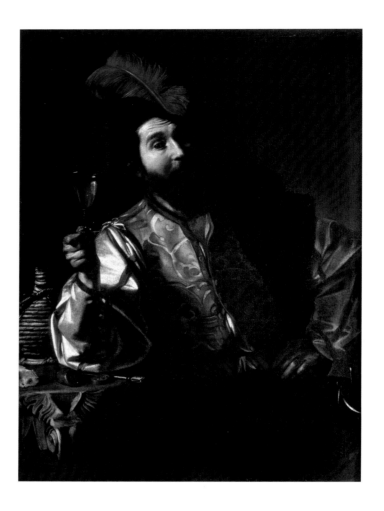

Cat. 19 (*facing page*) Nicolas Tournier, *Young Man with a Flask*, before 1624

Liechtenstein Museum, Vienna. The elegiac tone in Valentin and Tournier's tavern and gaming scenes underscores the idea that the pleasures of the senses – wine, women, gambling and song – are dangerous and transitory, although they can be enjoyed through the beauty of the artist's brush.

The Manfredian tavern scenes are constructed from a repertoire of familiar figures and motifs adapted from Caravaggio's oeuvre or invented by Manfredi and his followers. The man emptying the contents of a flask into his mouth in *A Group of Revellers,* for example, becomes a familiar motif in the work of Manfredi, Valentin, Tournier, and Régnier. This shared repertoire has made the attribution of some paintings difficult. As an example, the pair of paintings today in the Galleria Estense, Modena, *Young Man with a Flask* and *Man Raising a Glass* (cat. 19 and fig. 65) was

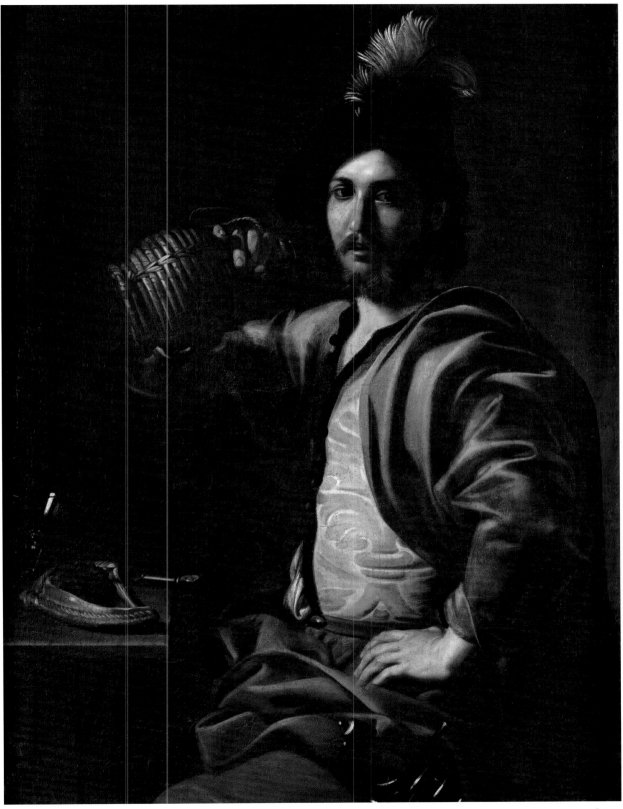

Cat. 19

listed in the 1624 inventory of Cardinal Alessandro d'Este as by Bartolomeo Manfredi, though current scholarship largely favours an attribution to Tournier. Since copies or paintings executed in the workshop were sometimes sold as autograph replicas, attributions made on the basis of such inventories, even early ones, require caution.[34] The pose of *A Man with a Flask*, left arm akimbo with hand on hip, and aspects of his clothing are similar to the young man in the Capitoline *Fortune Teller*, though the man is older and bearded, a familiar type in Tournier's work. The d'Este inventory stated that the pictures represent two "Tedeschi."[35] This identification links the figures, by both attire and attributes, to the *tedesco*, a stock character in the *commedia dell'arte*. This German or Swiss mercenary, who sometimes enacted the part of a military musician, was a prodigious drinker brandishing a goblet, flask or barrel of drink. He was typically outfitted in breeches and doublet that were slashed or striped with contrasting colours like yellow and red, along with a beret (sometimes plumed), a cloak, and a breastplate or weapon. Other *commedia dell'arte* characters such as the Spanish captain Spavento appear to have sometimes mixed elements of dress from Spanish, French, Italian and German officers for a colourful, fantastic appearance – a fashion that might be compared with the eclectic use of dress by Caravaggesque artists.[36]

In *Soldiers Playing Cards and Dice* in the National Gallery of Art, Washington (cat. 20), Valentin elaborates his Dresden *Cardsharps* in the Manfredian manner, adding a pair of dice players and placing one of them in the spot occupied by Caravaggio's older cheat. Intent on his hand, the young dupe kneels forward on his stool, oblivious to the helmeted man behind him signalling his accomplice. Eye-catching motifs – a bare shoulder, Valentin's signature vermillion cut-beret, gleaming armour and white doublet – disrupt the darkness. Valentin painted confidently *alla prima,* adjusting the composition to calibrate the action among the figures. Pentimenti, legible in x-radiograph, show that the right arm of the man in the red beret was originally extended horizontally. Valentin must have judged that the initial position of his hand pointing toward his opponent, just above the hands of the seated cheat cradling his cards, crowded the fulcrum of the composition. He also repositioned downward the head of the soldier in a white doublet.[37] His guarded posture contrasts with the spontaneous response of his rival, who appears to protest the results of the throw. He shields the dice with his hand in a gesture that possibly suggests foul play. They are likely playing *hasard*, a precursor of craps, the complex rules of which are not entirely understood today and which would have varied according to time and place. The game involved throwing one of the eight points (the total of the three dice) – three, four, five, six, or fifteen, sixteen, seventeen, or

Cat. 20 (*facing page*) Valentin de Boulogne, *Soldiers Playing Cards and Dice (The Cheats),* c. 1618–20

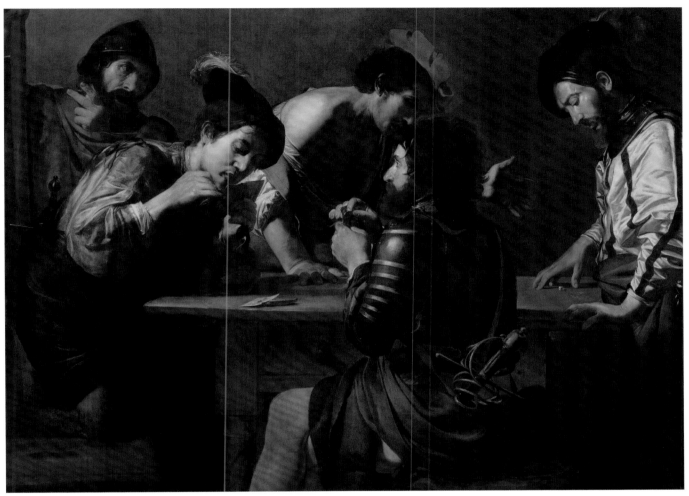

eighteen – known as "*hasards.*" At times during the course of the game, it was required to throw a *hasard* to win, and at others throwing a *hasard* resulted in a loss.[38]

Playing with dice has been associated with unproductive leisure (*otium*) since antiquity, and, as the word "hazard" implies, its outcome depended on chance rather than skill. Like card games, dicing was susceptible to trickery. The gambling thieves who pass time drinking and gambling in a tavern in the *Jeu de saint Nicolas*, an early thirteenth-century liturgical play, are named Pincedé (dice pincher), Rasoir (razor or shaver) and Cliquet (clicker), alluding to common methods of cheating at dice. The first play refers to "pinched" dice, constructed to fall on the long sides. As the cheater explains to the novice in *A Manifest Detection of the Most Vile and Detestable Uses of Dice-play, and Other Practices Like the Same*: "Lo, here … a well-favored die that seemeth good and square, yet is the forehead longer on the cater and trey than any other way, and therefore holdeth the name of a langret. Such be also called barred cater-treys, because commonly the longer end will of his own sway draw downward, and turn up to the eye sice, cinque, deuce, or ace."[39] Dice that are shaved on the corners would likewise favour certain numbers. The cheats would use sleight of hand or "foisting" to bring out the false dice. "Clicking" referred to throwing the dice just so across the board, manipulating how they came to rest. Tilted boards or tables were also used in cheating.[40]

Tournier's *Men Playing Dice* in Louisville (cat. 21), takes on a plaintive tone as the soldiers brace themselves to see how the dice have been cast.[41] Lending a lyrical note to the overall gravitas of the painting, a strong light grazes the neck of the man with the fur hat, the cheek of the young player, the wrinkled forehead and grey locks of the older man, and the fist of the pikesman. Tournier adapts Manfredi's use of standing figures to anchor the shallow composition. The pikesman on the right, his eyes shielded by his plumed helmet, is countered with the soldier wearing a breastplate at left. Arm akimbo, he turns to stare inscrutably at the viewer – a poetic adaption of the "commentator" employed by Manfredi and in earlier Northern moralizing prints and paintings. The palpable physicality of the figures – with weight-bearing hands grasping the table edge and an elbow thrust into the picture plane – shows the legacy of such Caravaggio paintings as both versions of *The Supper at Emmaus* and *The Taking of Christ*. Signs of cheating are not apparent and any moralizing intent is framed within a larger meditation about fate and humanity's capacity for both vice and virtue. A similar painting by Valentin de Boulogne, on the other hand, clearly depicts the biblical episode (John 19: 23–24) that relates how after Christ's crucifixion, soldiers took his garments, divided them and cast lots for his tunic. In *Soldiers Playing Dice for the Tunic of Christ* (Switzerland, Private Collection, c. 1620), the bright red

Cat. 21 (*facing page*) Nicolas Tournier, *Men Playing Dice*, c. 1622–24

SAINT PETER AND THE GAMBLERS

A frequent subject among Caravaggio's Roman followers was *The Denial of Saint Peter*, often expanded with gaming scenes. Although this inclusion of gamblers has been dismissed as an excuse to insert genre into a religious scene, it reinforces the significance of the biblical subject. It was not Caravaggio's painting of the subject, created late in his career and focused on just three figures (New York, The Metropolitan Museum of Art, c. 1609–10), but rather his readily accessible *The Calling of Saint Matthew* that provided a prototype. It inspired a host of fascinating variants of the biblical episode, many augmented with dice- or card-playing soldiers. Gerard Seghers, who came to Rome in 1613 after training in Antwerp, produced numerous variants of the *Denial of Saint Peter,* among them a large canvas in the North Carolina Museum of Art, Raleigh, c. 1620–25 (cat. 22). Although few are known from his early period, those produced in the decade following his return to Antwerp in 1620, including the Raleigh painting, are strongly Caravaggesque in style, in the Manfredian manner. (Indeed, it was in his *Life* of Seghers that Sandrart used that term.)[45] The subject allowed artists following in Caravaggio's wake to explore the dramatic nuances of a biblical narrative with a candid portrayal of sinners called to a spiritual awakening. The Gospels recount that Peter followed Christ after he was arrested. While Jesus was interrogated by the high priest, the Apostle went into the courtyard where a fire was kindled; seeing him, a maid asked if he was with Christ, and he denied it.[46]

The Denial of Saint Peter and *The Calling of Saint Matthew* have similar subjects: an apostle's response to Christ's call to faith. The worldly luxury of Matthew and his entourage is countered by the simplicity of Christ and Peter. The conversion of the tax collector's table to a gambling table with analogous figures in scenes of *The Denial* was apposite, for both were associated with usury and greed. Seghers' painting in Raleigh also shows his familiarity with Manfredi's *Denial of Saint Peter* today in Braunschweig. Set in a guards-room with soldiers engrossed in a game of dice, it was likely the earliest painting of this type (fig. 67).[47] Like Manfredi, Seghers shows the maidservant questioning Peter at the left of the picture. Hemmed in by his interrogators, Peter places his right hand on his breast and lifts up his other in denial. The robust figure seated on the viewer's side of the table – who holds a stack of cards behind his back and covers up a pile of gold coins on the table – evokes Judas. He harks back to Caravaggio's young cheat, but is shown as a dramatic silhouette. The candle on the table also lights up the bearded card player in a yellow doublet whose pose and startled expression recall that of the apostle in *The Calling of Saint Matthew.* However, Seghers upsets the majestic equilibrium of Caravaggio's painting

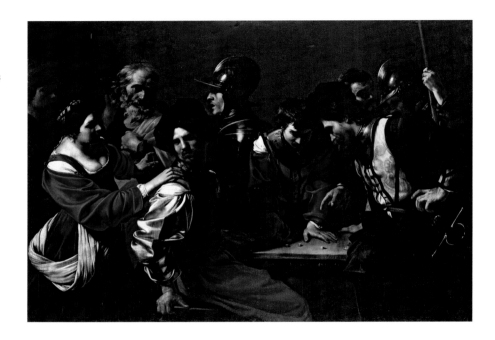

with the soldiers' expansive reactions to the serving maid's interrogation of Peter. The candle she holds creates lovely highlights on her neck, cheek and apron, and falls harshly on Peter's brow, as Seghers accentuates with broad strokes of paint the effects of the light shining upward on eye sockets, noses and wrinkled foreheads. This dramatic use of artificial light was introduced by Gerrit van Honthorst, who painted several versions of *The Denial of Saint Peter*. Harmonious colour also animates the painting. The helmeted soldier next to Peter originally held a staff in his right hand; Seghers painted it out and placed the soldier's hand on Peter's right shoulder, heightening the tension. The central figure with outstretched arms, one grasping Peter's wrist, further locks Peter into their company.[48] Such armed soldiers are familiar as the tormentors of Christ in scenes of the Passion painted by Caravaggesque artists. Seghers's depiction of gambling, here emblematic of human folly and sinfulness that dictates Christ's redemption, creates a menacing atmosphere and threat of violence that serve to intensify Peter's guilt and distress.

The artist known today as the Pensionante del Saraceni painted a deeply moving *Denial of Saint Peter* that focuses solely on the confrontation of the maid servant and the apostle, with no other figures or pictorial apparatus except the agency of light (cat. 23).[49] He must have had knowledge of Caravaggio's late painting of the subject, which was acquired by the Savelli family of Rome, probably in the second decade of

the sixteenth century.[50] The emotive power of the painting, like that of Caravaggio's, pivots on eloquent gesture and expression, highlighted and in deep shadow. Light falls strongly on the girl's imploring hands, open-mouthed profile and luminescent scarf. Peter's bald head and shoulders catch the light, as does the edge of his uplifted left hand. The same gesture, with the right hand on the breast, is found in Seghers's Raleigh painting. Honthorst employs this combination as well, in his paintings of *The Denial of Saint Peter* in Rennes and in a private collection in London, and he was possibly its inventor.[51] In the Vatican painting, Peter's troubled visage is obscured in shadow, pending his tears of penitence and the grace of redemption. Beautiful passages, like Peter's hair and beard and the fringe of the scarf, show the artist's great sensitivity as a still-life painter.

CODA: LA TOUR'S CHEAT

There is no more eloquent testimony of the long reach of Caravaggio's *Cardsharps* than Georges de La Tour's *The Cheat with the Ace of Clubs* (cat. 24), in the Kimbell Art Museum, and its twin, *The Cheat with the Ace of Diamonds* in the Louvre.[52] Pictorially, La Tour's is quite different from Caravaggio's painting, but it succeeds brilliantly at the game of deception. An authority on cheating counselled: "For the first and original ground of cheating is a counterfeit countenance in all things, a study to seem to be, and not to be indeed."[53] The temptress in pearls bears just such an inscrutable countenance. However, her sidelong gaze betrays her, and we are also brought into the deception by her wily partner who shows us his winning hand. The ace of clubs that he prepares to add to the six and seven of clubs in his hand results in a score of a fifty-five; and because his cards are of the same suit, this hand, known as *supremus*, surpasses the *primero* (different suits).

With the introduction of women and wine at the gambling table, La Tour's painting recalls earlier representations of the Prodigal Son. Going beyond Caravaggio in this respect, he presents the scene as a riot of indulgence and a banquet of the senses. La Tour's genius is the seductive quality of the paint and the joy evident in rendering the protagonists' dress. The dupe's clothing – an elaborate gold and silver brocade doublet, linen shirt with minutely embroidered collar and ruffled cuffs, watermelon pink satin sleeves and bows, vermillion breeches and cap with an orange-yellow feather – is fantastically inventive. Throughout the composition, La Tour lavishes his brush on details like the drizzled gold embroidered edges of the courtesan's slit sleeves. The cheat in tan and black, too, steals our attention as his

Cat. 23 (*facing page*) Pensionante del Saraceni, *Denial of Saint Peter*, c. 1615–20

Cat. 24

hands set in motion an eloquent dialogue of gestures. The frozen action of the painting at the climactic moment of deception may be traced to Caravaggio. Just how La Tour achieved his inspired treatment of the subject remains a mystery, but the theme was clearly transmitted by the Roman followers of Caravaggio returning to Northern Europe. The stillness of the figures, the abstraction of the illuminated faces, and even the placement of the figures around the table call to mind paintings by Tournier, for example, and La Tour may have known prints of the subject.[54] By the fourth decade of the seventeenth century, Caravaggio's *Cardsharps* brought forth its most ingenious progeny in La Tour's creation, even as its influence waned.

NOTES

1 The appreciation of Caravaggio's *Cardsharps* continues to this day with a rich art historical literature, from Denis Mahon's authoritative study of the ownership history of the painting from its creation through its rediscovery after it was lost sight of in the 1890s, until its purchase by the Kimbell Art Museum in 1987 (Mahon 1988), pp. 11–25, with an appendix by K. Christiansen, "Technical Report on *The Cardsharps*," pp. 26–27); to the engaging and insightful essays by G. Feigenbaum, "Gamblers, Cheats, and Fortune-Tellers," in Washington 1996, pp. 149–181, and H. Langdon, "Cardsharps, Gypsies, and Street Vendors," in London 2001, pp. 44–65, which place the subject in context; and numerous other studies bearing on the painting which can only be touched upon in this essay. See detailed entries by Cinotti 1983, pp. 554–556; Florence 1991, pp. 96–109; Marini 2001, pp. 401–404; Spike 2001 CD-ROM cat. 4.

2 Bellori, *Le Vite de' pittori, scultori e architetti moderni* (Rome, 1672), text and trans. in Hibbard 1983, p. 363. Caravaggio resided with Del Monte from about 1595 to 1600.

3 Baglione, *Le vite de' pittori, scultori, et architetti ….* (Rome, 1642), trans. in Hibbard 1983, p. 352.

4 For Spata, see P. Allerston, "The Second-hand Trade in the Art in Early Modern Italy," pp. 302, 306 in Fantoni et al. 2003 and S. Corradini and M. Marini, "The Earliest Account of Caravaggio in Rome," *The Burlington Magazine* 140 (1998), pp. 25–28.

5 See C. Whitfield, "The 'Camerino' of Cardinal del Monte," *Paragone* 59:77 (2008), pp. 3–38 and Sickel 2003. Sickel, pp. 50–88, discusses the relationship between the Orsi and Caravaggio's cultivated patrons, the Vittrici. Aurelio Orsi, who died in 1591, was Prospero's uncle, not his brother, as Mancini wrote in error. (p. 52).

6 For Anatolian carpets in Caravaggio's paintings, see J. Varriano, "Caravaggio and the Decorative Arts in the Two *Suppers at Emmaus*," *Art Bulletin* 69 (1986), pp. 218–224, and ibid., "Caravaggio's Carpets," *The Burlington Magazine* 134 (1992), p. 505.

7 For the identification of the *stiletto* and analysis of the arms and armour in Caravaggio's painting, see F. Rossi, "Caravaggio e le armi. Immagine descrittiva, valore segnico e valenza simbolica," in Bergamo 2000, pp. 77–88, esp. p. 79.

8 Christiansen 1990, p. 17; Vecellio 2008, p. 217.

9 For the cultural history of patterns and

striped cloth, see Mellinkoff 1993, vol. 1, esp. pp. 23–28, 40, 54; also Pastoureau 2001.

10 Ore 1953, esp. pp. 112–122, 206–212. In *primero* (also called *primera*) a 40-card deck was used (with the eight, nine, and ten cards removed) with four-card hands. Face cards were worth 10 points; 10 is added to cards with two to five marks; six and seven are tripled; an ace is worth 16. The five bids are *numerus* (two or three cards of the same suit); *primero* (all cards of different suits), which is surpassed by *supremus* (three cards of the same suit: six, seven, and ace, which add up to 55) as well as *fluxus* (four of a suit) and *chorus* (four of a kind—as four aces). See also L. Pericolo, "Caravaggio's *The Cardsharps* and Marino's "Gioco di primera": A Case of Intertextuality?," in *Memoirs of the American Academy in Rome* 53 (2008), pp. 149–150.

11 For marked cards see Ore 1953, pp. 210–212. For cheating at cards and dice see A.M. Cospi, "Advice to Magistrates (Il giudice criminalista)" (Florence, 1643), reprinted in Camporesi 1980, pp. 383–387; for a useful summary of gambling literature and cheating, see D. Bellhouse, "The Role of Roguery in the History of Probability," *Statistical Science* 8:3 (1993), pp. 410–420.

12 For rogue literature, with its vivid portraits of fraudsters, see Camporesi 1980; F. Porzio, "Aspetti e problemi della scena di genere in Italia" in Milan 1998, pp. 17–41; Langdon in London 2001; and T. Olson, "The Street has its Masters: Caravaggio and the Socially Marginal," in Warwick 2006, pp. 69–81.

13 Castellani's *Del Figliuol Prodigo*, printed in D'Ancona 1872, vol. 1, pp. 357–389; Castellani develops the opening scene from the *Prodigal Son Play* by Antonia Pulci, published in 1496, with many editions as late as 1627. See Kovács 2005, pp. 278–279.

14 Andreini 1609, pp. 61–62; Langdon in London 2001, p. 51. The dialogue inveighs against the consequences of gaming – from avarice, deceit and anger to theft and homicide.

15 Alemán 1708, vol. I, p. 441.

16 Sandrart 1925, p. 102, made this comment in his *Life* of Hans Holbein. The woodcut of gamblers was included in the 1545 Lyons edition, as well as the Italian edition, *Simolachri, historie et figure de la morte . . .* (Lyons, 1549) with the caption "For what is a man profited, if he shall gain the whole world, and lose his own soul?" (Matthew 16:26) for which see Lavin 1993, pp. 96–97, who relates the print to the Contarelli chapel. Sickel 2003, p. 116, remarks that Caravaggio may have gained access to the work, which was on the Index of Prohibited Works, through his friend the bookseller Ottavio Gabrielli. He may have also known Hans Sebald Belham's *Gamblers* of 1512, which depicts German mercenaries playing cards on their drum as a little devil flies above. See also B. Wind, "Pitture Ridicole: Some Late Cinquecento Comic Genre Paintings," pp. 25–35 *Storia dell'Arte* 20 (1974), p. 34.

17 The accompanying woodcut shows a quartet of men and women in foolscaps at the game table. See Smith 1992, p. 54 and fig. 80.

18 In courtly art of the late medieval period, playing chess or cards served as a metaphor for the pursuit of love, but such idyllic scenes gave way to moralizing intent, with much potential for sexual innuendo. For the iconography of chess and card play, see Smith 1992, pp. 45–56.

19 Smith 1992, pp. 169–171, for the Wilton House panel.

20 See the entries by V. Guazzoni in Gregori et al. 1994, p. 314–315, and M. Marubbi in New Haven 2004, pp. 164–165.

21 The fresco has been associated with the artist's lost paintings in the Salotto del Capitano in the Palazzo di Broletto, Brescia, commissioned in 1558 and described in the seventeenth century as including

"a conversation of men and women who play a game." See Nova 1994, pp. 311–314, who proposes that it may have belonged to an earlier fresco cycle. See Feigenbaum in Washington 1996, pp. 155–156.

22 Alemán 1708, vol. 1, p. 441.

23 For copies of *The Cardsharps* see Moir 1976, pp. 104–107, 137–138, who lists more than 30 painted copies, which number is now much larger; see also Cinotti 1983, pp. 554–555; Marini 2001, p. 404; Spike 2001 CD-ROM cat. 4; and M.C. Terzaghi, "The Cardsharps," pp. 42–49 in Rome 2010, p. 48. For the 1615 Mancini copy see Maccherini 1997, pp. 79–80, 84 n. 28 and for a detailed account of the 1621 Sannesi copy see Cavazzini 2008, pp. 132–133. Sometime before 1639, Caravaggio's patron, the Genoese banker Ottavio Costa, obtained a copy of *The Cardsharps* and in 1642 Cardinal Antonio Barberini the Younger commissioned copies of *The Cardsharps* and the *Lute Player*, both of which he had purchased from Del Monte's heirs in 1628 (Macioce 2010, docs. 1019 and 1053). For graphic copies of *The Cardsharps*, see S. Macioce, "La *Buona Ventura* e *Il Baro* di Caravaggio: Incisioni dal Fondo Corsini dell'Istituto Nazionale per la Grafica," in Calvesi and Zuccari 2009, pp. 169–185. As the array of copies that regularly appear on the art market testifies, the range of quality is considerable, the majority presumably painted after copies themselves. The painting in the Sir Denis Mahon Collection (Milan 2008) is arguably a copy.

24 See G. Merlo in Cremona 1987, pp. 66–67; F. Cappelletti in Milan 1998, pp. 308–309; Sotheby's 2000, pp. 142–145, lot 61; Hartje 2004, pp. 212–214, 312–315.

25 See Cavazzini 2008, pp. 68–69, who notes that Caravaggesque artists such as Tournier likely copied paintings, not drawings, as part of their training. For Tournier's painting in Le Mans, see Foucart-Walter 1982,

pp. 111–112; A. Brejon de Lavergnée in Cremona 1987, pp. 113–114; Hilaire in Montreal 1993, pp. 98–100; Toulouse 2001, pp. 80–82; Hartje 2004, pp. 314; and Hémery in Zuccari 2010, p. 722.

26 For the Five Senses, see Ferino-Pagden 1996, esp. L. Konecny, "I Cinque Sensi da Aristotele a Costantin Brancusi," pp. 23–48; and Koflin 2005, pp. 56–57.

27 Foucart-Walter 1982, p. 112, identifies the source of the relief as a sarcophagus of the *Triumph of Dionysus* (Capitoline Museums, Rome). See A. Lemoine, "Questioni di iconografia caravaggesca. La scena di genere, tra "ludicrum" moralizzato e refessione metafisica," in Spezzaferro 2009, pp. 187–196, for an interpretation of Valentin's similar genre scenes alluding to the five senses as a meditation on vanity, human destiny, and the interactions among wine, music and the melancholic humour.

28 For the theme of wine, excess and moral corruption in paintings by Caravaggio and his followers, see L.F. Bauer, "Moral Choice in Some Paintings by Caravaggio and His Followers," *Art Bulletin* 83 (1991), pp. 391–398.

29 Rombouts makes a similar statement that sight trumps hearing and the other senses in *A Lute Player* (cat. 6). See R. Spear "The Critical Fortune of a Realist Painter," in New York 1985, pp. 22–27, for myriad, often recondite, interpretations of *Boy Bitten by a Lizard*, rejoining that it should be borne in mind that Mancini reported the painting was sold on the open market. Cavazzini 2008, p. 135, observes the popularity of "subjects of immediate comprehension, such as the Five Senses or the Four Elements" on the market in early 16th-century Rome. M. Heimbürger, "Interpretazioni delle pitture di genere del Caravaggio secondo il 'metodo neerlandese'," *Paragone* 41:24 (1990), pp. 3–18 interprets Caravaggio's genre

paintings as *double entendre* of the elements and senses under the influence of northern European examples; while these were undoubtedly known, also through the intermediary of Lombard art, Caravaggio's sensibility may be likened to the aesthetic of the lyrical mode, for which see E. Cropper, "The Petrifying Art: Marino's Poetry and Caravaggio," *Metropolitan Museum Journal* 26 (1991), pp. 193–212, Cropper in Warwick 2006, pp. 47–56, and A. Colantuono in Warwick 2006, pp. 57–68. For example, the Garden of Pleasure in the epic *Adone* by Caravaggio's friend the poet G.B. Marino, is divided into five sections, each devoted to one of the senses. See Fried 2010, *passim*, for further readings of *Boy Bitten by a Lizard* and as a self-portrait.

30 See Kolfin 2005, p. 56. Hendrik Goltzius' allegory of Touch, engraved by Jan Pietersz Saenredam (1595), carries the inscription: "Don't touch with your hands that which is already harmful when seen, so as not to be affected by an even greater evil presently," for which see F. del Torre in Ferino-Pagden 1996, pp. 116–119. The eroticism of the palm reading is underscored in Valentin's *Fortune Teller* (cat. 16), in which the gypsy is robbed of a fowl, a common erotic symbol. For the cock, see Wind, "Pitture Ridicole," p. 31.

31 For the sense of touch see C. Nordenfalk, "The Sense of Touch in Art," in *The Verbal and the Visual: Essays in Honor of William Sebastian Heckscher*, ed. K-L. Selig and E. Sears, pp. 109–132 (New York, 1990), esp. p. 111. Since cards, dice, and board games were objects held in the hand, they were employed as symbols of touch in still-lifes of the Five Senses by artists including Jacques Linard, Lubin Baugin, and Sebastian Stoskopff, for which see Ferino-Pagden 1996, pp. 20, 45, 242–245.

32 See Gregori in Cremona 1987, pp. 62–63; Weller in Raleigh 1998, pp. 62–65; and R. Vodret in Sydney 2003, pp. 148–149.

33 In 1531, the Sicilian nobleman Fabrizio Valguarnera, who was in Rome, pressured Valentin to accept the commission for a large picture with many figures including "a gypsy, soldiers and other women who play instruments," as Valentin testified at a trial in which Valguarnera was accused of stealing some diamonds. This painting, *Gathering with a Fortune-teller* or *The Five Senses* (Vienna, Liechtenstein Museum), was inventoried in Valguarnera's collection as "The Five Senses." See Rome 1994, pp. 196–203 and G. Swoboda in Milan 2005, p. 310, for this work and Sandrart's description of a similar painting.

34 On this point, see Cavazzini 2004, pp. 68–69.

35 "Doi quadri grandi con cornice d'oro, di dui Tedeschi, un che vuol bere in un fiasco, l'altro tiene un bicchiere di vino in mano, di Bartolomeo Manfredi," cited in Hartje 2004, pp. 385–386; see also Brejon de Lavergnée in Cremona 1987, pp. 110–112; Toulouse 2001, pp. 82–85; and Hémery in Zuccari 2010, pp. 722–725 for dating and attribution.

36 For an analysis of the military stock characters the *Capitano* and *tedesco* in the *commedia dell'arte*, see Katritzky 2006, pp. 213–218. See also Dekiert 2003, pp. 256–272, on related issues and dress in Utrecht Caravaggesque paintings of musicians.

37 Likewise, he painted out a plumed hat worn by the cheat in the foreground. See F. Gage's entry in Conisbee 2009, pp. 414–419. I am grateful to Sarah Fisher and Joanna Dunn for access to the x-radiograph and conservation reports.

38 For a discussion of dicing and *hasard*, see Kavanagh 2005, pp. 44–45.

39 G. Walker, "A Manifest Detection of Diceplay (1552)" in Kinney 1990, p. 75.

40 For the *Jeu de saint Nicolas* see Kavanagh 2005 pp. 31–48, esp. p. 32.

41 See Toulouse 2001, pp. 92–94; W. Prohaska

in Milan 2005, p. 322; Hémery in Zuccari 2010, p. 727.

42 Mojana 1989, pp. 66–67. Tournier possibly depicts this biblical episode in a painting at Attingham Park, Shrewsbury, National Trust (Toulouse 2001, pp. 90–92); compare with Nicolas Régnier's painting of the subject in Lille, for which see Lemoine 2007, pp. 215–226.

43 See Wind, "Pitture Ridicole," and Porzio in Milan 1998.

44 For this painting see London 1990, pp. 55–56; P. Giusti Maccari in Milan 2005, pp. 470–471.

45 The Raleigh painting, long attributed to Honthorst, was restored to Seghers on the basis of an engraving after the painting by Schelte A. Bolswert (d. 1659) with an inscription that it was made for the Antwerp sculptor Andries Colijns de Nole. See Weller 2009, p. 321.

46 Matthew 26:69–75; Mark 14:66–72; Luke 22:5–62; John 18:17–18, 25–27.

47 Papi's assertion (Milan 2005, pp. 258 and 280) that The Denial of Saint Peter in the Certosa di San Martino, Naples, generally attributed to the Master of the Judgment of Solomon, is a youthful Roman work by Jusepe de Ribera datable to about 1615 remains unconfirmed. For Manfredi's The Denial of Saint Peter, its religious context, and influence on other artists, see Hartje 2004, pp. 257–281, 339–341. For Tournier's paintings of the subject see L. Vertova, "La religiosità di Nicolas Tournier a Roma," pp. 91–102 in Bertrand and Trouvé 2003; for Seghers' versions, see B. Nicolson, "Gerard Seghers and the 'Denial of St Peter'," The Burlington Magazine 113:819 (1971), pp. 302–309.

48 Infrared reflectography reveals additional pentimenti – lowering the staff and hand of the soldier on the far right and repositioning the head and left hand of the central figure – which support the view that the Raleigh painting is the prime version rather than the painting owned by the Earl of Mansfield, Scone Place, Scotland. See Weller 2009, pp. 318–321 for a discussion of its attribution, technical notes, and references. Thanks are due to Dennis Weller for sharing conservation and curatorial files. See also Spear 1971, pp. 162–163; Bieneck 1992, pp. 140–141; Raleigh 1998, pp. 188–190.

49 The popularity of the painting is attested in several replicas (the Musée de la Chartreuse, Douai, and The National Gallery of Ireland, Dublin) and numerous copies. See M.G. Aurigemma, "Il Pensionante del Saraceni," in Zuccari 2010, pp. 553–556; see also the entries by Hilaire in Montreal 1993, pp. 80–82 (Douai); Spike in Sydney 2003, pp. 160–161; and Benedetti in Milan 2005, p. 346.

50 Christiansen in London 2005b, pp. 140–43.

51 Judson and Ekkart 1999, pp. 75–77.

52 See Washington 1996, passim (and noting the many variations in the two versions), including technical essays by Barry and Gifford, Barry, Berrie, and Palmer; Paris 1997, pp. 146–149, 188–191; Jaubert 1998, pp. 81–92.

53 See Walker in Kinney 1990, p. 72.

54 Compare with Tournier's Banquet Scene with a Lute Player (Saint Louis Museum of Art), for example. For prints of the subject, see De Jongh 1997, pp. 213–216.

following pages Michelangelo Merisi da Caravaggio, *Saint Francis in Ecstasy* (detail of cat. 27)

"BEAUTY FROM NATURE" AND DEVOTION:
THE CARAVAGGISTI'S NEW IMAGES OF THE SAINTS

FRANCESCA CAPPELLETTI

IT WOULD BE ALMOST IMPOSSIBLE TO ADDRESS THE TOPIC of individual saints by Caravaggio and his followers without citing a well-known passage from *Considerazioni sulla pittura* by Giulio Mancini, who offered astute, well-informed testimony regarding the artist and his school. Mancini wrote that the school spawned by Caravaggio's painting

> . . . is closely tied to nature, which is always before their eyes as they work. It succeeds well with *one figure alone* [emphasis mine], but in narrative compositions and in the interpretation of feelings, which are based on imagination and not direct observation of things, mere copying does not seem to me to be satisfactory . . . As a result the figures, though they look forceful, lack movement, expression, and grace . . . [1]

Describing the Caravaggesque work method, Mancini praised the type of painting here under examination: single figures of saints executed while observing a model, accompanied at most by angels or secondary figures who do not interact with the subject, but whose presence suggests a narrative scene. Mancini's passage also raises the contradictions that would come to be widely debated throughout the seventeenth century and in the development of Caravaggism: the alleged failure to execute large compositions that imbue the figures with movement and expression in accordance with traditional rules of history painting, and the resulting difficulty in creating complex scenes from the imagination. According to Giovanni Pietro Bellori it was precisely the ease of painting from a model, rather than struggling to meet the demands of preparatory studies and Renaissance rules of composition, that explained the practice of the half-length figure: "Because of the convenience of models and executing a head from life, those men abandoned the practices of istorie, which are the proper domain of painters, and devoted themselves to half-length figures, which previously were not much in use."[2]

Thus, even Caravaggio's paintings – not only those of his followers – could be considered by his contemporaries to be overly dependent on the model and "devoid of action," characterized by a certain immobility and crystallization of the composition. Artists and enthusiasts were perplexed by this fixed action, which today we interpret as emotionally charged on account of the forceful, mesmerizing chiaroscuro that reflects the figures' inner turmoil. A stunning example of such a heroic, isolated figure – depicted withstanding the shadows' encroachment is the *Saint John the Baptist in the Wilderness* (cat. 25), that was commissioned by Ottavio Costa in 1602 but executed somewhat later.[3] With his face more sullen than pensive and his gaze almost illegible in the encumbering pools of shadow, the image of the

Cat. 25 (*facing page*) Michelangelo Merisi da Caravaggio, *Saint John the Baptist in the Wilderness*, 1604–05

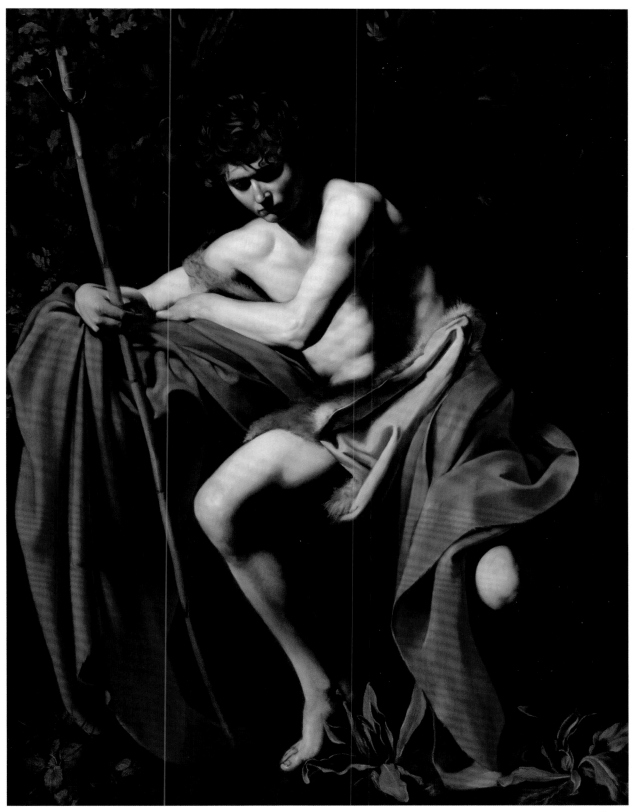

solitary, rustic Baptist is charged with energy deriving from the compressed pose of his legs and torso; he is enclosed by a forest of brownish oaks as autumn looms. During his retreat in the desert, according to the Scriptures, John strengthened his faith, intent not only to preach, but to "lament human misery." Eloquently attuned to its setting, the copy at the remote sanctuary of Conscente, in Liguria, which was initially intended to accommodate the original painting, was described in 1624 as capable of inducing true repentance in "not only the members of the confraternity, but also the other visitors"[4] who admired it at the end of their trek through the forest.

The suggestion that Caravaggio's effective images appealed to young painters can be found in the early seventeenth-century treatise by Karel van Mander, who highlights the artist's claim to paint "from life" without the traditional intermediary step of drawing. To paint based on a drawing, even a life drawing, is not the same as executing paintings in front of a repertoire of the natural world, physical bodies and expressions included. The results of this practice, however unorthodox it may be in comparison with academic tradition, are admirable and indeed constitute "an exceptionally beautiful style, one for our young artists to follow."[5]

Mancini further described the process of producing figures that are concentrated in a restricted space with a dark atmosphere pervaded by diagonal rays of light whose source is not indicated,

> A characteristic of this school is lighting from one source only, which beams down without reflections, as would occur in a very room with one window and the walls painted black . . . they give powerful relief to painting, but *in an unnatural way* [emphasis mine], something that was never thought of or done by any other painter like Raphael, Titian, Correggio or others.[6]

The method is new, but certainly not mimetic, but constructed entirely in the studio. The final rendering concentrates on the figure in a way that, even if it remains within iconographic tradition, confers new power to the image.

Caravaggio's *Saint Francis* is known through two prototypes, the first represented by the paintings at the Capuchin church of Santa Maria della Concezione, in Rome, and the church of San Pietro in Carpineto Romano (fig. 68); the second through the dramatically charged canvas in Cremona (cat. 26). Judging by the modulation of the light, the first two versions can be dated to about 1603, shortly after Caravaggio executed the Mattei *Saint John* (Rome, Pinacoteca Capitolina) and the Giustiniani *Love Triumphant* (Berlin, Gemäldegalerie). Orazio Gentileschi's testimony at the trial for the lawsuit brought against Caravaggio by Baglione in 1603 substantiates this dating indirectly. Among the objects that Caravaggio had borrowed, Gentileschi

Fig. 68 Michelangelo Merisi da Caravaggio, *Saint Francis in Meditation*, c. 1603, oil on canvas, 124 × 93 cm. Carpineto Romano, Church of San Pietro, on deposit at Galleria Nazionale d'Arte Antica, Palazzo Barberini, Rome

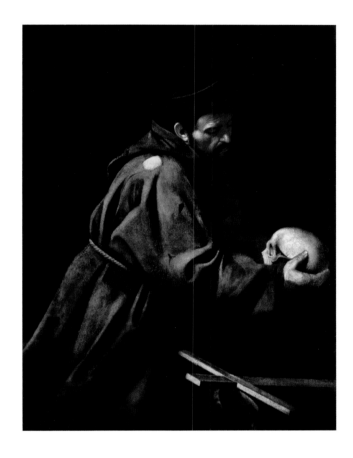

mentioned a Capuchin robe, which might have been worn by the model for the kneeling saint who holds a skull with both hands, an iconographic theme of meditation that was widespread in the late sixteenth century.[7] These two *Saint Francis* canvases illustrate the tricky question of authorship. Although we know that Caravaggio produced other versions of some of his early works – the *Gypsy Fortune Teller* and the *Lute Player*, for example – we also know that the production of copies of his work by other artists intensified at the beginning of the seventeenth century. Sometimes these copies were instigated by those who commissioned the original paintings – as in the case of the aforementioned Ottavio Costa.[8] The autograph nature of the *Saint Francis* at Santa Maria della Concezione is supported by its provenance: previous owners include Francesco de' Rustici, a Roman noble. Scholars have debated whether the Carpineto Romano canvas is an autograph version or a copy. However, the more dramatic treatment of light, the greater decisiveness in the

execution of the figure, and a certain number of pentimenti all point to the hand of Caravaggio.[9] Later by only a few years, the Cremona canvas, whose attribution has also been disputed,[10] shows the saint in a more intense, emotional state. With an intense facial expression, he contemplates the presumed pages of the New Testament narrative of the Passion of Christ, which foreshadows his own "imitation of Christ," the process that leads to a life that conforms with that of the Saviour's and culminates in receiving the stigmata.[11] Mina Gregori has identified convincing Carracci proto-types for this painting, among them a print by Annibale Carracci from 1585.[12] Again, the manner of painting, the absolute concentration on the figure immersed in a chiaroscuro that highlights only the essential details, signals its innovation with respect to tradition.

Another salient citation from Mancini concerns the players in the Caravaggesque movement, or at least those who appeared so to the writer during the ten years following Caravaggio's departure from Rome. Among Caravaggio's followers Mancini cited "Bartolomeo Manfredi, lo Spagnoletto [Jusepe de Ribera], Francesco called Cecco del Caravaggio, Spadarino [Giacomo Galli] and, in part, Carlo [Saraceni] Veneziano." To these we may add, drawing upon Baglione's testimony and the study of the works from the first two decades of the seventeenth century, Orazio Borgianni, Orazio Gentileschi, Antiveduto Gramatica, and Baglione himself. Mancini suggested that these artists "followed their own path." According to him, their experience of Caravaggio did not characterize all of their work, but rather served to enrich otherwise independent careers founded on solid training and subject to other influences and formative experiences. In his letter, dated around 1615, to the Dutch scholar Dirk Amayden in which he ranked painters according to methods of painting, Marchese Vincenzo Giustiniani suggested the eleventh level is to paint "directly from nature," and cited "Teodoro, Gherardo, Enrico and the like" among those who followed this practice. He also characterized the work of Dutch artists like Baburen, Honthorst and Ter Brugghen as among the most vital veins of Caravaggism of the second decade of the seventeenth century, admiring their good design and appreciating the colour and modulated use of chiaroscuro.

From the Piazza di Spagna to the Palazzo Giustiniani, and around the palaces of Caravaggio's former patrons, French artists from Valentin to Vouet and Régnier – who would soon become Vincenzo Giustiniani's household painter – intermingled. These were Caravaggio's early followers: some of whom were friends who imitated his style, earning his eventual wrath; some who looked to him for different possibilities for expression in the new manner of painting; and those who could not resist the novelty, though they did not like its inventor. All of them painted half-length figures,

Cat. 26 (*facing page*) Michelangelo Merisi da Caravaggio, *Saint Francis*, c. 1606–07

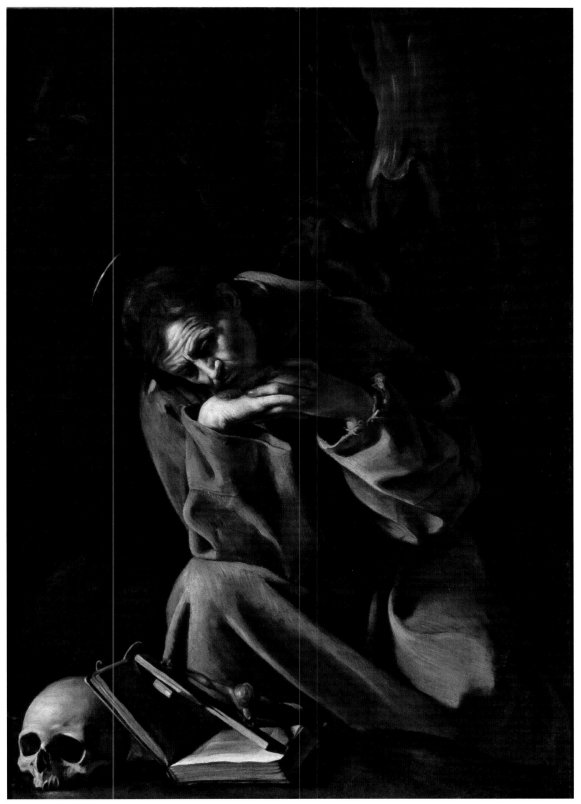

Cat. 26

leaving a legacy of unusual representations of the saints, inspired by the master's examples in private collections and his often controversial church altarpieces.

Returning to the iconography of Saint Francis, similar representations were already circulating in the second half of the sixteenth century, his cult given new impetus by the founding and activity of the Capuchins.[13] Near the end of the century, and prior to completing the works discussed earlier, Caravaggio executed a highly successful scene that would soon be disseminated through copies. The *Saint Francis in Ecstasy* (cat. 27), now in Hartford, Connecticut, likely dates to about 1597. A document discovered in the late nineteenth century – the 1607 will of Ruggero Tritonio, Abbot of Pinerolo – listed goods including a painting described as "divi Francisci signum a caravagio celeberrimo pictori," which Tritonio had received as a bequest from Ottavio Costa. In his will dated 1606, Costa, who also owned the aforementioned *Saint John* canvas, now in Kansas, as well as the *Judith and Holofernes*, today in Rome (fig. 76, p. 267), directed that Tritonio be given the choice of either a *Saint Francis* or a *Martha and Mary Magdalene*, both attributed to Caravaggio.[14] If the Hartford canvas is the same painting cited in the document, Tritonio likely received the gift well before Costa's death in 1639. Moreover, for a long time, an erroneous dating of Tritonio's will to 1597 made this date considered a secure *ante quem* for the execution of the painting.[15] Even if not supported by the will, a date of about 1597 can nevertheless be argued on stylistic grounds. The similarities between this work and the *Rest on the Flight into Egypt*, now at the Galleria Doria Pamphilj, Rome, are striking. The construction of the scene, the relationship of the figures to the landscape, and the use of a brighter palette are evident in each work. Furthermore, the models used in both canvases appear in other paintings from the same period. Reminiscences of Savoldo[16] appear in the depiction of the night sky broken by gleams of light, and the angel's pose evokes Peterzano[17] – a reference to the artist's Lombard training. The angel's face recalls the main figure in *The Cardsharps* (cat. 17), while its pose recalls the Cupid in *The Musicians* (cat. 1) commissioned by Cardinal del Monte.[18]

The Hartford painting is also interesting in respect of its iconography and the comforting presence of the angel, a figure that reappears shortly in the *Rest on the Flight*, and in the characterization of a Christ-like Saint Francis receiving the stigmata at his moment of ecstasy. Following fourteenth-century texts, the saint was considered to be virtually a "figure" of the Saviour.[19] His ecstatic vision, fuelled by his love for Christ, precedes the stigmata, visible here on his chest, but not yet on his hands. The identification with Christ through mystic experience is in a sense also underscored by the position of Saint Francis as he is supported by the angel, as Christ is traditionally shown during the Passion or as *Ecce Homo*.[20]

Cat. 27 (*facing page*) Michelangelo Merisi da Caravaggio, *Saint Francis in Ecstasy*, c. 1594–95

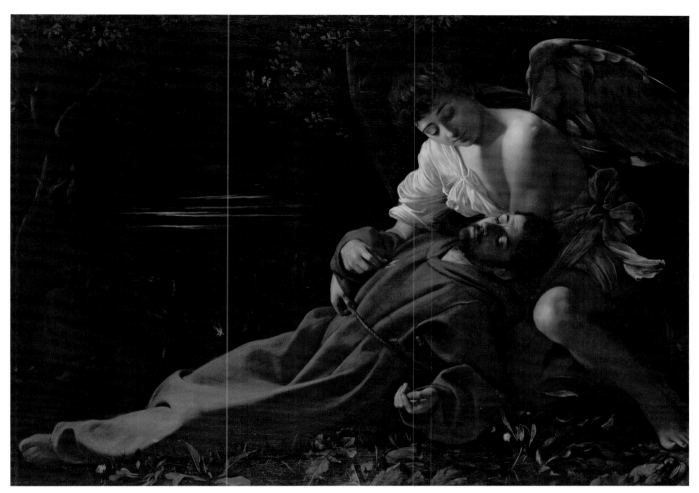

Cat. 27

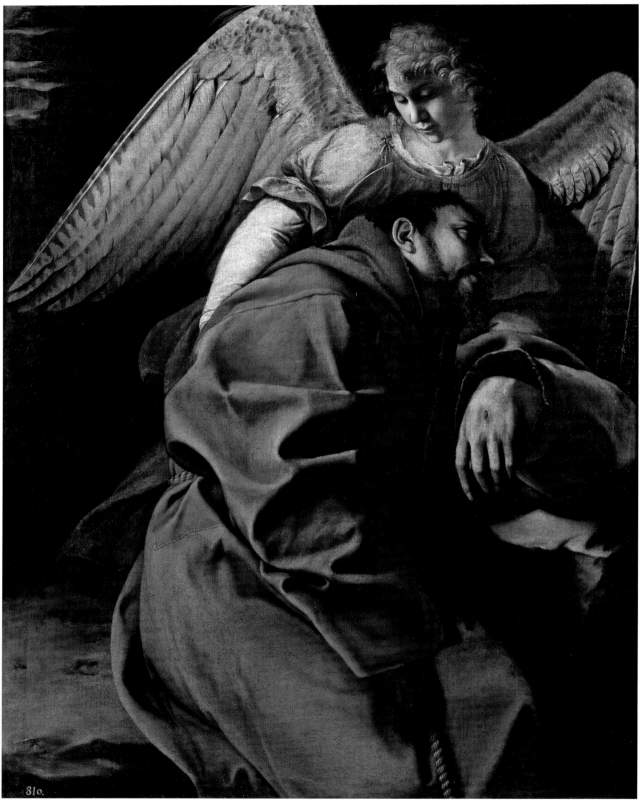

810.

Cat. 28

Fig. 69 Orazio Gentileschi, *Saint Francis and the Angel*, 1612–13, oil on canvas, 133 × 98 cm. Galleria Nazionale d'Arte Antica, Palazzo Barberini, Rome

Cat. 28 (*facing page*) Orazio Gentileschi, *Saint Francis in Ecstasy*, c. 1607

Cat. 29 (*following page*) Giovanni Baglione, *Ecstasy of Saint Francis*, 1601

Cat. 30 (*page 223*) Michelangelo Merisi da Caravaggio, *Saint Francis*, c. 1598

The Hartford canvas is often cited as having inspired some of the earliest related works by his followers in the first two decades of the seventeenth century, such as Orazio Gentileschi's *Saint Francis in Ecstasy* (cat. 28), although Caravaggio's painting has a different format featuring full-length figures, and was, perhaps, less stylistically interesting to them than his slightly later works, identified by a more clearly defined chiaroscuro such as in works developed after the Contarelli chapel.[21] In regard to the subject, Orazio's painting also recalls the iconography of the Passion of Christ, emphasized by the position of the saint, his back supported by the angel. The painter had studied this arrangement in two previous canvases, but here the nocturnal setting, the distribution of shadows on the faces, and the concentration on such details as the stigmatized left hand signal the adoption of Caravaggio's language and, at the same time, a more mature elaboration of the group compared with the earlier *Stigmatization of Saint Francis*.[22] Baglione, too, painted an *Ecstasy of Saint Francis* with two angels (cat. 29), dated 1601, of which two replicas are known. He makes the parallel between the saint and Christ even more explicit by including the Instruments of the Passion and highlights the contemplation of the heavens by turning the saint's face toward the sky, as in Orazio's roughly contemporary painting. The adaptable Baglione was also more greatly influenced by the style of the Contarelli chapel paintings than that of the *Saint Francis* Caravaggio painted for Costa. Orazio creates a more original compositional style in the painting at the Prado and a later one (fig. 69), executed for Orazio Griffio shortly after 1610.[23] The saint swoons in the angel's arms; he lies prostrate, his head no longer turned toward heaven, the mark left on his hand evidence of his intense divine encounter. In the painting in Rome, the delicate tones used for the angel, from luminous whites to pink, suggest that here Orazio takes a different lesson from Caravaggio, a bright and elegant style, which he refined by assimilating the early Caravaggio with other sources of inspiration such as Venetian painting.[24] Closely related to Caravaggio's Saint Francis in Hartford and to Gentileschi's interpretations thereof, is the stunning *Saint Francis* from the Piasecka Johnson collection (cat. 30),[25] first published by Ferdinando Bologna in 1987.[26] He dated it to the later 1590s and identified the painting with Caravaggio's *Saint Francis in Ecstasy* described in the Del Monte inventory of 1627. The smoothness of handling and moving intimacy of the painting recall the Hartford canvas and the *Flight into Egypt* (Rome, Galleria Doria Pamphilj), while the stronger chiaroscuro suggests a slightly later dating to about 1598–1600.

Precisely because of its refined, highly poetical qualities, others have suggested an alternative attribution to Orazio Gentileschi and a dating to about 1610. The saint is modelled in powerful chiaroscuro and emerges mysteriously from the dark. He fills

Cat. 30

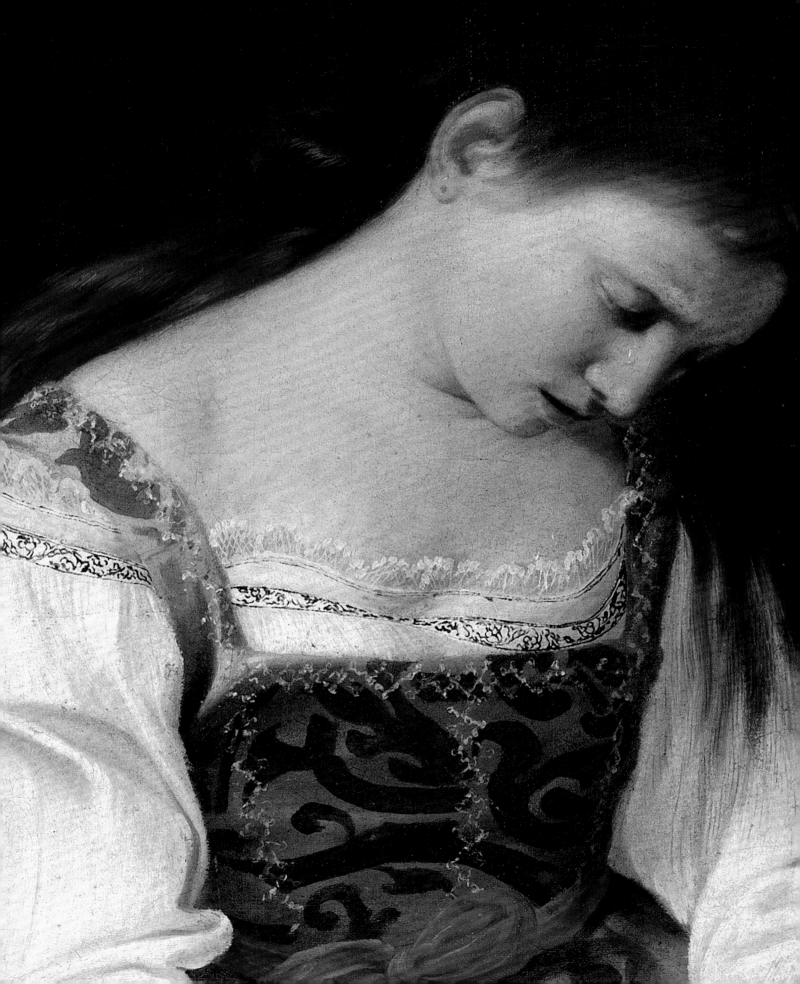

almost the entire canvas, his arms crossed emphatically over his breast and his eyes lifted heavenward. The plain wooden crucifix held in his left hand and the clearly visible wound on the back of his right hand suggest that we are witnessing his famous vision at Mount La Verna in the course of which he received his stigmata. The Saint's monumental, hyper-naturalistic presence coupled with the dramatic illumination convey a sense of solitary spiritual intensity and make this *Saint Francis* one of the most intriguing Caravaggesque images.

Around the same time that Caravaggio executed his Saint Francis for Costa, he painted his first Mary Magdalene, an example of the light, delicate painting Orazio Gentileschi would also study with interest at the start of the new century, making use not only of the oblique shaft of light but also most subtle chromatic harmonies such as those modulating the flesh tones and the hair of his *Lute Player* (Washington, National Gallery of Art).[27]

Caravaggio's *Penitent Magdalene* from around 1596 (cat. 31) represents the saint at the moment of her decision to abandon her previous life and worldly seductions, exemplified by the discarded jewellery and ointment jar near her feet. This was quite clear to the compiler of Camillo Pamphilj's inventory in 1666, who catalogued the painting as a "Magdalene who disdains the vanity of the world."[28] In 1657 Scanelli described it together with its usual companions the *Gypsy Fortune Teller* and the *Rest on the Flight*, at the Villa di Belrespiro, which Camillo had built.[29] The image of the dishevelled, tearful young woman cannot be disassociated from Bellori's well-known passage, which described the work as an example of Caravaggio's process of painting from a model, that is, ". . . when he happened to see one about the city that pleased him, he would stop at that invention of nature, without otherwise exercising his creative powers." Of the *Penitent Magdalene*, Bellori wrote that Merisi "painted a girl sitting on a chair with her hands in her lap, in the act of drying her hair; he portrayed her in a room, and by adding a jar of ointment on the floor, with necklaces and gems, he made her represent the Magdalene."[30] The employment of the same model used for the Virgin in the Doria Pamphilj *Rest on the Flight into Egypt*, the full-length representation of the saint and modulation of light that remains within the Venetian and Lombard tradition, has become more complex and hence suggests a date in the first years of his sojourn with Cardinal del Monte. The portrayal of the Magdalene (cat. 32) by Giovanni Antonio Galli, called Lo Spadarino, formerly attributed to Caravaggio and restored to Spadarino by Zeri,[31] tends toward further simplification of the sacred image; Spadarino's young and melancholy Magdalene, resting with folded hands over a skull, also lacks any descriptive detail and commands the pictorial space with the power of her enigmatic gaze.[32]

facing page Michelangelo Merisi da Caravaggio, *Penitent Magdalene* (detail of cat. 31)

Cat. 31 (*following page*) Michelangelo Merisi da Caravaggio, *Penitent Magdalene*, 1596–97

Cat. 32 (*page 227*) Giovanni Antonio Galli called Lo Spadarino, *Saint Mary Magdalen*, 1597–1649

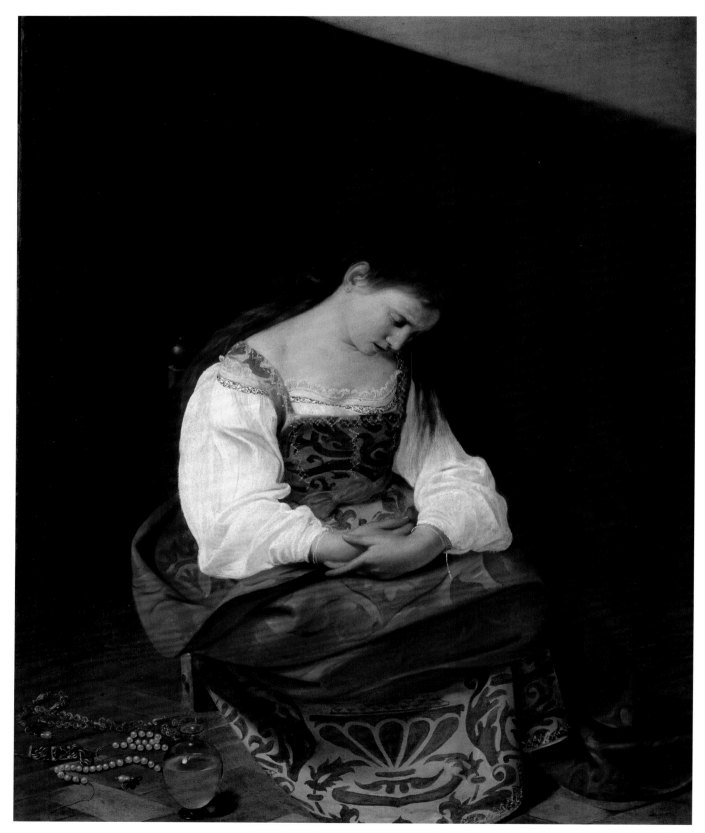

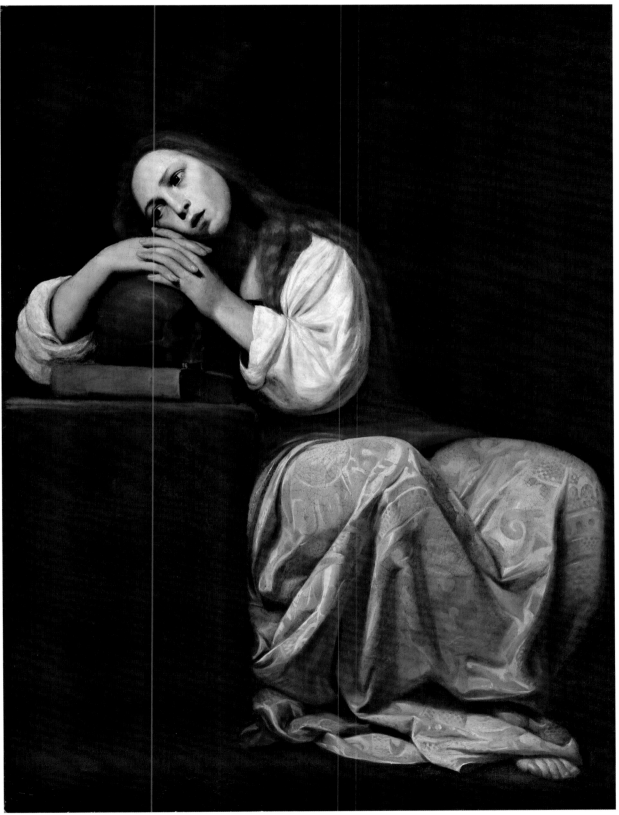

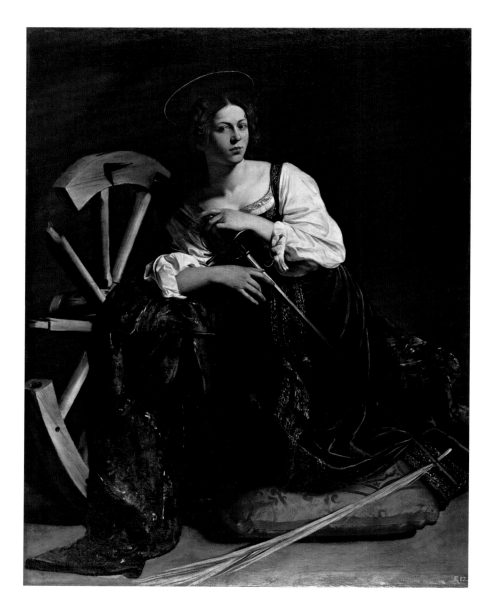

Fig. 70 Michelangelo Merisi da Caravaggio, *Saint Catherine*, 1597–98, oil on canvas, 173 × 133 cm. Museo Thyssen-Bornemisza, Madrid

Caravaggio created another female image for private devotion that shows even greater expressive force than the Doria *Magdalene*. The *Saint Catherine*, today in the Thyssen Collection, Madrid (fig. 70), belonged to Cardinal del Monte and is likely one of the last works Caravaggio painted for him. Bellori was the first to compare the *Saint Catherine* to later works, especially the Contarelli Chapel canvases, noting its "deeper colouring," for Michele was already beginning to strengthen the dark tones.[33] Listed in the 1627 Del Monte inventory, it was part of a lot including the *Cardsharps*, a painting by Reni and various Flemish landscapes acquired by Antonio Barberini. It remained in the Barberini Collection until the twentieth century.[34]

The contrasts of light and shadow in this painting are intensified, as the saint's face, neckline and the white of his sleeves emerge from the dark background into

broadly illuminated areas. The wooden wheel, the palm on the ground and the sharp blade of the sword, its blood-stained tip the only visible trace of martyrdom, together form an interplay of diagonals suggesting spatial depth, which is abruptly cancelled by the brown background. Caravaggio's style begins to gain in intensity and drama with his portrayal of a single figure painted from a model but surrounded by elements that in their stillness evoke abandoned objects and allude to the saint's legend. We find a similar isolation and majesty of the female figure and the fully developed softness of the shadows in the *Saint Margaret* (c. 1598) painted for the Bombasi chapel in Santa Caterina dei Funari,[35] by Annibale Carracci, whom Caravaggio – generally described in the sources as loath to esteem his contemporaries – admired and, according to Malvasia, not without reason.[36] The density of the colour, richness of the garments and concentration on the female figure in Annibale's painting are perhaps the elements that attracted Merisi's attention to the work of a painter against whom he had already begun to measure himself, with all the greater justification if we accept a dating for the *Saint Catherine* to the years immediately following, rather than prior to, the Contarelli Chapel.[37]

Baglione wrote that the Marchese Vincenzo Giustiniani, who once owned the *Saint Matthew and the Angel* (fig. 3a, p. 8), today known only through a black-and-white photograph,[38] purchased the work immediately following its rejection by the congregation of San Luigi dei Francesi.[39] However, Baglione's account has not been sufficiently substantiated in documents regarding the chapel. While the documents for the period from 1599 to 1602 contain much detail about the confusion and discontent relating to the management of the Contarelli heritage and a sculpture depicting Matthew and the Angel, originally commissioned from Jacob Cornelisz Cobaert, there is no mention of an altarpiece delivered by Caravaggio after the two side altars depicting the *Calling* and the *Martyrdom of Saint Matthew* (see figs. 1 and 2, pp. 6–7). The *Saint Matthew and the Angel* (fig. 3b, p. 9), was painted when the artist had already signed the contract for the chapel of Tiberio Cerasi at Santa Maria del Popolo.[40] In the second version, the saint is cloaked in bright orange and posed in elegant torsion with his knee on a bench. His face still resembles that of the model, yet appears to be inspired by figures of an intellectual nature and drawn from images of philosophers or those of Saint Jerome.[41] Here the angel is positioned above the saint, rather than beside him; his hand gesture recalls the *computo digitale* of classical rhetoric. The picture seems to be related to the period around 1602–03, when Caravaggio's style exhibited greater expressive equilibrium; details such as the cloak's worn edges do not compromise the grandeur of the towering figures in the extreme sobriety of the setting and the details.

Cat. 33 (*following page*) Nicolas Régnier, *Saint Matthew and the Angel*, c. 1625

Cat. 34 (*page 231*) Bartolomeo Cavarozzi, *Saint Jerome in His Study*, c. 1617

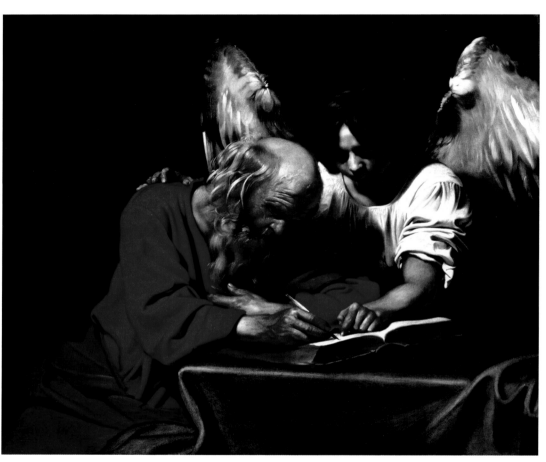

Cat. 33

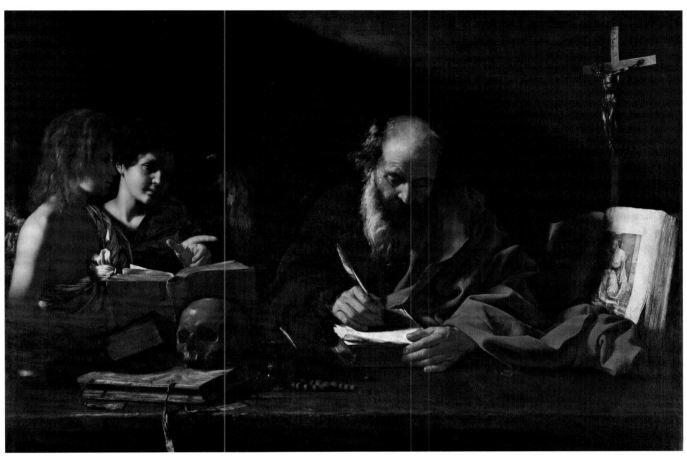

Cat. 34

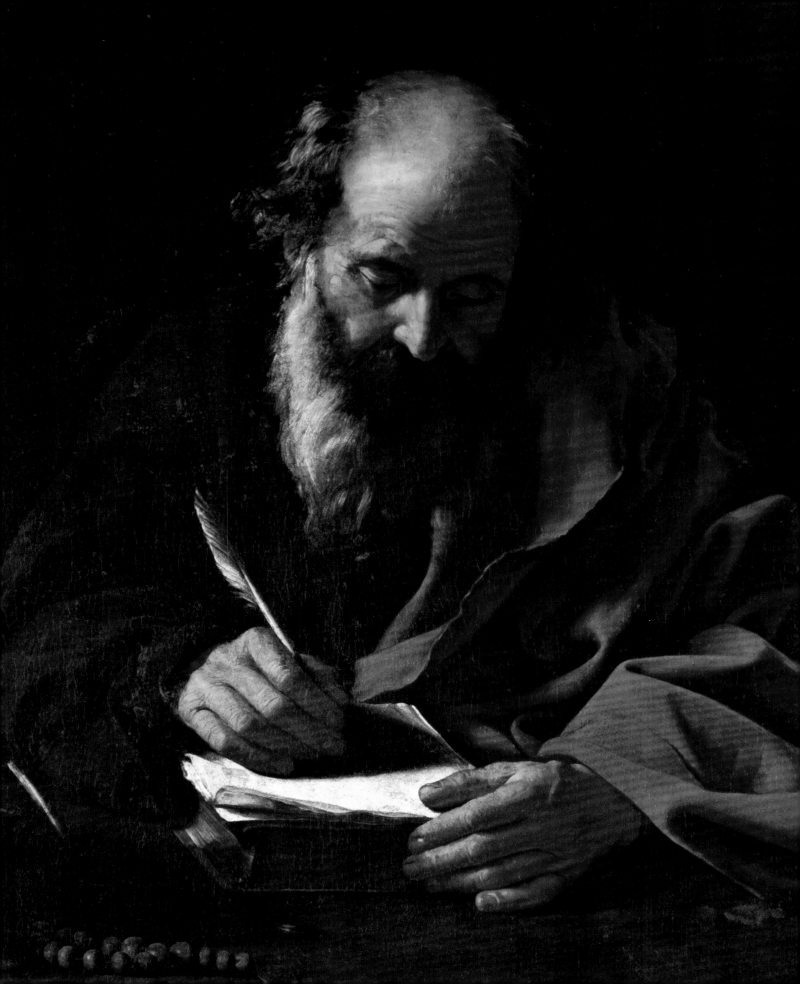

We know that the Giustiniani version likely served as a model for a copy by
Caroselli,[42] and for Nicolas Régnier's *Saint Matthew and the Angel* (cat. 33), in which
the saint is seated as the angel stands close to him, a magnificent green cloth on the
table in front of them. Régnier's *Matthew* was executed in the early 1620s, when the
painter was part of Vincenzo Giustiniani's circle and therefore had regular access to
the palazzo, during which time he used Caravaggio's work as a point of departure to
create his own original compositions.[43] Other ambitious large-format works, such as
the *Supper at Emmaus* in Potsdam, show the originality with which the prototype has
been examined. The Giustiniani inventories show that Régnier executed two copies
after originals by Caravaggio that were in the collection: the *Penitent Magdalene*, now
lost; and the *Incredulity of Saint Thomas* today in Potsdam (fig. 78, p. 270). By
assimilating the master's style through copying, Régnier attained a level of originality
in which perspectival invention and rich chromatic impasto would provide the
subsequent turning points in his style.[44] A painting of extraordinary beauty,
Bartolomeo Cavarozzi's *Saint Jerome in His Study* (cat. 34) was cited in a Medici
inventory of 1688. One of the high points of Viterbese painting, it was probably
executed around 1616–17.[45] The canvas surely reflects Caravaggio's lesson of the early
years of the century, recalling some of the lighting solutions, not only the diagonal
shaft from above, but also the pools of light on one of the angels' face and hand. Such
efforts do not diminish the objects, but rather bring them out of the darkness with
the loving skill expended on the still life with books and the skull on the table
covered by the marvellous flame-red patch of drapery. In particular, the saint's face,
with its long white beard, and the mellow chiaroscuro that caresses and defines its
features, has many points in common with the Roman work of Jusepe Ribera – so
much as to suppose Cavarozzi had a period of close contact with some of the Spanish
painter's works.[46]

Between 1613 and 1616, Ribera was presumably in Rome where he formulated a
harsh naturalism that emerges in the Cussida *Apostles* and the series of canvases
representing the Five Senses.[47] It is nourished by direct observation of Caravaggio's
images of individual saints at the Palazzo Giustiniani, where the Spaniard was much
appreciated, judging by the great number of his paintings in Vincenzo's collection.[48]
Ribera's *Saint Jerome* (cat. 35), while keeping in mind Caravaggio's paintings of the
same subject – for example the *Saint Jerome*s at the Borghese Gallery and in
Montserrat, the lattter of which has sometimes been identified as the one that
belonged to Benedetto Giustiniani[49] – exhibits a more dramatic use of chiaroscuro,
defining the muscles of saint's arm, as it mercilessly highlights the advanced age that
has crept over his flesh and tinges his beard and hair with white and grey. In *Saints*

Fig. 71 Orazio Borgianni, *Portrait of a Cardinal (St. Bonaventura?)*, c. 1610–16, oil on canvas, 87.6 × 74.9 cm. The Norton Simon Foundation, Pasadena

Cat. 37 (*facing page*) Michelangelo Merisi da Caravaggio, *Saint Augustine*, 1600

Peter and Paul (cat. 36), a scroll unfurled at centre complements the opened book while Saint Paul's serious, luminous face is contrasted with Saint Peter's fierce profile, as if the two are actually in a dispute over the the large scroll.[50] The lowered eyes and concentrated gazes – as in Ribera's *Saint Anthony Abbot* in Barcelona or Cavarozzi's aforementioned *Saint Jerome with Two Angels* – characterize these severe portrayals of saints by Caravaggist painters who focused on the modulation of light and dry but intensely described still-life passages that delineate pages, folded papers, and variously closed, open and foreshortened volumes with broken bindings. Caravaggio's composition of *Saint Augustine* (cat. 37) is considered the model for these descriptions of books and pens, as well as the Saint Matthew and Saint Jerome mentioned above. This work corresponds to the canvas mentioned at Vincenzo Giustiniani's residence, but it may already have belonged to his brother Benedetto around 1600, the most plausible date for the painting, by comparison with the witnesses in the *Martyrdom of Saint Matthew* in the Contarelli Chapel and the palette of the Odescalchi *Conversion of Saul*.[51]

The *Saint Matthew and the Angel* and *Saint Augustine* obviously served as references for painters who had access to the Palazzo Giustiniani such as Régnier, Ribera and Cavarozzi, the latter documented as being in close contact with Giovan Battista Crescenzi.[52] The *Saint Augustine* may also have been in the mind of Orazio

Borgianni, if he is the author of the *Portrait of a Cardinal* (fig. 71) as a similar sensitivity emerges in the construction of the figure writing and in the descriptive care of the fingers on which the light lingers. Borgianni was attracted as much by the new naturalism of Caravaggio as he was by the grand sixteenth-century tradition, starting with the school of Raphael. Absent from Rome between the end of the sixteenth century and the beginning of the next, Borgiani created several images of the Holy Family and saints employing a tenebrism that filled their faces with black shadows and frayed the figures' outlines. The *Saint Christopher* (cat. 38) is likely datable to around the time of the great altarpieces that the painter executed between 1608 (the *Apparition of the Virgin* in Sezze Romano) and 1610–12 (the *Holy Family* at the Galleria Nazionale d'Arte Antica di Palazzo Barberini).[53] As has been noted, Borgianni was also inclined to experiment with other types of tenebrist painting, comparable, for example, to the style of Lanfranco, whose Caravaggio-inspired luminist experiments he seems to presage in the Sezze altarpiece. He spent long periods in Spain and continued to send works to Spain even after returning to Rome. He did not have a peaceful relationship with Caravaggio[54] and the two artists did not rely on the same patrons. Like Borgianni, other painters probably looked at Caravaggio's public works or had occasional opportunities to view those in private collections during their stays in Rome, particularly in the first decade. This is the case of the Spanish painter Juan Baptista Maíno, whose presence in Rome is attested in 1605 and between 1609 and 1610.[55] Probably immediately following his years in Italy, he painted a *Saint John the Baptist* (cat. 39) that is reminiscent of Caravaggio and in fact was once attributed to the Lombard master.[56] In the painting, an adolescent Saint John with a creamy light chestnut, rather than a red-coloured cloak plays with a lamb and holds a small wreath of brightly coloured flowers in his hand, the only chromatic accent in a painting based on browns, much like Caravaggio's paintings of the same subject. The main figure's pose, his face half-hidden in shadow – evoking that of the young hero in Caravaggio's *David and Goliath* at the Prado and the Corsini *Saint John the Baptist* – makes this painting one of the most intensely Caravaggist and Italianate paintings in Maíno's production. In the early seventeenth century, he must have wandered the streets of Rome in the company of his brother Melchiorre and Tanzio da Varallo, a painter from the Piedmont who from 1600, spent more than a decade in Central Italy.[57] The chronology of Tanzio's works and the question of his adherence to Caravaggism are still open to study, but an inclination to pathos and a further quest for dramatic synthesis in the construction of religious images seem to characterize the experience of the painters from Lombardy and the Piedmont who drew near to the works of Caravaggio in the first decade of the seventeenth century.

Cat. 38 (*facing page*) Orazio Borgianni
Saint Christopher Carrying the Infant Christ,
c. 1615

Cat. 39 (*page 240*) Juan Bautista Maíno
Saint John the Baptist Playing with a Lamb,
c. 1608–10

Cat. 40 (*page 241*) Antonio Tanzio da
Varallo, *Saint John the Baptist*, c. 1627–29

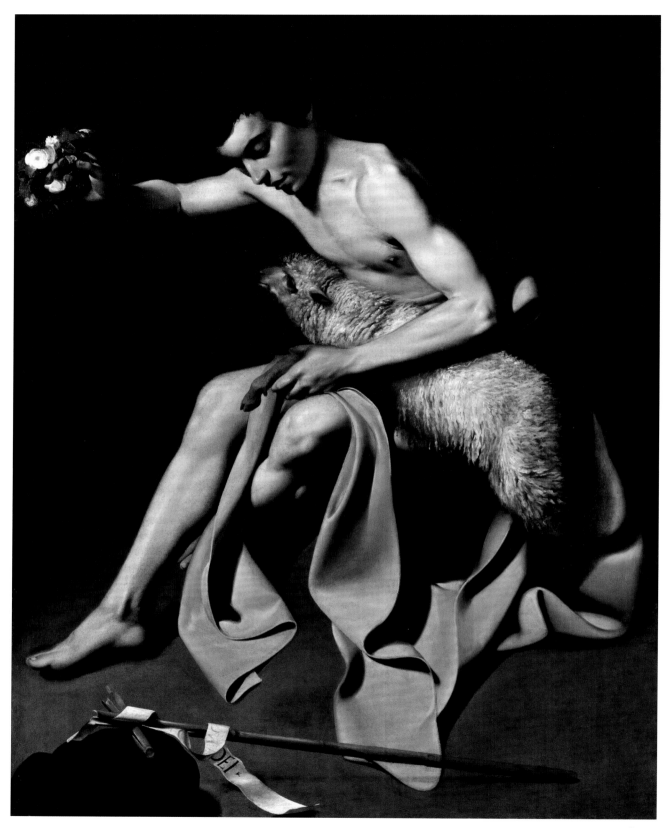

Tanzio painted the *Saint John the Baptist* (cat. 40) many years after his Roman experience, with the brilliant, nimble brushstroke of the frescoes he painted at the Sacro Monte in Varallo and in Novara between 1627 and 1629.[58] Though much remains of the Caravaggesque experience in this painting, and modern studies have thoroughly analyzed its relationship to Caravaggio's *Saint John in the Wilderness*, Tanzio's *Baptist* nonetheless makes explicit some iconographic details barely hinted at or entirely absent from Caravaggio's painting. Pointing to the lamb, this hermit Saint John looks heavenward with a feverish expression. The pathos of the image and the glistening palette bespeak Tanzio's new, more recent contacts with the Lombard milieu such as, for example, Daniele Crespi.[59]

The artists who knew Caravaggio in the first decade of the seventeenth century, even those who were passing strangers, studied and assimilated his style in an original manner, often blending it with a variety of experiences. Moreover, even for the painters considered to be his "followers," the adoption of the master's style is discernible only at intervals in works that can be securely dated before 1610. At this time, Carlo Saraceni was still almost entirely influenced by another type of naturalism, that of Adam Elsheimer, which was equally demanding but focused on the contrast of light and shadow and the quality of the air and atmospheric variations that has been called, in an anachronism that hits the mark, *plein air*.[60] Elsheimer's influence is also evident in the works of Maíno executed during the years he was in Rome.[61] Saraceni's work includes some references to Caravaggio, but only to his late sixteenth-century works, such as in the Camaldoli altarpiece, executed by Saraceni in 1608, followed a few years later by the *Saint Roch* at the Galleria Doria Pamphilij, Rome.[62] The *Holy Family in Saint Joseph's Workshop* (cat. 41) – in which the saint is represented in a carpenter' shop with materials and tools of the trade, animated by the presence of the baby Jesus and angels – is difficult to date.[63] The subject, also depicted by Gerrit van Honthorst and relatively dear to Caravaggist painting,[64] is treated with a brilliant colourism that defines Saraceni's entire production and is his main trait. The harmonies of pink and blue in the robes of the boy angel with soft, white wings are reused in reverse for the Christ child in an elegant instance of a lightened palette, the severity of the paintings for Santa Maria dell'Anima having subsided.[65]

Baglione describes Saraceni as a Francophile although he did not speak the language. Saraceni was accustomed to the company of such French artists as Jean Leclerc and Guy François – to whom works formerly attributed to Saraceni have sometimes been ascribed.[66] One of Saraceni's closest collaborators, perhaps a Frenchman, was devoted to interior scenes, had a great talent for still life and was

Cat. 41 (*facing page*) Attributed to Carlo Saraceni or Guy François, *The Holy Family in Saint Joseph's Workshop*, c. 1615

Cat. 41

largely responsible for developing Saraceni's interest in everyday objects detailed by the light so that they stand out among the painting's main figures. This as yet nameless painter, referred to as "Pensionante del Saraceni," was likely familiar with one of the paintings by Caravaggio that had inspired Saraceni: *Martha and Magdalene* (cat. 47). Some of Martha's distinctive features – her slightly opened mouth, and her hands gesturing peremptorily toward her sister – were reused for the maid in *The Denial of Saint Peter* (Rome, Pinacoteca Vaticana) as well as for the maids that bustle about in the Pensionante's kitchen scenes, often as main figures.[67] What relates these paintings to those of images of saints like the *Penitent Saint Jerome in His Study* (cat. 42) – ambitious for its scale alone – is the precise treatment of the objects arranged around the saint to convey facts about his life, to define the space of the painting or to fill the silence of a kitchen, study or meditation prior to martyrdom. Except for the version of the *Denial of Saint Peter* in Douai, the Pensionante does not seem to have indulged in the shrill, luminous colourism that constituted a part of Saraceni's production, thus maintaining, as in the *Cook* at the Pitti Palace, a brown palette that characterizes the work of Caravaggio in the years around 1600. In the *Saint Jerome* – datable to about 1615, even in the absence of definite references for the painter's development – one notes, besides the presence of the Caravaggesque prototypes of the same subject, there is a similarity to the paintings ascribed to Francesco Buoneri, called Cecco del Caravaggio, not coincidentally another Caravaggist painter inclined to produce splendid still lifes with objects.

Letters, seals and the martyr's gridiron surround the figure in the *San Lorenzo* by Cecco del Caravaggio (cat. 43), who was long suspected to be of French origin until he was identified with Francesco Buoneri, a painter from Lombardy.[68] The saint depicted with the deacon's purple dalmatic, martyred in the early centuries of Christianity for having distributed the community's possessions to the poor, is seated in prayer leaning against the grill on which he would be burned alive and the logs used for the fire – the instruments of his martyrdom. The composition, which places the half-figure behind a parapet on which various objects are exhibited, has been traced back to the type adopted by Caravaggio in his early paintings, while the sharp chiaroscuro contrasts on the figure's face and hands recall the master's more mature luminism, evident in his work after the Contarelli chapel. The attention to realism, particularly convincing in the folded hands on which the saint rests his cheek and in the texture of the fabric, reveals Cecco's Lombard roots, also evident in his still-life representation in the extreme foreground: the palm branch, the book's corner and the medallion protrude almost beyond the pictorial space, which is closed off and delimited by the parapet. Compared with the artist's mature achievements, the many

Cat. 42 (*facing page*) Pensionante del Saraceni, *The Penitent Saint Jerome in his Study*, c. 1615

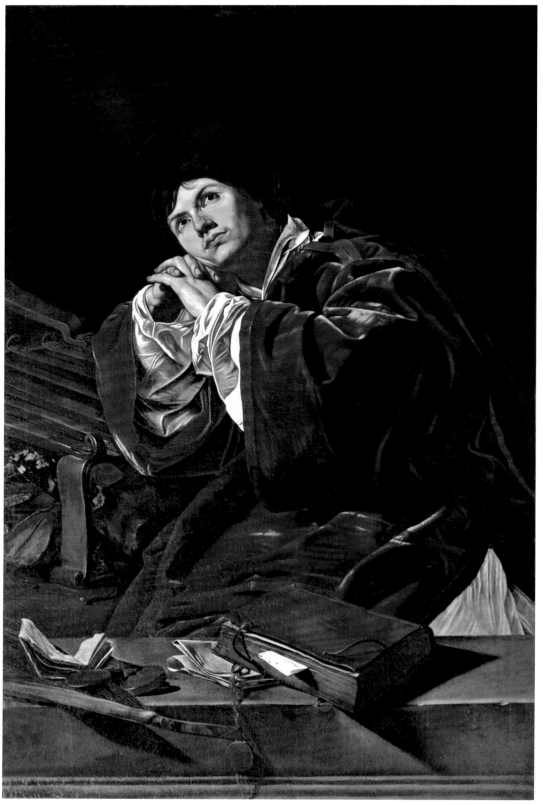

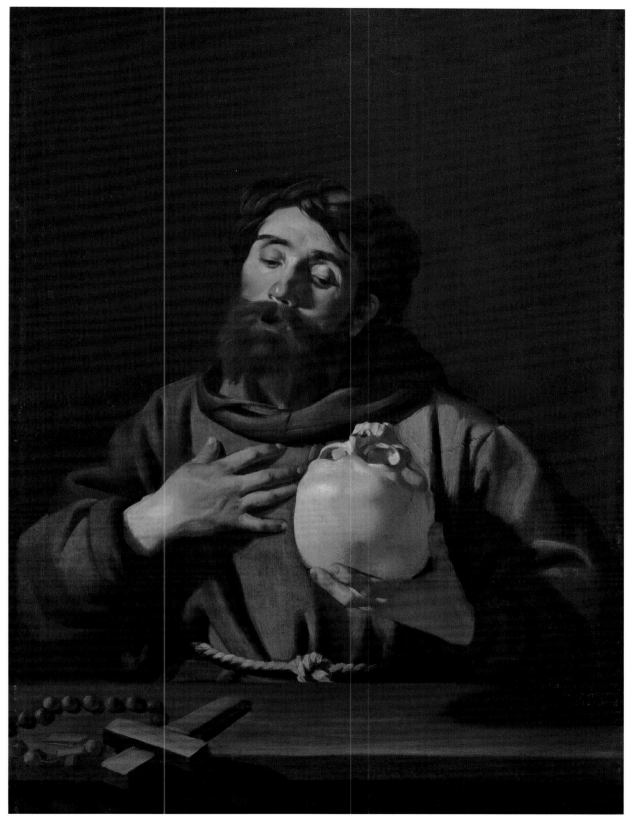

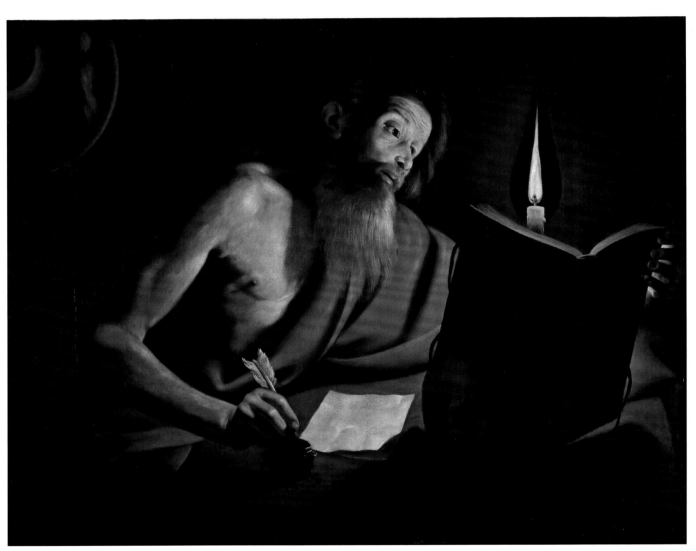

Cat. 45

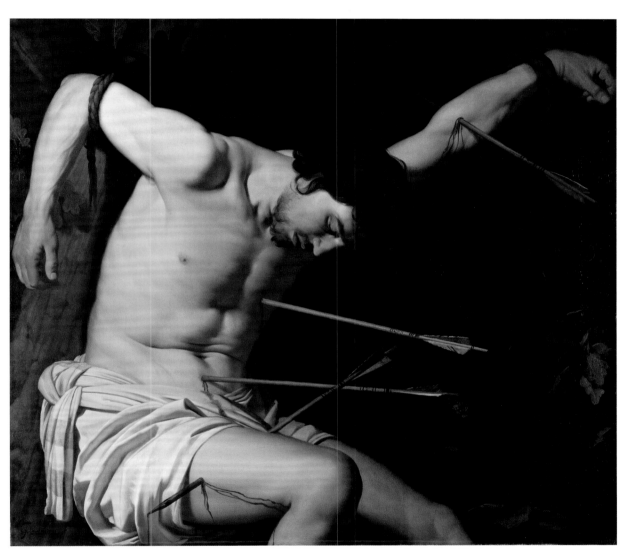

Cat. 46

NOTES

1. Mancini 1956–57, vol. I, p. 108.

2. Bellori 2005, p. 185.

3. On the painting and its collection history, see most recently Terzaghi 2007, pp. 273–275. Its presence in the Genoese banker's collection has been suggested by Spear 1971 from the presence of a copy of the painting in the church of Conscente, Liguria, decorated by Costa starting at the time it was consecrated in 1606

4. Costa 1624, I, cc. 367 r. v.

5. Van Mander 1604, trans. in Hibbard 1983, pp. 344–345.

6. Mancini, trans. in Hibbard 1983, p. 350

7. On the difficulty of demonstrating that Caravaggio was aware of some extraordinary prototypes, such as the *Saint Francis* of El Greco, see Gregori in New York 1985, pp. 294 ff.

8. Terzaghi 2007.

9. See Gregori, in New York 1985, pp. 294 ff, for the story of the discovery and early restorations of the two paintings; Gregori considers only the one at Santa Maria della Concezione in Rome authentic. See R. Vodret, in Bergamo 2000, pp. 217–219, for the results of the restoration of the *Saint Francis* in Carpineto, in which the attribution is confirmed and a date to the artist's last years proposed. For a summary of opinions and hypotheses on the commissioning of the two paintings, see the note by S. Macioce in Macioce 2003, pp. 5–8, and R. Vodret, "I doppi de Caravaggio," in Stockholm 2010, pp. 17–25.

10. Longhi 1943, p. 17; Mahon 1951, p. 234; New York 1985, pp. 310–312, which suggests a date of 1606, just after Caravaggio left Rome and before he arrived in Naples.

11. See M. Pupillo, "I San Francesco in meditazione di Caravaggio di Cremona e di Carpineto. Appunti di iconografia," in Ebert-Schifferer et al. 2007 for the identification of the Bible-reading episode in the *Life of Saint Francis* by Bonaventura da Bagnoregio.

12. Gregori 1985, loc. cit., and Gregori in Barcelona 2005, pp. 60–63.

13. See Askew 1969 for the iconography of Saint Francis within the new order of Capuchins; Pupillo in Ebert-Schifferer, et al. 2007.

14. L. Spezzaferro, "Ottavio Costa e Caravaggio: certezze e problemi," in Cinotti and Nitto 1975, p. 113.

15. Terzaghi 2007, for new insights and discussion on the patronage of Costa.

16. Longhi 1952, p. 24.

17. Calvesi 1954, p. 131.

18. Mahon 1952, p. 227.

19. Askew 1969 continues to be the seminal essay on the iconography of this painting.

20. Ibid.

21. Christiansen in Rome 2001 for the stronger attraction exerted by the works placed on altars and for the various versions of *Saint Francis with an Angel* by Orazio Gentileschi, pp. 50–55, 61–63, 110–112.

22. For this painting in a private collection and for its dating, see Christiansen in Rome 2001, no. 3, pp. 53–55.

23. Vodret in Hartford 1998, pp. 71-74; Christiansen in Rome 2001, n. 21, pp. 110–112.

24. See in this regard the reflections of Christiansen in Rome 2001, pp. 113-114.

25. Schütze 2009, pp. 288–289, no. 70, for a supporting opinion and the critical history.

26. Bologna 1987 and Bologna 2006, pp. 237–262; 465–471.

27. For this relationship and for the previous attribution to Caravaggio of the *Lute Player* as well, see Christiansen in Rome 2001, pp. 113–114.

28. For a summary of the inventory citations, see F. Cappelletti, "Il lusso e l'ordine: origini e storia della collezione Doria Pamphilj," in Milan 1996, pp. 38–39.

29. F. Scannelli da Forlì, *Il microcosmo della pittura, overo Trattato diviso in due libri* (Cesena, 1657), p. 277.

30. Bellori 2005, p. 180.

31. Zeri 1976, pp. 444–445.

32. Papi 2003, pp. 133–134, no. 16, proposes a fascinating and convincing parallel with Paulus Bor, which remains unproven.

33. Bellori 2005, p. 180.

34. Frommel 1971; Aronberg Lavin 1975; Cinotti 1983.

35. On this question, see Cappelletti 2009, p. 47.

36. Malvasia 1678.

37. An later dating, to which we shall return, is given by Papi in Florence 2010.

38. The Giustiniani painting was in Berlin in 1945; for references to it in inventories of the collection, see Salerno 1960 and Danesi Squarzina 2003, pp. 388–389.

39. Baglione 1642.

40. The Contarelli documents are known thanks to H. Röttgen, "Giuseppe Cesari, die Contarelli-kapelle und Caravaggio," in *Zeitschrift für Kunstgeschichte*, 27 (1964), pp. 205, 207–208, trans. into Italian in Röttgen 1974, pp. 11–44; some of the contracts were given in A. Bertolotti, *Artisti lombardi a Roma nei secoli XV, XVI e XVII. Studi e ricerche negli archivi romani*, II (Milan, 1881), pp. 119–120, then transcribed in full by M. Cinotti, in G.A. Dall'Acqua and M. Cinotti, *Il Caravaggio e le sue grandi opere da San Luigi dei Francesi* (Milan 1971), pp. 146 ff.

41. I. Lavin, "Divine Inspiration in Caravaggio's Two Saint Matthews," *Art Bulletin*, 56:1 (Mar., 1974), pp. 59–81.

42. Although the reference might also be to the Contarelli *Saint Matthew*.

43. Lemoine 2007.

44. See Lemoine 2007 for a convincing overall interpretation of the style and the role of Régnier during his years in Rome.

45. Papi in Florence 2010, p. 142, no. 16; Benedetti in Milan 2005, p. 438; G. Papi. "Nuove considerazioni sul naturalismo caravaggesco a Firenze," in *Artemisia*, exh. cat., ed. R. Contini and G. Papi (Florence

1991), p. 209, who first linked the work with the documents reporting the acquisition of a Cavarozzi painting by the Florentine court in 1617, published by Corti 1989.

46 Papi in Florence 2010, p. 142.

47 Papi 2002; Spinosa 2003.

48 For the relationship between Giustiniani and Ribera, see S. Danesi Squarzina in Rome and Berlin 2001 and Danesi Squarzina 2003; for the period in Rome and the new conclusions on the profile of Ribera, see G. Papi, "Jusepe de Ribera a Roma e il Maestro del Giudizio di Salomone." in *Paragone*, 44 (629), 2002, pp. 21–43.

49 Danesi Squarzina 2001, pp. 294–295.

50 Spinosa 2006, pp. 267–268.

51 See D. Franklin, "The Public Caravaggio," this volume, pp. 2–25.

52 For this connection and the relationship between the Crescenzis and the Giustinianis, refer to Pupillo in Ebert-Schifferer et al. 2007.

53 Vodret in Milan 2005; Papi 1993.

54 Baglione 1642; Papi 1993.

55 Finaldi in Madrid 2009, for Maíno's years in Italy and the works that caught his interest in Rome.

56 Ruiz Gómez in Madrid 2009, pp. 103–105, no. 11, for the critical history and a dating of 1608–10. In fact the iconographic reference to works by Spanish artists suggests execution immediately following the years in Italy. In 1611, the artist is documented in Toledo.

57 On Tanzio and Lombard and Piedmont painters in Rome in the sphere of Caravaggio and the Caravaggists, see see M.C. Terzaghi, "'Quasi tutti li pittori di Roma': i piemontesi", in Romano 1999, pp. 15–48; and especially the monographic exhibition Milan 2000.

58 Townsend, in Townsend–Ward 1995-96 and Townsend, in Milan 2000, pp. 129–132, entry 29.

59 Frangi in Milan 2000, for the comparison and a slightly later dating.

60 M. Chiarini, "Filippo Napoletano, Poelenburgh, Breenbergh e la nascita del paesaggio realistico in Italia," *Paragone*, 269, pp. 18–34.

61 See entries in Madrid 2009.

62 Ottani Cavina 1968; G. Capitelli, "Una testimonianza documentaria per il primo nucleo dalla raccolta del principe Camillo Pamphilj" in Milan 1996, pp. 57–69.

63 Ottani Cavina 1968; Zafran in Hartford 1998; Zafran in Rimini 2010.

64 In general quite uncommon, it had a certain success in the sphere of Caravaggio; see Nicolson 1991.

65 The paintings of the Story of Saint Benno at the German national church in Rome have been definitely dated to 1616, as suggested by Longhi; Ottani Cavina 1968; and M.G. Aurigemma, "Carlo Saraceni, un Veneziano a Roma" in Capitelli and Volpi 1995, pp. 117–138.

66 The most glaring case is probably the *Saint Cecilia* in the Galleria Nazionale d'Arte Antica di Palazzo Barberini, see Vodret in Rome 1999 for the critical matters.

67 For the construction of this group, Longhi 1943; Benedetti in Milan 2005; for the critical history and a further interpretation, see Papi in Florence 2010.

68 G. Papi, "Pedro Nunez del Valle e Cecco del Caravaggio (e una postilla per Francesco Buoneri)" *Arte Cristiana* 79 (1991), pp. 39–50.

69 Papi in Milan 2005.

70 Contini in Rome and Berlin 2001.

71 L. Lorizzo in Rome and Berlin 2001, pp. 312–313; S. Danesi Squarzina in Rome and Berlin 2001, pp. 314–315; Judson and Ekkart 1999.

72 For the critical history and the commission, A.M. Rybko in Rome 1990, pp. 257–260.

73 Nicolson 1990; Papi 1998 and Papi 1999; for a new analysis of the critical question, Prohaska in Milan 2005, pp. 99-102.

74 Nicolson 1960; J.-P. Cuzin, "Trophime Bigot in Rome: a suggestion," *Burlington Magazine* 121 (1979), pp. 30–305; Papi 1998; Vodret in Rome 1998.

75 Judson and Ekkart 1999, pp. 80–83, 70–72.

76 I. Lavin, "Five new youthful sculptures by Gianlorenzo Bernini and a revised chronology of his early works." *Art Bulletin* 50 (1968), pp. 223–248; Judson and Ekkart 1999.

following pages Michelangelo Merisi da Caravaggio, *Martha and Mary Magdalene* (detail of cat. 47)

STAGING RELIGIOUS HISTORY
FOR COLLECTORS AND CONNOISSEURS

SEBASTIAN SCHÜTZE

Wᴇɴ Cᴀʀᴀᴠᴀɢɢɪᴏ ᴀʀʀɪᴠᴇᴅ ɪɴ Rᴏᴍᴇ in the summer of 1592, he did not immediately find a path paved with gold. He had neither fame nor the privilege of an established patronage system.[1] The young painter had to carve out his niche on the highly competitive Roman art market to secure both personal and artistic independence. He started with small half-length figures such as the *Sick Bacchus* (cat. 2) and the *Boy Bitten by a Lizard* (cat. 3) moving progressively to larger, multi-figure compositions such as *Cardsharps* (cat. 17) and the *Gypsy Fortune Teller* (cat. 13). His innovative choice of subject matter, purposefully transgressing and infringing the boundaries of traditional pictorial genres, together with his stunning naturalistic modelling drew the attention of passionate collectors and connoisseurs such as Francesco Maria del Monte. The cardinal offered Caravaggio hospitality in his palace and, most importantly, introduced him to the inner circles of the Roman art world. Soon he began to paint religious subjects, again moving progressively from single figures such as the *Penitent Magdalene* (cat. 31), to more complex narratives such as the *Flight into Egypt* (Rome, Galleria Doria Pamphili), and finally to his first large-scale public commission, the spectacular side panels for the Contarelli chapel in San Luigi dei Francesi, executed in 1599–1600. From that point on his career was marked by a long series of prestigious commissions for churches and chapels in Rome, Naples, Malta and Sicily as well as a series of religious narratives executed for some of the most important and sophisticated collectors of his time. With these paintings, executed in half-length, Caravaggio created a revolutionary new genre of gallery pictures that was widely employed and further developed by his many followers throughout Europe.

Leon Battista Alberti had defined *historia* in his 1435–36 treatise *De Pictura* (On Painting) as the highest artistic genre, the "*ultimum et absolutum pictoris opus.*"[2] Alberti's definition remained authoritative for Caravaggio's contemporaries, including Giambattista Armenini, Giovanni Paolo Lomazzo, and Cristoforo Roncalli, and indeed for the entire early modern period. *Historia* comprised all forms of "narrative action" and thus mythological, historical and religious subjects, but within the genre religious narratives clearly played a dominant role especially in the Counter-Reformation age. The half-length format had been employed for religious narratives in Northern Italy since the fifteenth and sixteenth centuries.[3] Key examples include Andrea Mantegna's *Presentation at the Temple* (Berlin, Gemäldegalerie), Giovanni Bellini's *Lamentation* (Stuttgart, Staatsgalerie), Titian's *Christ and the Adulteress* (Vienna, Kunsthistorisches Museum), Giovanni Cariani's *Christ on his Way to Calvary* (Brescia, Pinacoteca Tosio Martinengo), Sebastiano del Piombo's *Martyrdom of Saint Agatha* (Florence, Galleria Palatina) and Lorenzo Lotto's *Christ and the*

Cat. 47 (*facing page*) Michelangelo Merisi da Caravaggio, *Martha and Mary Magdalene,* c. 1598

Adulteress (fig. 73). Compared with a full-length representation, the half-length format provoked a dramatic close-up effect, emphasizing immediacy and physical presence of the protagonists. Such foregrounding of action bridged the representational gap between the picture and its beholder and aimed for strong emotional responses. Over the course of the late fifteenth and early sixteenth centuries such artists as Antonello da Messina, Giovanni Bellini, Giovanni Cariani, or Lorenzo Lotto had explored ways of charging iconic images of the Passion Christ presenting his wounds, the crown of thorns, or carrying his cross with increasingly narrative elements through expressive gesture and mimic or the introduction of additional mourning figures.[4] Such *Andachtsbilder* – devotional images normally bust- or half-length – combined the hieratic power of the iconic image with the affective potential of the narrative. In the half-length narratives, painters adopted similar representational strategies to bring religious history literally "closer" to the beholder and stir his compassion. The boundaries between the two genres, an *Andachtsbild* of the Passion Christ highly charged with narrative elements such as Antonello da Messina's *Pietà with Angels* (Madrid, Museo del Prado) and a half-length narrative such as Sebastiano del Piombo's *Ubeda-Pietà* (Seville, Fundación Casa Ducal de Medinaceli), became increasingly fluid, as indicated also by the very same Italian term *Pietà* applicable to

Fig. 74 Ludovico Carracci, *Taking of Christ* (or *The Kiss of Judas*), after 1589–90, oil on canvas, 80 × 97 cm. Museum purchase, Fowler McCormick, Class of 1921, Fund, Princeton University Art Museum, Princeton

both paintings. Later in the sixteenth century, painters continued to adopt the half-length format in such paintings as Luca Cambiaso's *Adoration of the Magi* (London, private collection), Ludovico Carracci's *Taking of Christ* (fig. 74) or Palma il Giovane's *Christ and the Adulteress* (Genova, Palazzo Bianco). But these half-length paintings remained the exception and were almost unknown in central Italy. Caravaggio was well aware of this tradition from his early years in Lombardy and set off to fully explore the expressive potential of the genre in his Roman years.

Caravaggio first employed the half-length format for two religious narratives executed in 1598–99, the *Martha and Mary Magdalene* (cat. 47) and the *Judith and Holofernes*. The *Martha and Mary Magdalene* was probably commissioned by Olimpia Aldobrandini and is first documented in an inventory of her collection in 1606. After her death in 1637, the painting passed to her son, Cardinal Ippolito Aldobrandini, and was unmistakably described in his 1638 inventory: "A picture in horizontal format with a Magdalene and Martha, with a flower in her hand, in a black frame decorated with golden arabesk ornaments." The work stayed in the Villa Aldobrandini a Magnanapoli until the late eighteenth century, and was acquired by the Detroit Institute in 1973. In his first religious painting, the 1595–96 *Penitent Magdalene* for Girolamo Vittrici (cat. 31) Caravaggio emphasized the transitional moment of

Magdalene's conversion, her inner conflict and personal drama, rather than simply show the beautiful sinner or the ascetic penitent. A similar revision of traditional iconography also characterizes his painting in Detroit. Magdalene and her sister are arranged behind a wooden table. The compositional scheme was likely suggested by a representation of the same subject, which at the time belonged to the collection of Cardinal del Monte and was adorned with the name of Leonardo. Now attributed to Bernardo Luini and known in several versions (The San Diego Museum of Art), the painting offered Caravaggio a point of departure for his radically different reading of the story. Martha and Mary Magdalene are engaged in intense dialogue. The latter is turned frontally towards the viewer in the centre of the composition and looks across at her sister. Her left arm rests upon a framed convex mirror. Martha addresses her with her lips slightly parted, the rhetorical gesture of her hands seeming to reinforce her words. The significance of the moment and the narrative sequence of events are illuminated above all by the handling of the light, which symbolizes the action of the divine. Thus the light is most brilliant on Mary Magdalene's face and breast, lending her skin an almost porcelain smoothness. Illuminated by divine grace, she experiences her conversion, a moment of mystical union with God. Although her eyes are wide open as she looks towards her sister, whose face is veiled entirely in shadow, the Magdalene's gaze seems to be turned first and foremost inwards. To conjure this dramatic transitional moment of conversion, the artist has dressed Magdalene in an elegant gown and included the comb and powder jar on the table in reference to her former life of sin and luxury, while the sprig of orange blossom in her right hand and the slender gold band on the ring finger of her left hand characterize her as His mystic bride. The mirror is not one of the Magdalene's traditional attributes and thereby assumes a particular importance. Bundled like a prism, the divine light is reflected in the circular surface of the convex looking glass. This symbol of vanity, as familiar from *vanitas* allegories and representations of Venus at her toilette, had been used for similar purposes by the worldly Magdalene, but has now become a symbol of reflection and divine illumination. The radical transformation of the mirror's significance thus becomes a powerful metaphor for the spiritual experience of conversion.

Caravaggio's invention inspired important paintings by Orazio Gentileschi and Simon Vouet. Both differ greatly and explore distinct aspects of the theme. Vouet's version (cat. 48) can be dated to the early 1620s. It reverses Caravaggio's composition but otherwise follows it closely, from the general arrangement of figures behind the table to the rhetorical gestures of Martha's hands and the symbols of Magdalene's sinful life including the prominent convex mirror. At the same time Vouet has given

Cat. 48 (*facing page*) Simon Vouet,
Martha and Mary Magdalene, c. 1621

much more emphasis to Magdalene's vanity and life of luxury through her beautifully painted, shimmering silk dress and her exquisite jewellery, as well as through the oriental carpet on the table and the elaborately carved Siren holding the mirror. Her vain and capricious nature seems to be embodied by the affected movement of her right arm, and might be inspired directly by a kneeling ancient statue of Venus, at the time in the Massimi collection in Rome (Madrid, Museo del Prado).[5] Magdalene was engaged in her toilet, arranging the fanciful red hair ribbon in front of the mirror. She has just turned towards her sister, but Martha's admonishments do not yet seem to have found an open ear. Vouet's painting does not explore the spiritual intensity of the Detroit picture and its subtle symbolism of light and shadow. It represents indeed a slightly earlier moment in the narrative. His extravagant, courtly Magdalene conveys extraordinary beauty and elegance, but seems almost unaffected by the divine grace and illumination that will lead her to conversion. Accordingly, Vouet's eloquent Siren mirror is merely a symbol of vanity, while Caravaggio's mirror has been transformed into a powerful symbol of divine illumination.

Gentileschi's *Martha and Mary Magdalene* (fig. 75), executed during his Roman sojourn around 1615, uses stronger chiaroscuro and a more tonal colour scheme. The compositional arrangement differs considerably from Caravaggio's painting. Martha is

Fig. 76 Michelangelo Merisi da Caravaggio, *Judith and Holofernes*, 1599, oil on canvas, 145 × 195 cm. Galleria Nazionale d'Arte Antica, Palazzo Barberini, Rome

standing on the left, bending forward to address her sister. Magdalene is seated in front of her mirror and has just turned around to listen. Gentileschi emphasises the intense dialogue between the sisters, made palpable through their physical closeness, their gestures and gazes. Martha wears a mantle around her shoulders and a transparent veil on her head, while Magdalene keeps her dark blonde hair loose and exposes her décolleté. The differences between the two sisters are much less marked than in Vouet's picture, where the sober handling of the Martha figure seems almost to indicate a different hand. Gentileschi's Magdalene is dressed in a rather unadorned mauve gown, with no jewellery at all and holds a simple rectangular mirror. While Caravaggio emphasizes Magdalene's divinely inspired conversion and Vouet the vanity of her luxurious life, Gentileschi brings the intense dialogue between the sisters and the effects of Martha's admonishments to the fore.

The *Judith and Holofernes* (fig. 76), considerably larger in size than the Detroit picture, was probably commissioned by Ottavio Costa, a Genovese banker resident in Rome and is first documented in his 1632 testament. It remained in the family until the early nineteenth century and was acquired for the Galleria Nazionale d'Arte Antica in 1971. The painting illustrates the Old Testament account in the Book of Judith (13:7–8). The protagonists appear in the immediate foreground of an interior

indicated in only the barest detail. Judith, accompanied by her maid Abra, has entered the tent of Holofernes, who is lying drunk on his bed. With her left hand she has seized the Assyrian general by the hair and is halfway through severing his head from his trunk with the sword in her right hand. Holofernes' powerfully modelled body convulses as blood spurts in broad streams from his throat, and his face distorts with pain and shock. Providing a backdrop to the dramatic event is an artistically draped red curtain that refers to the setting of the scene – inside Holofernes' tent – and at the same time lends it the quality of a theatrical performance. The entire composition is determined by tension-laden opposites. Judith, aptly characterized by Roberto Longhi as the "Fornarina of Naturalism" in reference to Raphael's famous portrait, seems no match for the mighty Assyrian general.[6] She looks with evident horror at the pain-distorted face of her victim and, with her arms held out at full length, seems to keep as much distance as possible, indeed to recoil from the dreadful, bloody deed that she must nonetheless carry out to save her people. Her youthful beauty and the erotic charms with which she captivated Holofernes – and thus gained access to his tent – are accentuated by the old maid at her side. The latter is staring at the scene, standing ready with a dark sack in which to conceal Holofernes' severed head, which Judith will then present triumphantly to the people of Israel as proof of their liberation. The maid's almost grotesque facial expression thereby provides an effective foil to Judith's sensitive psychological characterization. All three figures are undoubtedly executed *dal naturale*. Whereas paintings of the subject traditionally showed either the moment before Holofernes' decapitation or the triumphant Judith bearing his already severed head, Caravaggio has chosen the dramatic climax of events. He is interested above all in depicting extreme emotions and the psychological dimension of the drama. The emphasis placed upon Judith's all too human weakness only reinforces the significance of her heroic deed. Caravaggio has transformed the Old Testament story into a *teatro degli affetti* of great psychological impact and impressive physical presence.

Among the interpreters of the Judith and Holofernes theme, Orazio and Artemisia Gentileschi are certainly the most prominent among Caravaggio's followers. Their representations explore different aspects of the Old Testament account and bring, at the same time, the artistic temperaments of father and daughter to the fore. Orazio has purposefully avoided the violent act of decapitation in all three of his paintings, choosing instead a later moment in time when Judith and her maidservant leave the tent of the Assyrian general. In particular the version in the Nasjonalmuseet in Oslo (cat. 49), datable to 1608–09, seems to emphasize a moment of calm reflection. With a mix of relief at having accomplished the terrifying mission and fear of being

Cat. 49 (*facing page*) Orazio Gentileschi, *Judith and her Maidservant with the Head of Holofernes*, c. 1608–09

Cat. 50 (*page 266*) Artemisia Gentileschi, *Judith Beheading Holofernes*, c. 1612–13

Cat. 51 (*page 267*) Claude Vignon, *Judith with the Head of Holofernes*, c. 1620

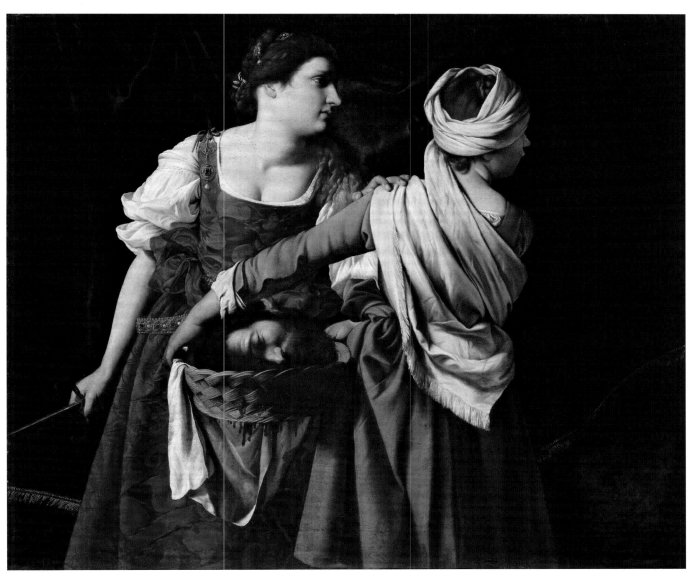

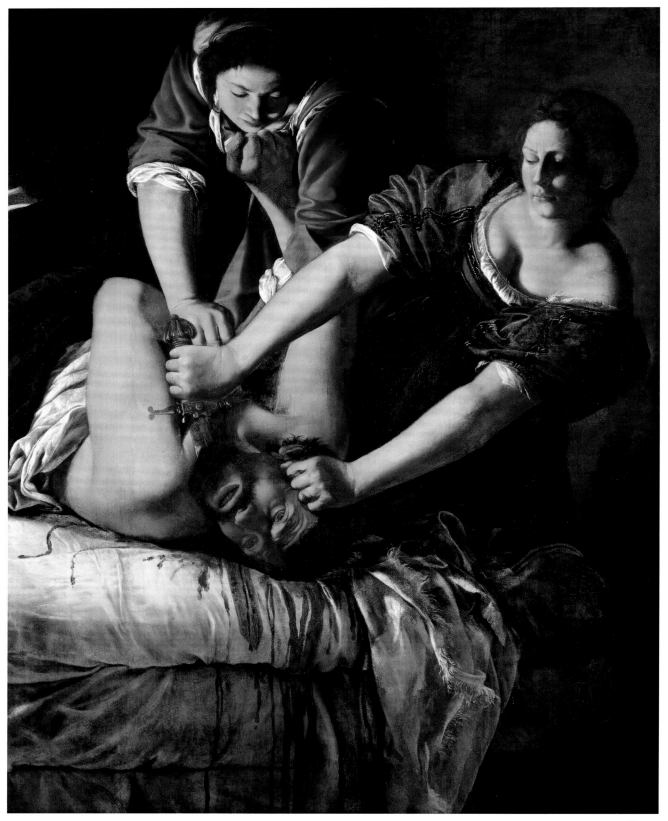

discovered, the two women look back at the bloody scene, which the viewer has to imagine outside the picture to the right. Judith is shown frontally in a beautiful red brocade dress and holding the sword in her right, while Abra is seen from the rear keeping with both hands a basket containing the head of Holofernes. Judith has posed her left hand reassuringly on her servant's shoulder, and both seem to form a solid block in the centre, as to underscore their common effort to kill the enemy. Like Caravaggio, Orazio plays on the contrast between sensual female beauty and the horrifying head of Holofernes with his blood still dripping on the white cloth. A sublime *contrapposto* that Giambattista Marino would describe in his *Galeria* with regards to Guido Reni's *Massacre of the Innocents* (Bologna, Pinacoteca Nazionale) as "l'horrore và col diletto," – horror goes with delight.[7] But compared with Caravaggio's violent action, Orazio decisively de-accelerates the narrative. He leaves it to the beholder to imagine the actual decapitation and prefers a more subtle and lyrical tone.

In her *Judith and Holofernes* (Florence, Galleria Palatina), painted in 1618–19, Artemisia Gentileschi follows her father's example closely, but renders the subject in slightly more dramatic terms by using a more restrained pictorial space and by accentuating her protagonists' anxious expression. Artemisia's most famous representations of the old testament heroine, today housed in the Museo Nazionale di Capodimonte in Naples (cat. 50), and in the Uffizi in Florence, are based directly on Caravaggio's painting. The Neapolitan version was painted around 1612–13 in Rome, shortly after her infamous rape and the following trial of Agostino Tassi, and has been interpreted almost as a kind of Freudian compensation. The composition is developed in a vertical format with the drunken Holofernes resting on his bed. Judith presses his head down and handles the sword with her right, while Abra tries forcefully from above to retain the struggling general. As in Caravaggio's painting, Judith is of extraordinary sensual beauty and performs the decapitation with outstretched arms to maintain a distance from her frightful, screaming victim. Streams of blood colour the white linen. Horror and delight are again the dominating theme, but Artemisia's heroine seems rather more confident than her famous predecessor. Most importantly, Caravaggio's grotesquely staring old servant has been replaced with a young maid who courageously assists Judith with her heroic task. Compared to Caravaggio's highly theatrical *mise-en-scène*, Artemisia offers a more turbulent, "realistic" hands-on interpretation.

Claude Vignon, the French painter from Tour is documented in Rome only from 1619–20 onwards, but probably arrived about a decade earlier in the eternal city. His painting from around 1620 is much smaller in format (cat. 51) and proposes a

Fig. 77 (*following page, top*) Michelangelo Merisi da Caravaggio, *Supper at Emmaus*, 1601, oil and tempera on canvas, 141 × 196.2 cm. Presented by the Hon. George Vernon, 1839, National Gallery, London

Fig. 78 (*following page, bottom*) Michelangelo Merisi da Caravaggio, *Incredulity of Saint Thomas*, 1601–02, oil on canvas, 107 × 146 cm. Gemäldegalerie, Schloß Sanssouci, Potsdam (Stiftung Preussische Schlösser & Gärten Berlin-Brandenburg, Berlin)

Fig. 79 (*page 271, top*) Bartolomeo Cavarozzi, *Supper at Emmaus*, c. 1615–25, oil on canvas, 139.7 × 194.3 cm. The J. Paul Getty Museum, Los Angeles

Fig. 80 (*page 271, bottom*) Hendrick ter Brugghen, *Incredulity of Saint Thomas*, c. 1621–23, oil on canvas, 108.8 × 136.5 cm. Rijksmuseum, Amsterdam

more traditional reading. Judith stands in the foreground and presents the head of Holofernes, while her maid is relegated to a secondary plane. The delicate young heroine, dressed in shimmering carmine red brocade with a pearl collier and fanciful feathered hat, looks overwhelmed and terrified at the viewer. Vignon carefully avoids any accentuation of the drama and hides Holofernes' bloody head in the shadow. The *Judith* presents a typical example of his elegantly dressed courtly heroes, mostly lost in their own narcissistic and often melancholic beauty. With his highly personal style, Vignon remained somewhat on the periphery of Caravaggism in Rome and after his return to France in 1623 quickly turned away from it in his grand commissions for Cardinal Richelieu and Louis XIII.

Caravaggio's *Martha and Mary Magdalene* and *Judith and Holofernes* interpreted religious history in a totally new way and soon caught the attention of other Roman collectors. Compared to public works, such gallery pictures were less restrained by counter-reformation *decorum* and offered Caravaggio greater freedom to develop a radically contemporary exegesis of biblical history. In rapid succession, he executed a spectacular series of such half-length narratives in the years 1601–03: the *Supper at Emmaus* (fig. 77) and the *Taking of Christ* (Dublin, National Gallery) for Ciriaco Mattei, the *Incredulity of Saint Thomas* (fig. 78) and the *Crowning with Thorns* (fig. 42, p. 115) for Benedetto and Vincenzo Giustiniani, and the *Sacrifice of Isaac* (Florence, Galleria degli Uffizi) for Maffeo Barberini. The extraordinary quality of these paintings as well as the prestige of their patrons quickly established these half-length pictures among collectors. Their theatrical lightning and stunning naturalism, their bold close-up compositions and their radical re-reading of textual sources and established iconographic traditions projected biblical history from the distant past right into seventeenth-century Rome. Each of these paintings caused numerous imitations and, more importantly, provoked a radically new take on religious history in general. Among the earliest and most original interpretations are Bartolomeo Cavarozzi's *Supper at Emmaus* (fig. 79), Bartolomeo Manfredi's *Taking of Christ* (Milan, Koelliker collection), Hendrick ter Brugghen's *Incredulity of Saint Thomas* (fig. 80) and Orazio Gentileschi's *Crowning with Thorns* (Braunschweig, Herzog Anton Ulrich Museum).

Caravaggio's *Sacrifice of Isaac* (cat. 52) was completed in 1603 for Maffeo Barberini, the later Pope Urban VIII. According to Genesis 22:1–13, following God's command, Abraham took his only son to the top of a mountain in the land of Moriah to sacrifice him there. Caravaggio's painting shows the dramatic climax of the biblical narrative. The powerfully built figure of Abraham, standing in the immediate foreground wearing ochre robes and wrapped in a red cloak, is on the point of

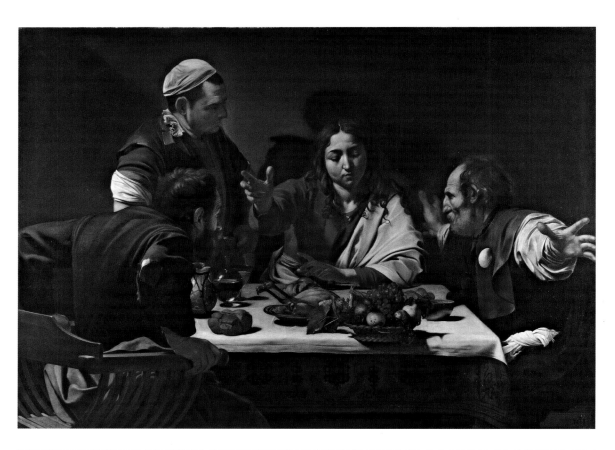

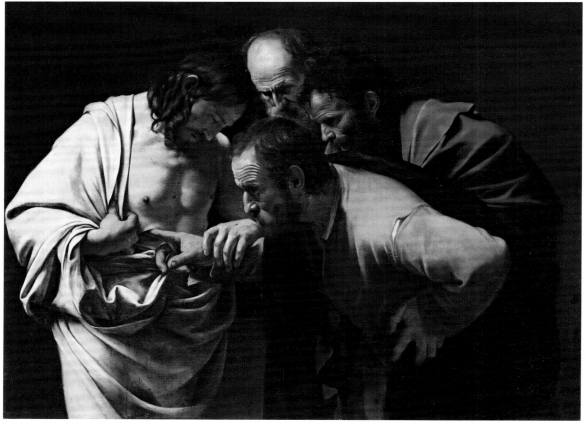

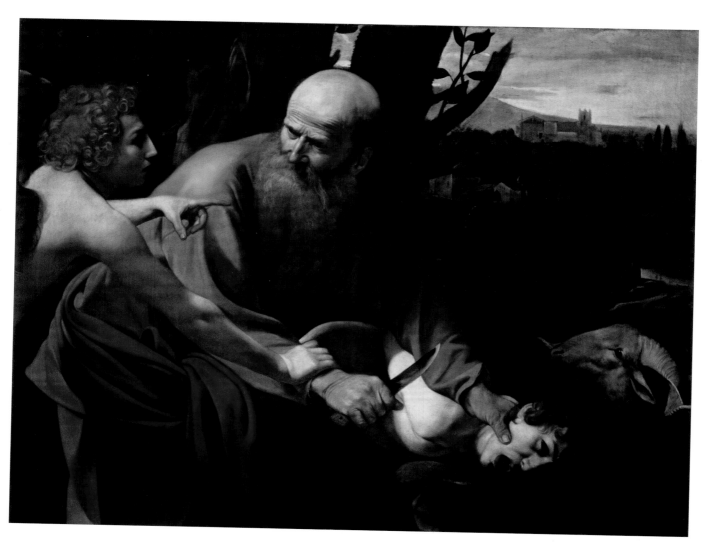

Cat. 52

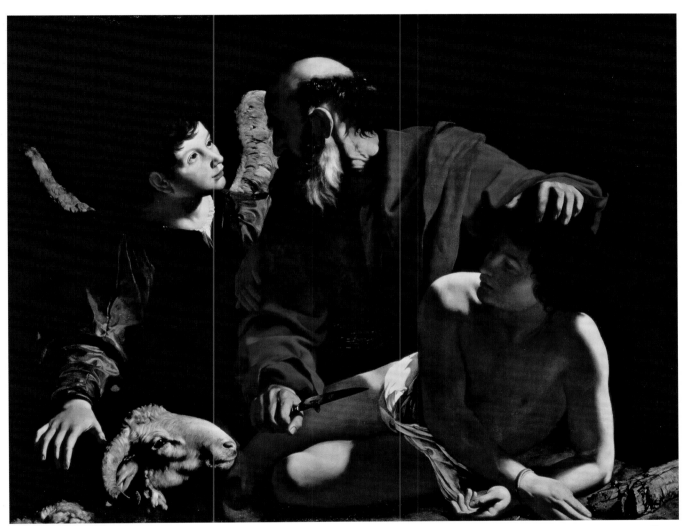

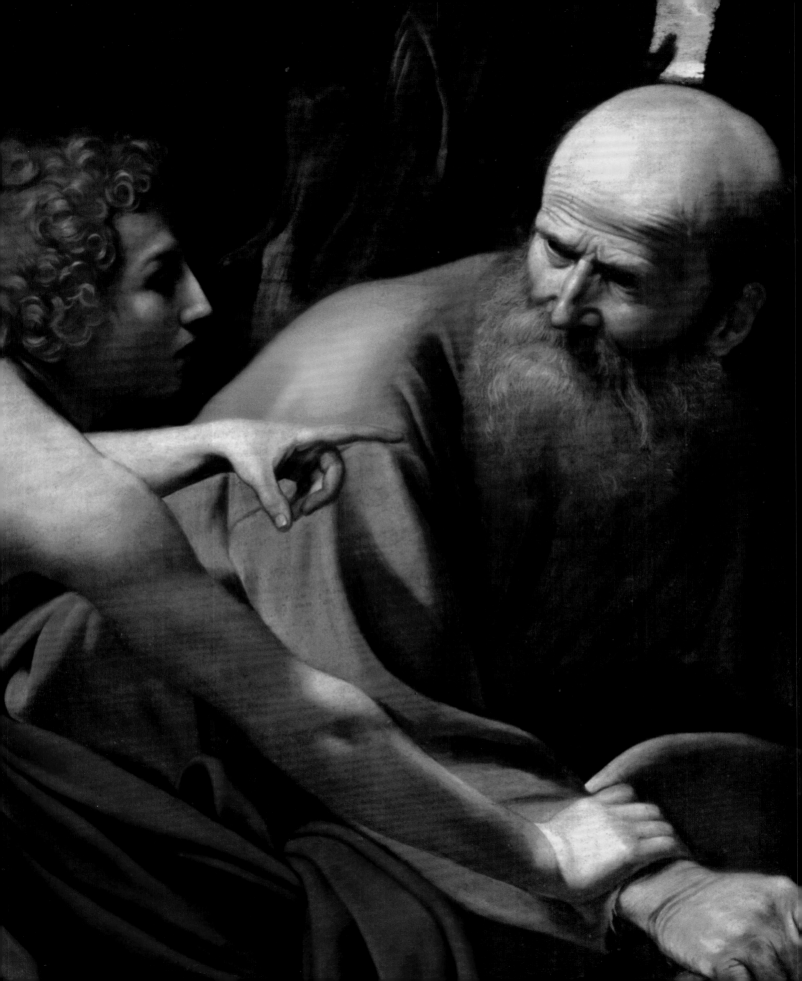

performing the sacrifice. He has seized Isaac, who is lying on the sacrificial altar, forcefully with his left hand and with his right holds the knife threateningly close to the boy's throat. Isaac, naked and twisting with his hands tied behind his back, turns his terrified gaze towards the viewer. At the last moment, the winged angel appearing from the left grasps the astonished Abraham's arm and with a pointing gesture of his left hand indicates that he is to sacrifice the ram in place of his son. The patriarch, prepared to sacrifice his only son, has passed the test and demonstrated his fear of God and his unconditional obedience. In typological terms the *Sacrifice of Isaac* refers directly to the Passion and Christ's sacrifice on the Cross. The scene is dramatically heightened by Caravaggio's naturalistic portrayal of the protagonists. Irritating and deviating from the biblical account and traditional iconography is the motif of the boy, who by no means accepts his fate and appears to struggle on the altar, filled with horror and dread. Abraham's unconditional obedience and resolve are contrasted with the all-too-human reaction of the unsuspecting boy.

Closely related to the Barberini painting is another *Sacrifice of Isaac* in the Barbara Piasecka Johnson collection (cat. 53). The composition is known in several versions, and its invention was first related to Caravaggio by Juan Ainaud in 1947. The painting in Lawrenceville first appeared on the art market in the early 1980s and is by far the best version preserved. Mina Gregori has published it in 1989 as an autograph work by Caravaggio and dated it to 1597–99. This attribution has been sustained by Maurizio Marini who dated the painting slightly later to around 1602. Other scholars, including Catherine Puglisi, John Spike, Ferdinando Bologna and, most recently, Marco Pupillo, Marieke von Bernstorff, and the present author have proposed instead an alternative attribution to Bartolomeo Cavarozzi. The extraordinarily beautiful and well-preserved painting has not been exhibited for many years, and its presentation in this context, we hope, will help to sustain its attribution. As in the Uffizi painting, Isaac is represented as an unusually adult boy and lies on the sacrificial altar right next to the picture plane. The beautifully designed body is painted from life and given in complex foreshortening. Abraham is standing just behind the altar. He is holding his son by the head and points his knife threateningly towards him. At the last moment a boyish angel has arrived from the left to invite the patriarch to sacrifice the ram instead. While in the upper right of the Uffizi picture the composition opens towards a hilly landscape, here the whole scenery is immersed in nightly dark. Everything is modelled with strong chiaroscuro and in a very naturalistic manner, including the head of the ram and the burnt log on the right. The two paintings in Florence and Lawrenceville differ, most notably, in their construction of the narrative. In the former the angel intervenes physically and withholds Abraham's right arm, while

Fig. 81 Orazio Gentileschi, *Sacrifice of Isaac*, 1621, oil on canvas, 254 × 152 cm. Galleria Nazionale di Palazzo Spinola, Genoa

the screaming Isaac looks directly at the beholder. The latter presents instead a less dramatic account, where the divinely illuminated angel quietly conveys his message and Isaac seems unaware of the danger he is facing. These differences have been interpreted by Gregori and Marini as the result of a first, more youthful interpretation by Caravaggio, while others find here the expression of a different artistic temperament like Cavarozzi. It seems thus fitting to look briefly at how other important Caravaggesque painters interpreted the theme. Bartolomeo Manfredi (Rome, Chiesa del Gesù) and Orazio Gentileschi (fig. 81) staged the Sacrifice in a vertical format, while Orazio Riminaldi did so in a horizontal (Rome, Palazzo Barberini) and a vertical composition (fig. 82). All four representations are distinguished by their naturalistic portrayal of the protagonists and ostentatiously beautiful rendition of the nude male body. In each work, the angel is not standing on the ground, as in Caravaggio's rendition, but intervening as divine messenger from above. In both Gentileschi's and Riminaldi's paintings the angel is physically holding Abraham's arm, as in the Uffizi picture, while in all four interpretations his son does

Fig. 82 Orazio Riminaldi, *Sacrifice of Isaac*, 1624–25, oil on canvas, 153 × 118 cm. Formerly Koelliker Collection, Milan

not show any fear or resistance, as in the Piasecka Johnson canvas. In Gentileschi's painting the pointing gesture of the angel's left hand further underlines the divine nature of his intervention. Gentileschi and Riminaldi emphasize particularly Issac's submission and acceptance of divinely determined fate. Gentileschi's Isaac has obediently lowered his head, while Riminaldi's has clasped his hands almost in a gesture of prayer. Riminaldi's Issac seems particularly close to the Piasecka Johnson picture in the complex foreshortening of the male nude.

The highly personal and immensely productive dialogue with Caravaggio in which painters like Gentileschi, Manfredi and Riminaldi engaged is most demonstrative in their interpretation of specific Caravaggio masterpieces, but no less eloquent in other instances where his stylistic and conceptual principles are more freely adopted. Two extraordinary Manfredi paintings, such as the *Ecce Homo* (cat. 54) and the *Apollo and Marsyas* (cat. 55), offer an excellent example in point. Manfredi's capacity to assimilate Caravaggio's art in an almost deceiving manner has been lauded by his early biographers. According to Bellori, he "transformed himself into Caravaggio, and

Fig. 83 Michelangelo Merisi da Caravaggio, *Crowning with Thorns*, 1602–03, oil on canvas, 178 × 125 cm. Palazzo degli Alberti, Prato

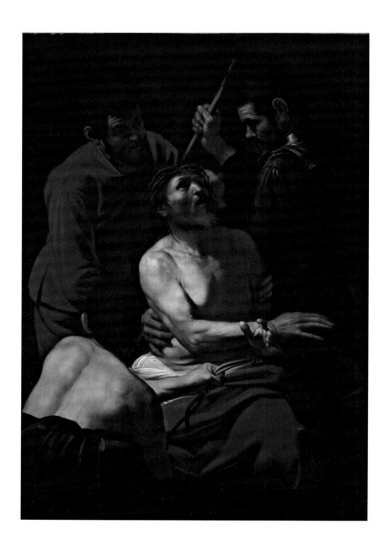

when he painted it seemed as though he were looking at nature through that man's eyes."[8] His personal take on Caravaggio, appropriately described by the German painter and art critic Joachim von Sandrart as *Manfrediana methodus*, has decidedly influenced the development of international Caravaggism.[9]

Manfredi's *Ecce Homo* is likely identical to a painting Giulio Mancini acquired in the spring of 1613 and shortly thereafter sent to his brother Deifebo in Siena. Its monumental simplicity and powerful chiaroscuro are directly based on Caravaggio's later Roman half-length narratives. Individual motifs from Caravaggio's *Crowning with Thorns* in Vienna (fig. 42, p. 115), but also from his *Crowning with Thorns* in Prato (fig. 83) and the later *Ecce Homo* in Genova (Galleria di Palazzo Bianco) are

Cat. 54 (*facing page*) Bartolomeo Manfredi, *Ecce Homo*, c. 1612

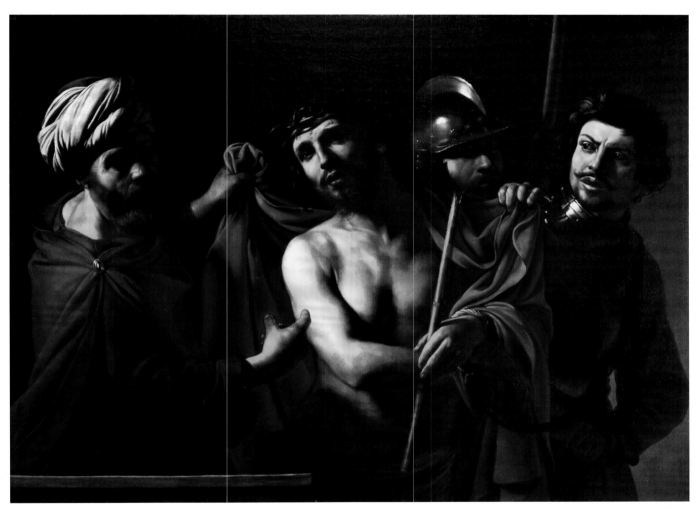

Cat. 54

incorporated with great originality and speak to Manfredi's profound understanding of Caravaggio's art. The compositional structure, with the Roman governor Pilate standing behind a balustrade running parallel to the picture plane to about half of the composition and the impressive, red-cloaked figure of Christ in the centre, are based on the Vienna *Crowning*. The pointing gesture of Pilate and the motif of the framing mantle held up behind Christ' shoulders are based on the Genova *Ecce Homo*, while the athletic body of Christ with the right arm passing in front of his chest seems to recall the Prato *Crowning*. Manfredi has certainly studied the Vienna *Crowning*, at the time in the Giustiniani collection in Rome, with particular care and re-interpreted it repeatedly in his own representations of the theme, starting with the earliest version in the Alte Pinakothek in Munich from around 1605–10.

Manfredi's profound assimilation of Caravaggio's art comes to the fore also in his recently discovered *Apollo and Marsyas* in the Saint Louis Art Museum. Caravaggio has rarely treated mythological subjects and, as far as we know, never in a half-length format, and mythological subjects shall remain rare among Caravaggesque painters in general. Caravaggio's lost *Mars Punishing Cupid* for Cardinal del Monte was re-interpreted in 1613 by the same Manfredi in his spectacular painting now in the Art Institute in Chicago (fig. 24, p. 65). A representation of *Apollo and Marsyas* from Caravaggio's hand is nowhere mentioned in the early sources. Manfredi interpreted the ancient myth in the same naturalistic vain as his religious narratives. Both protagonists are of stunning physical presence and appear right next to the picture plane in front of a bright blue sky. They seem almost to burst the pictorial space and are seen from a very low viewpoint. Marsyas is bound to a tree on the left, while Apollo, dressed in luminous red and crowned with a laurel wreath, is just starting to skin his counterpart. The painting is built on the antagonism between the dark animal-like nature of Marsyas and the sublime beauty of Apollo, between the cruel and terrifying punishment and the bright and luminous colours, all of which are fused in the beautifully balanced composition that inextricably and inescapably binds the figures together. Its undulating rhythm seems to be the only, if remote, reminder of the musical contest that caused the divine wrath and is dominated by an S-shaped line, which runs, without disruption, from Marsyas' right arm and shoulder to Apollo's left arm, shoulder and right hand. Manfredi's painting dates from around 1616–20 and anticipates in many ways Jusepe de Ribera's famous 1637 *Apollo and Marsyas* (Naples, Museo Nazionale di Capodimonte).

Hendrick ter Brugghen forms with Gerrit van Honthorst and Dirck van Baburen the first generation of the Utrecht Caravaggisti. His Italian sojourns are scarcely

Cat. 55 (*facing page*) Bartolomeo Manfredi, *Apollo and Marsyas*, c. 1616–20

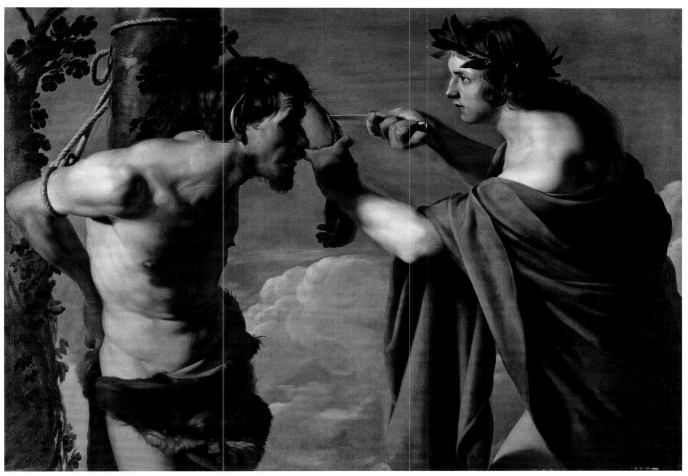

Cat. 55

documented, but his earliest paintings eloquently bespeak the intense study and profound understanding of Caravaggio's art. His 1616 *Supper at Emmaus* (Toledo, The Toledo Museum of Art) or his 1621 *Calling of Saint Matthew* (fig. 20, p. 45) offer a highly personal exegesis of Caravaggio's masterpieces for Ciriaco Mattei and the Contarelli chapel respectively, and demonstrate, in an exemplary fashion, how ter Brugghen moved progressively to ever more delicate colour schemes. His paintings have a highly poetical and often mystical expression, blending naturally and with alchemical beauty Caravaggesque style and strong Northern traditions. His *Liberation of Saint Peter* in the Mauritshuis in The Hague (cat. 56) is signed and dated 1624. The two protagonists are forced into a boldly restricted pictorial space. The boyish angel has just awakened his agitated counterpart and announces his divinely inspired liberation. Traditionally, the liberation of Saint Peter offered painters the occasion to describe in detail the nightly prison and the sleeping guards. Ter Brugghen radically avoids any such narrative divagation and points the beholder to the mystical core of the event. The intensity of Peter's spiritual experience is communicated and made palpable through the dramatic illumination, the physical presence of the figures and their expressive gestures and gazes. Both figures are based on life models that return in other works, but ter Brugghen's naturalism here as elsewhere is a hyper-naturalism of mystical complexion.

If Caravaggio introduced fundamental stylistic and conceptual innovations, he also made a number of themes particularly popular in seventeenth-century painting and decisively dominated their iconography. David, for example, had been a popular subject in Florentine Renaissance sculpture from Donatello to Michelangelo, but was relatively rare in gallery paintings. Caravaggio treated the subject several times throughout his career. His extant paintings in Madrid, Vienna and Rome alone offer differing interpretations of the theme which have been widely explored and ingeniously adopted by his followers. His full-length *David* in Madrid (fig. 84) is datable to 1598–99 and shows him binding the head of Goliath. The young Israelite had overwhelmed the giant with a single shot of his sling. He is kneeling on the back of the fallen enemy, has decapitated him with his own sword and is now focused on preparing his head which he will present in triumph to King Saul and his people. A second *David*, today preserved in the Kunsthistorisches Museum in Vienna (fig. 85), is probably identical to a painting acquired by Juan de Tasis y Peralta, the Conde de Villamediana, during his Italian sojourn in 1611–15. It has been variously dated to either 1600–01 or 1606–07. In the dramatically illuminated, horizontal half-length format, Caravaggio's young shepherd is triumphantly presenting the giant head of Goliath. The third *David* in the Villa Borghese in Rome (fig. 86) illustrates the same

Cat. 56 (*facing page*) Hendrick ter Brugghen, *The Liberation of Saint Peter*, 1624

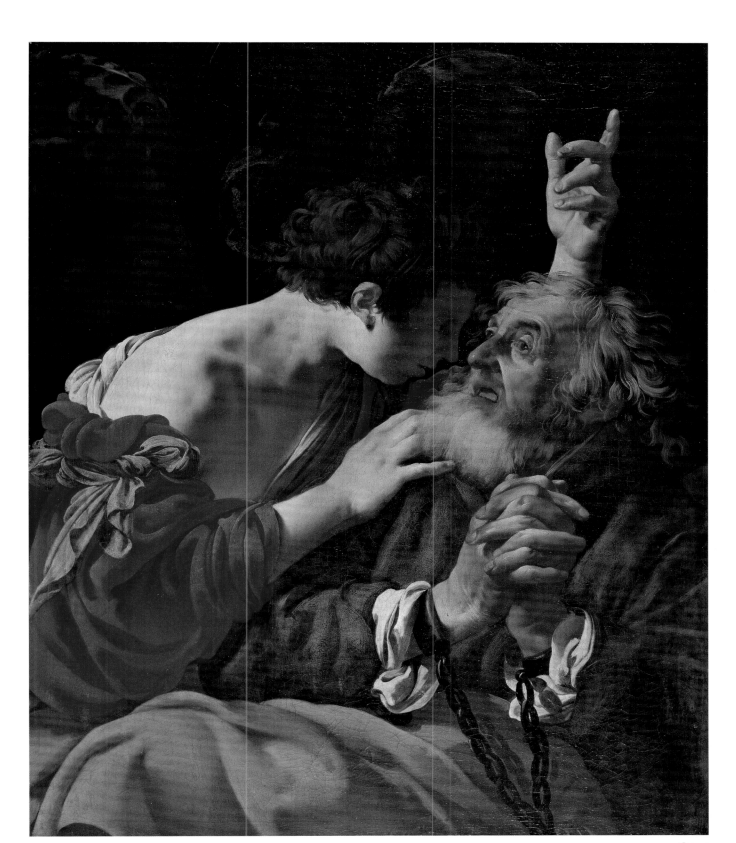

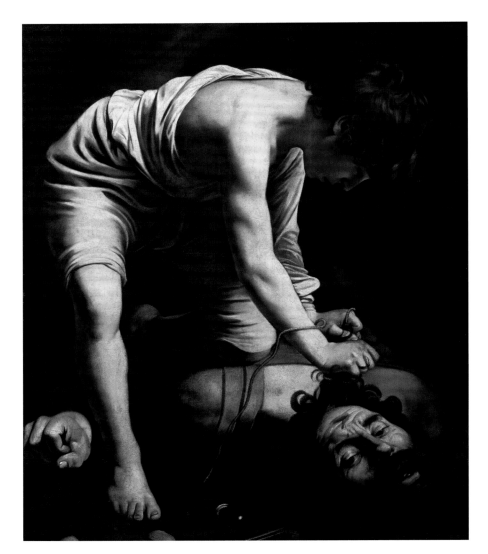

episode but in a radically different vain. It is already documented in the possession of
Cardinal Scipione Borghese in 1613, and was probably executed during Caravaggio's
second Neapolitan sojourn in 1609–10 and sent as a gift to the powerful nephew of
Paul V. It was conceived as a kind of pictorial petition for a papal pardon that would
allow the artist finally to return to Rome. The painting presents indeed a dramatic
plea of guilty, asking for charity and forgiveness, as the frightful decapitated head
shows the unmistakable traits of the artist himself. The young David is a rather tragic
hero and looks with a mix of sorrow and despair at the decapitated head. If
Giorgione, Michelangelo or later Bernini chose to identify themselves with the
triumphant David, no one but Caravaggio did so with his infamous victim.

The expressive potential of Caravaggio's representations was explored in depth by
his followers, and there are very few Caravaggesque artists that did not interpret the
subject. Manfredi painted his *David and Goliath* around 1615 (cat. 57). The young

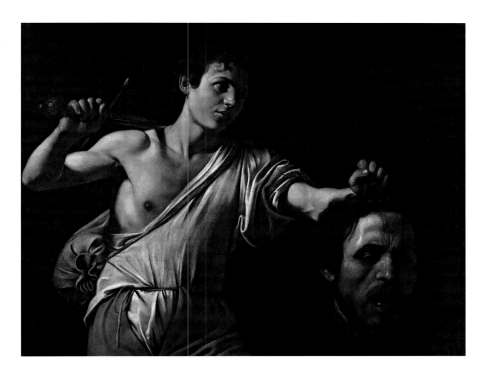

Fig. 85 (*right*) Michelangelo Merisi da Caravaggio, *David and Goliath*, c. 1606–07, oil on wood, 90.5 × 116 cm. Kunsthistorisches Museum, Vienna

Fig. 86 (*below*) Michelangelo Merisi da Caravaggio, *David and Goliath*, 1609–10, oil on canvas, 125 × 101 cm. Galleria Borghese, Rome

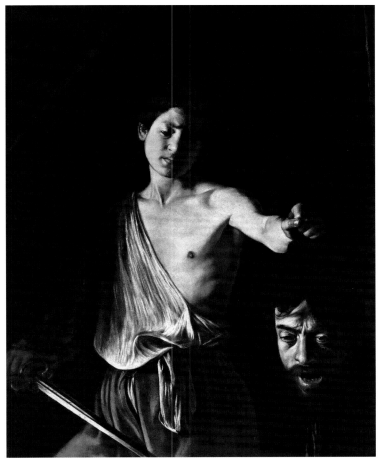

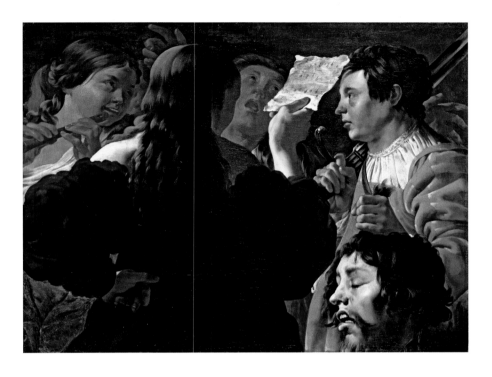

hero is dressed in colourful contemporary clothes, similar to the fashionable *bravi* in Caravaggio's *Cardsharps* (cat. 17) or the young companions in his *Calling of Saint Matthew* (see fig. 1. p. 6). His right hand is holding the sword while his left is presenting the head of Goliath with the wound on his forehead. But the cruelty of the event has been toned down and given place to a rather elegant theatrical performance. Manfredi stages a festive triumph of David who is moving to the right and accompanied by a dancing Israelite woman playing a tambourine. This theme was fully developed a few years later in Ter Brugghen's 1623 *David and the Praise-Singing Israelite Women* (fig. 87) where a whole chorus is introduced.

Valentin de Boulogne was the most faithful of Caravaggio's French followers and a convinced interpreter of the *Manfrediana methodus*. He might have arrived in Rome as early as 1609 and stayed in the city until his death in 1632. His *David and Goliath* in Madrid (cat. 58) was executed around 1620–22. The beautiful young David with his reddish blond hair and deep blue eyes addresses the viewer with irritating intensity. He is posing the giant head of Goliath on a stone block in front of him, and blood is spilling all over. Right next to the severed head, David is holding the terrifying oversized sword of his enemy. The mysteriously looking, almost melancholic hero has very refined and noble traits. He is accompanied by two experienced soldiers

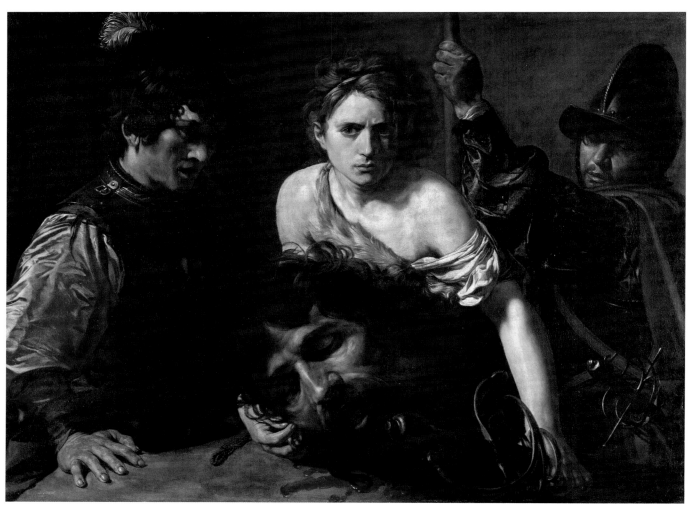

Cat. 58

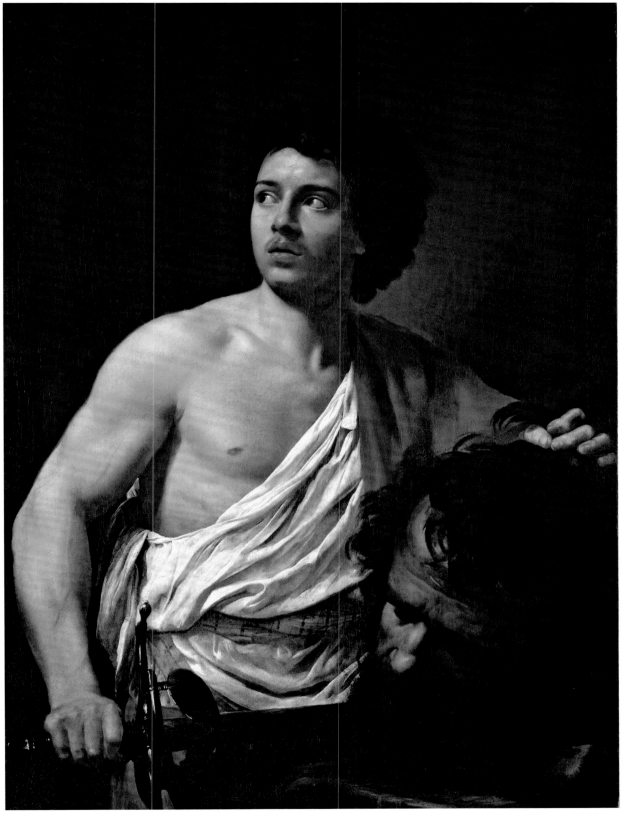

Cat. 59

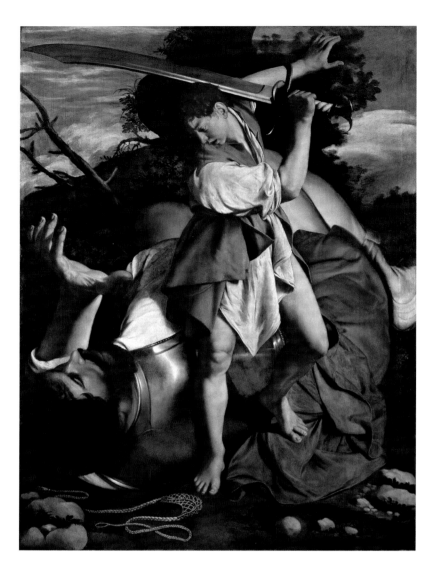

in contemporary armour with beautifully modelled red and dark green sleeves. David himself had been deemed too young for military service and had joined his older brothers in the camp only to bring them provisions. When Goliath appeared suddenly on the battlefield and frightened and ridiculed the Israelites again, the young shepherd decided fearlessly to take on the giant enemy and even refused to wear armour. The two soldiers in Valentin's painting are unprecedented in traditional iconography. They either represent the older brothers or, more generally, the Israelite forces emphasizing thereby David's youth and heroic achievement to kill Goliath almost nude and without armour.

Valentin's French contemporary Simon Vouet arrived in Rome in 1613 and stayed there until 1627, when he was called to France as court painter to Louis XIII. He executed his *David* probably in 1621 for Giovan Carlo Doria in Genova (cat. 59). The hero is presented frontally, holding the sword in his right and the head of Goliath in

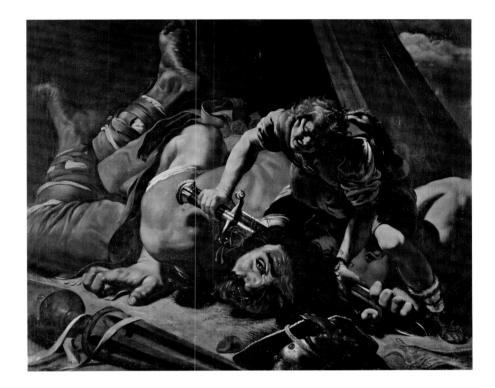

Fig. 89 Orazio Borgianni, *David and Goliath*, 1607–08, oil on canvas, 119 × 143 cm. Real Academia de Bellas Artes de San Fernando, Madrid

his left. The severed head rests on a stone block, and in the foreground, indistinctly in the shadow, David's sling and the stone bullet are posed. David has turned his head to the left and gazes with wide open eyes and slightly parted lips into the distance. His boyish and somewhat innocent expression contrasts with his strong muscular body. The textures of his white linen shirt with a kind of thin striped sash are rendered with ostentatious virtuosity and emphasize, at the same time, the admirable naturalism of the nude. Vouet's David seems more mature and somewhat better prepared for his heroic task than Manfredi's elegant counterpart or Valentin's mysterious shepherd boy. Other Caravaggesque painters such as Orazio Gentileschi and Orazio Borgianni have turned the David theme into full-length narratives. In Gentileschi's *David and Goliath* (fig. 88) the giant Philistine, hit by the slingshot, has fallen to the ground and David is striking out to decapitate him with his own sword. In Borgianni's painting (fig. 89) the dramatic climax has been further accentuated. His David is kneeling on Goliath's neck and, just like Caravaggio's "Judith," is in the process of severing his head. Gentileschi's beautifully balanced composition contrasts sharply with Borgianni's turbulent action, indicating the full range of interpretations.

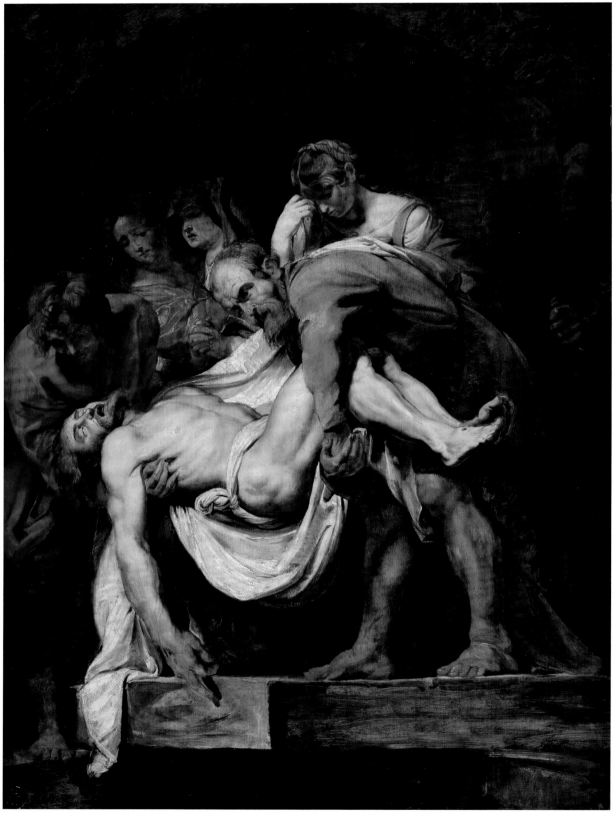

The examples presented in the exhibition illustrate the critical fortune of Caravaggio's religious narratives. He continued to explore the half-length format in his later years in Naples, Malta and Sicily in such paintings as *Salome with the Head of Saint John the Baptist* (Madrid, Museo del Prado), the *Denial of Saint Peter* (New York, The Metropolitan Museum) or the *Martyrdom of Saint Ursula* (Naples, Banca IMI-San Paolo) which had a particular impact in Southern Italy but were soon adopted in Rome and elsewhere. His public works and those for gallery settings belonged to different artistic genres, had different functions and responded to different expectations, but their reception quickly transcended those boundaries. When the young Rubens worked on his famous altarpiece for Santa Maria in Vallicella, he almost inevitably fell under the spell of Caravaggio's *Entombment* (fig. 7, p. 17), executed in 1602–03 for the very same church. As a kind of *Leitmotiv*, Caravaggio's powerful invention would accompany Rubens for his entire career. His small oil sketch, today in the National Gallery in Ottawa, was executed after his return to Antwerp around 1612–14 and offers a complex re-reading of Caravaggio's work, emphasizing through subtle changes, that Saint John and Nicodemus are lowering Christ's body into the tomb below (cat. 60). Notoriously, some of Caravaggio's Roman altarpieces were refused, only to be acquired immediately as highly prized art works for important collections, such as the *Death of the Virgin* which entered the gallery of Vincenzo Gonzaga in 1607 and is today housed in the Musée du Louvre in Paris. Caravaggio's *Calling of Saint Matthew* for the Contarelli chapel inspired numerous interpretations in the gallery format, while his *Incredulity* of *Saint Thomas* (fig. 78) provided the model for Giuseppe Vermiglio's and Louis Finson's altarpieces for San Tommaso dei Cenci in Rome and the cathedral of Saint-Saveur in Aix-en-Provence respectively. At the same time, Caravaggio's revolutionary half-length narratives established these as a highly successful format for gallery pictures. Compared with full-length representations these could be smaller in size and offered at lower prices without renouncing the essential life-size presence of the figures. Paradoxically, the necessity to cut off the figures to half-length did not diminish their naturalistic "credibility." On the contrary, such half-length compositions even intensified the effect of immediacy, presence and drama and bridged the representational gap between the picture and its beholders. Dramatic close-up and foregrounding of action provoked the compassion and affective response that were so much at the core of Caravaggio's art. Caravaggio's virtuosity to project biblical history right into the present deeply touched both the spiritual and the aesthetic sensibilities of his contemporaries. The extraordinary creative energies he released among the Caravaggisti can be experienced, at least in part, in the exhibition.

Cat. 60 (*facing page*) Peter Paul Rubens (after Michelangelo Merisi da Caravaggio), *The Entombment*, c. 1612–14

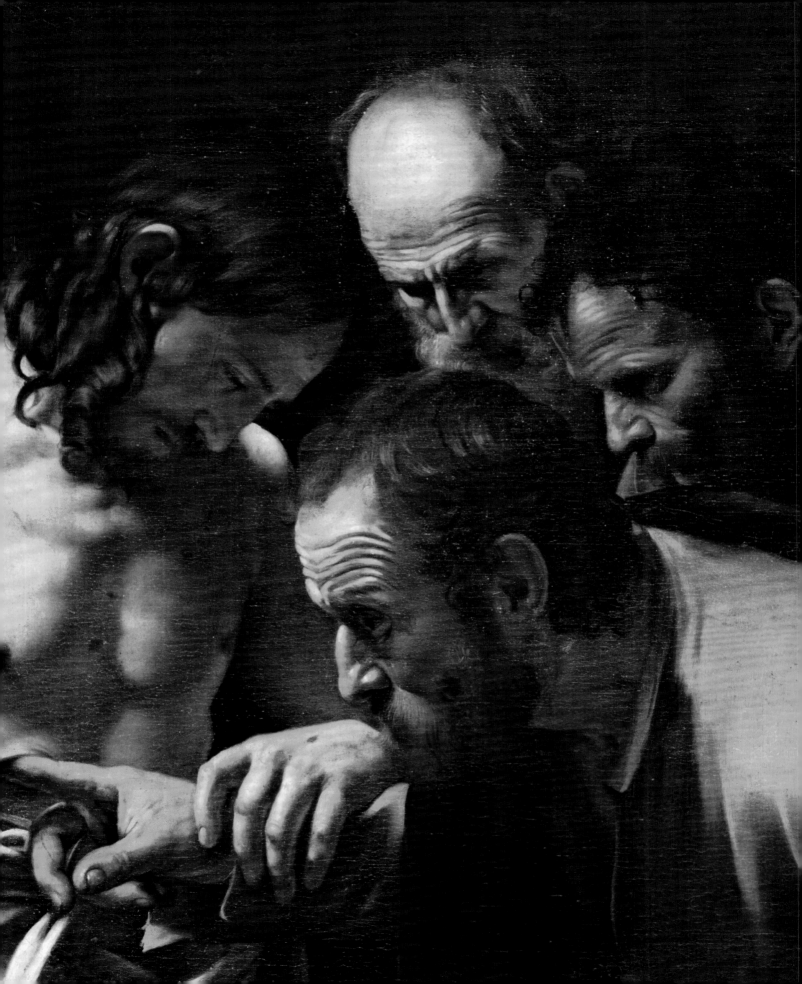

NOTES

1 The bibliography on the subject is over-whelmingly rich. For the most detailed, up-dated bibliography on Caravaggio and the Caravaggisti see Macioce 2010 and Zuccari 2010. For the preparation of this essay, apart from primary sources, standard monographs and museum catalogues, the following literature has been most helpful: Spear 1971; *I Caravaggeschi Francesi*, exh. cat., ed. A. Brejon de Lavergnée and J-P. Cuzin (Rome, 1973); Moir 1976; Braunschweig 1987; Nicolson 1989; Rome 1995; Rome 2001; Milan 2005; *Caravaggio in Holland. Musik und Genre bei Caravaggio und den Utrechter Caravaggisten*, exh. cat., ed. J. Sander, B. Eclercy, and G. Dette (Frankfurt, 2009); S. Ebert-Schifferer, *Caravaggio. Sehen – Staunen – Glauben. Der Maler und sein Werk* (Munich, 2009); V. von Rosen, *Caravaggio und die Grenzen des Darstellbaren. Ambiguität, Ironie und Performativität in der Malerei um 1600* (Berlin, 2009); Schütze 2009; Papi 2010; Fried 2010; Prohaska and Swoboda 2010.

2 L.B. Alberti, *De Pictura*, no. 35; idem., *On Painting and On Sculpture*, Latin-English edition, ed. C. Grayson, London 1972; L.B. Alberti, *Das Standbild. Die Malkunst. Grundlagen der Malerei*, Latin-German editon, ed. O. Bätschmann and C. Schäublin, Darmstadt 2000, pp. 256–257.

3 For the tradition of half-length religious narratives see S. Gianfreda, *Caravaggio, Guercino, Mattia Preti. Das halbfigurige Historienbild und die Sammler des Seicento*, Emsdetten/Berlin 2005. Notably in the earlier sixteenth century, though, the genre is more diffused than she acknowledges.

4 H. Belting, *Giovanni Bellini Pietà: Ikone und Bilderzählung in der venezianischen Malerei* (Frankfurt, 1985).

5 The arms of the statue are modern additions, but were probably in place in the early seventeenth century; see G. Swoboda, in Prohaska and Swoboda 2010, pp. 308–309.

6 R. Longhi, "La 'Giuditta' nel percorso di Caravaggio," in *Paragone Arte*, II (1951), 19, pp. 10–18, see p. 11.

7 G. Marino, *La Galeria*, Venice 1620, p. 58.

8 Bellori 1672, p. 215; Bellori 2005, p. 186.

9 Sandrart 1675, p. 301; Latin edition, Nürnberg 1683, p. 294.

facing page Michelangelo Merisi da Caravaggio, *Incredulity of Saint Thomas* (detail of fig. 78)

Artists' Biographies

NELDA DAMIANO

Dirck van Baburen
Wijk bij Duurstede, near Utrecht
c. 1594/95–1624 Utrecht

Gerrit van Honthorst, Hendrick ter Brugghen, and Dirck van Baburen were all members of the Caravaggesque school of Utrecht. Among this group of painters who spread Caravaggio's style in the Netherlands, van Baburen was the most famous. He studied with Paulus Moreelse, according to the register for the guild of painters, in which his name appeared in 1611. A late-seventeenth-century guide mentions a *Martyrdom of Saint Sebastian*, dated 1615 on the back and signed "Teodoro fiaminco," painted for the church of the Servites in Parma. Now conserved in Madrid (Thyssen-Bornemisza), this is the first known work painted by van Baburen during his stay in Italy.[1] In Rome, van Baburen became friends with David de Haen (c. 1585–1622); the parish registers for the church of Sant'Andrea delle Fratte indicate the two men lived at the same address in 1619–20.[2] A few years earlier, they had worked together on the decorations for the Chapel of the Pietà at the church of San Pietro in Montorio, a commission issued by Pietro Cussida, representative in Rome of King Philip III of Spain. Inside the chapel dedicated to the Passion of Christ is the only public commission executed by van Baburen, the altar painting *The Entombment*, which was a great success. Clearly inspired by Caravaggio's work conserved at the Vatican, the Dutch painter imitated almost in its entirety the group to the right of the Virgin and the weeping women, as well as the figure of Nicodemus.[3]

Although he had perfectly mastered the Caravaggesque vocabulary, van Baburen gave an original interpretation of the theme of Saint Francis meditating for the canvas in Vienna (cat. 44). Unlike the pose favoured by Caravaggio, showing the saint kneeling or prone, van Baburen presented a half-length

view, a perspective that he used frequently. To paint *The Taking of Christ,* today at the Borghese Gallery, van Baburen drew largely on details in the version that Caravaggio had produced for Marchese Ciriaco Mattei in 1602 (National Gallery of Ireland, Dublin), such as Christ's clasped hands and the crested helmets, although the composition is less compact. This painting was probably the last one executed by van Baburen before he returned to Utrecht, where he continued to pay homage to Caravaggio by producing, among others, *The Lute Player* (Centraal Museum, Utrecht), reminiscent of the master's prototype at the Hermitage.

1 Inv. NR.347 (1986.4)
2 J.G. Hoogewerff, *Nederlandsche kunstenaars te Rome (1600–1725): uittreksels uit de parochiale archieven* (The Hague, 1942), p. 229.
3 B. Treffers in Zuccari 2010.

Giovanni Baglione
Rome 1566–1643 Rome

Baglione is better known for his writings than for his art career. In addition to his guide to Roman churches (*Le nove chiese di Roma*, 1639), his *Vite de' pittori, scultori et architetti* (1642), containing more than 200 biographies of artists active in Rome between 1572 and 1642, has become an essential reference work. He studied painting with the Florentine artist Francesco Morelli, then joined the team of Giovanni Guerra and Cesare Nebbia, who supervised extensive decorative projects financed by Pope Sixtus V for the Vatican library, the Palazzo Laterano, and the Holy Staircase. After a brief stay in Naples, Baglione was involved, around 1591–92, in decoration of the transept of the Basilica of S. Giovanni in Laterano; in the early seventeenth century, he was long employed decorating the church of Santa

Cecilia in Trastevere for Cardinal Paolo Emilio Sfondrati (1561–1618).

Baglione's relationship with Caravaggio was complex and tumultuous. He was an early admirer of the Lombard master, as evidenced by his execution in 1600 of paintings in a Caravaggesque style, including *Saint Sebastian Healed by an Angel* (private collection) and the magnificent *Ecstasy of Saint Francis* (cat. 29), now in Chicago, which was inspired by Caravaggio's painting produced for the banker Ottavio Costa.[1] Emulating the master's technique in his response to Caravaggio's *Triumph of Earthly Love* (fig. 22, p. 56), Baglione executed two versions of *Divine and Profane Love* (Gemäldegalerie, Berlin and Palazzo Barberini, Rome) for Benedetto Giustiniani, the brother of Vincenzo, who owned Caravaggio's canvas. The growing animosity between the two artists culminated in August 1603, with Baglione bringing a lawsuit for libel against Caravaggio, who was likely bitter over having lost a prestigious commission, a monumental altar painting for the church of the Gesù, to Baglione.

Baglione's body of work cannot be reduced to his temporary adoption of Caravaggesque style. He was a talented draftsman and carefully studied ancient sculptures, the works of Raphael and Michelangelo, and paintings by Venetian artists during his stay in the court of the Gonzagas in 1621–22. He travelled frequently and his work took him, among other places, to Mantua, Spoleto, Todi and Savona. He received a number of honours, including the title of principe of the Accademia di San Luca, a position that he held for three years (1617–19) and Knight of the Order of Christ, in 1610.

1 For more on Caravaggio's painting designated as the one having belonged to

Costa (now in Hartford), see Terzaghi 2007, pp. 300–302, and Costa Restagno 2004.

TROPHIME BIGOT
Arles 1579–1650 Avignon

The Italianized form of the artist's family name ("trufamont bigoti") in a will written in Arles on 16 June 1605 reveals that the painter had already lived in Italy.[1] This signature likely confirms that he was the "Trufemond" mentioned by Sandrart among the artists living in Rome.[2] A "Theofilo Trofamonti" also appears in the 1638 inventory of Marchese Vincenzo Giustiniani. Unfortunately, the two works executed for this patron disappeared after the Second World War.[3] The parish registers of the church of San Lorenzo in Lucina establish his presence in Rome as of 1620. His name appears periodically in the registers, notably in 1630, when he was living in the Santa Maria del Popolo quarter with the painter Claude Lorrain. He stayed in Rome until at least 1634, as evidenced by his activity with the Accademia di San Luca.

Although the legitimacy of Bigot's stay in Rome is not questioned, art historians have not reached consensus about the works attributed to him. The strong stylistic coherence among a group of forty paintings – most of them candle-lit nocturnal scenes with half-length figures – led Nicolson to list the works under an artist he dubbed "the Candlelight Master," and whom he later posited was Trophime Bigot.[4] The heterogeneous manner of the paintings listed in Rome and Provence nevertheless has led some experts to hypothesize that there were two artists with the same name: Bigot the Elder and Bigot the Younger.[5] Finally, a more recent theory suggests there were three individuals: Trophime Bigot, the

"Candlelight Master," and one called "Maestro Jacomo."[6]

Beyond the thorny question of who painted the works, Caravaggio's undeniable influence is visible in both the tight framing of the action and the presentation of isolated figures meditating or performing a specific task. *Saint Jerome Reading* (cat. 45), of which there is another version in Rome (Palazzo Barberini), offers an eloquent example of the artist's assimilation of the Caravaggesque model.

To get beyond the impasse of attributions, Wolfgang Prohaska recently formulated a provisional chronology of Bigot's Roman works in which he grouped some of the paintings executed at the beginning of the artist's stay in Rome:[7] *The Arrest of Christ* (Galleria Spada, Rome), *The Denial of Saint Peter* (Palmer Museum of Art, Pennsylvania), and *Saint Sebastian Tended by Saint Irene* (Musée des beaux-arts, Bordeaux). Prohaska placed the *Judith Beheading Holofernes*, now in Parma, and *The Adoration of the Magi*, conserved in the sacristy of the church of San Marco in Rome at the end of Bigot's stay in the pontifical city.

1 J. Boyer, "Nouveaux documents inédits sur le peintre Trophime Bigot," *Bulletin de la Société de l'histoire de l'art français* (1964), 153–158.

2 J. von Sandrart, *Teutsche Academie der Bau* (Nuremberg, 1675–79).

3 These were two decorations over a door: *Holy Family with the Christ Child and Saint Joseph* and *Soldiers Playing Dice for Christ's Garments* (prev. in the ducal collection at Gotha).

4 B. Nicolson, "'The Candlelight Master,' a Follower of Honthorst in Rome," *Nederlands Kunsthistorish Jaarboek* (1960), pp. 121–164; "Un Caravagiste aixois, le maître à la chandelle," *Art de France* (1964), pp. 116–139.

5 J. Thuillier, "La Tour, énigmes et

hypothèses," in *Georges de La Tour*, exh. cat. (Paris, 1972); Benedict Nicolson, "Caravaggesques at Cleveland," *The Burlington Magazine* 114: 827 (February 1972), pp. 113–117.

6 G. Papi, "Trophime Bigot, il Maestro del lume di candela e Maestro Giacomo," *Paragone* 585 (1998), pp. 3–18.

7 W. Prohaska, "'Il problema' di Trophime Bigot," in Milan 2005.

ORAZIO BORGIANNI
Rome 1574–1616 Rome

The son of a Florentine carpenter, Orazio signed and dated his first work, *Saint Gregory in His Study* (private collection, Catania), in 1593, indicating a stay in Sicily. By March 1597 he was in Rome, involved in a quarrel that was resolved amicably.[1] Later in that year, he moved to Spain where he worked productively for about five years. In Pamplona in 1601, he painted a *Christ Meditating on His Crucifixion* (Convent of the Augustinas Recoletas); in June 1603 in Madrid, he became one of the founding members of the local Academy of Saint Luke along with Eugenio Cajés (Cascesi), also a Florentine; he was in Toledo between October 1603 and March 1604, where he met Luis Tristán, a painter in El Greco's circle, whom he may have encountered again in Rome in 1609.[2] Finally, with Cajés, he appraised the Marquis de Poza's inventory of 9 January 1605. The hypothesis that Borgianni took a second trip to Spain has been refuted by Gallo in part because no painting by the artist bearing a Caravaggesque seal has been found in Spain.[3] Borgianni's tribulations in Rome continued in June 1606, when he wounded a man named Antonio Pellegrini with his sword.[4] On 2 November 1606, he and Carlo Saraceni found themselves in court facing charges of having orchestrated an assault on Giovanni

Baglione. Borgianni was also a member of a number of institutions; in October 1606 he joined the Accademia di San Luca, in which he occupied, in succession, the positions of bookkeeper and rector alongside Guido Reni. In 1608 he joined the Accademia degli Humoristi; and in 1610, the congregation of the Virtuosi al Pantheon.

Although his typical composite style melded elements of Venetian and Emilian inspiration, Borgianni incorporated Caravaggesque formal qualities into *David and Goliath* now at the Real Academia de Bellas Artes de San Fernando, Madrid. Executed on commission for the Duke of Mantua, this work marked, according to Baglione, Borgianni's return to Rome.[5] His *Holy Family with Saint Elizabeth and Saint John* (Palazzo Barberini, Rome) also shows Caravaggio's influence in the poses of the characters, the detailed rendering of the instrument played by the angel, and the austere background.

Borgianni's career is unusual in comparison to those of the other Caravaggisti in that he did not draw the patronage of families such as the Mattei and Giustiniani. He was also known for his etchings, some of which took imagery from his paintings, such as *Saint Christopher*, of which a number of versions exist (see cat. 38), and a series of fifty-two sheets after Raphael's Loggia at the Vatican, dated 1615.

Borgianni's ties to Spain lasted throughout his life, as evidenced by his last wishes, which designated Francisco Castro, ambassador to Rome, as his executor, and his secretary, Juan de Lezcano, as heir.

1 M. Pupillo, "Orazio Borgianni 1597: un documento inedito," *Paragone* 551–555 (1996), pp. 150–158.

2 See R. Vodret, "Notes on Caravaggio's early Followers Recorded in Roman Parish Registers from 1600 to 1630," pp. 72–101, this volume.

3 M. Gallo, "Orazio Borgianni," in Zuccari 2010.

4 M. Gallo, "Orazio Borgianni, l'Accademia di S. Luca e l'Accademia degli Humoristi: documenti e nuove datazioni," *Storia dell'arte* 76 (1992), pp. 296–345.

5 Baglione 1642.

VALENTIN DE BOULOGNE
Coulommiers-en-Brie 1591 or 1594–1632 Rome

Valentin's family name refers to the French town of Boulogne-sur-Mer, in the Pas-de-Calais region, although this was not his birthplace. The year of his birth remains unresolved since the baptismal certificate, the existence of which was recorded in a nineteenth-century transcription as 1591, is now lost. His death certificate, written in Rome in 1632,[1] indicates he died at age thirty-eight, which would make his year of birth 1594.

Valentin came from a family of artists and was probably trained in his father's studio. He arrived in Rome, crossroads of the art scene, between 1610 and 1614, depending on the source. His name first appeared in the census of 1620, when he lived in the Santa Maria del Popolo parish.[2] In the parish church, two of Caravaggio's major works, *The Crucifixion of Saint Peter* and *The Conversion of Saint Paul* (figs. 5 and 6, pp. 14–15), were on view to Valentin and his contemporaries. Valentin's paintings obviously drew on themes favoured by the master, such as genre scenes (*Soldiers Playing Cards and Dice*, cat. 20; *Fortune Teller with Soldiers*, cat. 16) and religious episodes (*David with the Head of Goliath*, cat. 58).

Valentin became friends with his compatriot, Simon Vouet. With Vouet, who had chaired the Accademia di San Luca since 1624, he participated in creating the decorations for the Saint Luke festivities in

1626. Nicolas Poussin, whose style was opposite to that of the Caravaggisti, also worked on this project, and would meet Valentin again at Saint Peter's Basilica. Although Valentin was a member of the Accademia di San Luca only through the year 1626, he had a longer affiliation with the Schildersbent (or Bentvueghels) brotherhood, a group of Dutch and Flemish painters who were opposed to the conformist approach of the academy.

Later in his carer, Valentin received support from Cardinal Francesco Barberini, who commissioned a *David* (1527, private collection) and a large altar painting for Saint Peter's Basilica, *Martyrdom of Saint Processus and Saint Martinian* (fig. 36, p. 93), among other works. This work was hung beside Nicolas Poussin's *The Martyrdom of Saint. Erasmus,* inevitably leading to comparisons between the two artists. The *Samson* in Cleveland, one of the works painted by Valentin soon before his death, was a companion piece to the *David,* and both are mentioned in the Barberini inventory.[3]

Baglione attributes the artist's death to an absurd episode:[4] after a night of drinking, he took a dip in the Fontana del Babuino to cool off and contracted a fever to which he succumbed soon after. The generosity of one of his patrons, the scholar Cassiano dal Pozzo, ensured that he was given an honourable burial at the church of Santa Maria del Popolo.

1 See the death certificate of Valentin de Boulogne published in Mojana 1989.
2 Jacques Bousquet, "Valentin et ses compagnons: réflexions sur les caravagesques français à partir des archives paroissiales romaines," *Gazette des beaux-arts* 92 (1978), pp. 101–114. However, parish documents found by R. Vodret indicate that Valentin was in Rome in 1615, or even 1609. See

"Notes on Caravaggio's Early Followers," pp. 72–101.
3 See Aronberg Lavin, *Seventeenth-century Barberini Documents and Inventories of Art* (New York, 1975).
4 Baglione 1642.

HENDRICK TER BRUGGHEN
The Hague or Utrecht 1588–1629 Utrecht

Ter Brugghen was a member of the group of Caravaggisti in Utrecht who carefully studied the Lombard master's style. Little is known about the artist's childhood except that he came from a family with a certain social status; his father had a brilliant career as a civil servant, first as secretary to Prince William of Orange starting in 1581, and then as bailiff in the court of the States of Holland. According to the accounts of Joachim von Sandrart and Cornelis de Bie,[1] ter Brugghen apprenticed in the studio of Abraham Bloemaert in the first decade of the 1600s.[2]

The earliest documentation of ter Brugghen's presence in Italy dates from the summer of 1614, when he visited Milan with his colleague and friend Thijman van Galen. However, no documentary source confirms the date of his arrival in Rome. He is generally thought to have lived there between 1605 and 1616 – the latter date being the year when his name appeared on the registers of the Guild of Saint Luke in Utrecht and also when he married Jacoba Verbeeck. No painting attributed to his Roman period is dated or signed; the first work to display a date, 1616, is the *Supper at Emmaus* (Toledo Museum of Art).[3] The Toledo picture bears the mark of the Caravaggio prototype, today in Brera, particularly in the portrayal of the apostle about to stand up. To the lessons of Caravaggio, ter Brugghen skilfully adds his northern heritage, sometimes injecting his compositions with an element of irony, as

in *Crowning with Thorns* (Statens Museum for Kunst, Copenhagen), signed and dated 1620.

Ter Brugghen's return to the Netherlands did not put an end to his interest in Caravaggesque themes. His *Calling of Saint Matthew*, painted in two versions (Musée des beaux-arts André Malraux, Le Havre; fig. 20, p. 45), offers a clear analogy to Caravaggio's work, and his *Incredulity of Saint Thomas* is obviously inspired by the Giustiniani model (Potsdam). To these examples may be added the magnificent paintings featuring musicians, alone or in groups (National Gallery, London), with the chiaroscuro "candlelight" effect similar to that used by his countryman Honthorst. Worthy of mention is his interpretation of the episode of the liberation of Saint Peter, centred around two single figures, shown in a half-length format (cat. 56).

1 Sandrart 1675; C. de Bie, *Den spiegel van der verdrayde werelt* (Antwerp, 1708).
2 M.G. Roethlisberger and M.J. Bok, *Abraham Bloemaert and His Sons: Paintings and Prints* 1 (Doornspijk, 1993), pp. 567–570.
3 The date was revealed when the work was restored. See L.J. Slatkes and A. Blankert, *Holländische Malerei in neuem Licht: Hendrick ter Brugghen und seine Zeitgenossen* (Braunschweig, 1986), pp. 76–79; Slatkes and Franits 2007, pp. 111–113.

FRANCESCO BUONERI,
CALLED CECCO DEL CARAVAGGIO
Born 1588/89?, active 1613–1620

To this day, Cecco del Caravaggio remains an enigmatic figure, despite Papi's recent research on the artist.[1] He was identified as Francesco Buoneri through documents related to the decoration of the Guicciardini chapel in the church of Santa Felicita in Florence. In fact, the ambassador of Grand

Duke Cosimo in Rome, Piero Guicciardini, commissioned from "Francesco Buonero pittore" a painting of *The Resurrection* (fig. 48, p. 122). He received payments totalling 200 *scudi* between September 1619 and June 1620, and in a revision of the chapel's accounts the painter was called "Francesco del Caravaggio." Unlike the works executed by Honthorst (*The Adoration of the Shepherds*, Galleria degli Uffizi, badly damaged in 1993) and Giovanni Antonio Galli, known as Lo Spadarino (*Crucifixion*, today lost) for the same place of worship, Cecco's painting was rejected by the patron and sold in Rome for 160 *scudi*. The canvas was likely purchased by Cardinal Scipione Borghese, as evidenced by its presence in the seventeenth-century inventories.[2] The other thorny question concerns the painter's birthplace, which is variously reported as France, Spain and Italy.[3]

The first known work produced by Cecco while he was in Rome is *The Family of Darius before Alexander*, a fresco at the residence of Cardinal Alessandro Peretti Montalto (Villa Lante, Bagnaia), the nephew of Pope Sixtus V.[4] This information comes to us from Agostino Tassi, who, during a 1619 trial, reported that Cecco was among the group of painters working on the 1613 decorative project. Cecco's corpus was enhanced by the magnificent painting *The Expulsion of the Merchants from the Temple* (Gemäldegalerie, Berlin), commissioned by Marchese Vincenzo Giustiniani. The canvas displays numerous borrowings from the work of Caravaggio, but the composition is inspired largely by the *Martyrdom of Saint Matthew* in the Contarelli chapel at San Luigi dei Francesi. Cecco once again drew on his master's repertoire when he painted a series of works featuring musicians sitting behind a table laden with still lifes or musical instruments, such as the painting in London (cat. 5), reproduced in different versions

(Ashmolean Museum, Oxford; Ethnikí Pinakothiki, Athens).

One of the most eloquent examples of Caravaggio's influence is the splendid *San Lorenzo* (cat. 43), conserved at the church of Santa Maria in Vallicella. The pose of the saint with hands clasped and the meticulously rendered objects in the foreground are reminiscent of Caravaggio's *Saint Francis* in Cremona (cat. 26). It is not known, however, for whom this painting by Cecco was intended.

1 G. Corti, "Il 'Registro de'mandati' del l'ambasciatore gran-ducale Piero Guicciardinie la committenza artistica fiorentina a Roma nel secondo decennio del Seicento," *Paragone* 473 (1989), pp. 108–146; *idem* "Nota aggiuntiva," *Paragone* 493–495 (1991), pp. 133–137; G. Papi, *Cecco del Caravaggio* (Florence, 1992).

2 Papi 2001, p. 8; S. Corradini, "Un antico inventario della quadreria del Cardinale Borghese," in *Bernini scultore: La nascita del Barocco in Casa Borghese*, exh. cat., ed., A Coliva and S. Schütze (Rome, 1998), pp. 449–456.

3 S. Capelli, biographical note in Zuccari 2010.

4 L. Salerno, "Cavaliere d'Arpino, Tassi, Gentileschi and Their Assistants: A Study of Some Frescoes in the Villa Lante Bagnaia," *The Connoisseur* 589 (1960), pp. 157–162.

Michelangelo Merisi da Caravaggio
Milan 1571–1610 Porto Ercole

Exhaustive archival research has helped solidify the chronology of the Lombard painter's life and work.[1] He attended the Milan studio of Simone Peterzano in April 1584 and was still in that city in July 1592, as his name appears in a notarized document. Although the exact date of his arrival in Rome is unknown, all indications are that he went to stay in the residence of Cardinal del

Monte in 1595 and remained there until 1600. For his steadfast benefactor, Caravaggio executed, among others, *The Lute Player* (fig. 49, p. 130) and *The Musicians* (cat. 1). In 1598, he painted *Head of Medusa*, today in Florence (Galleria degli Uffizi), a gift from the cardinal to Ferdinando de' Medici.

In July 1599 Caravaggio began two paintings for the Contarelli Chapel at the church of San Luigi dei Francesi, *The Calling of Saint Matthew* (fig. 1, p. 6) and *The Martyrdom of Saint Matthew* (fig. 2, p. 7) and delivered them to Pietro Paolo Crescenzi about a year later. The altar painting *Saint Matthew and the Angel* (fig. 3b, p. 9) was commissioned for the chapel in February 1602 by Giacomo Crescenzi. In November 1601 Caravaggio completed another large-scale project for Tiberio Cesari destined for the church of Santa Maria del Popolo, *The Crucifixion of Saint. Peter* (fig. 5, p. 14) and *The Conversion of Saint Paul* (fig. 6, p. 15). During this period, he also produced paintings for Marchese Vincenzo Giustiniani, including *The Incredulity of Saint Thomas* (fig. 78, p. 270), *Triumph of Earthly Love* (fig. 22, p. 56), and *The Crowning with Thorns* (fig. 42, p. 115).

In June 1601 Caravaggio's new patron, Cardinal Gerolamo Mattei, welcomed him to lodge at his palace. The Mattei's support included that of the cardinal's brother, Ciriaco, for whom Caravaggio painted three key works in 1602 and 1603: *The Supper at Emmaus* (fig. 77, p. 270), *Saint John the Baptist* (Rome), and *The Arrest of Christ* (Dublin). In May 1603 Cardinal Maffei Barberini, the future Pope Urban VIII, commissioned *The Sacrifice of Isaac*, now in the Uffizi collection (cat. 52). Around the same time, he executed the splendid *Saint John the Baptist in the Wilderness* (cat. 25) for the banker Ottavio Costa.

In 1604 the *Entombment* (fig. 7, p. 17) was hung in the Vittrice chapel at the church of Santa Maria in Vallicella (today Vatican Museums). This work was copied numerous times, notably by Peter Paul Rubens (cat. 60). After a brief stay in Genoa in August 1605, Caravaggio undertook a prestigious commission for the altar devoted to Saint Anne at Saint Peter's Basilica in Rome. *Madonna and Child with Saint Anne* (fig. 10, p. 22), painted for the brotherhood of the Palafrenieri, was displayed briefly in the basilica in March 1606 then moved to the church of Sant'Anna at the Vatican. Cardinal Scipione Borghese purchased it in June of that year.

The death of Ranuccio Tomassoni in May 1606 marked the end of Caravaggio's stay in Rome. He first took refuge with the Colonna family in Paliano, south of Rome, and then went to Naples in October.

1 All of the information is drawn from Macioce 2010.

Bartolomeo Cavarozzi
Viterbo 1587–1625 Rome

According to Mancini,[1] Cavarozzi's fellow citizen Tarquinio Ligustri welcomed the young artist to Rome between 1600 and 1605 where he would soon meet the powerful Crescenzi family whose members became his main benefactors. His close relationship with this family may explain why he was also known as Bartolomeo del Crescenzi. His first public work, *Saint Ursula and Her Companions with Pope Ciriacus and Saint Catherine of Alexandria* (1608), painted for the church Sant'Orsola a Ripetta, is now conserved in the sacristy of the Basilica di San Marco (Rome).[2] This painting bears traces of the style of Pomarancio, reinforcing the hypothesis that Cavarozzi was one of his pupils.

Cavarozzi's manner of painting evolved gradually and his interest in Caravaggio's works became evident in 1615 when he executed one of several versions of *The Sorrows of Aminta* (cat. 7), a work belonging to Juan de Tassis y Peralta, Comte de Villamediana, and at the time attributed to Caravaggio.[3] A painting on the same subject appears in the inventory dated 1617–21 of Giovan Carlo Doria, Genoa (perhaps in fact Villamediana's painting, as he lived in Genoa before returning to Spain).[4] The mention of his work *The Disputation of Saint Stephen* in the 1616 inventories of the Mattei, patrons with a penchant for Caravaggesque paintings, also suggests that he tried his hand at the style of the Lombard master.[5] Another convincing example of Cavarozzi's familiarity with Caravaggio's pictorial inventions is *Saint Jerome in His Study* (cat. 34), likely produced for Grand Duke Cosimo II de' Medici, according to the mention of a payment received in April 1617.[6]

In 1617 or 1618, Cavarozzi travelled with Giovanni Battista Crescenzi to Madrid, where they stayed for an as yet unspecified period. While in Spain he would influence local artists and promote the diffusion of the genre. It is known that Cavarozzi returned to Rome in 1621. The following year, he painted *Virgin and Child* for Cardinal Scipione Cobelluzzi (Museo del Colle del Duomo, Viterbo[7]) and the *Visitation* for the chapel of the Palazzo dei Priori in Viterbo. His name appears on the Easter census for the parish of Santa Maria del Popolo in 1625, but by September of the same year it had been added to the parish's "book of the dead."

1 Mancini 1956–57.
2 I. Toesca, "Un 'opera giovanile del Cavarozzi e i suoi rapporti con il Pomarancio," *Paragone* 123 (1960), pp. 57–59.
3 E. Fumagalli, "Precoci citazioni di opere del

Caravaggio in alcuni documenti inediti," in *Come dipingeva il Caravaggio*, ed. M. Gregori and E. Acanfora (Milan, 1996), pp. 143–150; G. Papi, "Il primo 'Lamento di Aminta' e altri approfondimenti su Bartolomeo Cavarozzi," *Paragone* 695–697 (2008), pp. 39–51.
4 D. Sanguinetti, *Bartolomeo Cavarozzi: "sacre famiglie" a confronto* (Milan, 2005).
5 Cappelletti and Testa 1994.
6 G. Papi, "Riflessioni sul percorso caravaggesco di Bartolomeo Cavarozzi," *Paragone* 695–697 (1996), pp. 85–96.
7 F. Nicolai, "La collezione di quadri del cardinale Scipione Cobelluzzi : Cavarozzi, Grammatica e Ribera in un inventario inedito del 1626," *Studi romani* 52:3/4 (2004), pp. 440–462.

Guy François
Le Puy 1578–1650 Le Puy

François was among the artists who absorbed the Caravaggesque style but about whom little is known to this day. The only documentary evidence of his presence in Rome is his registration as a member of the Accademia di San Luca in 1608. Analysis of the corpus of paintings attributed to François is therefore based largely on stylistic considerations. Although the artist returned to his city of birth in 1612, Jean Penent has advanced the hypothesis that he stayed in Rome a second time, between 1614 and 1619, before he returned to Le Puy.[1]

The stylistic affinities with Carlo Saraceni indicate that François attended the Venetian painter's studio. In fact, one of the most problematic attributions is that of the canvas at the Palazzo Barberini, Rome *The Martyrdom of Saint Cecilia,* which some experts attribute to Saraceni and some to François. The version conserved at the Blanton Museum of Art (cat. 12), however,

seems to have garnered unanimous opinion in favour of attribution to the French artist. The painting is a stunning example of perfect integration of Caravaggesque effects, from the fine detailing of the instruments and the sheet music at the saint's feet, to the chromatic palette with its luminous whites and touches of scarlet, to the lighting that models the saint's garment.

François also took up a theme dear to Caravaggio: Saint John the Baptist. The version now in the Galleria Doria Pamphilj collection is clearly inspired by Caravaggio's prototype in Kansas (cat. 25), particularly in the rendering of the saint's drapery. François offers a similarly spare arrangement in his *Penitent Saint Mary Magdalene* at the Louvre: the figure, also covered by sinuously draped cloth, is painted in a half-length view behind a table on which sit the Holy Scriptures, a skull, and a crucifix.

Despite his rather modest graphic corpus, one drawing in particular attests to François's fascination with Caravaggio: a black chalk drawing of the famous *Entombment* painted for the Vittrice chapel at the church of Santa Maria in Vallicella, today in a private collection in Paris.[2]

1 J. Penent, *Le temps du caravagisme: la peinture de Toulouse et du Languedoc de 1590 à 1650* exh. cat. (Toulouse and Paris, 2001).
2 J.-C. Baudequin, "The Drawings of Guy François," *Master Drawings* 32 (1994), pp. 262–269.

Giovanni Antonio Galli, called Lo Spadarino
Rome 1585–1652 Rome

There is little documentation on this painter who was born into a Siennese family and baptized at the Roman basilica of San Lorenzo in Damaso.[1] Apparently, by the age of eighteen he had left home to live at the palace of San Marco, the residence of the Venetian cardinal Giovanni Dolfin. It is not known why Galli took refuge under the protection of the prelate, but he remained there until 1620. In 1614, he worked with Agostino Tassi on the decoration of the Hall of Moses at the residence of Cardinal Alessandro Peretti Montalto (Villa Lante, Bagnaia), and in July 1617, he received payment for frescoes carried out in the Sala Regia at the Palazzo del Quirinale. Also among his early works is *Saint Frances of Rome with an Angel* (Banca Nazionale del Lavoro, Rome), an intimate scene in which the two figures occupy the entire pictorial field.

His style of painting suggests that he was exchanging ideas with Carlo Saraceni, whom he likely met at the Cardinal's palace, and Gerrit van Honthorst. Galli and Honthorst each completed a painting for the Guicciardini chapel of Santa Felicita in Florence.[2] The affinities between the two artists have contributed to uncertainty regarding the attribution of some works; a few previously credited to Honthorst later falling into Galli's work. The latter's assimilation of Caravaggio's lessons is obvious in the splendid *Guardian Angel* in the church of San Rufo in Rieti. This disarmingly simple composition is dominated by the spread wings of the angel, who protects the young boy in a mute embrace. A similarly austere arrangement, against a dark background, characterizes the painting in Baltimore, *The Penitent Magdalene* (cat. 31). The Caravaggesque influence is also perceptible in the expressive intensity conveyed by the wise men in *Christ Among the Doctors* (today at Palazzo Reale, Naples). Galli also shared a major patron, Marchese Vincenzo Giustiniani, with Caravaggio. In fact, Giustiniani's 1638 inventory lists two paintings assigned to Galli: *The Resurrection* and *Saint John the Baptist in the Desert with a Lamb* (both now lost).

Galli obtained a prestigious commission that marked a turning point in his career: *The Miracle of Saint Valerie and Saint Martial*, an altarpiece for Saint Peter's Basilica in Rome, for which he received a series of payments from 1626 to 1633. Finally, starting in 1634, the artist's name appeared in the registers of the Accademia di San Luca.

1 R. Randolfi, "Ritrovamenti documentari per Giovanni Antonio Galli detto Lo Spadarino," *Studi di storia dell'arte* 10 (1999), pp. 71–88; G. Papi, *Spadarino*, Soncino (CR), 2003.
2 Honthorst executed *The Adoration of the Shepherds* (Galleria degli Uffizi, badly damaged in 1993) and Galli produced *The Crucifixion*, today lost.

Artemisia Gentileschi
Rome 1593–1652/53 Naples

Baptized in the church of San Lorenzo in Lucina on 10 July, Artemisia was the first child of Orazio Gentileschi, one of the principal representatives of Caravaggism (see biography p. 303). Trained by her father, Artemisia showed an undeniably early talent, as displayed in her first signed painting, dated 1610, *Susanna and the Elders*. Her personal life was shattered by the rape trial brought against Agostino Tassi, Orazio's friend and collaborator, in 1612. After the hearings Tassi was sentenced to exile. Perhaps to escape her circumstances, Artemisia married Pietro Stiattesi later that year and moved to Florence. Orazio supported his daughter's decision and recommended her to the grand duchess of Tuscany, Marie-Christine de Lorraine, to whom he also sent a painting testifying to his student's talents.

Artemisia's formative years in Rome were strongly influenced by her direct observation of Caravaggio's works. Her interpretation of the theme *Judith Decapitating Holofernes* (cat. 50) presents a dramatic tension that surpasses even the cold intensity of Caravaggio's version (at the Palazzo Barberini, Rome). She would interpret this story in unusual ways, the most original being the canvas in Detroit (c. 1623–25), in which Judith and her maidservant are seen furtively hiding the severed head following the violent act.

In Florence Artemisia began a family and enjoyed a gratifying reputation. She became the first female member of the Accademia del Disegno and she undertook a number of paintings for Grand Duke Cosimo II de' Medici. Despite her success, she had difficulty making a living and there is documentary evidence that she contracted numerous debts. She returned to Rome in 1621 then moved to Venice in 1627 where she received, among others, a commission from the king of Spain, Philip IV. She produced many works for the king after she moved to Naples in 1630.

Artemisia sent her works to Ferdinando II de' Medici (gifts from the king of Spain) and other important patrons such as Duke Francesco I d'Este and Cassiano dal Pozzo, a fervent collector of Caravaggesque paintings who acquired several on behalf of the Barberini cardinals. The artist often expressed the desire to return to Rome and sought Cassiano's assistance in various letters. In 1638 she joined her father in London at the court of Charles I of England. After he died, she remained for some time in the English court; then, unable to find favour in the courts of either the Medici or the Este, she returned to Naples where she collaborated on various major projects with established artists.

ORAZIO GENTILESCHI
Pisa 1562–1639 London

Orazio Gentileschi's career and life have been extensively studied by Bissell,[1] based on rich archival sources. The son of the Florentine goldsmith Giovanni Battista Lomi, Orazio was thirteen or fifteen (two handwritten letters give contradictory information) when he went to Rome, where he adopted his paternal grandfather's name.[2] In 1588 he was employed decorating the Sistine Library at the Vatican, and in 1593 he painted the *Presentation of Christ,* a fresco in Santa Maria Maggiore Basilica. Several years later, he worked on the decorations for the San Giovanni in Laterano Basilica and for the church of Santa Maria dei Monti.

He became friends with Caravaggio around 1600, but their relationship was tested when Giovanni Baglione sued them both for libel in 1603. Caravaggio stated that he had not had contact with Gentileschi for three years, whereas Gentileschi reduced this period of silence to six or seven months.[3] Despite diverging accounts, Gentileschi's attraction to Caravaggio's work is undeniable. Works such as *Saint Francis in Ecstasy* (cat. 28) and numerous interpretations of *David and Goliath* (National Gallery, Dublin; Gemäldegalerie, Berlin) reveal both careful observation of the Lombard master's compositions and a predilection for the same themes. The story of *Judith and Holofernes,* produced in a number of variants (cat. 49), also falls fully within the Caravaggesque repertoire. Gentileschi became a member of the Accademia di San Luca in 1604; the following year, he was admitted to the congregation of the Virtuosi al Pantheon.

Starting in 1611 Gentileschi collaborated with Agostino Tassi to fresco the Consistory Hall of the Palazzo del Quirinale (no longer extant) and the Casino delle Muse, the summer residence of Cardinal Scipione Borghese. The relationship between the two men ended when Gentileschi's daughter accused Tassi of rape. During the years preceding his departure from Rome, Gentileschi received a number of private commissions that took him far from sites in the pontifical city.

In 1621 Gentileschi accepted Giovan Antonio Sauli's invitation to move to Genoa. He also worked for Carlo Emanuele di Savoia before entering the employ of Marie de' Medici, in Paris. Marie's daughter, Henrietta Maria, moved to England following her marriage to Charles I, and Gentileschi established himself in London in the fall of 1626. His many attempts to return to his homeland, involving in particular the Medici in Florence, were unsuccessful.

1 See R.W. Bissell, *The Baroque Painter Orazio Gentileschi: His Career in Italy,* 2 vol. (Ann Arbor, 1966), and *Orazio Gentileschi and the Poetic Tradition in Caravagesque Painting* (Ph.D. diss., Pennsylvania State University, 1981).

2 F. Paliaga "Un pittore pisano a Roma nel Seicento: Orazio Gentileschi; note in margine alla mostra di Orazio ed. Artemisia Gentileschi," *Bollettino storico pisano* 71 (2002), 227–230.

3 S. Ludovici, *Vita del Caravaggio dalle testimonianze del suo tempo* (Milan, 1956).

ANTIVEDUTO GRAMATICA
Rome 1569–1626 Rome

Born to Siennese parents,[1] Gramatica was likely trained in the studio of Giovanni Domenico Angelini, according to his testimony during a trial in 1591, at which he defended the interests of his master who had been swindled by the solicitor Orlandi Landi (who had apparently seized paintings in the studio).[2]

On 28 October 1593, Gramatica became a member of the Accademia di San Luca and several years later he completed his first public work, *Christ the Saviour with Saint Stanislaus of Krakow, Saint Adalbert of Prague and Saint Hyacinth Odrowaz,* an altar painting for the San Stanislao dei Polacchi church in Rome. In 1604 he was admitted to the Virtuosi al Pantheon congregation. Cardinal Francesco Maria del Monte became one of his most important benefactors as indicated by the inventories of the cardinal's collections (1627, 1628), which include more than a dozen Gramatica paintings. A list of the artist's prestigious patrons also includes Cardinal Alessandro Peretti Montalto, Ferdinando Gonzaga, Vincenzo Giustiniani, and the Mattei family, whose respective inventories included many of the artist's works. Gramatica also obtained commissions from Spain, probably due to his long-standing friendship with Orazio Borgianni.

Gramatica led a prolific studio that employed even Caravaggio, if we are to believe Bellori and the Spanish painter Cristoforo Orlandi, who reported that he met Caravaggio there around 1600.[3] There is no doubt that Gramatica's work was influenced by Caravaggio's paintings, particularly those featuring musicians. He sometimes adapted aspects of this theme to his portrayals of religious figures, including the magnificent *Saint Cecilia with Two Angels* (cat. 10). The motif of the female saint recurs throughout his repertoire, and we know of at least two examples, one at the Prado in Madrid, and another, signed and dated 1611, in a private collection. The artist tackled the musician theme most directly on the painting preserved in Turin, *The Theorbo Player* (1611–13). Finally, *The Adoration of the Shepherds* (church of San Giacomo, Rome) was inspired largely by two of Caravaggio's masterpieces: the painting of the same name

executed in Sicily and *Madonna and Child with Saint Anne* (fig. 10, p. 22).

Gramatica's career ended on a rather sad note: after he was elected *principe* of the Accademia di San Luca in January 1624, he quickly lost this title when he suggested that a painting by Raphael, *Saint Luke Painting the Virgin,* be sold to finance restoration of the Santi Luca e Martina church in Rome.

1 For more details on the baptismal certificate, see A. Triponi, "Antiveduto Grammatica: una disputa del primo Seicento romano; nuovi documenti," *Storia dell'arte,* N.S. 103 (2002), 119–140 (pp. 119, 124, note 9).

2 This account is reported in Baglione 2008.

3 R. Bassani and F. Bellini, *Caravaggio assassino: la carriera di un "valenthuomo" fazioso nella Roma della Controriforma* (Rome, 1994), pp. 99–100.

GERRIT VAN HONTHORST
Utrecht 1592–1656 Utrecht

The son of a painter, Honthorst was trained in Abraham Bloemaert's studio. The leader of a large community of Dutch painters active in Rome, he earned the nickname "Gherardo delle Notti" due to his many paintings portraying figures lit by a candle (generally placed in the centre of the composition). His presence in Rome has been established through a drawing signed and dated 1616 (Nasjonalgalleriet, Oslo) reproducing Caravaggio's *The Martyrdom of Saint Peter* in Santa Maria del Popolo. This copy is one of the first clues to the unfailing admiration that he had for the Lombardi master.

Honthorst's encounter with the Giustiniani family, which owned one of the richest collections in Europe and no fewer than fifteen of Caravaggio's paintings, certainly contributed to his intimate knowledge of the master's work. As related

by his student and friend, Joachim von Sandrart, the painter first resided at the palace of the Marchese Vincenzo Giustiniani located near the Church of San Luigi dei Francesi. For this family, he executed, among others, *Christ Before Caiaphas* (fig. 72, p. 248) and *The Denial of Saint Peter* (Gemäldegalerie, Berlin), a work clearly derived from Caravaggio's *The Calling of Saint Matthew* (fig. 1, p. 6).

Unlike many foreign artists, Honthorst obtained various public commissions, the first of which was a painting for the Carmelite Order, *Saint Paul Taken to Heaven,* for the church of Santa Maria della Vittoria, in 1617.[1] His relationship with this order also gave rise to the production, in 1618, of an altar painting, *The Beheading of Saint John the Baptist* for the church of Santa Maria della Scala (fig. 18, p. 41). The monks of this church reserved a better reception for this painting than for Caravaggio's painting *Death of the Virgin* (fig. 9, p. 20), which was rejected for its lack of decorum. That same year Honthorst painted for Flaminia Colonna Gonzaga a *Madonna and Child with Saints Francis and Bonaventure,* signed and dated (Capuchin church, Albano Laziale).

Honthorst left Rome during the summer of 1620 at the height of his career, having received his fee for *Adoration of the Shepherds,* a commission from Piero Guicciardini, ambassador of Grand Duke Cosimo II de' Medici, attesting to his visibility beyond the pontifical city. Returning to his native land, he joined the Guild of Saint Luke and ran a successful studio. A stay in England (1628) and a residency in the court of Frederick Henry, Prince of Orange, at The Hague (1637), punctuated the last period of his life.

1 T. Megna, "Gherardo delle Notti a Roma: le commissioni pubbliche, il 'patronage' Giustiniani e nuovi elementi documentari,"

in *Decorazione e collezionismo a Roma nel Seicento: vicende di artisti, committenti, mercanti*, ed. F. Cappelletti (Rome, 2003).

GEORGES DE LA TOUR
Vic-sur-Seille 1593–1653 Lunéville

La Tour was the son of a baker with a thriving business in the region. Little is known about his training as an artist; some experts posit that he studied under Claude Dogoz, an important local painter who employed many apprentices, and Jacques-Charles Bellange, established at the court of Duke Charles III, in Nancy. He may also have benefited from the patronage of Alphonse de Rambervillers, lieutenant-general in the bailiwick of the Bishopric of Metz in Vic-sur-Seille, also an art lover and collector and a family friend. La Tour's residency in his hometown is supported by two documents: one naming him as godfather to a child born on 20 October 1616 and the other confirming his marriage to Diane Le Nerf on 2 July 1617. The earliest evidence of a payment to La Tour dates only from 1623 (the subject of the commission for Henri II is not specified) and the only dated paintings are *Saint Peter Repentant* in Cleveland (1645) and *The Denial of Saint Peter* in Nantes (1650).

There is no documentation confirming that La Tour spent any time in Rome. However, the city's cultural influence and the establishment there of a large colony of French artists, including Jacques Callot, Claude Lorrain, Jean Le Clerc, and Claude Deruet, would lead us to assume that La Tour visited Rome before 1616. Material evidence of this would be thematic (rather than stylistic) analogies resulting from attentive but not necessarily direct observation of Caravaggio's paintings. According to some authors, Caravaggesque interpretations produced by Flemish and Dutch artists such as Honthorst and ter Brugghen were a primary source of inspiration for La Tour.[1] Following the manner of these north European artists, he produced numerous works in which the scene is lighted by a single candle, notably the remarkable *Repentant Magdalen* (National Gallery of Art, Washington), of which a number of versions were made (Musée du Louvre; Los Angeles County Museum of Art).

Despite speculation about the trip to Rome, it is undeniable that La Tour painted versions of two key themes in the Caravaggesque repertoire: the fortune-teller and the cardsharps. In the former category is the magnificent painting at the Metropolitan Museum of Art, while the paintings at the Kimbell Art Museum (cat. 24) and the Louvre are convincing examples of the latter category. The theme of Saint Jerome in his study is another subject of which La Tour was particularly fond (Musée de Grenoble; Nationalmuseum, Stockholm). Finally, it is likely that the artist was able to study Caravaggio's *Annunciation* commissioned by Henri II, Duke of Lorraine, donated for the high altar of the Primatiale de Nancy around 1609 (Musée des beaux-arts, Nancy).[2]

1 See L. Slatkes, "Georges de La Tour and the Netherlandish Followers of Caravaggio," in Washington 1996, pp. 202–217. The author does not exclude the possibility of a trip to Rome. See also J.-P. Cuzin, "La Tour Seen from the North: Observations on La Tour's Style and the Chronology of His Works," pp. 184–199 in ibid.
2 For more information on this work see F. Cappelletti in Rome 2010, pp. 208–213.

JUAN BAUTISTA MAÍNO
Pastrana (Guadelajara) 1581–1649 Madrid

Maíno's father was a merchant from Milan who had settled in Pastrana some years before his birth. The family does not seem to have had any ties to the arts, and nothing is known of the artist's early training. Maíno is documented in Rome by 1604–05.[1] The *stati d'anime* of 1610 suggests he may have employed an assistant, indicating some success. However, no work can be securely dated to this period. Maíno later claimed to have travelled throughout Italy, naming Rome, Genoa and the Spanish territories. Family ties may have encouraged him to visit Milan and Lombardy, and the naturalist aesthetic of some sixteenth-century Northern Italian painting may well have been congenial to him.

Maíno was in his early twenties when he arrived in Rome. A later seventeenth-century Spanish source tied him to Annibale Carracci and Guido Reni. While references to these artists can be found in his work, the claim implies narrowly orthodox interests for the painter; in fact, the influence of Caravaggio on Maíno is clear. His interests were broad and he was likely aware of the work of Gentileschi and Elsheimer. Given later references in his own painting, he must also have studied antiquities and works of the High Renaissance. His milieu would thus be broadly similar to that of many young artists in the city.

By 1611 Maíno was in Toledo and would remain in the Iberian Peninsula for the rest of his life. He took vows as a Dominican in 1613. Maíno's association with the Spanish royal court, facilitated by his Dominican ties, dates from the mid-teens. At this time he was also named drawing master to the Infante, who later as Philip IV would act as his patron. He was a judge in the competition of 1626–27 for the commission of a painting commemorating the expulsion

of the Moriscos (awarding Velázquez the prize), and in 1634–35 contributed to the decoration of the Buen Retiro, Madrid. Maíno's work and his professional opinion as both an artist and a Dominican were clearly valued by both the royal court and his Order.

1 Madrid 2009 is the essential source on Maíno.

Bartolomeo Manfredi
Ostiano 1582–1622 Rome

Manfredi's baptismal certificate is one of the few reliable documents in an otherwise vague chronology of this artist's life.[1] Dates for his arrival in Rome vacillate between 1603 and 1607, the earlier date standing if one accepts that the Bartolomeo cited by Tommaso Salini in the famous trial brought by Giovanni Baglione in 1603 was indeed Manfredi ("*Bartolomeo servitore del detto Caravaggio*"). His adroit emulations of Caravaggio's compositions indicate that he was in direct contact with the master. Manfredi's early encounter with Pomarancio, to which Baglione alludes in his *Life*, may have occurred in the Gonzaga court in Mantua, which could explain why the young Manfredi joined Pomarancio's studio when he moved to Rome.[2]

Manfredi's skill at copying Caravaggio has exacerbated the problematic issue of attribution and made it difficult to distinguish his works from those of the master's and artists who later followed his method. The painter and writer Joachim von Sandart speaks of a "Manfredian method" (*Manfrediana Methodus*), which posits the idea of a creative approach that follows precise parameters. According to a number of experts, Manfredi's pictorial style, which had numerous followers, was successful because it appealed to collectors left bereft by

Caravaggio's death. However, Manfredi was not regarded as a mere imitator of the Lombard artist; his works were admired in their own right by his contemporaries and by highly placed patrons such as the Giustiniani and Medici.

Although he was most interested in genre scenes (*Group of Revellers*, fig. 62, p. 188), allegorical subjects (*Allegory of the Four Seasons*, fig. 63, p. 190; *Bacchus and a Drinker*, fig. 39, p. 108), and mythology (*Apollo and Marsyas*, cat. 55), Manfredi executed many paintings inspired by biblical episodes. An eloquent example is *The Triumph of David* (cat. 57), in which the composition is tightly organized around the victorious young man marching before his people, personified by the young girl at his side.

In August 1622 Manfredi accepted a commission from Ferdinand Gonzaga, Duke of Mantua, to paint four canvases, the subject of which will never be known as the artist died on 12 December of that year.[3]

1 G. Merlo, "Precisazioni sull'anno di nascita di Bartolomeo Manfredi," *Paragone* 435 (1986), p. 42–46.
2 R. Morselli, "Bartolomeo Manfredi and Pomarancio: Some New Documents," *Burlington Magazine* 129 (October 1987), pp. 666–668.
3 Ibid.; E. Parlato, "Manfredi's Last Year in Rome," *Burlington Magazine* 134 (July 1992), p. 442.

Nicolas Régnier
Maubeuge c. 1588–1667 Venice

Born in a town on the border between France and Flanders, Régnier studied in Antwerp with Abraham Janssens.[1] He went to Italy in 1616 and served the Farnese court in Parma until 1617. His presence in Rome in 1620 is confirmed by the parish registers of

Sant'Andrea delle Fratte, which indicate that he shared his home with two other painters from northern Europe, David de Haen and Dirck van Baburen.[2] The three became the founding members of the Bentvueghels. Régnier benefited from the unfailing patronage of Marchese Vincenzo Giustiniani, who hosted him in his palace as the "domestic painter" around 1622, the year that his friend David de Haen died (and whom he may have replaced). The marquis' inventory includes nine paintings by Régnier, making him one of the best-represented artists in this collection. The inventory includes the monumental *Supper at Emmaus* (today in Potsdam), inspired by Caravaggio's versions in London and Milan.

Régnier accumulated a number of successes and honours: he was the only member of the Bentvueghels whose name was among those in the congregation of the Virtuosi al Pantheon in November 1623. In January 1624, he was also appointed to the Accademia di San Luca as provveditore, or assistant to the studio's rector.

During his long stay with Giustiniani, Régnier attentively studied Caravaggio's works and painted a *Penitent Magdalene,* likely the only copy of the original that presented the saint standing up (both Caravaggio's and Régnier's versions have disappeared).[3] He also reprised Caravaggio's famous *Incredulity of Saint* Thomas (private collection, Milan) for Camille I Massimo, the marquis' nephew, who owned at least four of his paintings.[4]

Caravaggio had an undeniable influence on Régnier, whose work stands out among those reinterpreting the models studied. The *Saint Matthew and the Angel* (cat. 33) is an example of this, cast in an intimate and unusual composition in which the angel lays his hand on the saint's shoulder and guides his writing in the pages of the book. Some paintings offer an interesting variant on the

theme of deception, combining card players and a fortune teller. Other canvases portray original themes, including that of the young dupe sniffing a substance that appears to tranquilize him (Koelliker collection, Milan; Wilanów Palace, Warsaw).

Régnier left Rome between March 1625 and June 1626, having married Cecilia Bezzi several years before. He moved to Venice, where he had an exemplary career, earning uncommon fame for a foreign artist.

1 Information drawn from A. Lemoine, "Nicolas Régnier et son entourage: nouvelles propositions biographiques," *Revue de l'Art* 1 (1997), pp. 54–63.
2 Only Papi places Régnier's arrival in 1610 on the basis of parish registers that mention a "Signor Niccolo Raneri Fiammingo"; see G. Papi, "Un documento su Nicolas Régnier e qualche nuova prospettiva," *Paragone* 593 (1999), pp. 12–20.
3 Moir 1976, pp. 109, 142–143, n. 239.
4 Danesi Squarzina 2003, pp. 182, 186 and 188–189.

Jusepe de Ribera, called Il Spagnoletto
Játiva 1591–1652 Naples

Born into a modest Spanish family with a shoemaker father, Ribera tried his luck in Italy. In 1611 he painted a canvas for the Brotherhood of Saint Martin for the church of San Prospero in Parma (now lost). A notarial act of 5 June 1612 confirms his presence in Rome. [1] The document is significant, as it is a lease contract for a house in which the owner gives the artist permission to pierce an opening in the roof, leading to speculation that the natural light that fascinated Caravaggio was already of interest to Ribera. In 1613 his name appears in the registers of the Accademia di San Luca, an affiliation corroborated by the painting in Strasbourg, *Saints Peter and Paul*

(cat. 36), on which the label "Academicus romanus" is part of the signature.

The attributions of works produced by Ribera during his stay in Rome have been heavily revised and expanded by recent studies. Although it is difficult to establish incontestable attributions due to documentary gaps,[2] it is known that the Giustiniani family owned more than a dozen works by Ribera, including a *Saint Gregory* (Palazzo Barberini, Rome) and a *Christ Among the Doctors* (Cathédrale Saint-Mammès, Langres).[2] Caravaggio's influence is obvious in the painting *Saint Jerome* (cat. 35), both for its naturalist style and for its figure portrayed in a half-length view.

Ribera was still in Rome in 1616, living on Via Margutta with his brother Juan and other compatriots, but was active in Naples during that year, as evidenced by the payment obtained in late July for a *Saint Mark the Evangelist* (now lost) commissioned by Marc Antonio Doria, also a patron of Caravaggio's. He married the daughter of the Sicilian painter Giovanni Bernardino Azzolino and began a prolific career. In Naples, he was able to gain a new appreciation of Caravaggio's works as seen in his *Lamentation over the Dead Christ* (London, National Gallery) and *Saint Bartholomew* (National Gallery of Art, Washington).

During the 1620s he further explored the making of prints, and in 1626 he travelled to Rome to receive honours linked to his appointment as a Knight of the Order of Christ. He enjoyed great success with the viceroys of the Neapolitan kingdom, who commissioned a number of paintings for churches in Spain.

1 S. Danesi Squarzina, "New documents on Ribera, 'pictor in Urbe,' 1612–16," *Burlington Magazine* 148:1237 (2006), pp. 244–251.
2 G. Papi, "Jusepe de Ribera a Roma e il Maestro del Giudizio di Salomone,"

Paragone 629 (July 2002), pp. 21–43; "Ancora su Ribera a Roma," *Les cahiers d'histoire de l'art*, 1 (2003), 63–74; "Ribera 3," *Paragone* 655 (2004), pp. 16–21.
3 Danesi Squarzina 2003.

Orazio Riminaldi
Pisa 1593–1630 Pisa

Riminaldi was likely trained by Aurelio Lomi, Orazio Gentileschi's brother, although none of his early works have come to light. In the absence of documentation it is impossible to know the exact date of his arrival in Rome, although a manuscript biography indicates that he had moved to the city by 1620 and lived there until 1627.[1] He probably attended Gentileschi's studio, as the artist would have been a natural first contact given their common Pisan origins and their connection through Aurelio.[2] Gentileschi may have introduced the young painter to Caravaggio's works, especially those in the churches of San Luigi dei Francesi and Santa Maria del Popolo. Riminaldi associated with French Caravaggesque circles in 1624–25 and became friends with Simon Vouet. When Vouet was appointed director of the Accademia di San Luca, Riminaldi took the position of "censor," in charge of ensuring that the institution's rules were respected.

Riminaldi was not devoted exclusively to the Caravaggesque style and took occasional inspiration from more classic models such as those conveyed by Domenichino and Guido Reni, two figures of the Bolognese school dominant at the time, especially after Caravaggio's death. While no painting by Riminaldi has been found portraying tavern scenes or card players, themes dear to Caravaggio, paintings such as the *Triumph of Earthly Love* (cat. 9) and *The Martyrdom of Saint Cecilia* (both at Galleria Palatina, Florence) undeniably bear the Caravaggesque

seal. As such, the *Triumph* is reminiscent of Caravaggio's version painted for Marchese Vincenzo Giustiniani (fig. 22, p. xx) and *Saint John the Baptist*, painted for Ciriaco Mattei (Pinacoteca Capitolina, Rome). Mattei's brother, Asdrubale, also acquired a work by Riminaldi, *The Sacrifice of Isaac* (Palazzo Barberini, Rome), already recorded in the 1631 inventory.

During his stay in Rome Riminaldi completed two paintings for the Duomo in Pisa, *Samson Slaying the Philistines* and *Moses Raising the Brazen Serpent* between 1620 and 1626, as evidenced by the payments he received.[3] In March 1627, he obtained a down payment for decoration of the cupola in the Pisa cathedral; he never finished this commission as he died of plague in 1630.

1 Biblioteca degli Uffizi, ms. 60.
2 P. Carofano, "Gli anni romani di Orazio Riminaldi, caravaggesco eterodosso," in *Luce e ombra: caravaggismo e naturalismo nella pittura toscana del Seicento*, ed. P. Carofano (Pisa, 2005).
3 G. Guidi, "Notizie di Orazio Riminaldi nei documenti pisani," *Paragone* 269 (1972), pp. 79–87.

THEODOOR ROMBOUTS
Antwerp 1597–1637 Antwerp

A will written in September 1616 indicates that Rombouts was preparing for a long voyage to Italy to further the training that he had received from Abraham Janssens. However, his presence in Rome is documented only as of 1620 in the parish censuses of Sant' Andrea delle Fratte. Like his compatriots, he became fascinated with Caravaggio, although his interpretation of the master's repertoire was more theatrical, with his characters' gestures and facial expressions sometimes verging on caricature. An example of this is the stunning *The Quack Doctor's Surgery*, of which there are several versions, the best known being those in Prague and Ghent. The only other Caravaggist to explore a similar theme was his compatriot Honthorst (Musée du Louvre). Rombouts also favoured horizontal formats and tight framing on the main subject, as exemplified in *The Denial of Saint Peter*, now in Vaduz (Kunstmuseum Liechtenstein).

Rombouts repeatedly depicted the theme of the musician, alone or in a group. For instance, *The Lute Player*, conserved in Philadelphia (cat. 6), evokes Caravaggio's compositions, especially in its attention to such details as the rich carpet covering the table on which the sheet music lies. However, unlike the prototype with its sensual, refined ambience, this painting, with the figure staring at the viewer, has an austere mood. The work was a clear success with dealers and collectors, as evidenced by the numerous copies that have survived, including the one in Antwerp (Koninklijk Museum voor Schone Kunsten). The subject of musician is treated in an unusual way in the painting in Kansas (Helen Foresman Spencer Museum of Art, Lawrence), in which the two figures are standing up, filling a vertical format that is reminiscent of some Caravaggio compositions, including *Portrait of Alof de Wignacourt* (Musée du Louvre).

The second part of Rombouts' stay in Italy took place in Florence, where he lived from 1621 to the fall of 1624.[1] During this period, he submitted two paintings of saints (today lost) to the church of the Santissima Annunziata. The altar painting *Saint Francis Receiving the Stigmata*, which can be viewed at the Church of Santi Simone e Giuda, was recently added to Rombouts's catalogue.[2] It is likely one of the last paintings completed by the artist before he returned to the Netherlands.

1 G. Papi, "Sul soggiorno fiorentino di Theodor Rombouts," *Paragone* 577 (1998), pp. 26–38.
2 Ibid.

PETER PAUL RUBENS
Siegen 1577–1640 Antwerp

Soon after his father's death, Rubens and his family moved to Antwerp, his mother's city of birth. He attended the studio of Tobias Verhaecht in 1591, then continued his training with Adam van Noort (1592) and Otto van Veen (1594–95). In 1598 he was listed as a master in the registers of the Guild of Saint Luke. He went to Italy in May 1600, accompanied by his brother, Philippe, and his student, Deodaat van der Mont. Noticed by the Duke of Mantua, Vincenzo Gonzaga, Rubens was invited to his court, where he remained for eight years. His position enabled him to travel to Florence, Venice, Genoa and Rome, where he made numerous copies of works by Italian masters. He spent the longest time in Rome, from 1601 to 1602 and from 1606 to 1608.

In 1602 Rubens fulfilled various commissions, including three paintings ordered by Archduke Albert, governor of the Netherlands, for the Basilica di Santa Croce in Gerusalemme: *Saint Helen and the Exaltation of the Holy Cross*, flanked by *The Crowning with Thorns* (today Cathédrale de Grasse) and *The Raising of the Cross* (destroyed; replacement copy, Grasse). It is not known whether Rubens was in contact with Caravaggio during his first stay in the pontifical city, but it is obvious that he studied Caravaggio's oeuvre conscientiously. One such opportunity arose when he painted *Saint Gregory in Adoration before the Virgin with Child, with Saints Domitilla, Maurus, and Papianus* (today Musée de Grenoble) at the church of Santa Maria in Vallicella in 1607–08.[1] In close proximity was one of

Caravaggio's key works, *The Entombment,* which had been on display in the Vittrice chapel since September 1604. This painting had a great impact on Rubens, and he produced both a version that was almost a copy of the original, today in Ottawa (cat. 60), and a freer interpretation in the canvas now in the collection at the Courtauld Institute of Art in London. Also in 1608 Rubens was commissioned by the Oratorians of Saint Philip Neri to paint an *Adoration of the Shepherds* for their church in Fermo.

Rubens showed his profound admiration of Caravaggio when he recommended that the Duke of Mantua purchase the painting by the Lombard master rejected by the brothers of Santa Maria della Scala, *Death of the Virgin* (Musée du Louvre). In 1620 he reiterated his support for Caravaggio by leading a campaign to acquire the *Madonna of the Rosary* for the church of Saint Paul in Antwerp (today Kunsthistorisches Museum, Vienna).

Following his mother's death in 1608, Rubens returned to Antwerp, where he would soon be appointed official painter of the court of Archduke Albert and of Infante Isabella of Spain.

1 The painting was never hung above the high altar, and finally the artist placed it in his funerary chapel in Antwerp, where it remained until the eighteenth century. The first version was replaced by a triptych, also by Rubens, illustrating a similar subject and remains in the church in Rome.

Carlo Saraceni
Venice c. 1579–1620 Venice

Saraceni's presence in Rome is confirmed by his apprenticeship with the Vicenzan sculptor and painter Camillo Mariani (1556–1611) in 1598.[1] In fact, Saraceni was surely among the artists who hoped to benefit from the numerous commissions for the Jubilee of 1600, presented under the auspices of the pontifical family of Clement VIII Aldobrandini. Saraceni's heterogeneous style bore a resemblance to the "Venetian" manner of Tintoretto, Veronese and Bassano, and to the Bolognese school although the artist was also inspired by Adam Elsheimer's naturalism and landscapes. In November 1606 Saraceni's personal life was upset by Giovanni Baglione's charges that he and Orazio Borgianni had orchestrated an assault against him. Saraceni became a member of the Accademia di San Luca in 1607.

Caravaggio's influence can be glimpsed in Saraceni's *Rest on the Flight into Egypt,* which adorned the Camaldolese hermitage in Frascati, painted for Olimpia Aldobrandini in 1611–12.[2] The borrowings are more obvious in *The Martyrdom of Saint Cecilia* (cat. 11), in which the angel's pose and the delicate rendering of the musical elements are reminiscent of those in *Triumph of Earthly Love* (fig. 22, p. 56). Despite adopting the Caravaggesque style, Saraceni was chosen by the Carmelites of Santa Maria della Scala to produce a painting to replace Caravaggio's *The Death of the Virgin,* which had been rejected for its irreverence. Saraceni's first offering was, in turn, rejected, but he proposed a second version in a much more traditional and "reassuring" style, with a Madonna crowned with angels and surrounded by the faithful.[3]

Around 1616 or 1617, Saraceni painted a fresco in the Sala Regia of the Palazzo del Quirinale, a project in which Agostino Tassi and Lanfranco also participated. During this period, he undertook the decorative cycle of Marian episodes in the Ferrari chapel (Santa Maria in Aquiro). He seems to have fully assimilated Caravaggio's dramatic vocabulary and monumental character for the altar paintings *Saint Benno Receiving the Keys of Miessen* and *The Martyrdom of Saint Lambert* at Santa Maria dell'Anima.

Saraceni returned to Venice around 1619. In his native city he ran a studio with Jean Le Clerc, who made engravings of his compositions and completed the huge painting for the ducal palace, *Doge Enrico Dandolo Campaigning for the Crusade,* left unfinished when his friend and colleague died.

1 Baglione 1642.
2 The date 1606 that appears on the canvas has been the subject of documented revision by L. Testa, "Novità su Carlo Saraceni: la committenza Aldobrandini e la prima attività romana," *Dialoghi di storia dell'arte* 7 (1998), 130–137; and *idem,* "Carlo Saraceni," in Zuccari 2010.
3 M. Marini, "Carlo Saraceni 'venetiano' e la sua aderenza alla riforma cattolica: 'seguitando in parte la maniera del Caravaggio'," in *Per l'arte: da Venezia all'Europa,* ed. M. Piantoni and L. DeRossi (Monfalcone / Gorizia, 2001) pp. 263–267.

Pensionante del Saraceni
Active between 1620 and 1630

Among the artists who adopted Caravaggio's manner, none is more enigmatic than the one commonly called Pensionante del Saraceni (literally, lodger of Saraceni). Longhi was the first to document a body of works with a certain stylistic unity,[1] but, to date, a striking absence of documentary sources has made it impossible to attach an artist's name to it.[2] Longhi used the designation "Saraceni" because he discerned a painting style analogous to that of the Venetian artist during his Caravaggesque period. This name is still used, even though a number of authors have suggested that the artist in question was of French origin. The masterpiece of the corpus, on which Longhi based his argument, is the painting

conserved at the Vatican Museum (cat. 23). The subject, previously described as Job mocked by his wife,[3] is in fact likely the Denial of Saint Peter. The canvas, which was very popular, was reproduced in a number of versions and copies (Musée de la Chartreuse, Douai; National Gallery of Ireland, Dublin). The composition, with its cropped figures, its chromatic palette, and the gestural action of the two protagonists, clearly refers to Caravaggesque prototypes. To the short list of religious works carried out by the artist, we can now add the imposing *Penitent Saint Jerome in His Study,* conserved in Ottawa (cat. 42).

Pensionante has also been credited with a series of paintings of delicate still lifes, a splendid example of which is in Washington, D.C. (National Gallery of Art). *Still Life with Fruits and Carafe,* exceptional in its quality of execution, was previously attributed to Caravaggio.[4] The artist also favoured genre scenes: generally austere and displaying few human figures, they stand apart from the themes of the cheater and the fortune-teller associated with the Caravaggesque school. *The Fruit Vendor* (Detroit Institute of Arts), tightens the action around the young woman who is lackadaisically paying the vendor. A similar formula is adopted for *The Chicken Vendor* (Prado, Madrid), although the unusual position of the purchaser, placed behind the farmer, foretells a deception: with one hand, the young man is giving the vendor two pieces of change for two chickens, but with the other hand, he is snatching a third fowl. Some episodes feature a single character, such as the lone cook (or fishmonger) in the work in the Galleria Corsini, Florence, who conducts his business behind an imposing table overloaded with fish.

1 R. Longhi, "Ultimi studi sul Caravaggio e la sua cerchia," *Proporzioni,* 1 (1943), pp. 5–63.
2 Only the still life in Washington was listed in the 1621 inventory of Cardinal Giacomo Sannesi. See A. Ottani Cavina, "Per il Pensionante del Saraceni," in *Scritti di storia dell'arte in onore di Federico Zeri,* 2 vols. (Milan, 1984), pp. 608–614.
3 B. Nicolson, "The Art of Carlo Saraceni," *The Burlington Magazine* 112 (1970), pp. 312–315.
4 R. Longhi, "Quesiti caravaggeschi. II. I precedenti," *Pinacotheca* 1:5–6 (Marzo–Giugno 1929), pp. 258–320, 274.

Gerard Seghers
Antwerp 1591–1651 Antwerp

Gerard Seghers was trained in Antwerp, registering in the Guild of Saint Luke as a pupil at the age of twelve. While his teacher(s) are unknown, Gaspard de Grayer, Hendrick van Balen, and Abraham Janssens have been variously claimed. Seghers' presence in Rome is secure, if not well documented; he likely arrived in 1613. The importance of Caravaggio and Manfredi for the young artist is obvious, and we can assume contacts with other Northern artists, Honthorst in particular. His stay in Rome ended around 1617–19, when, thanks to the patronage of Cardinal Zapata y Cisneros, he went to Madrid possibly to work for the royal court. He returned to Antwerp around 1620. In the late 1620s, Seghers replaced Caravaggio with Rubens for inspiration, reflecting both local taste and his professional ties to his countryman. His career was a success, and his importance was acknowledged by court appointments. His strong links to the Jesuits have recently come to scholarly attention.

1 For a short introduction see D.P. Weller, *Seventeenth-century Dutch and Flemish Paintings* (North Carolina Museum of Art,

2009) and M.C. Guardata, "Gerard Seghers e l'ambiente gesuitico romano," pp. 659–666 in Zuccari 2010.

Leonello Spada
Bologna 1576–1622 Parma

Spada was first apprenticed to a master of ornamental design, Cesare Baglioni, and continued his career as a *quadraturista* with Girolamo Curti. Influenced by the Carracci school, he adopted a style resembling Ludovico's during the first decade of the seventeenth century. Documentary sources indicate Spada worked in the Emilia region until 1609 where he resurfaced in 1614 while working on the transept of the Basilica della Madonna della Ghiara at Reggio Emilia. The hypothesis that he travelled to Rome in the interim, long based on the presence of a painting at the Capuchin church of Santa Maria della Concezione, has been ruled out.[1] We do know, however, that Spada accepted a commission from Alof de Wignacourt, grand master of the Order of Saint John of Jerusalem, to paint frescoes at his palace in Valletta. Whether he passed through Rome enroute to Malta is still open to debate, but it is agreed that Spada discovered Caravaggio's works during his stay on the island. His repertoire was enriched with inventions based on the Caravaggesque model: figures presented in a half-length view, dark backgrounds with a focus on the main action. The subjects themselves, also drawing on a Caravaggesque current, were very successful among collectors such as the Barberinis, who owned no fewer than eleven of Spada's paintings, including a *Saint Jerome* recently attributed to Spada following a careful re-reading of the family's inventories (Palazzo Barberini, Rome).[2]

Spada's predilection for Caravaggesque themes such as Judith and Holofernes, David and Goliath, and the Taking of Christ

unjustly garnered him the nickname "ape of Caravaggio" from his contemporaries.[3] This seems harsh, for in some cases, Spada convincingly distanced his work from the prototypes. In his interpretation of *The Arrest of Christ* (Galleria Nazionale, Parma), for example, he replaced the officers in Caravaggio's painting (today in Dublin) with a group of criminals, intensifying the distressing nature of the scene. The composition was very popular, as evidenced by the large number of copies produced. A flash of originality is also found in the *Judith and Holofernes*, now in Bologna, in which the artist, unlike his contemporaries, decided to capture the moment preceding the beheading, when the young widow is observing her drunken enemy. Spada's patrons also included Cardinal Alessandro d'Este, who acquired more than twenty paintings between 1612 and 1622, including *The Gypsy Fortune Teller* (cat. 15), proving that the artist's interest in Caravaggio continued. In 1617 Spada moved to the court of Ranuccio Farnese in Parma.

1 The painting portraying Saint John the Baptist is part of a group of four compositions commissioned by the Bolognese gentleman Giacomo Domenichini from Leonello Spada, Guido Reni, Lucio Massari, and, possibly, Alessandro Tiarini. The collector bequeathed the works to the shrine when he moved to Rome to serve Pope Gregory XI. See S. Macioce, "Leonello Spada (Bologna 1576–Parma 1622)," in Zuccari 2010.
2 S. Schütze, "Maffeo Barberini tra Roma, Parigi e Bologna : un poeta alla scoperta della "Felsina pittrice'," in *I cardinali di Santa Romana Chiesa : collezionisti e mecenati*, ed. Marco Gallo (Rome, 2002), pp. 41–55.
3 Malvasia 1678.

NICOLAS TOURNIER
Montbéliard 1590 –1639 Toulouse

We know little about Tournier's youth except that his parents, Protestants from Besançon, took refuge in Montbéliard. After his early training with his father and uncle, both of whom were painters, Tournier may have continued his apprenticeship in Flanders or Italy, a common practice for artists in this region, although nothing in Tournier's stylistic vocabulary indicates a northern influence.

It is not known when he left Montbéliard or arrived in Rome, but parish records prove that he was there between 1619 and 1626. The artist's faith was put to the test in Catholic Rome and some authors suggest this might explain the predominance of the theme of the Denial of Saint Peter in his work (notably the often-copied version at the High Museum of Art in Atlanta).[1]

Because Tournier did not move in circles that usually hosted foreign artists and his name does not appear in the inventories of collections of the time, the chronology of his production is based largely on a formal analysis of the paintings attributed to him. One thing is certain: like many of his contemporaries, he carefully studied Caravaggio's oeuvre and followed with particular curiosity the Caravaggesque interpretations produced by one of his main disciples, Bartolomeo Manfredi. In fact, Tournier's interest in imitating Manfredi has made it difficult to distinguish their respective oeuvres. For example, it was long believed that *Revellers* (cat. 18) was by Manfredi, until the original resurfaced in London. The two paintings at the Galleria Estense in Modena, *Young Man with a Flask* and *Man Raising a Glass* (cat. 19 and fig. 65, p. XX), fall more coherently within Tournier's career, even though the inventory of ducal collections attributes the paintings to Manfredi. Tournier frequently

used the prototype of the calm young man with the steady gaze in the Modena painting in other compositions portraying groups of people.

Tournier's most ambitious invention crowded with an impressive gallery of figures is *Le corps de garde* in Dresden. The Louisville painting, *Men Playing Dice* (cat. 21), in which the player entrusts his fate to a throw of the dice, portrays a similar dramatic intensity. Tournier's Roman period seems to have ended with the production of the splendid *Christ Blessing the Children* (or *Sinite Parvulos*) in the Corsini collection (Palazzo Corsini, Rome).

In 1627, Tournier signed a contract with the metropolitan chapter of Narbonne to produce a *Virgin and Child with Saint Catherine and Mary Magdalene*. Over the next ten years, he split his time between Narbonne, Carcassonne, and Toulouse, where he received numerous commissions for religious subjects.

1 Luisa Vertova, "Riflessioni su Nicolas Tournier," *Antichità viva* 33:2–3 (1994), pp. 43–51.

ANTONIO D'ENRICO,
CALLED TANZIO DA VARALLO
Riale d'Alagna c. 1585–1632/33 Varallo

The recent discovery of documents related to Tanzio has forced us to take a completely new look at his career.[1] A *processetto matrimoniale* – a declaration of civil status signifying intention to marry – between the artist and the widow Apollonia Aversano (they never married), dated 2 June 1610 and written in Naples, provides valuable information: Tanzio states that he is twenty-five years old and has been living in the Naples parish of Santa Maria della Carità, a neighbourhood very popular with the art

community, for nine years. He was a young orphan when he left his hometown with his brother Melchiorre, who was also his art teacher, and other compatriots. His father, Giovanni d'Enrico, died in 1586; his mother, Caterina Cesa, at an unknown date. He arrived in Rome in 1598 or 1599 and attended the studio of Cavalier d'Arpino for about three years. There is no satisfactory explanation for the discrepancy between Tanzio's declared dates of his stay in Rome in the *processetto* and the date of the safe-conduct he obtained to enter the pontificate in 1600. Perhaps he gave approximate dates, a common practice. In any case he was definitely in Rome during the Jubilee, a time of artistic effervescence during which he saw Caravaggio's newly unveiled "novelties": *The Calling of Saint Matthew* and *The Martyrdom of Saint Matthew* at San Luigi dei Francesi (figs. 1 and 2, pp. 6–7), and *The Crucifixion of Saint Peter* and *The Conversion of Saint Paul* at Santa Maria del Popolo (figs. 5 and 6, pp. 14–15).[2] These works no doubt left a strong impression on the young artist.

Tanzio later found Caravaggio's paintings in Naples, where the Lombard master had taken refuge in 1606. Among the numerous themes explored by Caravaggio, Tanzio favoured the portrayals of Saint John the Baptist, a choice that led to a number of variants, including those conserved in Ohio (Allen Memorial Art Museum, Oberlin) and Tulsa (cat. 40). The latter is clearly borrowed from the model painted by Caravaggio in 1604 for Ottavio Costa (cat. 25), a painting that Tanzio would have seen through copies or during a hypothetical return to Rome.

1 G. Porzio and D.A. D'Alessandro, "Nuovi documenti per i soggiorni meridionali di Tanzio da Varallo e per il contesto pittorico napoletano di primo Seicento," *Ricerche sul '600 napoletano* (2009), pp. 123–139.
2 See D. Franklin, "The Public Caravaggio," pp. 2–25, this volume.

CLAUDE VIGNON
Tours 1593–1670 Paris

At a young age, Vignon went to Paris,[1] where he studied with Jacob Bunel, an artist active in the court of Henri IV and Marie de' Medici. Because almost all of Bunel's work has been lost, it remains difficult to determine the extent of his influence on Vignon.[2] Around 1609–10, Vignon went to Rome, but as with other foreign painters, his time there is not well documented. His name does appear in the parish censuses for the church of San Lorenzo in Lucina in 1619 and 1620, when he had lodgings on the same street as Simon Vouet.[3]

Ambitious and curious, Vignon was receptive to the many schools of painting that had converged in Rome; nevertheless, his work bears the manifest stamp of Caravaggio, whose recent death had only increased his renown. One of Vignon's first works showing the Lombard master's influence is *The Four Fathers of the Church,* a painting that uses the typically Caravaggesque horizontal format and figures shown in half-length view (Curia Generale della Compagnia di Gesù, Rome). Vignon's passion for Caravaggio is obvious in *The Martyrdom of Saint Matthew* (Musée des beaux-arts d'Arras), inspired by the painting at the church of San Luigi dei Francesci, although he interprets the subject more directly and dramatically by frankly showing the act of violence and the blood that soils the saint's garment. The frame is tight around the action and the figures seem to invade the viewer's space, while the bright colours and painting style take inspiration from the Venetian tradition. Vignon also portrayed the popular theme of Judith's beheading of Holofernes (cat. 51).

In *The Adoration of the Magi* (Dayton Art Museum), completed toward the end of his stay in Rome, Vignon forsook Caravaggism to adopt a clearly Venetian, if not Nordic,

manner. His Roman career culminated with his winning first prize in a painting competition organized by Cardinal Ludovisi, nephew of Pope Gregory XV, for *The Wedding at Cana*, a monumental work produced between 1621 and 1623 (once housed in the Neues Palais in Potsdam, but destroyed during the Second World War).

Finally, encouraged by his friend the publisher François Langlois, Vignon made several etchings in Rome that were greeted enthusiastically. He sometimes replicated the works of other artists, such as *The Two Lovers* by fellow Frenchman Simon Vouet, or reproduced his own inventions, such as *The Adoration of the Magi*. When he returned to Paris in 1623, he did not leave behind all traces of the Caravaggesque spirit, as can be seen in *Christ among the Doctors,* a painting signed and dated in that year (Musée de Grenoble).

1 I. Ardouin-Weiss, "Abraham Bosse et la ville de Tours," in *Abraham Bosse: savant graveur, Tours, vers 1604–1676, Paris*, ed. S. Join-Lambert and M. Préaud (Paris; Tours, 2004), p. 19.
2 About this painter, see *Marie de Médicis: un gouvernement par les arts*, ed P. Bassani Pacht (Paris, 2003), pp. 75–79, 138; and *Maria de' Medici: (1573–1642); una principessa fiorentina sul trono di Francia*, ed. C. Caneva and F. Solinas, Livourne (2005), pp. 223–228.
3 P. Bassani Pacht in Zuccari 2010.

SIMON VOUET
1590 Paris–1649 Paris

A precocious talent, Vouet learned the basics of the trade under the supervision of his father, a painter by training. After living in London, Constantinople and Venice, he appeared in Rome on the March 1613 census, among the faithful in the parish of San Lorenzo in Lucina.[1] He was soon able to supplement the allowance he received from

the king of France, which provided basic financial stability, with numerous commissions from important patrons, including the Barberini and Giustiniani families. He also promoted the strategic distribution of his compositions through engravings by Claude Vignon, Johann Friedrich Greuter, and Claude Mellan.

With the exception of a trip to Genoa (1621–22), where he worked for the Doria family, Vouet's Italian experience was concentrated in Rome where he eagerly immersed himself in the Caravaggesque style. For example, he repeatedly explored the theme of the fortune teller. One version, in the Palazzo Barberini (fig. 53, p. 162), created in 1617 for Cassiano dal Pozzo, an enthusiastic collector of his works, was strongly influenced by the version painted by

Caravaggio for Cardinal del Monte (cat. 13). A variant (cat. 14), dating from the same period, is in Ottawa. His *David and Goliath* painted during his sojourn in Genoa (cat. 59) also testifies to his fascination with Caravaggio even when he was away from Rome. To genre scenes were added religious portrayals destined for houses of worship, including *The Birth of the Virgin* in the church of San Francesco a Ripa (c. 1620) and episodes from the life of Saint Francis for the Alaleoni chapel of San Lorenzo in Lucina (c. 1624), the only decorative cycle that he produced in Rome.

The election as pope in 1623 of Cardinal Maffeo Barberini, Vouet's longstanding benefactor, resulted in his obtaining the prestigious commission for an altar painting for Saint Peter's Basilica, an honour never

before bestowed upon a foreign painter. Unfortunately, the canvas, *The Adoration of the Cross with Saints,* was destroyed in the eighteenth century. Vouet's fame also led to his being appointed, by Cardinal del Monte, to the position of principe of the Accademia de San Luca.

Despite his success, Vouet ended his Roman experience in 1527 to become first painter n the court of King Louis XIII, where he began another chapter in his prolific career.

1 F. Solinas, "Ferrante Carlo, Simon Vouet et Cassiano dal Pozzo. Notes et documents inédits sur la période romaine," in *Simon Vouet: actes du colloque international*, ed. S. Loire (Paris 1992), pp. 135–147.

NELDA DAMIANO AND
CHRISTOPHER ETHERIDGE

EARLY YOUTHS AND MUSICIANS

1

Michelangelo Merisi da Caravaggio
The Musicians c. 1595
oil on canvas
92.1 × 118.4 cm
The Metropolitan Museum of Art, New York
Rogers Fund, 1952 (52.81)

PROVENANCE: Cardinal Francesco Maria
Bourbon del Monte, Rome; by descent to
Alessandro del Monte, Rome, 1626; his sale,
5 May 1628; Cardinal Antonio Barberini,
Rome, 1628; his gift to Maréchal Charles I de
Créquy, 1634; Cardinal Richelieu, Paris, by
1642; his estate sale 7 January – 8 February,
1650, lot no. 996; Marie Wignerod de
Pontcourlay, Duchess d'Aiguillon, Paris,
1650. David Burns, Fernacre, UK by 1920s,
and by descent; with Joe Cookson, Kendal,
UK, 1947; W.G. Thwaytes, Penrith, UK,
1947; Metropolitan Museum of Art, 1952.

REFERENCES: Baglione 1642, p. 136; Bellori
1672, p. 216; Mahon 1952; Cinotti 1983,
pp. 476–479, no. 38; M. Gregori and
R. Lapucci in Florence 1991, pp. 110–123,
no. 3; Spike 2001, pp. 31–36, no. 6; Marini
2005, pp. 395–398, no. 16; Schütze 2009,
pp. 37, 69, 245–246, no. 4; Barbara Savina in
Rome 2010, pp. 60–66.

2

Michelangelo Merisi da Caravaggio
Sick Bacchus 1593–94
oil on canvas
67 × 53 cm
Galleria Borghese

PROVENANCE: Cavaliere d'Arpino, Rome by
1607; Cardinal Scipione Borghese, Rome,
1607, and by descent; Galleria Borghese,
1902.

REFERENCES: Mancini 1956–57, p. 226;
Baglione 1642, p. 136; Longhi 1927,
pp. 28–31; Cinotti 1983, pp. 505–510, no. 52;
Hermann Fiore 1989; Hermann Fiore in
Bergamo 2000; Spike 2001, pp. 16–19, no. 3;
Marini 2005, pp. 377–379, no. 7; Schütze
2009, pp. 31, 244, no. 1.

KIMBELL ART MUSEUM ONLY

3

Michelangelo Merisi da Caravaggio
Boy Bitten by a Lizard 1594–96
oil on canvas
65 × 52 cm
Fondazione di Studi di Storia dell'Arte
Roberto Longhi, Florence

PROVENANCE: Pierre d'Atri, Paris; Roberto
Longhi, 1928; Fondazione Longhi.

REFERENCES: Mancini 1956–57, p. 140;
Baglione 1642, p. 136; Sandrart 1675, p. 189;
M. Gregori and R. Lapucci in Florence 1991,
pp. 124–127, no. 4a; Spike 2001, pp. 36–40,
no. 7.2; Marini 2005, p. 395, no. 15 [16 in
2001]; Schütze 2009, p. 245, no 3a.

4

Gerrit van Honthorst
A Smiling Young Man Squeezing Grapes
c. 1622
oil on canvas
83.3 × 66.7 cm
Worcester Art Museum, Massachusetts
Charlotte E.W. Buffington Fund

PROVENANCE: Count Moltke, Copenhagen
(by 1777?), and by descent; Winkel &
Magnussen, Copenhagen, 1–2 June 1931,
lot no. 59; von Kaufmann, Copenhagen,
1931; Christie's, London 14 May 1965,
lot no. 120; with David M. Koetser, Zurich;
with Guttman Arts Ltd., New York;
Worcester Art Museum, 1968.

REFERENCES: Judson and Ekkart 1999,
pp. 194–195, no. 249.

5
Cecco del Caravaggio
A Musician or Maker of Musical Instruments
c. 1610–15
123.8 × 98.4 cm
oil on canvas
Apsley House, London

PROVENANCE: Burland, Liverpool; with
Henry Graves & Co. by 1845; Arthur
Wellesley, 1st Duke of Wellington, London,
1845, and by descent; gift of the 7th Duke to
the nation, 1947; Apsley House.

REFERENCES: Spear 1971, pp. 86–87, no 23;
Papi 2001, pp. 120–121, no. 7.

6
Theodor Rombouts
A Lute Player c. 1620
oil on canvas
111.1 × 99.7 cm
Philadelphia Museum of Art
John G. Johnson Collection 1917

PROVENANCE: John G. Johnson; his bequest
to the City of Philadelphia, 1917.

REFERENCES: R. Vodret and C. Strinati in
London 2001, p. 105, no. 35.

7
Bartolomeo Cavarozzi
The Sorrows of Aminta c. 1625
oil on panel
100 × 120 cm
Musée du Louvre, Paris
Gift of Paul Jamot 1937

PROVENANCE: Émile Bernard, Paris by
c. 1905; Paul Jamot, Paris by c. 1907; his gift
to the Musée du Louvre, 1937.

REFERENCES: Loire 2006, pp. 100–102;
von Bernstorff 2010, pp. 142–144, 167–168.

8
Orazio Riminaldi
Triumph of Earthly Love c. 1624–25
oil on canvas
142 × 112 cm
Galleria Palatina, Palazzo Pitti, Florence

PROVENANCE: Grand Prince Ferdinando de
Medici, Florence by 1713, and by descent;
Galleria Palatina.

REFERENCES: P. Carofano in Milan 2005,
pp. 452–453, VII.9; S. Casciu in Florence
2010, pp. 234–235, no. 59.

NATIONAL GALLERY OF CANADA ONLY

9
Gerrit van Honthorst
Orpheus c. 1615–20
oil on canvas
170 × 200 cm
Museo di Palazzo Reale, Naples
Soprintendenza per i Beni Architettonici
Paesaggistici Storici Artistici ed
Etnoantropologici per Napoli e Provincia,
Museo dell Appartamento Storico

PROVENANCE: Palazzo Reale, Naples by
1826.

REFERENCES: Papi 1999, pp. 145–146, no. 18;
G. Papi in Milan 2005, pp. 366–367, no. V.6.

10
Antiveduto Gramatica
Saint Cecilia with Two Angels c. 1620
oil on canvas
95 × 121 cm
Museu Nacional de Arte Antiga, Lisbon
Purchased (through King D. Fernando's
fund) from Maria Cândida Dias da Silva in
1866

PROVENANCE: Gift of Ferdinand II of
Portugal, 1866.

REFERENCES: Riedl 1998; Papi 1995,
pp. 90–91, no. 10.

11
Carlo Saraceni
The Martyrdom of Saint Cecilia c. 1610
oil on canvas
135.9 × 98.4 cm
Los Angeles County Museum of Art
Gift of The Ahmanson Foundation

PROVENANCE: Natale Rodinini, Rome,
and by descent. Matthiesen Fine Art Ltd.,
London, 1985; Barbara Piasecka Johnson
Collection, Princeton, 1986; gift of
The Ahmanson Foundation, 1996.

REFERENCES: R. Vodret and C. Strinati in
London 2001, p. 101, no. 32; J.T. Spike in
Sydney 2003, pp. 180–181, no. 51.

12
Guy François
Martyrdom of Saint Cecilia c. 1608–13
oil on canvas
126.4 × 97.2 cm
Blanton Museum of Art, University of Texas
at Austin
The Suida–Manning Collection, 1999

PROVENANCE: Bertina & Robert Manning
by 1978.

REFERENCES: Ficacci 1980.

FORTUNE TELLERS

13
Michelangelo Merisi da Caravaggio
The Gypsy Fortune Teller c. 1595
oil on canvas
115 × 150 cm
Musei Capitolini – Pinacoteca Capitolina,
Rome

PROVENANCE: Cardinal Francesco Maria
Bourbon del Monte, Rome; by descent to
Alessandro del Monte, Rome, 1626; his sale,
5 May 1628; Cardinal Carlo Emmanuele Pio,

Rome, 1628 and by descent; sold to Benedict XIV, 1750; his gift to the Pinacoteca Capitolina, 1750.

REFERENCES : Murtola 1604, p. 472 ; Mancini 1956–57, p. 224; Baglione 1642, p. 136; Cinotti 1983, pp. 519–521, no. 58 ; M. Gregori and R. Lapucci in Florence 1991, pp. 86–95, no. 1; Spike 2001, pp. 27–31, no. 5; Moffitt 2002; Marini 2005, pp. 403–404, no. 19; Guarino and Masini 2006, pp. 334–336; Schütze 2009, pp. 70, 249, no. 9.

14
Simon Vouet
The Fortune-teller c. 1620
oil on canvas
120 × 170.2 cm
National Gallery of Canada, Ottawa
Purchased 1957

PROVENANCE: Cardinal Ippolito Aldobrandini, Rome by 1638? Private collection, France by 1955; with Galerie Heim, Paris, 1955; National Gallery of Canada, 1957.

REFERENCES: Crelly 1962, no. 92; Laskin and Pantazzi 1987, pp. 309–311; J. Thuillier in Paris 1990, no. 8; Washington 1996, pp. 173, 284, no. 45; H. Langdon in London 2001, p. 58, no. 14; D. Jacquot in Nantes 2008, p. 114, no. 13.

15
Leonello Spada
The Gypsy Fortune Teller c. 1614–16
oil on canvas
211 × 158 cm
Galleria, Museo e Medagliere Estense,
Modena, IT

PROVENANCE: Cardinal Alessandro d'Este, Rome by 1618, and by descent; Galleria Estense.

REFERENCES: C. Casali in Modena 1998, pp. 276–277, no. 77; Monducci 2002, pp. 172–173, no. 143.

16
Valentin de Boulogne
Fortune Teller with Soldiers c. 1620
oil on canvas
149.5 × 238.5 cm
Toledo Museum of Art
Purchased with funds from the Libbey
Endowment. Gift of Edward Drummond
Libbey

PROVENANCE: Duke of Rutland, Belvoir Caste, UK by 1750(?) and by descent; Christie's, London, 16 April 1926, lot no. 7; Blacker; Sotheby's, London, 1 June 1953, lot no. 157; private collection, UK(?); with Colnaghi, London by 1981; Toledo Musem of Art, 1981.

REFERENCES: Paris 1974, pp. 207–211, no. 64; Mojana 1989, pp. 60–61, no. 4.

CARDSHARPS AND TAVERN SCENES

17
Michelangelo Merisi da Caravaggio
The Cardsharps c. 1595
oil on canvas
94.2 × 130.9 cm
Kimbell Art Museum, Fort Worth, Texas

PROVENANCE: Cardinal Francesco Maria Bourbon del Monte, Rome; by descent to Alessandro del Monte, Rome, 1626; his sale, 5 May, 1628; Cardinal Antonio Barberini, Rome, 1628; by desecent to Prince Maffeo Barberini Colonna di Sciarra, 8th Prince of Carbognano, Rome, 1849; private collection, Europe, by 1895. Private collection, Europe by 1987; Kimbell Art Foundation, 1987.

REFERENCES: Scanelli 1657, p. 197; Bellori 1672, p. 216; Cinotti 1983, pp. 554–556, no. 70; Mahon 1988, pp. 11–25; M. Gregori and R. Lapucci in Florence 1991, pp. 96–109, no. 2; Spike 2001, pp. 20–27, no. 4; Marini 2005, pp. 401–403, no. 18; Schütze 2009, pp. 70, 248–249, no. 8; M.C. Terzaghi in Rome 2010, pp. 42–49.

18
Nicolas Tournier
Revellers c. 1618–20
oil on canvas
129 cm × 192 cm
Musée de Tessé, Le Mans, France

PROVENANCE: Everard Jabach, Paris, by 1662; Louix XIV of France, 1662, and by descent; revolutionary seizure; deposited at the Musée de Tessé, 1958.

REFERENCES: Paris 1974, pp. 112–117 no. 32; Toulouse 2001, pp. 80–82, no. 1.

19
Nicolas Tournier
Young Man with a Flask before 1624
oil on canvas
130 × 93 cm
Galleria, Museo e Medagliere Estense,
Modena, Italy

PROVENANCE: Cardinal Alessandro d'Este, Rome by 1624, and by descent; Galleria Estense.

REFERENCES: C. Casali in Modena 1998, pp. 284–285, no. 80; Toulouse 2001, pp. 82–85, no. 3.

20
Valentin de Boulogne
Soldiers Playing Cards and Dice (The Cheats)
c. 1618–20
oil on canvas
121 × 152 cm
National Gallery of Art, Washington
Patrons' Permanent Fund 1998.104.1

PROVENANCE: Borros de Gamançon,
Périgeux, France by mid-1800s. Private
collection, near Bordeaux by 1989; Drouot
Richelieu, Paris 11 December, 1989,
lot no. 58; Jacques Chevreux, Paris; National
Gallery of Art, 1998 through Eric Turquin,
Paris.

REFERENCES: Mojana 1989, pp. 58–59,
no. 3b; Conisbee 2009, pp. 414–419, no. 88.

21
Nicolas Tournier
Men Playing Dice c. 1622–24
oil on canvas
120.2 × 171.5 cm
Collection Speed Art Museum, Louisville
Kentucky
Gift of the Charter Collectors, 1987.12

PROVENANCE: Sir Robert Wilmot,
Osmaston, UK by 1811, and by descent; with
Colnaghi, London, 1987; Speed Art
Museum, 1987.

REFERENCES: Nicolson 1989, p. 199;
Toulouse 2001, pp. 92–94, no. 7;
W. Prohaska in Milan 2005, pp. 322–323,
no. IV.17.

22
Gerard Seghers
The Denial of Saint Peter c. 1620–25
oil on canvas
157.5 × 227.3 cm
North Carolina Museum of Art, Raleigh
Purchased with funds from the State of
North Carolina

PROVENANCE: Andreas Colyns de Nole,
Antwerp by 1638. Deyne collection, Ghent
by 1753. Philippe Louis Parizeau, Paris by
1789; his sale, Paris 26 March 1789, lot
no. 104; Jean-Baptiste-Pierre Le Brun, Paris,
by 1791; his sale, Paris, 11 April – 8 May 1791,
lot no. 87; Lerouge collection by 1799;
his sale, Paris, 11–12 January 1799, lot no. 5.
Cardinal Joseph Fesch by c. 1810; his sale,
Rome, 17 March 1845, lot. 217; with
Alessandro Aducci. With French & Co., NY
by 1952; purchased 1952.

REFERENCES: Spear 1971, pp. 162–163,
no. 61; Raleigh 1998, pp. 188–190, no. 35;
Weller 2009, pp. 318–321, no. 66.

23
Pensionante del Saraceni
Denial of Saint Peter c. 1615–20
oil on canvas
100 × 129 cm
Musei Vaticani, Vatican City

PROVENANCE: Sacchetti family, Rome;
sold to Benedict XIV, 1748; his gift to the
Pinacoteca Capitolina; Napoleonic seizure,
subsequently restituted?; Vatican Palace, 1818;
deposited in the Pinacoteca Vaticana, 1909.

REFERENCES: Sydney 2003, pp. 160–161,
no. 41.

24
Georges de La Tour
The Cheat with the Ace of Clubs c. 1630–34
oil on canvas
97.8 × 156.2
Kimbell Art Museum, Fort Worth, Texas

PROVENANCE: Count Isaac IV Pictet,
Pregny, Switzerland (by 1823?) and by
descent; with Andrée Stassart, Belgium, 1981;
Kimbell Art Foundation, 1981.

REFERENCES: Thuillier 1992, p. 288, no. 39;
Washington 1996, p. 269, no. 18.

INDIVIDUAL SAINTS

25
Michelangelo Merisi da Caravaggio
Saint John the Baptist in the Wilderness
1604–05
oil on canvas
172.7 × 132.1 cm
The Nelson-Atkins Museum of Art, Kansas
City, Missouri
Purchase William Rockhill Nelson Trust,
52–25

PROVENANCE: Ottavio Costa, Rome;
by descent to Piero Francesco Costa, 1683;
his gift to the Order of St. John of Jerusalem,
Malta, 1723; James, 5th Baron Aston of
Forfar, UK by 1751, and by descent; with
Agnew's and Edward Speelman & Sons,
London, 1951; the Nelson-Atkins Museum,
1952.

REFERENCES: Spear 1971, pp. 75–76, no. 17;
Spezzaferro 1974; Cinotti 1983, pp. 443–444,
no. 21; Rowlands 1996, pp. 215–226, no. 25;
Spike 2001, pp. 178–182, no. 39; Costa
Restagno 2004, pp. 63–69; Marini 2005,
pp. 483–485, no. 62; Terzaghi 2007,
pp. 295–300; Schütze 2009, pp. 122, 268,
no. 35; M. Pupillo in Rome 2010,
pp. 152–157.

26
Michelangelo Merisi da Caravaggio
Saint Francis c. 1606–07
oil on canvas
128 × 90 cm
Museo Civico, Ala Ponzone, Cremona, Italy

PROVENANCE: Gift of Filippo Ala Ponzone,
Cremona, 1879.

REFERENCES: Longhi 1943, p. 17; Röttgen
1974, pp. 208–213; Cinotti 1983, p. 423,
no. 9; M. Gregori and R. Lapucci in
Florence 1991, pp. 290–299, no. 17; Spike,
2001, pp. 259–261, no. 61; Marini 2005,

pp. 481–483, no. 61; P. Caretta and V. Sgarbi in Milan 2005, pp. 160–161, no. I.VII; M. Gregori in Barcelona 2005, pp. 60–63, no. 5; Schütze 2009, pp. 158, 274–275, no. 46.

27
Michelangelo Merisi da Caravaggio
Saint Francis in Ecstasy c. 1594–95
oil on canvas
92.4 × 127.6 cm
Wadsworth Atheneum Museum of Art, Hartford, Connecticut
The Ella Gallup Sumner and Mary Catlin Sumner Collection Fund

PROVENANCE: Ottavio Costa, Rome by 1606; by descent to the Marchese Giuseppe Origo, Rome; his gift to the Congregazione degli Operai della Divina Pietà, Rome, 1834; sold to the Marchese Antonio De Cinque, Rome, 1854; Sacro Monte di Pietà, Rome, by 1857; sold 1875. Dr. Guido Grioni, Trieste by 1929; with Arnold Seligmann, Rey & Co., New York by 1943; purchased 1943.

REFERENCES: Askew 1969, pp. 284–294; Spezzaferro 1974, pp. 579–586; Cinotti 1983, pp. 440–442, no. 19; Spike 2001, pp. 40–46, no. 8; Costa Restagno 2004, pp. 63–69; Marini 2005, pp. 388–390, no. 11; Lorizzo 2006, pp. 53–55; Terzaghi 2007, pp. 273–274, 300–304; Schütze 2009, pp. 75, 250–251, no. 11.

28
Orazio Gentileschi
Saint Francis in Ecstasy c. 1607
oil on canvas
126 × 98 cm
Museo Nacional del Prado, Madrid

PROVENANCE: Spanish Royal collection by 1746, and by descent; Museo del Prado.

REFERENCES: Bissell 1981, pp. 141–142, no. 9; B.L. Brown in London 2001, pp. 268–269,

no. 101; K. Christiansen in New York 2001, pp. 61–63, no. 6; G. Finaldi in Barcelona 2005, pp. 161–171, no. 35.

29
Giovanni Baglione
Ecstasy of Saint Francis 1601
oil on canvas
155.3 × 116.8 cm
The Art Institute of Chicago
Bequest of Suzette Morton Davidson
2002.378

PROVENANCE: Cardinal Bernardino Spada, Rome by 1636? Borghese collection, Rome by 1650; Cardinal Joseph Fesch, Rome by c. 1804; his contribution to a charity auction by the city of Lyon, 1836. Breval, Fontaine St. Martin, near Lyon, by 1909. Henry Charles Ponsonby Moore, 10th Early of Drogheda, London and Dublin, by 1947; Michele de Benedetti, Rome, 1947 through Agnew's, London; Suzette Morton Zurcher (later Davidson), Santa Barbara and Chicago, 1959 through Agnew's, London; her bequest to the Art Institute of Chicago, 2002.

REFERENCES Spear 1971, pp. 44–45, no. 3; O'Neil 2002, pp. 85, 202–203.

30
Michelangelo Merisi da Caravaggio
Saint Francis c. 1598
oil on canvas
103 × 76.5 cm
Barbara Piasecka Johnson Collection Foundation

PROVENANCE: Barbara Piasecka Johnson, Princeton, USA by 1987 through Matthiesen Art Gallery, London.

REFERENCES: F. Bologna in Warsaw 1990, pp. 174–179, no. 29; D. Jaffé in Sydney 2003, pp. 96–97, no. 9.

NATIONAL GALLERY OF CANADA ONLY

31
Michelangelo Merisi da Caravaggio
Penitent Magdalene 1596–97
oil on canvas
122.5 × 98.5 cm
Galleria Doria Pamphilj, Rome

PROVENANCE: Camillo Pamphilij, Rome by 1664, and by descent.

REFERENCES: Mancini 1956–57, p. 224; Scanelli 1657, pp. 199, 277; Belori 1672, p. 215; Cinotti 1983, pp. 510–512, no, 53; Spike 2001, pp. 76–80, no. 16; L. Testa in Volpi 2002, p. 135; Sickel 2003, pp. 55–64; Marini 2005, pp. 404–406, no. 20; Schütze 2009, pp. 72, 250, no. 10.

NOT IN EXHIBITION

32
Giovanni Antonio Galli called Lo Spadarino
Saint Mary Magdalen 1597–1649
oil on canvas
133 × 98.7 cm
Walters Art Museum, Baltimore, Maryland
37.651

PROVENANCE: Don Marcello Massarenti, Rome by 1897; Henry Walters, Baltimore, 1902; his bequest to the Walters Art Museum, 1931.

REFERENCES: Zeri 1976, no. 316, pl. 223, pp. 444–445; Papi 2003.

33
Nicolas Régnier
Saint Matthew and the Angel c. 1625
oil on canvas
107.9 × 123.8 cm
Collection of the John and Mable Ringling Museum of Art, the State Art Museum of Florida, a Division of Florida State University
Bequest of John Ringling, 1936

PROVENANCE: John Ringling, by 1924–36.

REFERENCES: Spear 1971, pp. 198–199, no. 80; Lemoine 2007, pp. 39, 48, 221–222, no. 15.

34
Bartolomeo Cavarozzi
Saint Jerome in His Study c. 1617
oil on canvas
116 × 173 cm
Galleria Palatina, Palazzo Pitti, Florence

PROVENANCE: Galleria Palatina, Florence by 1890.

REFERENCES: S. Benedetti in Milan 2005, pp. 438–439, no. VII.2; M. Von Bernstorff in Ebert-Schifferer et al., 2007, pp. 217–229; G. Papi in Florence 2010, pp. 142–143, no. 16; Von Bernstorff 2010, pp. 63–74.

35
Jusepe de Ribera
Saint Jerome c. 1613
oil on canvas
125.7 × 99.5 cm
Art Gallery of Ontario, Toronto
Gift of Joey and Toby Tanenbaum, 1995
Acc. 95/150

PROVENANCE: Bourbon Princes of Sicily and Naples by 1861/2; Hapsburg, Feldman Inc., New York, 9 January 1990, lot no. 49; Joey and Toby Tanenbaum, Toronto, 1990; their gift to the Art Gallery of Ontario, 1995.

REFERENCES: Naples 1992, p. 133, no. 1.13; Spinosa 2006, p. 257, no. A3; Papi 2007, pp. 152–153, no. 34.

36
Jusepe de Ribera
Saints Peter and Paul c. 1616
oil on canvas
126 × 112 cm
Musée des Beaux-Arts, Strasbourg

PROVENANCE: Monastery of S. Lorenzo, the Escorial, by 1681. Gustav Rothau, before 1890; Galerie Georges Petit, 29–31 May 1890, lot no. 233; Musée des Beaux-Arts, Strasbourg.

REFERENCES: Naples 1992, pp. 134–135, no. 1.14; Spinosa 2006, pp. 267–268, no. A32; Papi 2007, pp. 168, no. 53.

37
Michelangelo Merisi da Caravaggio
Saint Augustine c. 1600
oil on canvas
120 × 99 cm
Private Collection

PROVENANCE: Cardinal Benedetto Giustiniani, Rome? Marchese Vincenzo Giustiniani, Rome, by 1638; by descent to Marchese Pantaleo Vincenzo Giustiniani, Rome by 1857; sold between 1859 and 1862. Private collection.

No references.

NATIONAL GALLERY OF CANADA ONLY

38
Orazio Borgianni
Saint Christopher Carrying the Infant Christ
c. 1615
oil on canvas
104 × 78 cm
National Gallery of Scotland, Edinburgh
Presented to the Royal Scottish Academy by Sir John Watson Gordon 1850; transferred to the National Gallery of Scotland 1910

PROVENANCE: Gift of Sir John Watson Gordon to the Royal Scottish Academy, 1850; National Gallery of Scotland, 1910.

REFERENCES: A.E. Peréz Sánchez in New York 1985, pp. 104–105, no. 21.

39
Juan Bautista Maíno
Saint John the Baptist Playing with a Lamb
c. 1608–10
oil on canvas
130 × 102 cm
Kunstmuseum Basel, Switzerland

PROVENANCE: Bequest of Gedeon Meyer, 1874.

REFERENCES: Cinotti 1983, pp. 557–558, no. 73; Madrid 2009, pp. 103–105, no. 11.

40
Antonio Tanzio da Varallo
Saint John the Baptist c. 1627–29
oil on canvas
165.1 × 114 cm
Philbrook Museum of Art, Tulsa, Oklahoma
Gift of Samuel H. Kress

PROVENANCE: Cav. Enrico Marinucci, Rome; Contini Bonacossi, Florence, by 1939; Samuel H. Kress, 1939; his gift to the Philbrook Museum of Art, 1953.

REFERENCES: Tulsa 1995; R.P. Townsend in Milan 2000, pp. 129–132.

41
Attributed to Carlo Saraceni or Guy François
The Holy Family in Saint Joseph's Workshop
c. 1615
oil on canvas
113.3 × 84 cm
Wadsworth Atheneum Museum of Art, Hartford, Connecticut
The Ella Gallup Sumner and Mary Catlin Sumner Collection Fund

PROVENANCE: M.A. Dehaspe. Frederick Mont, NY; purchased Wadsworth Atheneum Museum of Art, 1963.

REFERENCES: Ottani Cavina 1968, p. 103, no. 20; Spear 1971, pp. 160–161, no. 60.

42
Pensionante del Saraceni
The Penitent Saint Jerome in his Study
c. 1615
oil on canvas
171.4 × 122.4 cm
National Gallery of Canada, Ottawa
Purchased 2004

PROVENANCE: Müller collection, Strasbourg
by c. 1800, and by descent; National Gallery
of Canada, 2004 through Hall & Knight,
New York.

REFERENCES: Franklin and Gritt 2008.

43
Cecco del Caravaggio
San Lorenzo c. 1615–20
oil on canvas
143 × 95 cm
Government of Italy, Ministry of the Interior
Santa Maria in Vallicella, Rome

PROVENANCE: Santa Maria in Vallicella,
Rome.

REFERENCES: A. Cottino in Rome 1995b,
pp. 170–171, no. 48; Papi 2001, pp. 121–123,
no. 8; G. Gruber in Milan 2005,
pp. 222–223, no. II.22.

NOT IN EXHIBITION

44
Dirck van Baburen
Saint Francis 1615–16
oil on canvas
114 × 84 cm
Kunsthistorisches Museum, Vienna

PROVENANCE: Hapsburg collections by 1765,
and by descent; Gemäldegalerie,
Kunsthistorischen Museums.

REFERENCES: Slatkes 1965, pp. 49–50, 110,
no. A6; W. Prohaska in Prohaska and
Swoboda 2010, pp. 141–145.

45
Trophime Bigot
Saint Jerome Reading c. 1635
oil on canvas
96 × 119.6 cm
National Gallery of Canada, Ottawa
Purchased 1960

PROVENANCE Arthur Percy Summerfield,
Birmingham, UK; private collection, France
by c. 1953/4?; with Schaeffer Galleries,
New York, by c. 1953/4; National Gallery of
Canada, 1960.

REFERENCES: Laskin and Pantazzi 1987,
pp. 32–34.

46
Gerrit van Honthorst
Saint Sebastian c. 1623
oil on canvas
101 × 117 cm
National Gallery, London

PROVENANCE: Philips, London 27 July 1832,
lot no.138? Private collection, near Bristol by
c. 1928; Mabel Berryman c. 1928; National
Gallery, London 1930.

REFERENCES: Judson and Ekkart 1999,
pp. 103–105, no. 85; Papi 1999, pp. 164–166,
no. 35.

RELIGIOUS COMPOSITIONS

47
Michelangelo Merisi da Caravaggio
Martha and Mary Magdalene c. 1598
Oil and tempera on canvas
97.8 × 132.7 cm
Detroit Institute of Arts
Gift of the Kresge Foundation and Mrs.
Edsel B. Ford

PROVENANCE: Olimpia Aldobrandini, Rome
by 1606, and by descent. Panzani family,
Arezzo by 1897; Indalecio Gómez between

1904–1909, and by descent; Detroit Institute
of Arts, 1973 through David Carritt.

REFERENCES: Cummings 1974; Cinotti 1983,
pp. 424–427, no. 10; M. Gregori and
R. Lapucci in Florence 1991, pp. 174–187,
no. 7; Spike 2001, pp. 93–97, no. 21; Marini
2005, pp. 418–419, no. 28; Schütze 2009,
pp. 76, 86–87, 255–256, no. 20.

48
Simon Vouet
Martha and Mary Magdalene c. 1621
oil on canvas
110 × 140 cm
Kunsthistorisches Museum, Vienna

PROVENANCE: George Villiers, 1st Duke of
Buckingham, London by 1628; by descent to
the 2nd Duke; his sale, Antwerp, 1649;
Hapsburg collections, 1649, and by descent;
Gemäldegalerie, Kunsthistorischen
Museums.

REFERENCES: Crelly 1962, p. 221, no. 152;
G. Swoboda in Prohaska and Swoboda 2010,
pp. 305–311.

49
Orazio Gentileschi
*Judith and her Maidservant with the Head of
Holofernes* c. 1608–09
oil on canvas
136 × 160 cm
The National Museum of Art, Architecture
and Design, Oslo

PROVENANCE: Scarpa collection, Motta di
Livenza, Italy; sale, Jules Sambon, Milan,
14 November 1895, lot no.67 (bought in);
gift of Jules Sambon to a charity sale,
Syndicat de la Presse, Petit Palais, Paris,
13–23 June, 1917, lot no. 46; Wangs Kunst
og Antikvitetshandel, Oslo, 1917;
U.J.R. Börresen, Oslo by 1918;
Nasjonalgaleriet, Olso, 1945.

REFERENCES: Bissell 1981, pp. 155–156,

no. 27; Bissell 1999, pp. 318–320, no. X13; K. Christiansen in Rome 2001, pp. 82–86, no. 13.

50
Artemisia Gentileschi
Judith Beheading Holofernes c. 1612–13
oil on canvas
158.8 × 125.5 cm
Museo di Capodimonte, Naples

PROVENANCE: Saveria de Simone, Naples, until 1827; Museo di Capodimonte.

REFERENCES: Bissell 1999, pp. 191–198, no. 4; J.W. Mann in Rome 2001, pp. 308–311, no. 55.

NATIONAL GALLERY OF CANADA ONLY

51
Claude Vignon
Judith with the Head of Holofernes c. 1620
oil on canvas
102 × 82 cm
Koelliker Collection

PROVENANCE: Koelliker Collection.

REFERENCES: G. Papi in Milan 2005, pp. 296–297, no. IV.5.

52
Michelangelo Merisi da Caravaggio
Sacrifice of Isaac 1602–03
oil on canvas
104 × 135 cm
Galleria degli Uffizi, Florence

PROVENANCE: Maffeo Barberini, Rome; by descent to Prince Maffeo Barberini Colonna di Sciarra, 8th Prince of Carbognano, Rome, 1849; Società di Credito e di Industria Edilizia, Venice, Edoardo Almagià & Angelo Sinigaglia, 1897. Charles Fairfax Murray by 1917; his gift to the Galleria degli Uffizi, 1917.

REFERENCES: Bellori 1672, p. 224; Cinotti 1983, pp. 429–431, no. 12; M. Gregori and R. Lapucci in: Florence 1991, pp. 226–237, no. 11; Gallo in Macioce 1996, pp. 331–360; Spike 2001, pp. 161–165, no. 34; Marini 2005, pp. 480–481. no. 60; Schütze 2009, pp. 157, 168–169, 267, no. 32; C. Acidini in Rome 2010, pp. 168–175; G. Papi in Florence 2010, pp. 113–115, no. 5.

53
Michelangelo Merisi da Caravaggio
Sacrifice of Isaac c. 1598–99
oil on canvas
116 × 173 cm
Barbara Piasecka Johnson Collection Foundation

PROVENANCE: Barbera Piasecka Johnson, Princeton, USA by 1989.

REFERENCES: Gregori 1989; M. Gregori in Warsaw 1990, pp. 166–173, no. 28; M. Gregori and R. Lapucci in: Florence 1991, pp. 152–173, no. 6; Puglisi 1998, p. 397, no. 8; Spike 2001, pp. 340–341, no. 94; Marini 2005, pp. 474–475, no. 57; Bologna 2006, pp. 320–321, no. 48; Marini 2007; Schütze 2009, p. 289, no. 71; von Bernstorff 2010, pp. 155–160.

NATIONAL GALLERY OF CANADA ONLY

54
Bartolomeo Manfredi
Ecce Homo c. 1612
oil on canvas
111.8 × 152.4 cm
Memphis Brooks Museum of Art, Memphis, Tennessee
Purchase 89.12

PROVENANCE: Private collection, Rome, by 1981; with Patrick Matthiesen, London, 1981; Memphis Brooks Museum of Art, 1988.

REFERENCES: Raleigh 1998, pp. 66–68, no. 3; Hartje 2004, pp. 321–322, no. A 14.

55
Bartolomeo Manfredi
Apollo and Marsyas c. 1616–20
Oil on canvas
95.5 × 136 cm
Saint Louis Art Museum
Friends Fund and funds given by
Mr. and Mrs. John Peters MacCarthy, Phoebe and Mark Weil, and Christian B. Peper
62.2004

PROVENANCE: Gian Luigi Mercati, Rome by 1628. Don Gonzalo Maria de Ulloa Ortega-Montanés, 9th Count of Adanero, Madrid by 1882, and by descent; Sotheby's, London July 10, 2003, lot no.37; with Derek Johns, London; St. Louis Art Museum, 2004.

REFERENCES: Hartje 2004, pp. 344–347, no. A25; Sickel 2006, pp. 210–211.

56
Hendrick ter Brugghen
The Liberation of Saint Peter 1624
oil on canvas
104.5 × 86.5 cm
Royal Picture Gallery Mauritshuis, The Hague
Purchased with the support of the Rembrandt Society, no. 966

PROVENANCE: Count Moltke, Copenhagen (by 1756?), and by descent; (Winkel & Magnussen, Copenhagen 1–2 June 1931?); Alfred Andersen, Copenhagen, 1931 through 1954. H. Cramer Gallery, the Hague, 1963; Koninklijk Kabinet van Schilderijen,1963.

REFERENCES: G. Jansen in Braunschweig 1987, pp. 123–125, no. 18; L.M. Helmes in Milan 2005, pp. 380–381, no. V.13; Slatkes and Franits 2007, 128–130, no. A36.

57
Bartolomeo Manfredi
David and Goliath (The Triumph of David)
c. 1615
oil on canvas
128 × 97 cm
Musée du Louvre, Paris
Acquired in 1990

PROVENANCE: Art Collector's Association, London, 1920; private collection, Sweden; Bukowski, Stockholm, 25–28 April 1989, lot no. 451; art market, New York; art market, Paris; Musée du Louvre, 1990.

REFERENCES: Hartje 2004, pp. 323–326, no. A16; M.C. Guardata in Milan 2005, pp. 292–293, no. IV.3; Loire 2006, pp. 207–209.

58
Valentin de Boulogne
David With the Head of Goliath and Two Soldiers 1620–22
oil on canvas
99 × 134 cm
Museo Thyssen-Bornemisza, Madrid

PROVENANCE: Private collection, UK; Baron Heinrich Thyssen-Bornemisza, 1930, and by descent; Museo Thyssen-Bornemisza.

REFERENCES: Mojana 1989, pp. 90–11, no. 19; Contini 2002, pp. 100–104, no. 19.

59
Simon Vouet
David and Goliath c. 1621
oil on canvas
123 × 95.5 cm
Musei di Strada Nuova, Palazzo Bianco, Genoa

PROVENANCE: Giovanni Carlo Doria, Genoa by 1625; by descent to Cecilia Spinola Doria, Genoa, by 1721; Giovanni Maria & Giovanni Battista Cambiaso, Genoa by 1766; by descent to Marchese G.B. Cambiaso, Genoa by 1923; purchased 1923.

REFERENCES: Crelly 1962, p. 163, no. 36; Paris 1990, pp. 204–205, no. 11; Farina 2002, pp. 140–141, Pericolo in Boccardo et al. 2003, pp. 91–95; P. Boccardo in Milan 2005, pp. 330–331, no. IV.21; Collange in Nantes 2008, pp. 132–133, no. 27; Pericolo in Boccardo et al. 2003, pp. 91–95.

60
Peter Paul Rubens
The Entombment c. 1612–14
oil on oak
88.3 × 66.5 cm
National Gallery of Canada, Ottawa
Purchased 1956

PROVENANCE: Prince Johann Adam Andreas I of Liechtenstein (1710, through the Forchondt, Antwerp?), and by descent; National Gallery of Canada, 1956 through Agnew's, London.

REFERENCES: Laskin and Pantazzi 1987, pp. 259–260; London 2005a, p. 134.

General Bibliography

A

AGO 2002
R. Ago. "Collezioni di quadri e collezioni di libri a Roma tra XVI e SVIII secolo." *Quaderni storici* 37 (2002), pp. 379–403.

AGO 2006
R. Ago. *Il gusto delle cose. Una storia degli oggetti nella Roma del Seicento.* Rome, 2006.

ALEMÁN 1708
M. Alemán. *The Life of Guzman de Alfarache.* Vol. I. London, 1708.

ANDREINI 1609
F. Andreini. *Le Bravure del Capitano Spavento.* Venice, 1609.

ARONBERG LAVIN 1975
M. Aronberg Lavin. *Seventeenth-century Barberini Documents and Inventories of Art.* New York, 1975.

ASKEW 1969
P. Askew. "The Angelic Consolation of St. Francis of Assisi in Post-Tridentine Italian Painting." *Journal of the Warburg and Courtauld Institutes* 32 (1969), pp. 280–304.

B

BAGLIONE 1642
G. Baglione. *Le vite de' pittori, scultori et architetti. Dal pontificato di Gregorio XIII. In fino a' tempi di Papa Urbano VIII nel 1642.* Rome, 1642

BAGLIONE 2008
G. Baglione. *Le vite de'pittori, scultori et architetti dal Pontificato di Gregorio XIII fino a tutto quello d'Urbano VIII* (Rome, 1649). Facsimile edition. Bologna, 2008.

BARCELONA 2005
J. Milicua and M.M. Cuyàs, eds. *Caravaggio y la pintura realista europea* (exh. cat.). Barcelona 2005.

BASSANI 1992
P.P. Bassani. *Claude Vignon 1593–1670.* Paris, 1992.

BELLORI 1672
G.P. Bellori. *Le Vite de' Pittori, Scultori et Architetti Moderni.* Rome, 1672.

BELLORI 2005
G.P. Bellori. *The Lives of the Modern Painters, Sculptors and Architects* (1672), ed. A. Sedgwick Wohl, H. Wohl, and T. Montanari. Cambridge 2005.

BELTRAMME 2001
M. Beltramme. "La pala dei Palafrenieri: precisazioni storiche e ipotesi iconografiche su uno degli ultimi 'rifiuti' romani di Caravaggio." *Studi romani* 49 (2001), pp. 72–100.

BERGAMO 2000
F. Rossi, ed. *Caravaggio: la luce nella pittura lombarda* (exh. cat.). Milan, 2000.

BERTRAND and TROUVÉ 2003
P.F. Bertrand and S. Trouvé, eds. *Nicolas Tournier et la peinture caravagesque en Italie, en France et en Espagne* (conference proceedings). Département d'Histoire de l'Art et d'Archéologie de l'Université de Toulouse-Le Mirail, 7–9 June 2001. Toulouse, 2003.

BIENECK 1992
D. Bieneck. *Gerard Seghers, 1591–1651: Leben und Werk des Antwerpener Historienmalers.* Lingen, 1992.

BISSELL 1981
R.W. Bissell. *Orazio Gentileschi and the Poetic Tradition in Caravaggesque Painting.* University Park, 1981.

BISSELL 1999
R.W. Bissell. *Artemisia Gentileschi and the Authority of Art.* University Park, 1999.

BISSELL et al. 2005
R.W. Bissell et al. *Masters of Italian Baroque Painting. The Detroit Institute of Arts.* London, 2005.

BOBER and RUBENSTEIN 1986
P.P. Bober and R. Rubenstein. *Renaissance Artists and Antique Sculpture: A Handbook of Sources.* London and Oxford, 1986.

BOCCARDO et al. 2003
P. Boccardo, C. Di Fabio, and P. Sénéchal, eds. *Genova e la Francia. Opere, artisti, committenti, collezionisti.* Milan 2003.

BOLOGNA 1987
F. Bologna. "Alla ricerca del vero San Francesco in estasi di Michel Agnolo da Caravaggio per il cardinale Francesco Maria Del Monte." *Artibus et historiae* 8 (1987), pp. 159–177.

BOLOGNA 2006
F. Bologna. *L'incredulità del Caravaggio e l'esperienza delle "cose naturali,"* rev. ed. Milan, 2006.

BOSCHLOO 1974
A.W.A. Boschloo. *Annibale Carracci in Bologna: Visible Reality in Art after the Council of Trent.* Trans. R.R. Symonds. 2 vols. The Hague, 1974.

BOSTON 1999
F. Mormondo, ed. *Saints and Sinners* (exh. cat.). Boston, 1999.

BOTTARI and TICOZZI 1922–25
G. Bottari and S. Ticozzi. *Raccolta di lettere sulla pittura, scultura ed architettura.* 8 vols. Milan, 1922–25.

BOWCUTT BUTLER 1972
T. Bowcutt Butler. "Giulio Mancini's 'Considerations on Paintings'." Ph.d. diss. 2 vols. Cleveland, 1972.

BRAUNSCHWEIG 1987
A. Blankert and L.J. Slatkes, eds. *Holländische Malerei in neuem Licht : Hendrick ter Brugghen und seine Zeitgenossen.* Braunschweig, 1987.

BURKE 1987
P. Burke. *The Historical Anthropology of Early Modern Italy.* Cambridge, 1987.

C

CALVESI 1994
M. Calvesi. "Tra vastità di orizzonti e puntuali prospettiva. Il collezionismo di Scipione Borghese dal Caravaggio, al Reni e al Bernini." In *Galleria Borghese,* ed. A. Coliva. Rome, 1994, pp. 272–299.

CALVESI and ZUCCARI 2009
M. Calvesi and A. Zuccari. *Da Caravaggio ai Caravaggeschi.* Rome, 2009.

CAMPORESI 1980
P. Camporesi, ed. *Il Libro dei Vagabondi: Lo "speculum cerretanorum" di Teseo Pini, "Il vagabondo" di Rafaele Frianoro e altri testi di "furfanteria..* 2nd ed. Turin, 1980.

CAMPORI 1969
G. Campori. *Gli artisti italiani e stranieri negli Stati estensi. Catalogo storico corredato di documenti inediti par G. Campori* (Modena 1855). Facsimile edition. Rome 1969

CAPITELLI and VOLPI 1995
G. Capitelli and C. Volpi eds., *Caravaggio e il Caravaggismo :dal Corso di Storia dell'Arte Moderna I tenuta da Silvia Danesi Squarzina.* Università degli Studi di Roma "La Sapienza." Rome, 1995.

CAPPELLETTI 2009
F. Cappelletti. *Caravaggio: Un ritratto somigliante.* Milan, 2009.

CAPPELLETTI and TESTA 1994
F. Cappelletti and L. Testa. *Il trattenimento di virtuosi. La collezioni secentesche di quadri nei Palazzi Mattei di Roma.* Rome, 1994.

CAVAZZINI 2004
P. Cavazzini. "La diffusione della pittura nella Roma di primo Seicento: collezionisti ordinari e mercanti." *Quaderni storici* 116 (2004), pp. 353–374.

CAVAZZINI 2008
P. Cavazzini. *Painting as Business in Early Seventeenth-Century Rome.* University Park, PA, 2008.

CHORPENNING 1987
J.F. Chorpenning. "Another Look at Caravaggio and Religion." *Artibus et historiae* 8 (1987), pp. 149–158.

CHRISTIANSEN 1990
K. Christiansen. *A Caravaggio Rediscovered: The Lute Player* (exh. cat.). New York, 1990.

CINOTTI 1983
M. Cinotti. "Michelangelo Merisi detto il Caravaggio: Tutte le opere." *I pittori bergamaschi dal XIII al XIX secolo. Il Seicento.* I, pp. 203–641. Bergamo, 1983.

CINOTTI and NITTO 1975
M. Cinotti and C. Nitto, eds. *Novità sul Caravaggio: saggi e contributi.* Milan, 1975

CONISBEE 2009
P. Conisbee. *French Paintings of the Fifteenth through the Eighteenth Century.* The Collections of the National Gallery of Art Systematic Catalogue. Washington, 2009.

CONTINI 2002
R. Contini, *Seventeenth and Eighteenth-century Italian Painting: The Thyssen-Bornemisza Collection.* London 2002.

CORTI 1989
G. Corti. "Il "Registro de' mandati" dell'ambasciatore granducale Piero Guicciardini e la committenza artistica fiorentina a Roma nel secondo decennio del Seicento." *Paragone* 473 (1989), pp. 108–146.

COSTA RESTAGNO 2004
J. Costa Restagno. *Ottavio Costa (1554–1639). Le sue case e i suoi quadri.* Bordighera, 2004.

COZZI 1961
G. Cozzi. "Intorno al cardinale Ottavio Paravicino, a monsignor Paolo Gualdo e a Michelangelo da Caravaggio." *Rivista storica italiana* 73 (1961), pp. 36–68.

CRELLY 1962
W.R. Crelly. *The Painting of Simon Vouet.* New Haven, 1962.

CREMONA 1987
M. Gregori, ed. *Dopo Caravaggio: Bartolomeo Mangredi e la Mandrediana Methodus* (exh. cat.). Cremona, 1987.

CROPPER 1992
E. Cropper. "Vincenzo Giustiniani's Galleria: The Pygmalion Effect." In *Cassiano dal Pozzo's Paper Museum* 2. Milan, 1992, pp. 101–126.

CUMMINGS 1974
F.J. Cummings. "Detroit's 'Conversion of the Magdelen' (the Alzaga Caravaggio)." *The Burlington Magazine* 116 (1974), pp. 561–564.

CUZIN 1977
J-P. Cuzin. *La diseuse de bonne aventure de Caravage.* Paris, 1977.

D

D'ANCONA 1872
A. d'Ancona, ed. *Sacre rappresentazioni dei secoli XIV, XV e XVI.* 3 vols. Florence, 1872.

DANESI SQUARZINA 1997–98
S. Danesi Squarzina. "The Collections of Cardinal Benedetto Giustiniani." *Burlington Magazine* 139 (1997), pp. 766–791; 140 (1998), pp. 102–118.

DANESI SQUARZINA 2003
S. Danesi Squarzina. *La Collezione Giustiniani.* Milan 2003.

DE BENEDICTIS 1998
C. De Benedictis. *Per la storia del collezionismo italiano: fonti e documenti.* 2nd ed. Florence, 1998.

DE JONGH 1997
E. De Jongh and G. Luijten. *Mirror of Everyday Life: Genreprints in the Netherlands 1550–1700.* Amsterdam and Ghent, 1997.

DEKIERT 2003
M. Dekiert. *Musikanten in der Malerei der niederländischen Caravaggio-Nachfolge. Vorstufen, Ikonographie und Bedeutungsgehalt der Musikszene in der niederländischen Bildkunst des 16. und 17. Jahrhunderts* (Bonner Studien zur Kunstgeschichte 17). Münster, 2003.

DELLA PERGOLA 1959
P. Della Pergola. *Galleria Borghese. I Dipinti.* 2 vols. Rome, 1959.

E

EBERT-SCHIFFERER et al. 2007
S. Ebert-Schifferer et al. *Caravaggio e il suo ambiente: ricerche e interpretazioni* (Studi della Bibliotheca Hertziana, 3). Milan, 2007.

EEBERT-SCHIFFERER 2009
S. Ebert-Schifferer. *Caravaggio: Sehen – Staunen – Glauben; der Maler und sein Werk.* Munich 2009

ENGGASS 1967
R. Enggass. "Le virtù di un vero nobile. L'Amore Giustiniani di Caravaggio." *Palatino* 11 (1967), pp. 13–20.

ENGGASS and BROWN 1970
R. Enggass and J. Brown. *Italy and Spain 1600–1750: Sources and Documents.* Englewood Cliffs, NJ, 1970.

F

FANTONI et al. 2003
M. Fantoni, L.D. Matthew, and S.F. Matthews-Grieco, eds. *The Art Market in Italy (15th–17th Centuries) / Il mercato dell'arte in Italia (secc. XV–XVII).* Modena, 2003.

FARINA 2002
V. Farina. *Giovan Carlo Doria : promotore delle arti a Genova nel primo Seicento.* Florence 2002.

FERINO-PAGDEN 1996
S. Ferino-Pagden, ed. *Immagini del Sentire: I cinque sensi nell'arte* (exh. cat.). Milan, 1996.

FICACCI 1980
L. Ficacci. *Guy François (1578?–1650).* Rome, 1980.

FLORENCE 1991
M. Gregori, ed. *Michelangelo Merisi da Caravaggi: Come nascono I Capolavori* (exh. cat.). Florence, 1991.

FLORENCE 2010
G. Papi, ed. *Caravaggio e caravaggeschi a Firenze.* Florence, 2010.

FOUCART-WALTER 1982
E. Foucart-Walter. *Le Mans, Musée de Tessé: Peintures françaises du XVIIe siècle.* Paris, 1982.

FRANKLIN and GRITT 2008
D. Franklin and S. Gritt. "A New Painting for Ottawa by the Pensionante del Saraceni." *National Gallery of Canada Review.* VI (Ottawa, 2008), pp. 51–61.

FRIED 2010
M. Fried. *The Moment of Caravaggio.* Princeton, 2010.

FRIEDLAENDER 1955
W. Friedlaender. *Caravaggio Studies.* Princeton, 1955.

FROMMEL 1971
C.L. Frommel. "Caravaggios Fruewerk und der Kardinal Francesco del Monte." *Storia dell'arte*, 9/10 (1971), pp. 5–52.

FURLOTTI 2003
B. Furlotti, ed. *Le collezioni Gonzaga. Il carteggio tra Roma e Mantova (1587–1612).* Milan, 2003.

G

GALLO 1997
M. Gallo. *Orazio Borgianni Pittore Romano (1574–1616) e Francisco de Castro, conte di Castro.* Rome, 1997.

GARAS 1967
K. Garas. "The Ludovisi Collection of Pictures in 1633." *Burlington Magazine* 109 (1967), pp. 287–289, 339–349.

GENOA 2004
P. Boccardo, ed. *L'età di Rubens. Dimore, committenti e collezionisti genovesi* (exh. cat.). Genoa, 2004.

GILBERT 1995
C.E. Gilbert. *Caravaggio and His Two Cardinals.* University Park, PA, 1995.

GOLDTHWAITE 1993
R.A. Goldthwaite. *Wealth and the Demand for Art in Italy 1300–1600.* Baltimore and London, 1993.

GREGORI 1989
M. Gregori. "Il Sacrificio di Isacco : un inedito e considerazioni su una fase savoldesca del Caravaggio." *Artibus et Historiae* 20 (X), 1989, pp. 99–142.

GREGORI et al. 1994
M. Gregori et al., *Sofonisba Anguissola e le sue Sorelle* (exh. cat.). Rome, 1994.

GUARINO and MASINI 2006
S. Guarino and P. Masini. *Pinacoteca Capitolina: catalogo generale.* Rome, 2006.

H

HARTFORD 1998
C. Strinati, R. Vodret, and E.M. Zafran, eds. *Caravaggio and his Italian Followers: From the Collections of the Galleria Nazionale d'Arte Antica di Roma* (exh. cat.). Hartford, 1998.

HARTJE 2004
N. Hartje. *Bartolomeo Manfredi (1582–1622).* Weimar, 2004.

HASKELL and PENNY 1981
F. Haskell and N. Penny. *Taste and the Antique: the Lure of Classical Sculpture, 1500–1900.* New Haven, 1981.

HERMANN-FIORE 1989
K. Hermann-Fiore. "Il Bacco malato autoritratto del Caravaggio ed altre figure bacchiche degli artisti." In *Quaderni de Palazzo Venezia* 6 (1989), pp. 95–134.

HESS 1967
J. Hess. "Modelle e modelli del Caravaggio." In *Kunstgeschichtliche Studien zu Renaissance und Barock.* Vol. 1, pp. 275–288. Rome, 1967.

HIBBARD 1983
H. Hibbard. *Caravaggio.* New York and London, 1983.

J

JAUBERT 1998
A. Jaubert. *Palettes.* Paris, 1998.

JONES 1988
P.M. Jones. "Federico Borromeo as Patron of Landscapes and Still Lifes: Christian Optimism in Italy ca. 1600." *Art Bulletin* 70 (1988), pp. 261–272.

JONES 1993
P.M. Jones. *Federico Borromeo and the Ambrosiana: Art Patronage and Reform in Seventeenth-Century Milan.* Cambridge and New York, 1993.

JONES 1995
P.M. Jones. "Art Theory as Ideology: Gabriele Paleotti's Hierarchical Notion of Painting's Universality and Reception." In *Reframing the Renaissance: Visual Culture in Europe and Latin America 1450–1650,* ed. C. Farago. New Haven and London, 1995, pp. 127–139.

JONES 2004a
P.M. Jones. "Italian Devotional Paintings and Flemish Landscapes in the *Quadrerie* of Cardinals Giustiniani, Borromeo, and Del Monte." *Storia dell'arte* 107 (2004a), pp. 81–104.

JONES 2004b
P.M. Jones. "Reflections on Collecting in Rome and Milan in the Early Seicento: The *Quadrerie* of Cardinals Giustiniani, Del Monte, and Borromeo." *Studi Borromaica* 18 (2004b), pp. 223–235.

JONES and WORCESTER 2002
P.M. Jones and T. Worcester, eds. *From Rome to Eternity: Catholicism and the Arts in Italy, ca. 1550–1650.* Leyden, 2002.

JUDSON and EKKART 1999
J.R. Judson and R.E.O. Ekkart. *Gerrit van Honthorst, 1592–1656.* Doornspijk, 1999.

K

KATRITZKY 2006
M.A. Katritzky. *The Art of Commedia: A Study in the Commedia dell'arte 1560–1620 with Special Reference to the Visual Records.* Amsterdam and New York, 2006.

KAVANAGH 2005
T.M. Kavanagh. *Dice, Cards, Wheels:
A Different History of French Culture.*
Philadelphia, 2005.

KINNEY 1990
A.F. Kinney, ed. *Rogues, Vagabonds, & Sturdy
Beggars: A New Gallery of Tudor and Early
Stuart Rogue Literature Exposing the Lives,
Times, and Cozening Tricks of the Elizabethan
Underworld.* Amherst, 1990.

KIRWIN 1971
W.C. Kirwin. "Addendum to Cardinal
Francesco Maria del Monte's Inventory:
the Date of the Sale of Various Notable
Paintings." *Storia dell'arte* 9/10 (1971),
pp. 53–56.

KOLFIN 2005
E. Kolfin. *The Young Gentry at
Play: Northern Netherlandish Scenes of
Merry Companies, 1610–1645.* Trans.
M. Hoyle. Leiden, 2005.

KOVÁCS 2005
L. Kovács. "The Dramatisation of the
Parable of the Prodigal Son in Catalan
and European Sixteenth Century Drama."
In *Mainte belle oeuvre faicte: Études sur
le théâtre médiéval offertes à Graham A.
Runnalls,* ed. D. Hüe, M. Longtin, and
L. Muir, pp. 265–288. Orléans, 2005.

L

LASKIN and PANTAZZI 1987
M. Laskin and M. Pantazzi, eds. *Catalogue of
the National Gallery of Canada, Ottawa:
European and American Painting, Sculpture,
and Decorative Arts* I Ottawa, 1987.

LAVIN 1993
I. Lavin. *Past–Present: Essays on Historicism
in Art from Donatello to Picasso.* Berkeley,
Los Angeles, and Oxford, 1993.

LECCE 1996
C. Cieri Via, ed. *Immagini degli dei.
Mitologia e collezionismo tra '500 e '600*
(exh. cat.). Lecce, 1996.

LEMOINE 1999–2000
A. Lemoine. "Nicolas Régnier, 'peintre
domestique' du marquis Vincenzo
Giustiniani." *Actualité de l'histoire de l'art
italien en France* 6 (1999/2000), pp. 28–33.

LEMOINE 2007
N. Lemoine. *Nicolas Régnier (alias Niccolò
Renieri) c. 1588–1667: Peintre, collectionneur et
marchand d'art.* Paris, 2007.

LISCIA BEMPORAD 1988
D. Liscia Bemporad, ed. *Il costume nell'età
del Rinascimento.* Florence, 1988.

LOIRE 1992
S. Loire, ed. *Simon Vouet. Actes du colloque
international.* Paris, 1992.

LOIRE 2006
S. Loire. *Peinture italiennes du xviiᵉ siècle du
musée du Louvre: Florence, Gênes, Lombardie,
Naples, Rome et Venise.* Paris, 2006.

LONDON 1990
M. Bellamy, ed. *Three Eyes: The Old Master
Painting from Different Viewpoints* (exh. cat.).
London, 1990.

LONDON 2001
B.L. Brown, ed. *The Genius of Rome,
1592–1623* (exh. cat.). London, 2001.

LONDON 2005a
D. Jaffé and E. McGrath, eds. *Rubens:
A Master in the Making.* London, 2005.

LONDON 2005b
N. Spinosa, ed. *Caravaggio: The Final Years*
(exh. cat.). London, 2005.

LONDON 2006
M. Amjar-Wollheim and F. Dennis, eds.
At Home in Renaissance Italy (exh. cat.).
London, 2006.

LONGHI 1927
R. Longhi. "Precisazioni nelle gallerie
italiane. I.R. Galleria Borghese, Michelangelo
da Caravaggio."In *Vita artistica.* II:2 (1927),
pp. 28–35.

LONGHI 1943
R. Longhi. "Ultimi studi sul Caravaggio e
la sua cerchia." *Proporzioni* I (1943), pp. 5–63.

LORIZZO 2006
L. Lorizzo. *La collezione del cardinale Ascanio
Filomarino: pittura, scultura e mercato dell'arte
tra Doma e Napoli nel Seicento; con una nota
sulla vendita dei beni del cardinal Del Monte.*
Naples, 2006.

LYDECKER 1987
J.K. Lydecker. "The Domestic Setting of the
Arts in Renaissance Florence." Ph.D. diss.
The Johns Hopkins University, 1987.

M

MACCHERINI 1990–93
M. Maccherini. *Caravaggio e i caravaggeshi
nel carteggio familiare di Giulio Mancini.*
Ph.D. diss. Università degli studi di Roma
'La Sapienza'; Università degli studi di
Firenze; Università degli studi di Parma.
Dottorato di Ricerca in *Storia dell'Arte* Vᵉ
ciclo, 1990–93.

MACCHERINI 1997
M. Maccherini. "Caravaggio nel carteggio
familiare di Giulio Mancini." *Prospettiva* 86
(1997), pp. 71–92.

MACCHERINI 1999
M. Maccherini. "Novità su Bartolomeo
Manfredi nel carteggio familiare di Giulio
Mancini: lo 'Sdegno di Marte' e i quadri di
Cosimo II granduca di Toscana." *Prospettiva*
93/94 (1999), pp. 131–141.

MACCHERINI 2004
M. Maccherini. "Ritratto di Giulio
Mancini." In *Bernini dai Borghese ai*

Barberini. La cultura a Roma intorno agli anni venti; Atti del convegno, Accademia di Francia a Roma, Villa Medici, 17 – 19 febbraio 1999, ed. O. Bonfait. Rome, 2004, pp. 47–57.

MACIOCE 1996
S. Macioce, ed. Michelangelo Merisi da Caravaggio, la vita e le opere attraverso i documenti. Atti del Convegno Internazionale di Studi. Rome, 1996.

MACIOCE 2010
S. Macioce, ed., Michelangelo Merisi da Caravaggio. Documenti, foni e inventari 1513–1875. Il edizione correctta, integrata e aggionata. Rome 2010.

MADRID 2009
L. Ruiz Gomez, ed. Juan Bautista Maino, 1581–1649 (exh. cat.). Madrid, 2009.

MAGNUSSON 1982
T. Magnusson. Rome in the Age of Bernini. 2 vols. Stockholm, 1982.

MAHON 1951
D. Mahon. "Egregius in Urbe Pictor: Caravaggio Revised." The Burlington Magazine 93 (1951), pp. 223–235.

MAHON 1952
D. Mahon. "Addenda to Caravaggio." The Burlington Magazine 94 (Jan., 1952), pp. 2–23.

MAHON 1971
D. Mahon. Studies in Seicento Art and Theory [London, 1947]. Westport, CT, 1971.

MAHON 1988
D. Mahon, "Fresh Light on Caravaggio's Earliest Period: His 'Cardsharps' Recovered." The Burlington Magazine 130 (1988), p. 10–25.

MALVASIA 1678
C.C. Malvasia. Felsina Pittrice, vite de pittori bolognesi. 2 vols. Bologna, 1678.

MANCINI 1956–57
G. Mancini. Considerazioni sulla pittura. [Rome, 1618–21], ed. A. Marucchi. 2 vols. Rome, 1956–57.

MARINI 2001
M. Marini. Caravaggio "pictor praestantissimus": L'iter artistico completo di uno dei massimi rivoluzionari dell'arte di tutti i tempi. 3rd ed. Rome, 2001.

MARINI 2005
M. Marini, Caravaggio "pictor praestantissimus": L'iter artistico completo di uno dei massimi rivoluzionari dell'arte di tutti i tempi. Rome, 2005.

MARINI 2007
M. Marini, ed. Michelangelo da Caravaggio 1602: "La notte di Abramo" / Michelangelo da Caravaggio 1602: "The Night of Abraham." Rome, 2007.

MELLINKOFF 1993
R. Mellinkoff. Outcasts: Signs of Otherness in Northern European Art of the Late Middle Ages. 2 vols. Berkeley, 1993.

MILAN 1996
I capolavori della collezione Doria Pamphilj da Tiziano a Velázquez (exh. cat.). Milan, 1996.

MILAN 1998
F. Porzio, ed. Da Caravaggio a Ceruti: La scena di genere e l'immagine dei pitocchi nella pittura italiana (exh. cat.). Milan, 1998.

MILAN 2000
M. Bona Castellotti, ed. Tanzio da Varallo: realismo, fervore e contemplazione in un pittore del Seicento. Milan, 2000.

MILAN 2005
V. Sgarbi, ed. Caravaggio e l'Europa: Il movimento caravaggesco internazionale da Caravaggio a Mattia Preti (exh. cat). Milan, 2005.

MILAN 2008
D. Benati and A. Paolucci, eds. Caravaggio: I "Bari" della collezione Mahon (exh. cat.). Milan, 2008.

MODENA 1998
J. Bentini, ed. Sovrani passioni. Le raccolte d'arte della Ducale Galleria Estense (exh. cat.). Modena, 1998.

MOFFITT 2002
J.F. Moffitt. "Caravaggio and the Gypsies." Paragone, 623–625 (2002), pp. 129–156.

MOIR 1976
A. Moir. Caravaggio and his Copyists. New York, 1976.

MOJANA 1989
M. Mojana. Valentin de Boulogne. Milan, 1989.

MONTREAL 1993
M. Hilaire and P. Ramade et al. Century of Splendour: Seventeenth-century French Painting in French Public Collections (exh. cat.). Montreal, 1993.

MURTOLA 1604
G. Murtola. Rime, Cioè gli occhi d'Argo. Le lacrime. I pallori. I nei. I baci. Le Veneri. Gl'Amori. Venice, 1604.

N

NANTES 2008
B. Chavane and E. Guigon, eds. Simon Vouet (les années italiennes 1613/1627) [exh. cat.]. Nantes, 2008.

NAPLES 1992
N. Spinosa and A.E. Pérez Sánchez, eds. Jusepe de Ribera, 1591–1652 (exh. cat). Naples, 1992.

NEGRO and PIRONDINI 1994
E. Negro and M. Pirondini, eds. La scuola dei Carracci dall'accademia alla bottega di Ludovico. Modena, 1994.

NEW HAVEN 2004
A. Bayer, ed. *Painters of Reality: The Legacy of Leonardo and Caravaggio in Lombardy* (exh. cat.). New Haven, 2004.

NEW YORK 1985
M. Gregori et al. *The Age of Caravaggio* (exh. cat). New York, 1985.

NEW YORK 2001
K. Christiansen and J.W. Mann, eds. *Orazio and Artemisia Gentileschi* (exh. cat.). Rome / New York / St. Louis, 2001.

NICOLSON 1990
B. Nicolson. *Caravaggism in Europe,* rev. ed. 3 vols. Turin, 1990.

NOVA 1994
A. Nova. *Girolamo Romanino.* Turin, 1994.

O

O'NEILL 2002
M.S. O'Neill. *Giovanni Bagione: Artistic Reputation in Baroque Rome.* Cambridge, 2002.

ORE 1953
Ø. Ore. *Cardano. The Gambling Scholar,* trans. from the Latin of Cardano's *Book of Games of Chance* by S.H. Gould. Princeton, 1953.

O'REGAN 1994
N. O'Regan. *Institutional Patronage in Post-Tridentine Rome: Music at Santissima Trinità dei Pellegrini 1550–1650.* London, 1994.

OTTANI CAVINA 1968
A. Ottani Cavina. *Carlo Saraceni.* Milan, 1968.

OTTAWA 2009
D. Franklin, ed. *From Raphael to Carracci: The Art of Papal Rome.* Ottawa 2009.

P

PAPI 1993
G. Papi. *Orazio Borgianni.* Soncino, Cremona, 1993.

PAPI 1995
G. Papi. *Antiveduto Gramatica.* Soncino, Cremona, 1995.

PAPI 1999
G. Papi. *Gherardo delle Notti: Gerrit Honthorst in Italia.* Soncino, Cremona, 1999.

PAPI 2001
G. Papi. *Cecco del Caravaggio.* Soncino, Cremona, 2001.

PAPI 2003
G. Papi. *Spadarino.* Soncino, Cremona, 2003.

PAPI 2007
G. Papi. *Ribera a Roma.* Soncino, Cremona, 2001.

PARIS 1974
A. Brejon de Lavergnée and J.P. Cuzin, eds. *Valentin et les Caravagesques français* (exh. cat.). Paris 1974.

PARIS 1990
J. Thuillier, B. Brejon de Lavergnée, and D. Lavalle. *Vouet* (exh. cat.). Paris, 1990.

PARIS 1997
J-P Cuzin and P. Rosenberg, eds. *Georges de La Tour* (exh. cat.). Paris, 1997.

PASTOUREAU 2001
M. Pastoureau. *The Devil's Cloth: A History of Stripes and Striped Fabric,* trans. J. Gladding. New York, 2001.

PIRONDINI et al. 2002
E. Monducci. *Leonello Spada (1576–1622).* Manerba, Reggio Emilia, 2002.

PREIMESBERGER 1998
R. Preimesberger. "Golia e Davide." In *Docere delectare movere. Affetti, devozione e retorica nel linguaggio del primo barocco romano.* Rome 1998.

PRESSOUYRE 1984
S. Pressouyre. *Nicolas Cordier: recherches sur la sculpture à Rome autour de 1600.* 2 vols. Rome, 1984.

PRINZ 1988
W. Prinz. *Galleria. Storia e tipologia di una spazio architettonico,* ed. C. Cieri Via. Modena, 1988.

PROHASKA and SWOBODA 2010
W. Prohaska and G. Swoboda. *Caravaggio und der internationale Caravaggismus* (Sammlungskataloge des Kunsthistorischen Museum, 6), Vienna and Milan, 2010.

PUGLISI 1998
C. Puglisi. *Caravaggio.* London, 1998.

PUPILLO 1997
M. Pupillo. "Pauperismo e iconografia francescana nella pittura del Caravaggio: due contesti documentari." In *Arte francescana e pauperismo dalla Valle dell'Aniene: l'exemplum' di Subiaco. Atti delle giornate di studio.* Subiaco, 1997, pp. 152–168.

PUPILLO 1999
M. Pupillo. "Di nuovo intorno al cardinale Ottavio Paravicino, a monsignor Paolo Gualdo e a Michelangelo da Caravaggio: una lettura ritrovata." *Arte veneta* 54 (1999), pp. 164–169.

PUPILLO 2001
M. Pupillo. *La SS. Trinità dei Pellegrini di Roma. Artisti e committenti al tempo di Caravaggio.* Rome, 2001.

R

RALEIGH 1998
D.P. Weller, L.J. Slatkes, and R. Ward, eds. *Sinners & Saints: Darkness and Light: Caravaggio and his Dutch and Flemish Followers* (exh. cat.). Raleigh, 1999.

RICE 1997
L. Rice. *The Altars and Altarpieces of New St. Peter's: Outfitting the Basilica, 1621–1666.* Cambridge and New York, 1997.

RIEDL 1998
H.P. Riedl. *Antiveduto della Grammatica (1570/71–1626). Leben und Werk.* Berlin–Munich, 1998.

RIMINI 2010
M. Goldin and E.M. Zafran, eds. *Caravaggio e altri pittori del Seicento : capolavori dal Wadsworth Atheneum di Hartford.* Rimini, 2010.

ROMANO 1999
G. Romano, ed. *Percorsi caravaggeschi tra Roma e Piemonte.* Turin, 1999.

ROME 1990
L'arte per i papi e per i principi nella campagna romana: grande pittura del '600 e del '700 (exh. cat.). Rome, 1990.

ROME 1994
O. Bonfait, ed. *Roma 1630: Il trionfo del pennello* (exh. cat.). Rome, 1994.

ROME 1995a
R. Vodret, ed. *Caravaggio e la collezione Mattei* (exh. cat.). Rome, 1995.

ROME 1995b
A. Cottino, ed. *La natura morta al tempo di Caravaggio* (exh. cat). Rome, 1995.

ROME 1999
C. Strinati and R. Vodret, eds. *Caravaggio e i suoi: percorsi caravaggeschi in Palazzo Barberini.* Rome, 1999

ROME 2001
K. Christiansen and J.W. Mann, ed. *Orazio and Artemisia Gentileschi* (exh. cat.). Rome, 2001.

ROME 2008
F. Petrucci, ed. *Dalle collezioni romane. Dipinti e arredi in dimore nobiliari e raccolte private XVI–XVIII secolo* (exh. cat.). Rome, 2008.

ROME 2010
C. Strinati, ed. *Caravaggio* (exh. cat.). Rome, 2010.

ROME and BERLIN 2001
S. Danesi Squarzina, ed. *Caravaggio e i Giustiniani. Toccar con mano una collezioniste del Seicento* (exh. cat.). Milan, 2001.

RÖTTGEN 1974
H. Röttgen. *Il Caravaggio: ricerche e interpretazioni.* Rome, 1974.

RÖTTGEN 1993
H. Röttgen. "Quel diavolo è Caravaggio. Giovanni Baglione e la sua denuncia satirica dell'*Amore terreno.*" *Storia dell'arte* 79 (1993), pp. 326–340.

RÖTTGEN 2002
H. Röttgen. *Il Cavalier Giuseppe Cesari D'Arpino.* Rome, 2002.

ROWLANDS 1996
E.W. Rowlands. *Italian Paintings, 1300–1800.* Kansas City, MO, 1996.

S

SALERNO 1960
L. Salerno. "The Picture Gallery of Vincenzo Giustiniani." *Burlington Magazine* 102 (1960), pp. 21–27, 93–104, 135–148.

SANDRART 1675
J. von Sandrart. *Teutsche Academie der Bau-, Bild- und Mahlerey-Künste.* Nuremberg, 1675.

SCANNELLI 1657
F. Scannelli. *Il microcosmo della pittura overo Trattato diviso in due libri [1657]*, microfiche. Bologna, 1989.

SCHÜTZE 2009
S. Schütze. *Caravaggio: The Complete Works.* London, 2009.

SETTIS 1983
S. Settis. "Origine e significato delle gallerie in Italia." In *Gli Uffizi. Quattro secoli di una galleria. Atti del Convengo Internazionale di Studi, Firenze 20–24 settembre 1982*, ed. P. Barocchi and G. Ragioneri. Florence, 1983, pp. 309–317.

SHERMAN 2000
C.R. Sherman. *Writing on Hands: Memory and Knowledge in Early Modern Europe.* Carlisle, PA, 2000.

SICKEL 2003
L. Sickel. *Caravaggios Rom.* Berlin, 2003.

SICKEL 2006
L. Sickel. "Zwei römische Privatsammler des frühen Seicento. Ippolito Gricciotto, Paolo Mercati und die Nachfolger Caravaggios." In *Marburger Jahrbuch für Kunstgeschichte* XXXIII (2006), pp. 197–223.

SLATKES 1965
L.J. Slatkes. *Dirck van Baburen (c. 1595–1624): A Dutch Painter in Utrecht and Rome.* Utrecht, 1965.

SLATKES and FRANITS 2007
L.J. Slatkesa and W. Franits. *The Paintings of Hendrick ter Brugghen, 1588–1629* (cat. raisonné). Amsterdam, 2007.

SMITH 1992
E.L. Smith. *The Paintings of Lucas van Leyden.* Columbia, Missouri and London, 1992.

SOTHEBY'S 2000
Sotheby's. *Important Old Master Paintings* (January 28, 2000). New York, 2000.

SPARTI 2008
D.L. Sparti. "Novità du Giulio Mancini. Medicina, arte e presunta *Connoisseurship.*" *Mitteilungen des Kunsthistorischen Institutes in Florenz* 52 (2008), pp. 53–72.

SPEAR 1971
R.E. Spear, ed. *Caravaggio and His Followers* (exh. cat.). Cleveland, 1971.

SPEZZAFERRO 1974
H. Spezzaferro. "The Documentary Findings: Ottavio Costa as Patron of Caravaggio." *The Burlington Magazine*, 116 (1974), pp. 579–586.

SPEZZAFERRO 1998
L. Spezzaferro. "Nuove riflessioni sulla pala dei palafrenieri." In *La Madonna dei Palafrenieri di Caravaggio nella collezione di Scipione Borghese*, ed. A. Coliva. Venice, 1998, pp. 51–59.

SPEZZAFERRO 2009
L. Spezzaferro, ed. *Caravaggio e l'Europa: L'artista, la storia, la tecnica e la sua eredità. Atti del convengo internazionale di studi Milano 3 e 4 febbraio 2006.* Milan, 2009.

SPIKE 2001
J.T. Spike. *Caravaggio.* New York, 2001.

SPINOSA 2006
N. Spinosa. *Ribera: L'opera completa*, rev. ed. Naples, 2006.

STOCKHOLM 2010
R. Vodret, ed. *I doppi di Caravaggio : il mistero svelato dei due San Francesco in meditazione* (exh. cat.). Stockholm 2010. Published also in English: *Caravaggio: The Mystery of the Two Saint Francis in Meditation.*

SYDNEY 2003
E. Capon, ed. *Caravaggio & His World: Darkness & Light* (exh. cat.). Sydney, 2003.

SYRACUSE 2004
G. Grado and V. Abbate, eds. *Mario Minniti l'eredità di Caravaggio a Siracusa* (exh. cat.). Syracuse 2004.

T

TERZAGHI 2007
M.C. Terzaghi. *Caravaggio, Annibale Carracci, Guido Reni tra le ricevute del banco Herrera & Costa.* Rome, 2007.

TESTA 2004
L. Testa. "'Degna di esser uomo e di far nel pontificato e prime parti...' Olimpia Aldobbrandini senior: la collezione e i rapporti con gli artisti." In *Sul Carro di Tespi. Studi di Storia dell'arte per Maurizio Calvesi*, ed. S. Valeri. Rome, 2004, pp. 139–167.

THORNTON 1991
P. Thornton. *The Italian Renaissance Interior.* London and New York, 1991.

THORNTON 1997
D. Thornton. *The Scholar in His Study: Ownership and Experience in Renaissance Italy.* New Haven and London, 1997.

THUILLIER 1992
J. Thuillier. *Georges de La Tour.* Paris, 1992.

TOULOUSE 2001
A. Hémery, ed. *Nicolas Tournier, 1590–1639. Un peintre caravagesque* (exh. cat.). Toulouse, 2001.

TRINCHIERI CAMIZ 1991
F. Trinchieri Camiz. "Music and Painting in Del Monte's Household." *Metropolitan Museum Journal* 26 (1991), pp. 213–226.

TROY 1988
T. Troy. "Caravaggio and the Roman Oratory of Saint Philip Neri." *Studies in Iconography* (1988), pp. 61–89.

TULSA 1995
R.P. Townsend and R. Ward, eds. *Caravaggio and Tanzio: The Theme of St. John the Baptist* (exh. cat.). Tulsa and Kansas City, 1995.

V

VAN MANDER 1604
K. van Mander. *Het schilder-boeck waerin voor erst de leerlustighe lueght den grondt der edel vry schilderconst in verscheyden deelen wort voorgedraghen.* Haarlem 1604.

VARRIANO 1997
J. Varriano. "Leonardo's Lost Medusa and other Medici Medusas from the Tazza Farnese to Caravaggio." *Gazette des Beaux-Arts* 139 (1997), pp. 73–81.

VECELLIO 2008
C. Vecellio. *Cesare Vecellio's Habiti Antichi et Moderni: The Clothing of the Renaissance World*, trans. M.F. Rosenthal and A.R. Jones. London, 2008.

VENTURI 1882
A. Venturi. *La R. Galleria Estensi in Modena.* Modena, 1882.

VERSTEGEN 2003
I. Verstegen. "Federico Barocci, Federico Borromeo, and the Oratorian Orbit." *Renaissance Quarterly* 56 (2003), pp. 56–87.

VODRET 2010
R. Vodret. *Caravaggio: The Complete Works.* Milan, 2010.

VOLPI 2002
C. Volpi, ed. *Caravaggio nel IV Centenario della Cappella Contarelli. Atti del Convegno Internazionale di Studi, Roma, 24–26 Maggio 2001.* Rome, 2002.

VON BERNSTORFF 2010
M. von Bernstorff. *Agent und Maler als Akteure im Kunstbetrieb des frühen 17. Jahrhunderts:*

Giovan Battista Crescenzi und Bartolomeo Cavarozzi. Römische Studien der Bibliotheca Hertziana, 28. Munich, 2010.

W

WADDY 1990
P. Waddy. *Seventeenth-Century Roman Palaces: Use and Art of the Plan.* New York, 1990.

WARSAW 1990
J. Grabski. *Opus Sacrum: Catalogue of the Exhibition from the Collection of Barbara Piasecka Johnson.* Warsaw, 1990.

WARWICK 2006
G. Warwick, ed. *Caravaggio: Realism, Rebellion, Reception* Newark, 2006.

WASHINGTON 1996
P. Conisbee, ed. *Georges de La Tour and His World* (exh. cat.). Washington, 1996.

WAŹBIŃSKI 1994
Z. Waźbiński. *Il cardinale Francesco Maria del Monte 1549–1626.* 2 vols. Florence, 1994.

WELLER 2009
D.P. Weller. *Seventeenth-Century Dutch and Flemish Paintings* (coll. cat.). Raleigh, 2009.

Z

ZERI 1959
F. Zeri. *La galleria Pallavicini in Roma. Catalogo dei dipinti.* Florence, 1959.

ZERI 1976
F. Zeri. *Italian Paintings in the Walters Art Gallery.* Baltimore, 1976.

ZUCCARI 1981a
A. Zuccari. "La politica culturale dell'Oratorio Romano della seconda metà del Cinquecento." *Storia dell'arte* 41 (1981), pp. 77–112.

ZUCCARI 1981b
A. Zuccari. "La politica culturale dell'Oratorio Romano nelle imprese artistiche promosse da Cesare Baronio." *Storia dell'arte* 42 (1981), pp. 171–193.

ZUCCARI 1984
A. Zuccari. *Arte e committenza nella Roma di Caravaggio.* Turin, 1984.

ZUCCARI 1999
A. Zuccari. "Un carteggio di Francesco M. Del Monte e alcune notazioni sul *Martirio di san Matteo* del Caravaggio." *Storia dell'arte* 93/94 (1999), pp. 292–302.

ZUCCARI 2010
A. Zuccari, ed. *I Caravaggeschi: percorsi e protagonisti.* 2 vols. Milan, 2010.

PHOTOGRAPH CREDITS

All photographs have been provided by the owner or custodian of the works reproduced, except where noted below:

CATALOGUE

Alinari/Art Resource, NY 31
Archivio Collezione Koelliker 51
Archivio Fotografico del Centro di Documentazione per la Storia, l'Arte e l'Immagine di Genova 59
Archivio Fotografico Museo Civico ala Ponzone 26
Bridgeman Art Library International 47
Digital Image © 2009 Museum Associates/LACMA/Art Resource, NY 11
Divisão de Documentação Fotográfica – Instituto dos Museus e da Conservação, I.P. 10
Image © The Metropolitan Museum of Art/Art Resource, NY 1
Kimbell Art Museum, Fort Worth, Texas/Art Resource, NY 17, 24
Kunstmuseum Basel, Photo Martin P. Bühler 39
Erich Lessing/Art Resource, NY 8, 57
Musées de la Ville de Strasbourg, Photo N. Fussler 36
Image courtesy National Gallery of Art, Washington 20
Photo © 2010 AGO 35
Photo © 2011 The Philbrook Museum of Art, Inc., Tulsa, Oklahoma 40

Photo © English Heritage Photo Library 5
Photo © Museo Thyssen-Bornemisza, Madrid 58
Photo © NGC 14, 42, 45, 60
Photo Jamison Miller 25
Photo Jaques Lathion 49
Photo Rick Hall 12
Photography © The Art Institute of Chicago 29
Réunion des Musées Nationaux/Art Resource, NY 7
Royal Cabinet of Paintings Mauritshuis The Hague 56
Scala/Art Resource, NY 13, 52
Scala/Ministero per i Beni e le Attività Culturali/Art Resource, NY 2, 50
Su concessione del Ministero per i Beni e le Attività Culturali – Archivio Fotografico della SBSAE di Modena e Reggio Emilia 15, 19
Vatican Museums 23
Wadsworth Atheneum Museum of Art/Art Resource, NY 27, 41
Whitfield Fine Art 37

FIGURES

Alinari/Art Resource, NY 23, 65, 86
Archivio Fotografico Soprintendenza Speciale P.S.A.E. e Polo Museale della città di Roma 8, 19, 25, 28–29, 34–35, 53, 69
Benito Navarrete 32
bpk Berlin/Art Resource, NY 3a, 14, 22, 45, 75, 78

Bridgeman Art Library International 52, 60
Erich Lessing/Art Resource, NY 2, 3b, 38, 40–41, 51, 73
Image © The Metropolitan Museum of Art/Art Resource, NY 47
Musées, Ville de Bourges 64
Per concessione della Soprintendenza per i Beni Storici Artistici ed Etnoantropologici dell'Umbria 37
Per gentile concessione del Ministero per i Beni e le Attività Culturali 55
Photo © The British Library Board. All Rights Reserved (685.b.7(1) folio C7) 58
Photo © CMU/Ernst Moritz 20
Photo © Museo Thyssen-Bornemisza, Madrid 70
Photo © National Gallery, London/Art Resource (NY) 72, 77
Photo © National Gallery of Ireland 88
Photo Hans-Peter Klut 61
Photograph courtesy of The Metropolitan Museum of Art/Image © The Metropolitan Museum of Art 50
Photography © The Art Institute of Chicago 24, 48
Réunion des Musées Nationaux/Art Resource, NY 9
Scala/Art Resource, NY 1, 4–7, 10, 16–18, 21, 39, 44, 49, 59, 76, 83–84, 89
Vatican Museums 12, 36
Whitfield Fine Art 66